Ps **Adobe Photoshop**

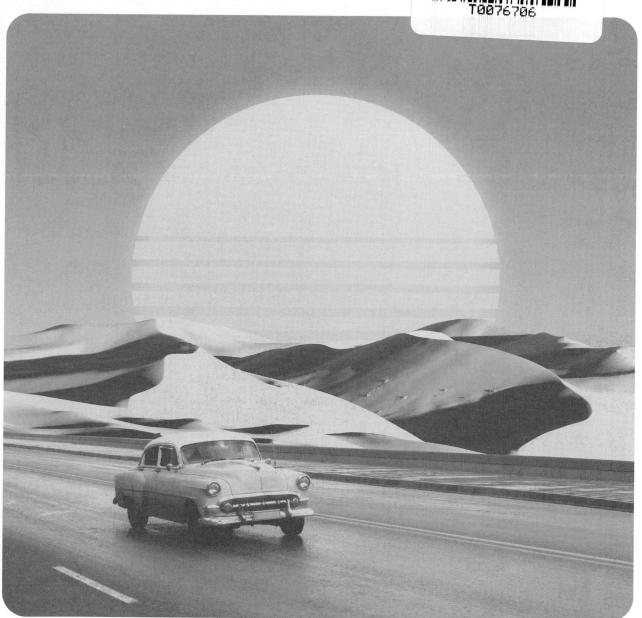

Classroom in a Book®

The official training workbook from Adobe

Conrad Chavez

3 2023

WHERE ARE THE LESSON FILES?

Purchase of this Classroom in a Book in any format gives you access to the lesson files you'll need to complete the exercises in the book.

1 Go to adobepress.com/PhotoshopCIB2023.

2 Sign in or create a new account.

3 Click Submit.

4 Answer the questions as proof of purchase.

5 The lesson files can be accessed through the Registered Products tab on your Account page.

6 Click the Access Bonus Content link below the title of your product to proceed to the download page. Click the lesson file links to download them to your computer.

CONTENTS

GETTING STARTED

Adobe® Photoshop®, the benchmark for digital imaging excellence, provides professional image editing features enhanced by machine learning and cloud integration. Photoshop supports a wide range of workflows including print, web, and video. Photoshop gives you the digital editing tools you need to transform images more easily than ever before.

Photoshop works with other important tools that you'll use in this book. Adobe Camera Raw, included with Photoshop, helps you get the most quality out of camera raw images. Adobe Bridge is a digital asset manager that helps you browse and organize files you want to use with Photoshop and other Adobe Creative Cloud applications.

About Classroom in a Book

Adobe Photoshop Classroom in a Book® (2023 release) is part of the official training series for Adobe graphics and publishing software, developed with the support of Adobe product experts. The lessons are designed to let you learn at your own pace. If you're new to Adobe Photoshop, you'll learn the fundamental concepts and features you'll need to master the program. And if you've been using Adobe Photoshop for a while, you'll find that Classroom in a Book teaches many advanced features, including tips and techniques for using the latest version of the application and preparing images for the web.

Although each lesson provides step-by-step instructions for creating a specific project, there's room for exploration and experimentation. You can follow the book from start to finish or do only the lessons that match your interests and needs. Each lesson concludes with a review section summarizing what was covered.

What's new in this edition

This edition covers new features in Adobe Photoshop, such as improved selection tools, updated Neural Filters, and new masking features in Adobe Camera Raw.

This edition also includes many new tips about working effectively with this robust and professional application. You'll learn best practices for organizing, managing, and showcasing your photos, as well as how to optimize images for the web. And throughout this edition, look for tips and techniques from one of Adobe's own experts, Photoshop evangelist Julieanne Kost.

Prerequisites

Before you begin to use *Adobe Photoshop Classroom in a Book (2023 release)*, you should have a working knowledge of your computer and its operating system. Make sure that you know how to use the mouse and standard menus and commands, and also how to open, save, and close files. If you need to review these techniques, see the documentation for your Microsoft® Windows® PC or Apple® Mac® computer.

To complete the lessons in this book, you'll need Adobe Photoshop (2023 release) and Adobe Bridge 2023 installed on your computer. The exact version number of the software is different than the year in the application name; this book was specifically tested using Photoshop version 24.0, Bridge version 12.0, and Camera Raw 15.0:

- To find the version of Photoshop that you are running, choose Help > System Info and look at the first line (Adobe Photoshop Version).

- To find the version of Bridge that you are running, choose Help > About Bridge (Windows) or Adobe Bridge > About Bridge (macOS) and look at the first line in the window that opens.

- To find the version of Camera Raw that you are running, look in the Camera Raw window title bar when Camera Raw is open.

If your versions of those applications are older, you may be able to get the versions matching this book by opening the Creative Cloud desktop application and clicking the Updates button. If newer versions don't appear in the Updates list, see if your computer meets the current system requirements because they may have changed.

If your versions are newer and don't match some of the steps in this book, you may be able to install a version matching this book; see "Installing a different version."

● **Note:** The official version numbers of Adobe applications don't necessarily align with years because many existed before the year was part of the name. For example, Photoshop was released in 1990 as version 1, and the year did not appear in the name until Photoshop CC 2014, which was officially version 15.

Installing Adobe Photoshop, Adobe Bridge, and Adobe Camera Raw

Before you begin using *Adobe Photoshop Classroom in a Book (2023 release)*, make sure that your system is set up correctly and that you've installed the required software and hardware. You must license the Adobe Photoshop software separately. For system requirements and complete instructions on installing the software, visit helpx.adobe.com/photoshop/system-requirements.html.

● **Note:** For Windows, a 64-bit operating system is required. (All supported versions of macOS are already 64-bit.)

In the Photoshop system requirements, system memory (also called *random access memory* or *RAM*) is used by the operating system and applications. The graphics processing unit (GPU) of your computer needs its own memory (also called *graphics memory*, *video RAM,* or *VRAM*) for things such as GPU acceleration. If your computer has *discrete graphics* hardware (also called a *dedicated GPU or video card*), that hardware has its own graphics memory. If your computer has *integrated graphics* (more common in lower-cost computers and laptop computers), its graphics memory is subtracted from system memory. Photoshop can use discrete or integrated graphics.

Many of the lessons in this book use Adobe Bridge, and one lesson uses Adobe Camera Raw. You install Photoshop and Bridge on your computer using the Adobe Creative Cloud desktop application, available at adobe.com/creativecloud/desktop-app.html; follow the onscreen instructions. Adobe Camera Raw is automatically installed when you install Photoshop.

Installing a different version

If your version of Photoshop, Bridge, or Camera Raw is newer than those used in this edition of Classroom in a Book and works differently than in the lessons, you may be able to install a compatible version using the Creative Cloud desktop application:

● **Note:** You can use the Creative Cloud desktop application to install the two most recent major versions of an application; for example, if the current version is 22, you can install version 22 or 21.

1 Start the Creative Cloud desktop application, and in the All Apps section, click the ... menu and choose Other Versions.

2 Find the versions of the software listed in "Prerequisites," and click Install for each of those versions.

Adobe Camera Raw is not in the list because it's updated automatically. To install an older version of Camera Raw, download its installer from:

helpx.adobe.com/camera-raw/kb/camera-raw-plug-in-installer.html

Installing fonts

Some lessons in this book may suggest specific fonts. If a suggested font is not installed on your computer, you may be able to sync it to your computer using Adobe Fonts, which is part of a personal Creative Cloud subscription. (Adobe Fonts might not be included in some educational or organizational subscriptions.) To activate a font from Adobe Fonts and sync it to your computer while in Photoshop, choose Type > More from Adobe Fonts and follow the directions.

Starting Adobe Photoshop

You start Photoshop just as you do most software applications.

To start Adobe Photoshop in Windows: Click the Start button in the taskbar, and in the alphabetical list under A, click Adobe Photoshop 2023.

To start Adobe Photoshop on a Mac: Click the Adobe Photoshop 2023 icon in the Launchpad or Dock.

If you don't see Adobe Photoshop, type **Photoshop** into the search box in the taskbar (Windows) or in Spotlight search (macOS), and when the Adobe Photoshop 2023 application icon appears, select it, and press Enter or Return.

Online content

Your purchase of this Classroom in a Book includes the following online materials provided on your Account page on adobepress.com.

Lesson files

To work through the projects in this book, you will need to download the lesson files by following the instructions on the next page.

Web Edition

The Web Edition is an online interactive version of the book providing an enhanced learning experience. Your Web Edition can be accessed from any device with a connection to the Internet, and it contains:

- The complete text of the book
- Hours of instructional video keyed to the text
- Interactive quizzes

Accessing the lesson files and Web Edition

You must register your purchase on adobepress.com to access the online content:

1 Go to adobepress.com/PhotoshopCIB2023.

2 Sign in or create a new account.

3 Click Submit.

4 Answer the question as proof of purchase.

5 The lesson files can be accessed from the Registered Products tab on your Account page. Click the Access Bonus Content link below the title of your product to proceed to the download page. Click the lesson file link(s) to download them to your computer.

The Web Edition can be accessed from the Digital Purchases tab on your Account page. Click the Launch link to access the product.

● **Note:** If you purchased a digital product directly from adobepress.com or peachpit.com, your product will already be registered. However, you still need to follow the registration steps and answer the proof of purchase question before the Access Bonus Content link will appear under the product on your Registered Products tab.

Restoring default preferences

Like many applications, Adobe Photoshop stores various general settings in a document called a *preferences file*. Each time you quit Photoshop, certain workspace settings (such as the last-used options for some tools and commands) are recorded in the preferences file. Any changes you make in the Preferences dialog box are also saved in the preferences file.

To ensure that what you see onscreen matches the images and instructions in this book, you should restore the default preferences as described at the beginning of each lesson. If you choose to not reset your preferences, be aware that the tools, panels, and other settings in Photoshop may not match those described in this book.

If you have changed the settings in the Edit > Color Settings dialog box, those settings are saved in a different location than the Preferences file, so use the following procedure to save them as a preset before you start work using this book. When you want to restore your color settings, you can simply select the preset you created.

▶ **Tip:** Color Settings can affect whether you see color profile alert messages when you open a document or paste content in Photoshop. One clue that color settings were altered is that profile alerts appear when they previously didn't, or they no longer appear when they used to.

To save your current color settings:

1 Start Adobe Photoshop.

2 Choose Edit > Color Settings.

3 Note what is selected in the Settings menu:

 - If it is anything other than Custom, write down the name of the settings file, and click OK to close the dialog box. You do not need to perform steps 4–6 of this procedure.

 - If Custom is selected in the Settings menu, click Save (*not* OK).

The Save dialog box opens. The default location is the Settings folder, which is where you want to save your file. The default filename extension is .csf (color settings file).

4 In the File Name field (Windows) or Save As field (macOS), type a descriptive name for your color settings, preserving the .csf file extension. Then click Save.

5 In the Color Settings Comment dialog box, type any descriptive text that will help you identify the color settings later, such as the date, specific settings, or your workgroup.

6 Click OK to close the Color Settings Comment dialog box, and again to close the Color Settings dialog box.

To restore your color settings:

1 Start Adobe Photoshop.

2 Choose Edit > Color Settings.

3 From the Settings menu in the Color Settings dialog box, choose the settings file you noted or saved in the previous procedure, and click OK.

Additional resources

Adobe Photoshop Classroom in a Book (2023 release) is not meant to replace documentation that comes with the program or to be a comprehensive reference for every feature. Only the commands and options used in the lessons are explained in this book. For comprehensive information about program features and tutorials, refer to these resources:

Home screen: In Photoshop, the Learn section of the Home screen offers tutorials.

Search command: Choose Edit > Search to open the Discover panel, which offers a wealth of tutorials, suggestions, and links before you even enter a search term. If you enter a term (such as "crop") and press Enter or Return, the Discover panel can highlight relevant Photoshop tools and commands for you and provides links to more information.

▶ **Tip:** If you find that the Discover panel (Edit > Search) is useful, consider memorizing its keyboard shortcut in Photoshop: Press Ctrl+F (Windows) or Command+F (macOS). To close the panel, press the shortcut again.

Adobe Photoshop Help and Support: Choose Help > Photoshop Help to open the Discover panel with a list of online help resources including the User Guide and Support Community. You can also use your web browser to go to helpx.adobe.com/support/photoshop.html to find Help and Support content on Adobe.com.

Photoshop tutorials: Choose Help > Hands-On Tutorials to open the Discover panel with a list of guided lessons. Follow along in Photoshop with the provided sample documents. To find more tutorials online, go to helpx.adobe.com/photoshop/tutorials.html.

Photoshop blog: blog.adobe.com/en/topics/photoshop brings you tutorials, product news, and inspirational articles about using Photoshop.

Julieanne Kost's blog: jkost.com/blog/ is where veteran Adobe product evangelist Julieanne Kost posts useful tips and videos that introduce and provide valuable insights on the latest Photoshop features.

Adobe Support Community: community.adobe.com lets you tap into user forums where you can ask questions about Photoshop and other Adobe applications.

Adobe Photoshop product home page: Find product information at adobe.com/products/photoshop.html.

Plug-ins menu: To find add-on "plug-in" software modules to extend and add features to your Creative Cloud tools, in Photoshop choose Plugins > Browse Plugins.

Creative Cloud desktop application: Click Discover to see tutorials, online streaming video, inspirational examples of creative work, and other links and resources for Photoshop and other Adobe applications you have installed.

Resources for educators: adobe.com/education and edex.adobe.com offer a treasure trove of information for instructors who teach classes on Adobe software. Find solutions for education at all levels, including free curricula that use an integrated approach to teaching Adobe software and can be used to prepare for the Adobe Certified Associate exams.

> **Tip:** You'll see the same Creative Cloud learning resources (and access to your work stored on Creative Cloud servers) when you use the Creative Cloud mobile app or when you're signed into creative.adobe.com.

Adobe Authorized Training Centers

Adobe Authorized Training Centers offer instructor-led courses and training on Adobe products.

A directory of AATCs is available at learning.adobe.com/partner-finder.html.

1 GETTING TO KNOW THE WORK AREA

Lesson overview

In this lesson, you'll learn how to do the following:

- Open image files in Adobe Photoshop.

- Select and use tools in the Tools panel.

- Set options for a selected tool using the options bar.

- Use various methods to zoom in to and out from an image.

- Select, rearrange, and use panels.

- Choose commands in panel and context menus.

- Open and use a panel in the panel dock.

- Undo actions to correct mistakes or to make different choices.

 This lesson will take about an hour to complete. To get the lesson files used in this chapter, download them from the web page for this book at adobepress.com/PhotoshopCIB2023. For more information, see "Accessing the lesson files and Web Edition" in the Getting Started section at the beginning of this book.

As you work on this lesson, you'll preserve the start files. If you need to restore the start files, download them from your Account page.

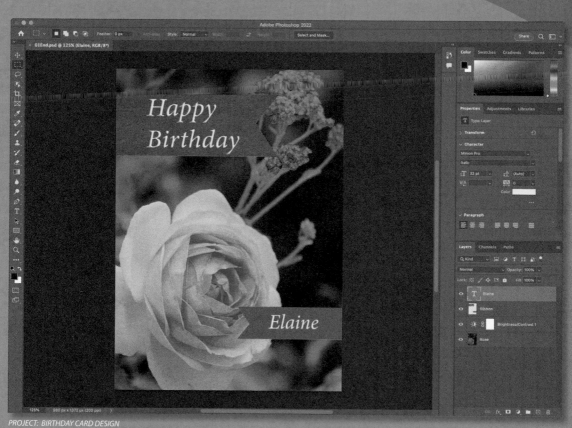

PROJECT: BIRTHDAY CARD DESIGN

As you work with Adobe Photoshop, you'll discover that you can often accomplish the same task in several ways. To make the best use of the extensive editing capabilities in Photoshop, you must first learn to navigate the work area.

Starting to work in Adobe Photoshop

The Adobe Photoshop work area includes menus, toolbars, and panels that give you quick access to tools and options for editing and adding elements to your image. You can also add features by installing third-party software known as *plug-ins*.

In Photoshop, you primarily work with bitmapped digital images: continuous-tone images that have been converted into a series of small squares, or picture elements, called *pixels*. You can also work with vector graphics, which are drawings made of smooth lines that retain their crispness when scaled. You can create original artwork in Photoshop, or you can import images from many sources, such as:

- Photographs from a digital camera or mobile phone

- Stock photography, such as images from the Adobe Stock service

- Scans of photographs, transparencies, negatives, graphics, or other documents

- Captured video clips

- Artwork created in drawing or painting programs

Starting Photoshop

● **Note:** Typically, you won't need to reset defaults when you're working on your own projects. However, you'll reset the preferences before working on most lessons in this book to ensure that what you see onscreen matches the descriptions in the lessons. For more information, see "Restoring default preferences" on page 5.

To begin, you'll start Adobe Photoshop and reset the default preferences.

1 Click the Adobe Photoshop 2023 icon in your Start menu (Windows) or the Launchpad or Dock (macOS), and then simultaneously hold down Ctrl+Alt+Shift (Windows) or Command+Option+Shift (macOS) to reset the default settings.

If you don't see Adobe Photoshop 2023, type **Photoshop** into the search box in the taskbar (Windows) or in Spotlight (macOS), and when the Adobe Photoshop 2023 application icon appears, select it, and press Enter or Return.

2 When prompted, click Yes to confirm that you want to delete the Adobe Photoshop Settings file.

Using the Home screen

After starting Photoshop, the first thing you see is the Home screen, which gives you a number of ways to get started, as shown in the following illustration.

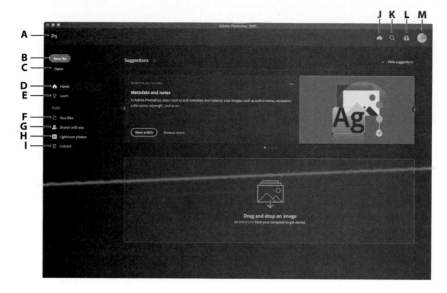

A. Switch to Photoshop workspace
B. Create new document
C. Open document
D. Home screen content and recently opened local documents
E. Learn with tutorials
F. Cloud Documents you created on Windows, Mac, or iPad
G. Cloud Documents shared with you
H. Your photos in the Lightroom cloud
I. Deleted Cloud Documents
J. Cloud storage sync status
K. Search, Help, and Learn
L. What's New in Photoshop
M. Visit your Creative Cloud account in a web browser

On the left you see a list of view options:

- **Home** helps you use and learn about the current version and includes a tour. After you've opened at least one locally stored document, a Recent section of previously opened documents will appear at the bottom of the Home screen.

- **Learn** presents links to tutorials that open in Photoshop, where the Learn panel leads you through a lesson's steps that you follow using Photoshop itself.

- **Your Files** lists Photoshop Cloud Documents, including those you created on devices such as an iPad. You'll learn more about Cloud Documents in Lesson 3, "Working with Selections."

- **Shared with You** lists Cloud Documents that others have invited you to see by using the File > Invite command.

- **Lightroom Photos** lists images synced to your Creative Cloud account's Lightroom online photo storage (not Lightroom Classic local storage).

- **Deleted** lists Cloud Documents you've deleted, in case you change your mind and want to recover them (similar to the Recycle Bin or Trash on your computer desktop). This list includes Cloud Documents only, not files you deleted from Lightroom Photos or from your computer's local storage.

When you click the Search icon in the upper-right corner and enter text, Photoshop looks for matching content in the Learn tutorials about Photoshop and in Adobe Stock images. When a document is open, the Search icon can also find specific

▶ **Tip:** To skip past the Home screen and go straight to the Photoshop application workspace, click the Photoshop icon in the upper-left corner.

▶ **Tip:** To manage files in the Deleted list, click the ellipsis (…) button next to a file, and choose Restore or Permanently Delete.

commands and tools in Photoshop and can find content in your cloud-synced Lightroom images. For example, enter "bird" to find your Lightroom cloud photos that contain birds.

The Home screen automatically hides when you open a document, which is what you're going to do next. You can return to the Home screen by clicking the Home icon in the upper-left corner of the application window.

Open a document

Photoshop provides a number of ways to open documents. For this lesson, you'll use the traditional Open command, which works like the Open command you've probably used in other applications.

► **Tip:** If you drag and drop a compatible file anywhere on the Home screen, Photoshop will open it.

1 Choose File > Open. If a dialog box appears that says Cloud Documents at the top, click On Your Computer at the bottom of the dialog box.

2 Navigate to the Lessons/Lesson01 folder that you copied to your hard drive from the peachpit.com website. (If you haven't downloaded the files, see "Accessing the lesson files and Web Edition" on page 4.)

3 Select the 01End.psd file, and click Open. Click OK if the Embedded Profile Mismatch dialog box appears, and click No if a message about updating text layers appears.

The 01End.psd file opens in its own window, in the default Photoshop workspace. The end files in this book show you what you are creating in each project. In this project, you'll create a birthday card.

A. *Options bar*
B. *Switch to Home screen*
C. *Tools panel*
D. *Share button*
E. *Search, Help, and Learn*
F. *Workspaces menu*
G. *Panels*

● **Note:** This illustration shows the Mac version of Photoshop. The arrangement is similar on Windows, but operating system styles may vary.

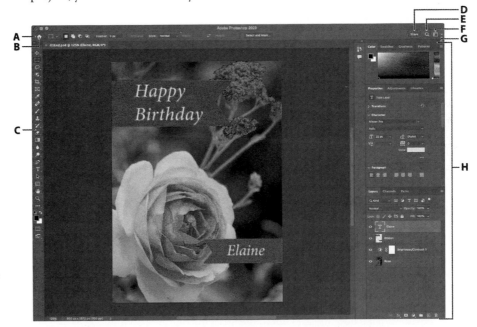

The default workspace in Photoshop consists of the menu bar and options bar at the top of the screen, the Tools panel on the left, and several open panels in the panel dock on the right. When you have documents open, one or more document windows also appear, and you can display them at the same time using the tabbed interface. The Photoshop user interface is similar to the one in Adobe Illustrator® and Adobe InDesign®, so learning how to use the tools and panels in one application makes it easier to learn and use the other applications.

There is one main difference between the Photoshop work area on Windows and that on the Mac: Windows always presents Photoshop in a contained window. On macOS, you can choose whether to work with an *application frame*, which contains the Photoshop document windows and panels within a frame that is distinct from other applications you may have open; only the menu bar is outside the application frame. The application frame is enabled by default; to disable the application frame, choose Window > Application Frame, but note that the illustrations in this book are created with the application frame enabled.

4 Choose File > Close, or click the close button (the x next to the filename) on the tab of the document window. Do not close Photoshop, and don't save changes to the document. The filename is added to the Recent list on the Home screen.

▶ **Tip:** When you open multiple documents in Photoshop, each is identified by a tab at the top of its document windows, similar to the tabbed windows in a web browser.

Using the tools

Photoshop provides an integrated set of tools for producing sophisticated graphics for print, web, and mobile viewing. We could easily fill the entire book with details about the wealth of Photoshop tools and tool configurations, but that's not the goal of this book. Instead, you'll gain experience by using a few important tools on a sample project. Every lesson will introduce you to more tools and ways to use them. By the time you finish all the lessons in this book, you'll have a solid foundation for exploring other parts of Photoshop.

Selecting and using a tool from the Tools panel

The Tools panel is the tall, narrow panel on the left side of the work area. It contains selection tools, painting and editing tools, foreground- and background-color selection boxes, and viewing tools.

You'll start by using the Zoom tool, which also appears in many other Adobe applications, including Illustrator, InDesign, and Acrobat.

1 Choose File > Open, navigate to the Lessons/Lesson01 folder, and double-click the 01Start.psd file to open it.

● **Note:** For a complete list of the tools in the Tools panel, see the appendix, "Tools panel overview."

The 01Start.psd file contains the background image and a ribbon graphic that you'll use to create the birthday card that you viewed in the end file.

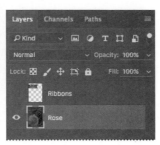

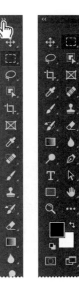

▶ **Tip:** You can customize the Tools panel by arranging, removing, and adding tools. To do this, hold down the Edit Toolbar icon (•••) that appears after the Zoom tool, and choose Edit Toolbar.

2 Click the double arrows just above the Tools panel to toggle to a double-column view, which may be better for smaller displays such as those on laptops. Click the double arrows again to return to a single-column Tools panel, which might use space more efficiently on a large desktop display.

3 Examine the status bar at the bottom of the work area (Windows) or document window (macOS), and notice the percentage that appears on the far left. This represents the current enlargement view of the image, or zoom level.

4 Move the pointer over the Tools panel, and hover it over the magnifying-glass icon until a tool tip appears. The tool tip displays the tool's name (Zoom tool) and keyboard shortcut (Z).

Zoom level Status bar

100% 980 px x 1372 px (200 ppi) ⟩

▶ **Tip:** To select the Zoom tool using a keyboard shortcut, press the Z key. Tool shortcuts are single keys (do not press modifier keys such as Ctrl or Command). If a tool has a keyboard shortcut, you'll see it in the pop-up tool tip.

5 Click the Zoom tool icon (🔍) in the Tools panel to select it.

6 Move the pointer over the document window. The pointer now looks like a tiny magnifying glass with a plus sign in the center of the glass (🔍).

7 Click anywhere in the document window.

▶ **Tip:** The zoom percentage also appears in the document tab.

The image enlarges to a preset percentage level, which replaces the previous value in the status bar. If you click again, the zoom advances to the next preset level, up to a maximum of 12800%.

8 Hold down the Alt key (Windows) or Option key (macOS) so that the Zoom tool pointer appears with a minus sign in the center of the magnifying glass (⊖), and then click anywhere in the image. Then release the Alt or Option key.

Now the view zooms out to a lower preset magnification, so you can see more of the image, but in less detail.

9 If Scrubby Zoom is selected in the options bar, click anywhere on the image and drag the Zoom tool to the right. The image enlarges. Drag the Zoom tool to the left to zoom out.

● **Note:** You can use other methods to zoom in and out. For example, when the Zoom tool is selected, you can select the Zoom In or Zoom Out mode on the options bar. You can choose View > Zoom In or View > Zoom Out. Or, you can type a new percentage in the status bar and press Enter or Return.

10 Deselect Scrubby Zoom in the options bar if it's selected. Then, using the Zoom tool, drag a rectangle to enclose part of the rose blossom.

The image enlarges so that the area you enclosed in your rectangle now fills the entire document window.

11 Click Fit Screen in the options bar to see the entire image again.

You have used the Zoom tool in different ways to change the document window magnification: clicking, holding down a keyboard modifier while clicking, dragging to zoom in and out, dragging to define a magnification area, and clicking a button in the options bar. You can customize tools by using options, keyboard combinations, and gestures (for example, clicking versus dragging). You'll have opportunities to use these techniques as you work through the lessons in this book.

Zooming and scrolling with the Navigator panel

The Navigator panel (choose Window > Navigator to open it) is another speedy way to make large changes in the zoom level, especially when the exact percentage of magnification is unimportant. It's also a great way to inspect a magnified image, because the thumbnail shows you exactly what part of the image appears in the document window.

The slider under the image thumbnail in the Navigator panel enlarges the image when you drag to the right (toward the large mountain icon) and reduces it when you drag to the left.

The red rectangular outline represents the area of the image that appears in the document window. When you zoom in far enough that the document window shows only part of the image, you can drag the red outline around the thumbnail area to see other areas of the image. This is also an excellent way to verify which part of an image you're working on when you work at very high zoom levels.

Brightening an image

One of the most common edits you're likely to make is to brighten an image taken with a digital camera or phone. You'll brighten this image by changing its brightness and contrast values.

1 In the Layers panel, on the right side of the workspace, make sure the Rose layer is selected.

2 In the Adjustments panel (above the Layers panel in the panel dock), click the Brightness/Contrast icon (✺) to add a Brightness/Contrast adjustment layer. The Properties panel opens, displaying the Brightness/Contrast settings.

3 In the Properties panel, move the Brightness slider to **98** and the Contrast slider to **18**.

The image of the rose brightens.

In these lessons, we'll often instruct you to enter specific numbers in panels and dialog boxes to achieve particular effects. When you're working on your own projects, experiment with different values to see how they affect your image. There is no right or wrong setting; the values you should use depend on the results you want.

4 In the Layers panel, click the eye icon for the Brightness/Contrast adjustment layer to hide its effect, and then click the eye icon again to show the effect.

Adjustment layers let you make changes to your image, such as adjusting the brightness of the rose, without permanently altering the actual pixels. Because you've used an adjustment layer, you can always disable the edit by hiding or deleting the adjustment layer—and

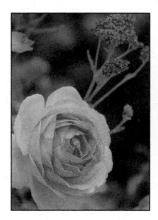

you can edit the adjustment layer at any time. You'll use adjustment layers in several lessons in this book.

Layering is a fundamental and powerful feature in Photoshop. Photoshop includes many kinds of layers, some of which contain images, text, or solid colors, and others that simply interact with layers below them. You'll learn more about layers in Lesson 4, "Layer Basics," and throughout the book.

5 Double-click the Properties panel tab to collapse it.

6 Choose File > Save As, name the file **01Working.psd**, and click OK or Save.

7 Click OK in the Photoshop Format Options dialog box.

Saving the file with a different name ensures that the original file (01Start.psd) remains unchanged. That way, you can return to it if you want to start over.

You've just completed your first task in Photoshop. Your image is bright and punchy and ready for a birthday card.

Sampling a color

● **Note:** When a layer mask is selected, the default foreground color is white, and the default background color is black. You'll learn more about layer masks in Lesson 6, "Masks and Channels."

Photoshop uses a *foreground color* and *background color* when you paint on a layer. Most of the time you'll pay attention to the foreground color, such as the color loaded for a brush. By default, the foreground color is black, and the background color is white. You can change the foreground and background colors in several ways. One way is to use the Eyedropper tool to sample a color from the image. You'll use the Eyedropper tool to sample the blue of one ribbon so that you can match that color when you create another ribbon.

First you'll display the Ribbons layer so you can see the color you want to sample.

1 In the Layers panel, click the Visibility column for the Ribbons layer to make the layer visible. When a layer is visible, an eye icon (👁) appears in that column.

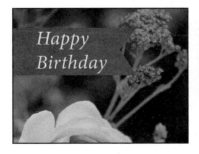 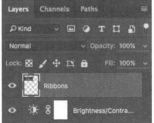

A ribbon with "Happy Birthday" written on it appears in the document window.

2 Select the Ribbons layer in the Layers panel so that it's the active layer.

● **Note:** If Photoshop displays a dialog box telling you about the difference between saving to Cloud Documents and On Your Computer, click Save On Your Computer. You can also select Don't Show Again, but that setting will deselect after you reset Photoshop preferences.

3 Select the Eyedropper tool (🖋) in the Tools panel.

4 Click the blue area in the Happy Birthday ribbon to sample a blue color.

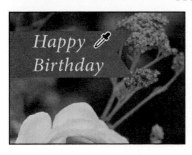

Note: If you have trouble finding the Eyedropper tool, click the Search icon near the top-right corner of the workspace, and type **eyedropper**. Click Eyedropper Tool in the search results; the tool will be selected in the Tools panel for you.

The foreground color changes in the Tools panel and the Color panel. Anything you paint will be this color until you change the foreground color again.

Working with tools and tool properties

When you selected the Zoom tool in the previous exercise, you saw that the options bar provided ways for you to change the view of the current document window. Now you'll learn more about setting tool properties using context menus, the options bar, panels, and panel menus. You'll use all of these methods as you work with tools to add the second ribbon to your birthday card.

Setting the unit of measure

You can change the unit of measure you use to work in Photoshop. This greeting card will be printed, so you'll work in inches.

1 Choose Edit > Preferences > Units & Rulers (Windows) or Photoshop > Preferences > Units & Rulers (macOS).

2 In the Units section, choose Inches from the Rulers menu, and click OK.

Tip: When rulers are displayed (View > Rulers), you can change the unit of measure by right-clicking (Windows) or Control-clicking (macOS) a ruler.

Tip: If you can't remember where to find a preference setting, look for it using the Search Preferences field in the upper-right corner of the Preferences dialog box, in the title bar.

Using context menus

Unlike the menus that drop down from a menu bar, a *context menu* pops up under the pointer. It contains commands and options that may apply to the object under the pointer or to the current selection or state of the document. Usually, the commands on a context menu are also available in the menu bar or panel menus, but a context menu can save time because it can display relevant commands where the pointer is so you don't have to look through the menu bar. Context menus are sometimes called "right-click" or "shortcut" menus.

1 Change the view as needed (zoom or scroll) so that you can clearly see the lower third of the card.

2 Select the Rectangular Marquee tool (⬚) in the Tools panel.

The Rectangular Marquee tool selects rectangular areas. You'll learn more about selection tools in Lesson 3, "Working with Selections."

3 Drag the Rectangular Marquee tool to create a selection about 0.75 inches tall and 2.5 inches wide, ending at the right edge of the card. (See the illustration.) As you drag the tool, Photoshop displays the width and height of the selected area. It's okay if the size of your selection is a little different from ours.

A selection border is indicated by a dashed line called a *selection marquee* (also called *marching ants*), which is animated so that you can see it more easily.

4 Select the Brush tool (✐) in the Tools panel.

5 In the document window, right-click (Windows) or Control-click (macOS) anywhere in the image to open the Brush tool context menu.

Context menus usually show a list of commands, but in this case, it's a pop-up panel with options for the Brush tool.

6 Click the arrow next to the General Brushes preset group (folder) to expand it, select the first brush (Soft Round), and change the size to **65** pixels.

7 Press Enter or Return to close the context menu.

▶ **Tip:** You can also close a context menu by clicking outside it. Be careful when you click so that you don't paint an unwanted stroke or accidentally change a setting or selection.

8 Make sure the Ribbons layer is still selected in the Layers panel; then drag the Brush tool across the selected area until it's fully painted blue. Don't worry about staying within the selection; you can't paint outside the selection.

9 When the bar is colored in, choose Select > Deselect so that nothing is selected.

● **Note:** The Brush tool paints using the Foreground color, which you set earlier when you sampled a blue color using the Eyedropper tool.

The selection is gone, but the blue bar remains on the Ribbons layer.

Selecting and using a hidden tool

To save space on your screen, the Tools panel arranges some of the tools in groups, with only one tool shown for each group. The other tools in the group are hidden behind that tool. A small triangle in the lower-right corner of a button is your clue that other tools are available but hidden under that tool.

You'll use the Polygonal Lasso tool to remove a triangular notch from the color bar so that it matches the ribbon at the top of the card.

1 Position the pointer over the third tool from the top in the Tools panel until the tool tip appears. The tool tip identifies the Lasso tool (⌀), with the keyboard shortcut L.

2 Select the Polygonal Lasso tool (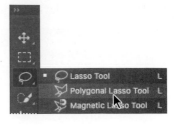), which is hidden behind the Lasso tool, using one of the following methods:

- Press and hold the mouse button over the Lasso tool to open the pop-up list of hidden tools, and select the Polygonal Lasso tool.

- Alt-click (Windows) or Option-click (macOS) the tool button in the Tools panel to cycle through the hidden tools until the Polygonal Lasso tool is selected.

- Press Shift+L, which cycles between the tools in the group (the Lasso, Polygonal Lasso, and Magnetic Lasso tools).

With the Lasso tool, you can draw free-form selections; the Polygonal Lasso tool makes it easier to draw straight-edged sections of a selection border. You'll learn more about selection tools, making selections, and adjusting the selection contents in Lesson 3, "Working with Selections."

3 Move the pointer over the left edge of the blue color bar that you just painted. Click just to the left of the upper-left corner of the bar to start your selection. You should begin your selection just outside the colored area.

4 Move the cursor to the right a little more than ¼ inch, and click about halfway between the top and bottom of the bar. You're creating the first side of the triangle. It doesn't need to be perfect.

5 Click just to the left of the bottom-left corner of the bar to create the second side of the triangle.

6 Click the point where you started to finish the triangle.

● **Note:** If the selected area is not deleted when you press the Delete key, make sure the Ribbons layer is selected in the Layers panel, and try again.

7 Press the Delete key on your keyboard to delete the selected area from the colored bar, creating a notch for your ribbon.

8 Choose Select > Deselect to deselect the area you deleted.

Note: The Select menu contains Deselect and Deselect Layers commands; be mindful of which one you need to choose.

The ribbon is ready. Now you can add a name to your birthday card.

Setting tool properties in the options bar

Next, you'll use the options bar to select the text properties and then type the name.

1 In the Tools panel, select the Horizontal Type tool (**T**).

The buttons and menus in the options bar now relate to the Type tool.

2 In the options bar, select a font you like from the first pop-up menu. (We used Minion Pro Italic, but you can use another font if you prefer.)

3 Specify **32 pt** for the font size.

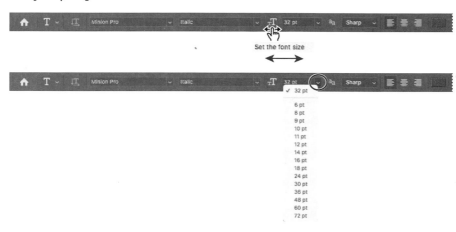

Tip: You can position the pointer over the labels of most numeric settings in the tool options bar, in panels, and in dialog boxes in Photoshop to display a "scrubby slider." Dragging the pointing-finger slider to the right increases the value; dragging to the left decreases the value. Shift-dragging changes it by 10 points.

You can specify 32 points by typing directly in the font-size text box and pressing Enter or Return or by *scrubbing* the font-size menu label (see the tip in the margin). You can also choose a standard font size from the font-size pop-up menu.

4 Click the Swatches tab to bring that panel forward, if it's not already visible; then click the triangle next to the Pastel preset group to expand it; and select any light-colored swatch. (We chose Pastel Yellow.)

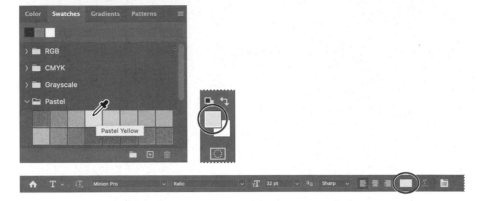

▶ **Tip:** When you move the pointer over the swatches, it temporarily changes into an eyedropper. Position the tip of the eyedropper over the swatch you want, and click to select it.

The color you select appears in two places: as the Foreground Color in the Tools panel and in the text color swatch in the options bar. The Swatches panel is one easy way to select a color; later you'll learn other ways to select a color in Photoshop.

5 Click the Horizontal Type tool once anywhere on the left side of the colored bar. "Lorem Ipsum" placeholder text appears as a sample of the current type specifications. It's selected by default so that you can immediately type over it.

6 Type a name; we typed Elaine. It replaces the placeholder text. Don't worry if the text isn't positioned well; you'll correct that later.

 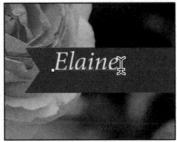

7 Click the check mark icon in the options bar (✓) to commit the text.

While pastel yellow looks OK, try a specific color that sets the name apart from the other ribbon's text. It's easier to find it if you change the Swatches panel display.

8 Click the menu button (≡) on the Swatches panel to open the panel menu, and choose Small List.

9 With the Horizontal Type tool, double-click the text. The text becomes selected.

10 In the Swatches panel, click the triangle next to the Light group of swatch presets to expand it, and then select the Light Yellow Orange swatch.

11 Click the check mark button (✓) to commit and deselect the text.

Now the text appears in the orange color.

Tip: If you want to select just some of the text in a layer, drag the Horizontal Type tool over a range of characters instead of double-clicking.

Tip: After you select a different color swatch, you can see the change in the foreground color swatch in the Tools panel, and in the color swatch in the options bar for the Horizontal Type tool.

Tip: You can also commit a text edit by clicking outside the text layer.

Undoing actions in Photoshop

In a perfect world, you'd never make a mistake. You'd never click the wrong object. You'd always correctly anticipate how specific actions would bring your design ideas to life exactly as you imagined them. You'd never have to backtrack.

For the real world, Photoshop gives you the power to step back and undo actions so that you can try other options. You can experiment freely, knowing that you can reverse the process.

Even beginning computer users quickly come to appreciate the familiar Undo command. You'll use it to move back one step and then step further backward. In this case, you'll go back to the light color that you originally chose for the name.

1 Choose Edit > Undo Edit Type Layer, or press Ctrl+Z (Windows) or Command+Z (macOS) to undo your last action.

The name returns to its previous color.

2 Choose Edit > Redo Edit Type Layer, or press Ctrl+Shift+Z (Windows) or Command+Shift+Z (macOS) to reapply the orange color to the name.

Undo reverses the last step.

Redo restores the undone step.

▶ **Tip:** To see the steps you can undo and redo, look at the History panel (Window > History).

Each time you use the Undo command it reverses one more step, so if you want to undo five steps, you can apply the Undo command (or its keyboard shortcut) five times. The Redo command works the same way.

If you want to switch back and forth between the current and previous steps you did, choose Edit > Toggle Last State or press Ctrl+Alt+Z (Windows) or Command+Option+Z (macOS) to go back, and then choose the same command again to go forward. Applying Toggle Last State multiple times is a great way to see a before/after comparison of your last edit.

▶ **Tip:** As you drag, magenta lines called *Smart Guides* may appear. They help align the edges and centers of dragged content to other objects and guides. If they are getting in your way, you can disable them by deselecting the View > Show > Smart Guides command or by holding down the Control key as you drag.

3 Once the name is back to the color you'd like it to be, use the Move tool (✛) to drag the name so it's centered in the blue bar.

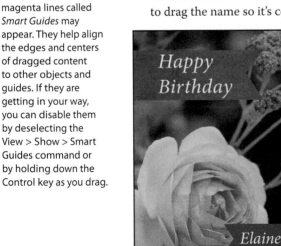

4 Save the file. Your birthday card is done!

More about panels and panel locations

Photoshop panels are powerful and varied. Rarely would you need to see all panels simultaneously. That's why they're in panel groups and why the default configurations leave many panels unopened.

The complete list of panels appears in the Window menu. Check marks appear next to the names of the panels that are open and active in their panel groups. You can open a closed panel or close an open one by selecting the panel name in the Window menu.

You can hide all panels at once—including the options bar and Tools panel—by pressing the Tab key. To reopen them, press Tab again.

You already used panels in the panel dock when you used the Layers and Swatches panels. You can drag panels to or from the panel dock. This is convenient for bulky panels or ones that you use only occasionally but want to keep handy.

● **Note:** When panels are hidden, a thin vertical strip appears along the left or right edge of the application frame. Hover the pointer over the strip to temporarily reveal the panels docked along that edge.

You can arrange panels in other ways as well:

- To move an entire panel group, drag that group's title bar to another location in the work area.

- To move a panel to another group, drag the panel tab into that panel group so that a blue highlight appears inside the group, and then release the mouse button.

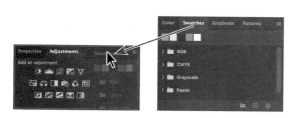

- To dock a panel or panel group, drag the title bar or panel tab onto the top of the dock.

- To undock a panel or panel group so that it becomes a floating panel or panel group, drag its title bar or panel tab away from the dock.

Expanding and collapsing panels

You can resize panels to use screen space more efficiently and to see fewer or more panel options, either by dragging or by clicking to toggle between preset sizes:

- To collapse open panels to icons, click the double arrow in the title bar of the dock or panel group. To expand a panel, click its icon or the double arrow.

- To change the height of a panel, drag its bottom edge.

- To change the width of a dock, position the pointer on the left edge of the dock until it becomes a double-headed arrow, and then drag to the left to widen the dock or to the right to narrow it.

- To resize a floating panel, move the pointer over the right, left, or bottom edge of the panel until it becomes a double-headed arrow, and then drag the edge in or out. You can also pull the lower-right corner in or out.

● **Note:** Some panels cannot be resized, such as the Character and Paragraph panels, but you can still collapse them.

- To collapse a panel group so that only the dock header bar and tabs are visible, double-click a panel tab or panel title bar. Double-click again to restore it to the expanded view. You can open the panel menu even when the panel is collapsed.

Notice that the tabs for the panels in the panel group and the button for the panel menu remain visible after you collapse a panel.

Special notes about the Tools panel and options bar

The Tools panel and the options bar share some characteristics with other panels:

- You can drag the Tools panel by its title bar to a different location in the work area. You can move the options bar to another location by dragging the grab bar at the far-left end of the panel.

- You can hide the Tools panel and options bar using Windows menu commands.

However, some panel features are not available or don't apply to the Tools panel or options bar:

- You cannot group the Tools panel or options bar with other panels.

- You cannot resize the Tools panel or options bar.

- You cannot stack the Tools panel or options bar in the panel dock.

- The Tools panel and options bar do not have panel menus.

▶ **Tip:** To restore the default Essentials workspace, click the workspace icon at the top-right corner of the application window, and choose Reset Essentials.

▶ **Tip:** The options bar and Properties panel may seem redundant at first, but they are distinctly different. The options bar provides settings for the current tool (the next thing you will create), and the Properties panel provides options for the selected layer or current document state (something you've already created).

Simplifying edits with the Properties panel

The number of panels in Photoshop can be overwhelming at times. As you gain experience with Photoshop, consider using the Properties panel for much of your work. As you select different kinds of objects, the Properties panel changes to show the options most relevant to the selected object. When nothing is selected, the Properties panel shows options about the document. This can save you time.

For example, if you select a type layer, the Properties panel shows you Transform options (in case you want to move or rotate the layer) and Character options (so you can change more type specifications than will fit in the options bar). This saves you time because you probably won't have to open the Transform or Character panel. If you want to use a more obscure option, you may need to open a more specialized panel, but for many common tasks, what you want to do may already be presented to you in the Properties panel. If you have the space, it's a good idea to leave the Properties panel open all the time.

Changing interface settings

By default, the panels, dialog boxes, and background in Photoshop are dark. You can lighten the interface or make other changes in the Photoshop Preferences dialog box:

1 Choose Edit > Preferences > Interface (Windows) or Photoshop > Preferences > Interface (macOS).

2 Select a different color theme, or make other changes.

When you select a different theme, you can see the changes immediately. You can also select specific colors for different screen modes and change other interface settings in this dialog box.

3 When you're satisfied with the changes, click OK.

Review questions

1 Describe at least two types of images you can open in Photoshop.

2 How do you select tools in Photoshop?

3 Describe two ways to zoom in to or out from an image.

4 How would you reverse the most recent change you made?

Review answers

1 You can open a photograph from a digital camera. You can also open a scanned image of a photographic print, a transparency or negative film frame, or a graphic. You can open images downloaded from the internet such as photography from Adobe Stock, or images uploaded to your Cloud Documents or your Lightroom photos.

2 To select a tool in Photoshop, click its icon in the Tools panel, or press the tool's keyboard shortcut. A selected tool remains active until you select a different tool. To select a hidden tool, either use a keyboard shortcut to toggle through the tools or click and hold the tool in the Tools panel to open a pop-up menu of the hidden tools.

3 Choose commands from the View menu to zoom in on or out from an image or to fit it onscreen, or use the zoom tools and click or drag over an image to enlarge or reduce the view. You can also use keyboard shortcuts or the Navigator panel to control the display of an image.

4 Choose Edit > Undo or Edit > Toggle Last State, or press its keyboard shortcut. (Another correct answer is to choose an earlier document state in the History panel, although that was not shown in this lesson.)

2 BASIC PHOTO CORRECTIONS

Lesson overview

In this lesson, you'll learn how to do the following:

- Understand image resolution and size.

- View and access files in Adobe Bridge.

- Straighten and crop an image.

- Adjust the tonal range of an image.

- Use the Spot Healing Brush tool to repair part of an image.

- Use the content-aware Patch tool to remove or replace objects.

- Use the Clone Stamp tool to touch up areas.

- Remove digital artifacts from an image.

- Apply the Smart Sharpen filter to finish retouching photos.

 This lesson will take about an hour to complete. To get the lesson files used in this chapter, download them from the web page for this book at adobepress.com/PhotoshopCIB2023. For more information, see "Accessing the lesson files and Web Edition" in the Getting Started section at the beginning of this book.

As you work on this lesson, you'll preserve the start files. If you need to restore the start files, download them from your Account page.

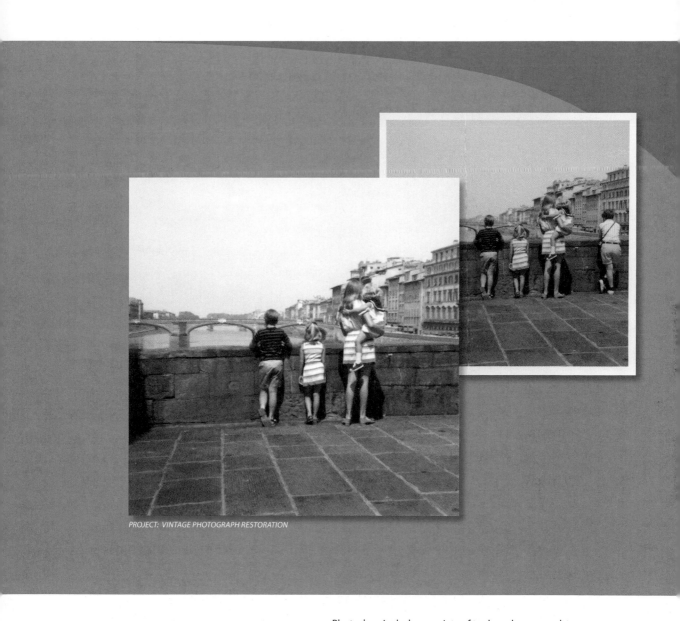

PROJECT: VINTAGE PHOTOGRAPH RESTORATION

Photoshop includes a variety of tools and commands for improving the quality of a photographic image. This lesson steps you through the process of acquiring, resizing, and retouching a vintage photograph.

Strategy for retouching

● **Note:** In this lesson, you retouch an image using Photoshop. For some images, such as those saved in camera raw format, it may be more efficient to work in Adobe Camera Raw, which is installed with Photoshop. You'll learn about the tools Camera Raw has to offer in Lesson 12, "Working with Camera Raw."

How much retouching you do depends on the image you're working on and your goals for it. For many images, you may need only to adjust its lightness or color or repair a minor blemish. For others, you may need to perform several tasks and employ more advanced tools and techniques.

Organizing an efficient sequence of tasks

Most retouching procedures follow these general steps, which you'll learn about in this lesson:

- Duplicating the original image; working in a copy of the image keeps the original safe in case you need to start over

- Ensuring that the resolution is appropriate for the way you'll use the image

- Cropping the image to its final size and orientation

- Adjusting the overall contrast or tonal range of the image

- Removing a color cast, such as correcting an image that is too bluish

- Repairing flaws in scans of damaged photographs (such as rips, dust, or stains)

- Adjusting the color and tone in specific parts of the image to bring out highlights, midtones, shadows, and desaturated colors

- Sharpening the image

The order of the tasks may vary depending on the project, and not every task may be necessary for all projects. In a basic workflow, correcting tones and color are early steps, and the last steps typically include adjusting the pixel dimensions and sharpening for the final delivery medium.

Adjusting your process for different intended uses

The decisions you make for retouching an image depend in part on how you'll use the image. For example, if an image is intended for black-and-white publication on newsprint, you might make different cropping and sharpening choices than if the image is intended for a full-color web page. Photoshop supports RGB color mode for web and mobile device authoring and desktop photo printing, CMYK color mode for preparing an image for printing using process colors, Grayscale mode for black-and-white printing, and other color modes for more specialized purposes. You can also use Photoshop to adjust image pixel dimensions or resolution. In general, plan to do most edits on a new full-resolution high-quality original image, and then for specific uses such as print or the web, make copies adjusted for the special requirements of each of those media.

Resolution and image size

When you edit an image in Photoshop for a specific use, you need to make sure the image contains an appropriate number of *pixels*, the small squares that describe an image and establish the degree of detail it contains. You can work this out from the *pixel dimensions*, or the number of pixels along an image's width and height.

Pixels in a photographic image

When you multiply an image's width by its height in pixels, you find out how many pixels are in the image. For example, a 1000 × 1000 pixel image has 1,000,000 pixels (one megapixel), and a 2000 × 2000 pixel image has 4,000,000 pixels (four megapixels). Pixel dimensions affect file size and upload/download time.

In Photoshop, *resolution* means the number of pixels per unit of physical length, such as pixels per inch (ppi).

Does changing resolution affect the storage size of a file? Only when the pixel dimensions change. For example, a 7 × 7 inch image at 300 ppi is 2100 × 2100 pixels; if you change either the size in inches or the ppi value (resolution) while keeping the pixel dimensions at 2100 × 2100 pixels, the file size does not change. But if you change the size in inches without changing the ppi value (or vice versa), the pixel dimensions must change, and so will the file size. For example, if the image in the previous example is changed to 72 ppi while maintaining 7 × 7 inches, the pixel dimensions must change to 504 × 504 pixels, and the file size decreases accordingly.

Resolution requirements vary depending on the intended output. An image might be considered *low resolution* when its ppi value is below 150 to 200 ppi. An image with a ppi value above 200 ppi is generally considered *high resolution* because it can contain enough detail to take advantage of the device resolution offered by commercial or fine-art printers and high-resolution (Retina/HiDPI) device displays.

Factors such as viewing distance and output technology influence the resolution our eyes actually perceive, and this affects resolution requirements too. A 220-ppi laptop display may appear to have the same high resolution as a 360-ppi smartphone, because the laptop is viewed farther away. But 220 ppi might not be enough resolution for a high-end printing press or fine-art inkjet printer, which might be capable of reproducing 300 ppi or more. At the same time, a 50-ppi image can appear perfectly sharp on a highway billboard because it's seen from hundreds of feet away.

Note: For computer displays and televisions, the term *resolution* often describes only the pixel dimensions (such as 1920 × 1080 pixels) instead of a pixel density ratio (300 pixels per inch). In Photoshop, resolution is the pixels per inch value, not the pixel dimensions.

Note: File size is determined by more than just the pixel dimensions. Additional factors include the file type, bit depth, number of channels and layers, and (if compressed) the compression method.

Tip: To determine the resolution needed for an image you'll print on a press, follow this industry guideline: Edit the image to a ppi value that is 1.5 to 2 times the halftone screen frequency (in lines per inch, or lpi) used by the printer. For example, if the image will be printed using a screen frequency of 133 lpi, the image should be 200 ppi (133 × 1.5).

Because of the way display and output technologies work, your images may not need to match the device resolution of high-resolution printers. For example, while some commercial printing platesetters and photo-quality inkjet printers have a device resolution of 2400 dots per inch (dpi) or more, the appropriate image resolution to send to those devices may be only 200 to 360 ppi for photos. This is because the device dots are grouped into larger halftone cells or inkjet dot patterns that build tones and colors. Similarly, a 500-ppi smartphone display may not necessarily require 500-ppi images. Whatever your medium, ask your production team or output service provider to verify the pixel dimensions or ppi value they require in the final images you deliver.

Opening a file with Adobe Bridge

In this book, you'll work with different start files in each lesson. You may make copies of these files and save them under different names or locations, or you may work from the original start files and then download them from the peachpit.com website again if you want a fresh start.

In this lesson, you'll retouch a scan of a damaged and discolored vintage photograph so it can be shared or printed. The final image size will be 7 × 7 inches.

In Lesson 1, you used the Open command to open a file. You'll start this lesson by comparing the original scan to the finished image in Adobe Bridge, a visual file browser that helps take the guesswork out of finding the image file that you need.

Note: If Bridge isn't installed, the File > Browse in Bridge command in Photoshop will start the Creative Cloud desktop app, which will download and install Bridge. After installation completes, you can start Bridge.

Note: If Bridge asks you if you want to import preferences from a previous version of Bridge, select Don't Show Again, and click No.

1 Start Photoshop, and then simultaneously hold down Ctrl+Alt+Shift (Windows) or Command+Option+Shift (macOS) to reset the default settings.

2 When prompted, click Yes to confirm that you want to delete the Adobe Photoshop Settings file.

3 Choose File > Browse In Bridge. If you're prompted to enable the Photoshop extension in Bridge, click Yes or OK.

Adobe Bridge opens, displaying a collection of panels, menus, and buttons.

4 Select the Folders tab in the upper-left corner, and then browse to the Lessons folder you downloaded onto your hard disk so that the lessons in the Lessons folder appear in the Content panel.

5 With the Lessons folder still selected in the Folders panel, choose File > Add To Favorites.

The Favorites panel lets you quickly access files, folders, applications, and other assets that you frequently use.

6 Click the Favorites tab to open the panel, and click the Lessons folder to open it. Then, in the Content panel, double-click the Lesson02 folder.

Thumbnail previews of the folder contents appear in the Content panel.

▶ **Tip:** In Bridge, if the Favorites panel list and a folder you want to add to Favorites are both visible, you can drag the folder and drop it in the Favorites panel. You can even drag and drop to add a folder from your computer desktop to the Favorites panel.

7 Compare the 02Start.tif and 02End.psd files. To enlarge the thumbnails in the Content panel, drag the thumbnail slider at the bottom of the Bridge window to the right.

In the 02Start.tif file, notice that the image is crooked, the colors are relatively dull, and the image has a green color cast and a distracting crease. You'll fix all of these problems in this lesson, and a few others. You'll start by cropping and straightening the image.

8 Double-click the 02Start.tif thumbnail to open the file in Photoshop. Click OK if you see the Embedded Profile Mismatch dialog box.

9 In Photoshop, choose File > Save As. Choose Photoshop from the Format menu, and name the file **02Working.psd**. Then click Save.

▶ **Tip:** In Bridge, you can see a larger preview of a selected item by using the Preview panel (choose Window > Preview). If that's not big enough, you can resize the Preview panel. Or, press the spacebar to see a full-screen preview of the selected item.

● **Note:** If Photoshop displays a dialog box about the difference between saving to Cloud Documents and On Your Computer, click Save On Your Computer. You can also select Don't Show Again, but that setting will deselect after you reset Photoshop preferences.

Straightening and cropping the image in Photoshop

You'll use the Crop tool to straighten, trim, and scale the photograph. By default, cropping deletes cropped pixels.

1 In the Tools panel, select the Crop tool (⌐↳).

Crop handles appear, and a *crop shield* covers the area outside the cropping region to help focus your attention on the cropped area.

2 In the options bar, choose W × H × Resolution from the Select A Preset Aspect Ratio or Crop Size menu. (Ratio is the default value.) A crop overlay appears.

3 In the options bar, type **7 in** for the width, **7 in** for the height, and **200** px/in for the resolution.

Tip: If you need to see crop edges more clearly, it's OK to change the view magnification while the crop rectangle is active.

Tip: The px/in value sets resolution for print. To crop for web/mobile graphics that do not specify ppi, you can leave the ppi resolution field blank.

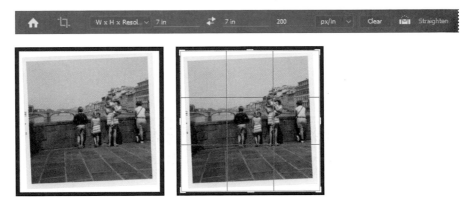

First, you'll straighten the image.

4 Click the Straighten icon in the options bar. The pointer changes to the Straighten tool.

5 Click the top-left corner of the image (where the sky ends), press the mouse button as you drag a straight line across the top edge, and then release.

Tip: If you want the document to keep the pixels outside the crop area, deselect Delete Cropped Pixels in the options bar. That will let you reveal previously cropped areas by enlarging the Crop tool rectangle, which is useful if you change your mind later.

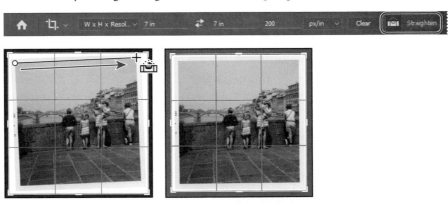

Photoshop straightens the image so that the line you drew is parallel with the top of the image area. You drew a line across the top of the photo, but you can also draw it along anything in the image that should be perfectly vertical or horizontal.

Now, you'll trim the white border and scale the image.

6 Drag the corners of the crop rectangle inward to crop out the white border. If you need to adjust the position of the photo inside the crop, position the pointer within the crop rectangle and drag the photo.

7 Press Enter or Return to accept the crop.

The image is now cropped, straightened, sized, and positioned according to the Crop tool options you used.

 Tip: The Crop tool will continue to create a 7 × 7 inch, 200 ppi crop as long as the current options bar settings are applied. If you want to crop with total freedom, click the Clear button in the Crop tool options bar.

Tip: If you need to adjust the crop after the crop rectangle disappears, choose Edit > Undo, and try again.

8 If the image dimensions are not already displayed in the status area at the bottom of the application window, click the arrow there and choose Document Dimensions from the pop-up menu that appears.

Tip: The units in the status bar (pixels, inches, etc.) match the units display set in the Photoshop Preferences dialog box, in the Units & Rulers pane.

You can use the status bar display to monitor various aspects of Photoshop or the current document. Before cropping, the image was 2160 × 2160 pixels at 240 ppi. After cropping to the dimensions and resolution specified in step 3, Document Dimensions shows that the image is now 1400 × 1400 pixels at 200 ppi.

9 Choose File > Save to save your work. Click OK if you see the Photoshop Format Options dialog box.

Tip: To straighten a photo and crop out a solid white background in a single step, choose File > Automate > Crop And Straighten Photos. It can also automatically separate multiple photos scanned as one document.

Adjusting the color and tone

You'll use Curves and Levels adjustment layers to remove the color cast and adjust the color and tone in the image. The Curves or Levels options may look complex, but don't be intimidated. You'll work with them more in later lessons; for now, you'll take advantage of their tools to quickly brighten and adjust the tone of the image.

1 In the Adjustments panel, click the Curves icon (first row, third button). This adds a Curves adjustment layer; its controls appear in the Properties panel.

2 Select the White Point tool on the left side of the Properties panel.

The White Point tool defines what color value should be made a neutral white. Once defined, all other colors and tones shift accordingly. When done correctly, this is a quick way to remove a color cast and correct image brightness. To set an accurate white point, click an area of the image that should be the brightest neutral area of the image that contains detail—not a blown-out area like the sun or a lamp and not a specular highlight such as a reflection of sunlight on chrome.

3 Click a white stripe on the girl's dress.

► **Tip:** If you want to know the color values of the pixels that the pointer is positioned over, they're displayed in the Info panel (Window > Info).

Clicking the white stripe with the White Point tool shifts the color balance and brightness based on how far the sampled color is from neutral white, improving the image. Try clicking different white areas, such as the child's sailor dress or sock, or a stripe on the woman's dress. You'll typically get the most balanced result by clicking the area that was closest to neutral bright white in the real world.

Now you'll use a Levels adjustment layer to refine the tonal range of the image.

4 In the Adjustments panel (if needed, click its tab to make it visible), click the Levels icon (▤) (first row, second button) to add a Levels adjustment layer.

For both Curves and Levels, the Properties panel displays a *histogram*—a graph displaying the distribution of tonal values in the image, from black on the left to white on the right. For Levels, the left triangle under the histogram represents the black point (the tonal level you want to set as the darkest in the image), the right triangle represents the white point (the tonal level you want to set as the lightest in the image), and the middle triangle represents the midtones.

5 Drag the left triangle (black point) under the histogram to the right, where significant shadow tones start to appear. Our value was **15**. All tones less than 15 become black.

6 Drag the middle triangle a little to the right to adjust the midtones. Our value was **.90**.

Now you'll *flatten* the image so it's easier to work with while you touch it up. Flattening an image merges all of its layers into the Background layer. Flatten only if you no longer need the flexibility of adjusting the edits you previously made using separate layers.

7 Choose Layer > Flatten Image.

The adjustment layers merge with the Background layer.

● **Note:** The color and tone edits in this section are relatively basic; it's possible to do them all using only Levels or Curves. Typically, Curves is used for edits that are more specialized or complex.

● **Note:** Flattening also removes content hidden beyond the visible edge of the canvas. For example, if you used the Crop tool with the Delete Cropped Pixels option disabled, flattening removes the hidden pixels that the Crop tool preserved.

As owner of Gawain Weaver Art Conservation, Gawain Weaver has conserved and restored original works by artists ranging from Eadweard Muybridge to Man Ray and from Ansel Adams to Cindy Sherman. He teaches workshops internationally as well as online on the care and identification of photographs.

Find out more at gawainweaver.com.

Real-world photo restoration

The tools in Photoshop make restoration of old or damaged photographs seem like magic, giving virtually anyone the power to scan, retouch, print, and frame their photo collections.

However, when dealing with works by famous artists, museums, galleries, and collectors need to preserve original objects to the greatest degree possible despite deterioration or accidental damage. Professional art conservators are called upon to clean dust and soiling from print surfaces, remove discoloration and staining, repair tears, stabilize prints to prevent future damage, and even paint in missing areas of a work.

BEFORE

Carleton E. Watkins, Nevada Fall, 700 FT, Yosemite Valley, CA, mammoth albumen print, 15⅝" × 20¾". This print was removed from its mount to remove the stains and then remounted.

"Photograph conservation is both a science and an art," says Weaver. "We must apply what we know about the chemistry of the photograph, its mount, and any varnishes or other coatings in order to safely clean, preserve, and enhance the image. Since we cannot quickly 'undo' a step in a conservation treatment, we must always proceed with great caution and a healthy respect for the fragility of the photographic object, whether it's a 160-year-old salt print of Notre Dame or gelatin silver print of Half Dome from the 1970s."

Many of the manual tools of an art conservator have analogous digital versions in Photoshop:

 An art conservator might wash a photograph to remove the discolored components of the paper, or even use a mild bleaching process known as light-bleaching to oxidize and remove the colored components of a stain or overall discoloration. In Photoshop, you can use a Curves adjustment layer to remove the color cast from an image.

 A conservator working on a fine-art photograph might use special paints and fine brushes to manually "in-paint" damaged areas of a photograph. Likewise, you can use the Spot Healing Brush tool in Photoshop to spot out specks of dust or dirt on a scanned image.

 A conservator might use Japanese papers and wheat-starch paste to carefully repair and rebuild torn paper before finalizing the repair with some skillful in-painting. In Photoshop, you can remove a crease or repair a tear in a scanned image with a few clicks of the Clone Stamp tool.

A fixative was applied to the artist's signature with a small brush to protect it when the mount was washed.

"Although our work has always been first and foremost about the preservation and restoration of the original photographic object, there are instances, especially with family photographs, where the use of Photoshop is more appropriate," says Weaver. "More dramatic results can be achieved in far less time. After digitization, the original print can be safely stored away, while the digital version can be copied or printed for many family members. Often, we first clean or unfold family photographs to safely reveal as much of the original image as possible, and then we repair the remaining discoloration, stains, and tears on the computer after digitization."

AFTER

Using the Spot Healing Brush tool

Note: The Spot
Healing Brush tool
automatically samples
from the area near
where you click or
drag. When you want
to heal using a sample
of another part of the
image, use the Healing
Brush tool instead.

The next task is to remove the crease in the photo. You'll use the Spot Healing Brush to erase the crease. While you're at it, you'll use it to address a few other issues.

The Spot Healing Brush tool quickly removes blemishes and other imperfections. It samples pixels around the retouched area and matches the texture, lighting, transparency, and shading of the sampled pixels to the pixels being healed.

The Spot Healing Brush is excellent for retouching blemishes in portraits, but also works nicely wherever there's a uniform appearance near the areas you want to retouch.

1 Zoom in to see the crease clearly.

2 In the Tools panel, select the Spot Healing Brush tool (✎).

3 In the options bar, open the Brush pop-up panel, specify a brush with a Size of about **25** px and **100%** Hardness, and make sure Content-Aware is selected.

4 In the document window, position the Spot Healing Brush at the top of the crease, and then drag it down along the crease. If it's easier to repair the crease with multiple shorter strokes, that's okay. As you drag, the stroke at first appears black, but when you release the mouse, the painted area is "healed."

Tip: To avoid
creating obvious new
seams or patterns, paint
the Spot Healing Brush
closely around the area
you're repairing. Don't
cover more area than
necessary; make the
brush size only slightly
larger than the blemish.

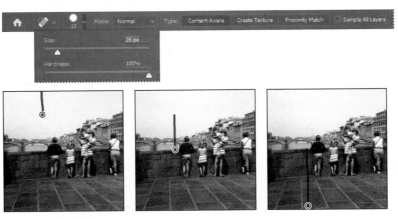

Tip: You may not
be able to see the
entire crease when
you're zoomed in, but
you can reposition the
view between strokes,
without switching tools.
Use the scroll bars, or
hold down the spacebar
to temporarily use the
Hand tool.

5 Zoom in to see the white hair in the upper-right area of the image. Then use the Spot Healing Brush to paint over the hair.

6 Zoom out, if necessary, to see the full sky. Then click the Spot Healing Brush wherever there are unwanted spots you want to heal.

7 Save your work so far.

Applying a content-aware patch

Use the Patch tool to remove larger unwanted elements, such as an unrelated person near the right edge of the photo. In Content-Aware mode, the Patch tool creates nearly seamless blending with the nearby content.

1. In the Tools panel, select the Object Selection tool (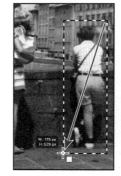), and hover it over each person in the photo, without clicking. Each person highlights when hovered.

The Object Selection tool automatically detects objects; clicking a highlighted area selects it. But if the highlight doesn't include the entire subject, the selection will be incomplete. To help ensure a more complete selection, you'll drag the tool instead.

2. Drag the Object Selection tool around the boy, and then release the mouse. The resulting selection fits the entire boy and his shadow.

If some outer edges aren't fully selected, such as the boy's hair, expanding the selection is a quick way to include them.

3. Choose Select > Modify > Expand, enter **2** for Pixels, and click OK.

4. In the Tools panel, select the Patch tool (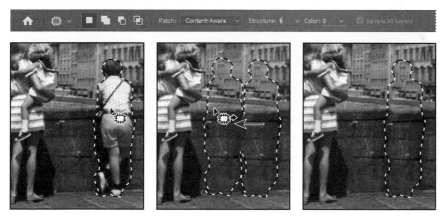), hidden under the Spot Healing Brush tool (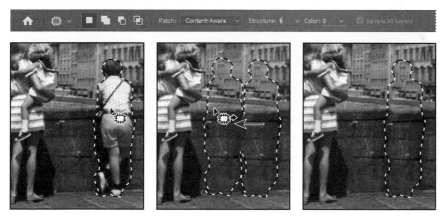). In the options bar, choose Content-Aware from the Patch menu. Type **4** into the Structure slider.

5. Position the pointer within the selection, and drag it to the left to replace the boy with the wall and background, without including the woman and child. Watch the patch preview, and release the mouse button when the patch looks good.

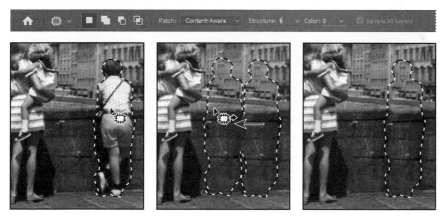

The selection changes to better match the area around it. The boy is gone, and where he stood is a section of the bridge wall and of a building.

> **Tip:** If the selection doesn't include all of the subject, hold down Shift as you drag the Object Selection tool around missing areas. To exclude unwanted areas, Alt-drag (Windows) or Option-drag (macOS) the tool. Or, to draw a more precise initial selection, choose Lasso from the Mode menu in the options bar.

> **Tip:** As long as the Patch tool selection is active, you can change the Structure value in the options bar to adjust how the patch matches the surrounding area.

> **Note:** The healing and content-aware tools may produce results that still need a small amount of manual touch-up. It isn't realistic to expect them to be perfect every time; the point of the tools is to reduce the total amount of retouching time.

6 Choose Select > Deselect.

The effect is impressive, but not quite perfect. You'll touch up the results next.

Repairing areas with the Clone Stamp tool

The Clone Stamp tool uses pixels from one area of an image to replace the pixels in another part of the image. Using this tool, not only can you remove unwanted objects from your images, but you can also fill in missing areas in photographs you scan from damaged originals.

You'll use the Clone Stamp tool to smooth out irregularities in the height of the bridge wall and the windows on the building, making the patch edge match up better.

▶ **Tip:** You may need to set a larger brush size when editing higher resolution images.

1 Select the Clone Stamp tool (🔖) in the Tools panel, and select a **60**-px brush with **30**% Hardness. Make sure that the Aligned option is selected.

2 Move the Clone Stamp tool to an area where the top of the bridge wall is smooth. That's the area you want to copy to smooth out the patched area.

3 Alt-click (Windows) or Option-click (macOS) to sample that location as a source point. (When you press Alt or Option, the pointer appears as target crosshairs.)

4 Drag the Clone Stamp tool across the top of the bridge wall in the patched area to even it out, and then release the mouse button.

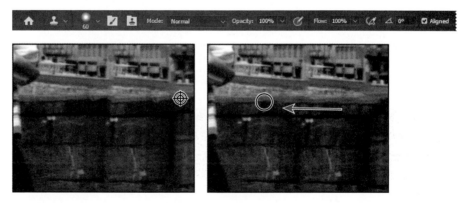

▶ **Tip:** Unlike the Spot Healing Brush and Patch tools you used earlier, the Clone Stamp tool doesn't try to make edits seamless. It simply copies pixels from the source point to where you drag, so it may take more manual work to make an edit look good.

Each time you click the Clone Stamp tool, it begins again with a new source point, maintaining its position relative to the first stroke you made. That is, if you begin painting farther right, it samples from stone that is farther right than the original source point. That's because Aligned is selected in the options bar. Deselect Aligned if you want to start from the same source point each time.

5 Select a source point where the bottom of the bridge wall is even, and then drag the Clone Stamp tool across the bottom of the wall where you patched it.

▶ **Tip:** The Photo Restoration filter can reduce the amount of manual retouching that's needed. Choose Filter > Neural Filters, enable Photo Restoration, and adjust options. For black-and-white photos, Neural Filters also include a Colorize filter. Neural Filters take advantage of machine learning; you'll learn more about them in Lesson 15, "Exploring Neural Filters."

6 Select a smaller brush size, and deselect Aligned. Then select a source point over the rightmost windows in the lowest row on the building you patched. Click across to create accurate windows there.

7 Repeat step 6 to make any adjustments you want to apply to the lowest area of the building and the wall that runs in front of it. Look carefully for areas that obviously repeat as a result of the cloning, and retouch them.

8 If you like, you can use a smaller brush size to touch up the stones in the patched portion of the wall.

9 Save your work.

Sharpening the image

The last task you might want to do when retouching a photo is to sharpen the image. There are several ways to sharpen an image in Photoshop, but the Smart Sharpen filter gives you the most control. Because sharpening can emphasize artifacts, you'll remove those first.

1 Zoom in to about **400**% to see the boy's shirt clearly. The colored dots you see are artifacts of the scanning process.

2 Choose Filter > Noise > Dust & Scratches.

3 In the Dust & Scratches dialog box, leave the default settings with a Radius of **1** pixel and Threshold at **0**, and click OK.

The Threshold value determines how dissimilar the pixels should be before they are eliminated. The Radius value determines the size of the area searched for dissimilar pixels. The default values are great for tiny dots of color like the ones in this image.

Now that the artifacts are gone, you can sharpen the image.

4 Choose Filter > Sharpen > Smart Sharpen.

5 In the Smart Sharpen dialog box, make sure that Preview is selected so you can see the effect of settings you adjust in the document window.

You can drag inside the preview window in the dialog box to see different parts of the image, or you can use the magnification buttons below the thumbnail to zoom in and out.

6 Make sure Lens Blur is chosen in the Remove menu.

You can choose to remove Lens Blur, Gaussian Blur, or Motion Blur in the Smart Sharpen dialog box. Lens Blur provides finer sharpening of detail and reduced sharpening halos. Gaussian Blur increases contrast along the edges in an image. Motion Blur reduces the effects of blur that resulted from the camera or the subject moving when the photo was taken.

7 Drag the Amount slider to about **60**% to sharpen the image.

8 Drag the Radius slider to about **1.5**.

The Radius value determines the number of pixels surrounding the edge pixels that affect the sharpening. The higher the resolution, the higher the Radius setting should usually be.

9 When you're satisfied with the results, click OK to apply the Smart Sharpen filter.

▶ **Tip:** Many dialog boxes, including Smart Sharpen, include a Preview option. It displays the result in the document window, not just in the dialog box. You can toggle the Preview option to compare before-and-after views of the document using the current settings.

10 Choose File > Save, and then close the project file.

Your image is ready to share or print!

Extra credit

Converting a color image to black and white

You can get great results converting a color image to black and white (with or without a tint) in Photoshop.

1 Choose File > Open, and navigate to the bike.tif file in the Lesson02 folder. Click Open.

2 In the Adjustments panel, click the Black & White button to add a Black & White adjustment layer.

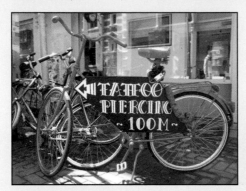

3 Adjust the color sliders to change the lightness of different colors, similar to the effects of using color filters with black-and-white film but with more control. You can also experiment with options from the preset menu, such as Darker or Infrared. Or, select the targeted adjustment tool (👆) in the upper-left corner of the Properties panel, position it over a color you want to adjust, and drag horizontally. The tool moves the sliders associated with the original color of the pixels where you started dragging; for example, dragging on the red bike frame adjusts the lightness of all red areas. We darkened the bike and made the background areas lighter.

4 If you want to colorize the entire photo with a single hue, select Tint in the Properties panel. Then, click the color swatch, and select a tint color (we used R=227, G=209, B=198).

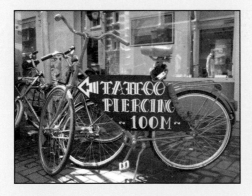

Review questions

1 What does *resolution* mean?

2 What are some ways to use the Crop tool to improve an image?

3 How can you adjust the tone and color of an image in Photoshop?

4 How can you instantly create a precise selection of an irregularly shaped object?

5 What tools can you use to remove blemishes in an image?

6 How can you remove artifacts such as colored pixels and scanned dust from an image?

Review answers

1 For media such as print, the term *resolution* refers to the number of pixels per unit of physical length in an image, such as pixels per inch (ppi). Printer resolution may be expressed in dots per inch (dpi), because device dots do not always correspond to image pixels. For media measured in pixels, such as web and video, resolution typically refers to pixel dimensions (height and width), not pixels per inch.

2 You can use the Crop tool to trim, straighten, resize, or change the resolution of an image.

3 You can adjust the tone and color of an image in Photoshop using the Curves and Levels adjustment layers.

4 The Object Selection Tool recognizes objects in an image. You can click a highlighted object you want to select, or drag around it, and the resulting selection will follow the outline of the object.

5 In this lesson, you used the Spot Healing Brush, content-aware Patch, and Clone Stamp tools to remove blemishes from an image. (Other healing/cloning/patching tools are also available in Photoshop but were not covered in this lesson.)

6 The Dust & Scratches filter removes artifacts from an image.

3 WORKING WITH SELECTIONS

Lesson overview

In this lesson, you'll learn how to do the following:

- Make specific areas of an image active using selection tools.

- Reposition a selection marquee.

- Move, rotate, and duplicate the contents of a selection.

- Use keyboard-mouse combinations that save time and hand motions.

- Deselect a selection.

- Adjust the position of a selected area using the arrow keys.

- Add to and subtract from a selection.

- Use multiple selection tools to make a complex selection.

- Save your work as a Photoshop cloud document you can easily open in Photoshop on other devices, and for online collaboration.

 This lesson will take about an hour to complete. To get the lesson files used in this chapter, download them from the web page for this book at adobepress.com/PhotoshopCIB2023. For more information, see "Accessing the lesson files and Web Edition" in the Getting Started section at the beginning of this book. The lesson steps that use Adobe Cloud Documents require Internet access.

As you work on this lesson, you'll preserve the start files. If you need to restore the start files, download them from your Account page.

PROJECT: SHADOWBOX COLLAGE

Learning how to select areas of an image is of primary importance—you must first select what you want to affect. As long as a selection is active, only the area within the selection can be edited.

About selecting and selection tools

▶ **Tip:** The concept of selecting the content you want to change is common across many image-editing applications. As soon as you understand how selections work in one application, you can use that knowledge in other similar applications.

When you want to edit just an area of a pixel layer, you use a two-step process. First, *select* (mark) the area you want to change, using one of the selection tools. Then use another tool, filter, or other feature to make the changes, such as moving the selected pixels to another location or applying a filter. When a selection is active, changes you make apply only to the selected area; other areas are unaffected.

The best selection tool to use typically depends on two things: what kind of selection you want and what visual characteristics distinguish an area, such as shape, color, or content. Similar selection tools are grouped in the Tools panel:

Content- and edge-based selections The Object Selection tool (⬚) uses machine learning to identify subjects that you select with a simple click or drag; this is a quick and easy way to select people, animals, and other non-geometric shapes (you used the Object Selection tool in Lesson 2). The Quick Selection tool (◔) quickly "paints" a selection by looking for distinct regions of content in the image.

Color-based selections The Magic Wand tool (⚲) selects parts of an image based on similarity in pixel color. It's useful for selecting odd-shaped areas that share a specific range of colors or tones.

Note: This lesson focuses on tools and techniques for manual and semi-automated selection. This lesson doesn't cover the fully automated selection commands such as Select > Sky (which you'll use in Lesson 5, "Quick Fixes") and Select > Subject (which you'll use in Lesson 6, "Masks and Channels").

Geometric selections The Rectangular Marquee tool (⬚) selects a rectangular area. The Elliptical Marquee tool (○) selects an elliptical area. The Single Row Marquee tool (⚏) and Single Column Marquee tool (⦙) select either a 1-pixel-high row or a 1-pixel-wide column, respectively.

Freehand selections The Lasso tool (⬭) traces a freehand selection around an area. The Polygonal Lasso tool (⬠) lays down straight-line segments around an area. The Magnetic Lasso tool (⬡) automatically follows edges, typically giving the best results when high contrast exists between the area you want to select and its surroundings.

Getting started

First, you'll look at the image you will create as you explore the selection tools in Photoshop.

1 Start Photoshop, and then simultaneously hold down Ctrl+Alt+Shift (Windows) or Command+Option+Shift (macOS) to restore the default preferences. (See "Restoring default preferences" on page 5.)

2 When prompted, click Yes to confirm that you want to delete the Adobe Photoshop Settings file.

3 Choose File > Browse In Bridge to open Adobe Bridge.

4 In the Favorites panel, click the Lessons folder. Then double-click the Lesson03 folder in the Content panel to see its contents.

5 Study the 03End.psd file. Move the thumbnail slider to the right if you want to see the image in more detail.

The project is a shadow box that includes a piece of coral, a sand dollar, a mussel, a nautilus, and a plate of small shells. The challenge in this lesson is to arrange these elements, which were scanned together on the single page you see in the 03Start.psd file.

● **Note:** If Bridge isn't installed, the File > Browse In Bridge command in Photoshop will start the Creative Cloud desktop app, which will download and install Bridge. After installation completes, you can start Bridge.

● **Note:** If Bridge asks you if you want to import preferences from a previous version of Bridge, click No.

Using cloud documents

Photoshop document sizes can become large, especially for high-resolution images that use many layers. When you work with documents stored online, large file sizes upload and download more slowly; on a limited data plan you may reach the data limit more quickly. Adobe cloud documents help you edit online documents efficiently by using file formats optimized for networks. For example, editing a Photoshop file as a cloud document means only the parts affected by an edit are transmitted, instead of the entire file. If you use Photoshop on both a computer and an Apple iPad and you save an image as a cloud document, you'll find it in the Photoshop Home screen on both devices, always updated with your latest changes.

Using cloud documents is easy; the only thing you have to do is save it to cloud documents. After you do this, your Photoshop document filename will have a .psdc filename extension to indicate that it's now a cloud document, and you will now find it listed in the cloud documents section in the Photoshop Home screen. The conversion to the PSDC format is automatic, so you don't have to think about it.

▶ **Tip:** Using cloud documents can be more efficient than putting a Photoshop file on a cloud-based file sharing service. A cloud document transfers only the parts of a file that change, and you can open it in one click on the Photoshop Home screen.

Note: If Photoshop displays a dialog box about the difference between saving to Cloud Documents and On Your Computer, for this lesson click Save To Cloud Documents. You can also select Don't Show Again, but that setting will deselect after you reset Photoshop preferences.

1 In Bridge, double-click the 03Start.psd thumbnail to open the image file in Photoshop. You've opened the document from your local storage.

2 Choose File > Save As, and click Save to Creative Cloud. If you see the standard Save As dialog box, first click the Save To Cloud Documents button.

▶ **Tip:** You can also find your cloud documents in the Creative Cloud app (mobile or desktop) and website, in the Your Files tab in the Cloud Documents panel. The list may also contain cloud documents from other Adobe applications.

3 Rename the file **03WorkingCloud**, and click Save. The file is uploaded to Cloud Documents. In the document window tab, you can see a cloud icon before the filename, and the filename now ends in .psdc.

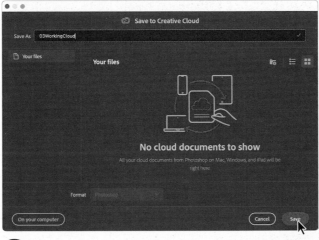

Note: Adobe cloud documents are stored in a different online area than Creative Cloud Files or Creative Cloud Libraries.

4 Close the document.

Now you'll open the cloud document. Again, this will be slightly different than opening a document from local storage.

1　In the Photoshop Home screen, select Your Files on the left side. It lists cloud documents you uploaded using your Adobe ID. You can also select Home, where the Recent list shows local and cloud documents you recently opened.

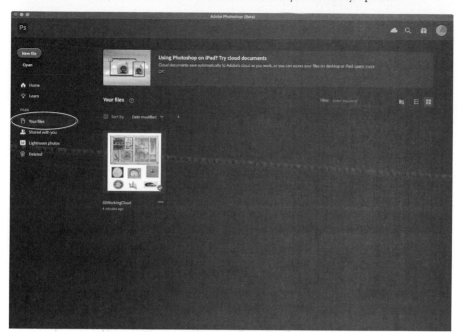

Tip: You can organize your cloud documents in folders on the server. When viewing Your Files on the Photoshop Home screen, click the folder icon near the top to create a new folder.

Tip: If you want to manage or delete a cloud document, click the document's ellipsis (…) button in the Your Files list on the Photoshop Home screen, and choose Rename, Delete, Make Available Offline Always, or Move.

2　Click 03WorkingCloud, the file you just saved. This downloads the file to your computer and opens it in Photoshop.

If you're editing a Photoshop Cloud (PSDC) Document, how can you provide that file to a client who requires a PSD file? By saving the cloud document to your own local storage. Again, the conversion is automatic, so it's easy and seamless.

1　Choose File > Save As. If you see the Cloud Documents dialog box, click Save On Your Computer at the bottom to see the conventional Save As dialog box. Notice that the filename extension is now .psd, because you are saving this document to your local storage, not Cloud Documents.

2　Name the document **03Working.psd**, and save it into the Lesson03 folder. Now you have your own local PSD format copy that you can distribute and back up traditionally (without cloud services).

For this lesson, you can continue with your local copy (03Working.psd), or you can close the local PSD copy and instead open and work with your cloud documents copy (03WorkingCloud.psdc).

Note: You can't find a cloud document on your computer by looking through folders on your desktop; you see cloud documents in the Home screen in Photoshop. A cloud document is stored on Adobe servers and cached only to your local storage. If you need a local copy of a cloud document, choose File > Save As and save it to your computer as described to the left.

Using the Magic Wand tool

The Magic Wand tool selects pixels of a specific color or color range. It's most useful when the color or tone of the area you want to select is distinct from its background.

The Tolerance option sets the range of tonal levels the Magic Wand tool selects, starting from the pixel you click. The default tolerance value of 32 selects the color you click plus 32 lighter and 32 darker tones of that color. If the Magic Wand tool doesn't select the entire area you expect, try increasing the Tolerance value. If the tool selects too much, try decreasing the Tolerance value.

1 Select the Zoom tool in the Tools panel, and then zoom in so that you can see the entire sand dollar in detail.

2 Select the Magic Wand tool (🪄), hidden under the Object Selection tool (🔲).

3 In the options bar, confirm that the Tolerance value is **32**. This value determines the range of colors the wand selects.

4 Click the Magic Wand tool on the red background outside the sand dollar.

▶ Tip: If a Magic Wand tool selection picks up too many similar colors outside the area you want to select, try enabling the Contiguous option in the options bar.

The Magic Wand tool perfectly selected the red background, because all of the colors in the background are similar enough to the pixel you clicked (within the 32 levels specified in the Tolerance setting). But it's the shell we want, so let's start over.

5 Choose Select > Deselect.

6 Position the Magic Wand tool over the sand dollar, and click.

Look carefully at the animated selection marquee that appears over the sand dollar. If this was a perfect selection, the selection marquee would tightly follow the outer edge of the sand dollar. But notice that some interior areas of the sand dollar show selection marquees, because their colors differ from the color you clicked by more than 32 levels (the Tolerance setting). The current selection isn't working because it doesn't include all interior colors.

When you want to select a subject that is mostly the same color and value, against a relatively solid background, you can often solve this by increasing the Tolerance value. But the more complex the subject or background, the more likely a wide Tolerance value will also select unwanted parts of the background. In that case, it's usually better to use a different selection tool, such as the Quick Selection tool. You'll do that next, but first let's deselect the current selection.

7 Choose Select > Deselect.

Using the Quick Selection tool

To use the Quick Selection tool you simply click or drag it within a subject, and the tool looks for the subject's edges. You can add or subtract areas of the selection until you have exactly the area you want. This works better than the Magic Wand tool because the Quick Selection tool is more aware of image content, instead of relying on color similarity alone. Let's see if the Quick Selection tool does a better job selecting the sand dollar.

▶ **Tip:** Notice that the Quick Selection tool looks for a subject outward from where you click or drag the tool, and the Object Selection tool looks for a subject inside the area you drag with that tool.

1 Select the Quick Selection tool (◔) in the Tools panel. It's grouped with the Object Selection tool (▥) and Magic Wand tool (🪄).

2 Select Enhance Edge in the options bar.

Selecting Enhance Edge should improve the quality of the selection, with edges that are truer to the object. If you're using a slower or older computer, you might notice a slight delay when using Enhance Edge.

3 Click or drag within the sand dollar (do not cross over into the background).

The Quick Selection tool looks at what content is probably connected to the area where you clicked or dragged and finds the full edge automatically, selecting the entire sand dollar. The sand dollar is simple enough that the Quick Selection tool can isolate it instantly. When the Quick Selection tool doesn't complete the selection initially, click or drag over areas you want to add to the selection.

▶ **Tip:** If the Quick Selection tool includes areas outside the subject, you can remove unwanted areas from the selection by clicking or dragging over them while holding down the Alt (Windows) or Option (macOS) key. That's the shortcut for selecting the Subtract From Selection icon in the options bar.

Leave the selection active so that you can use it in the next exercise.

Moving a selected area

Once you've made a selection, any changes you make apply exclusively to the pixels within the selection. The rest of the image is not affected by those changes.

To move the selected area to another part of the composition, you use the Move tool. This image has only one layer, so the pixels you move will replace the pixels beneath them. This change is not permanent until you deselect the moved pixels, so you can try different locations for the selection you're moving before you commit it.

▶ **Tip:** If you deselect an area by accident, you may be able to restore the selection by choosing Edit > Undo or Select > Reselect.

1 If the sand dollar is not still selected, repeat the previous exercise to select it.

2 Zoom out so you can see both the shadow box and the sand dollar.

3 Select the Move tool (⊕). Notice that the sand dollar remains selected.

4 Drag the selected area (the sand dollar) to the upper-left area of the frame, which is labeled "A." Position it over the silhouette in the frame, leaving the lower-left part of the silhouette showing as a shadow.

5 Choose Select > Deselect, and then choose File > Save.

There's more than one way to deselect a selection. You can choose Select > Deselect, press Ctrl+D (Windows) or Command+D (macOS), or click outside the selection with any selection tool.

Julieanne Kost is an official Adobe Photoshop evangelist.

Tool tips from the Photoshop evangelist

Move tool tip

If you're moving objects with the Move tool in a document with multiple layers and you need to select one of the layers, try this: With the Move tool selected, position the pointer over any area of an image, and right-click (Windows) or Control-click (macOS). The context menu that appears lists all layers where content exists under the pointer so that you can select a different layer.

Using the Object Selection tool

To use the Object Selection tool, all you have to do is draw a rough selection around the object you want to select, and the Object Selection tool identifies the object and creates a tight selection for it. For an object that has a complicated outline, such as the coral, the Object Selection tool will typically be much faster than trying to draw that irregular outline by hand.

1 Select the Object Selection tool (▦), which is grouped with the Quick Selection tool (◔) and Magic Wand tool (✦).

2 Drag a selection around the piece of coral. It doesn't have to be precise or centered. What's important is that it's a relatively tight selection with a small amount of space between the coral and the edges of the selection marquee. You're simply showing Photoshop which object you want to select.

> **Note:** A colored highlight may appear over an object when you hover over it with the Object Selection tool. The highlight indicates that it's automatically identifying a potential selection. If the area you want to select is highlighted, just click.

The Object Selection tool analyzes the area inside the rectangular selection, finds the object, and creates a selection marquee along its complicated edge.

3 Select the Move tool (✛), and drag the coral to the area of the shadow box labeled "B," positioning it so that a shadow appears to the left of and below the coral.

4 Choose Select > Deselect, and then save your work.

> **Tip:** If the Object Selection tool creates a selection that's too tight, choose Select > Modify > Expand and enter a pixel value; usually 1 to 3 is enough. As with other selection tools, you can add missed bits to the selection (by Shift-dragging the tool around the missed parts). Or subtract from the selection by holding down Alt (Windows) or Option (macOS) as you drag the tool around the area to remove.

Manipulating selections

You can move selections, reposition them as you create them, and even duplicate them. In this section, you'll learn several ways to manipulate selections. Most of these methods work with any selection; you'll use them here with the Elliptical Marquee tool, which lets you select ovals or perfect circles.

One of the most useful things you may find in this section is the introduction of modifier keys that can save you time and arm motions.

Repositioning a selection marquee while creating it

Selecting ellipses and rectangles can be tricky. Sometimes the selection will be off-center or the ratio of width to height won't match what you need. In this exercise, you'll learn techniques such as two important keyboard-mouse combinations that can make your Photoshop work much easier.

As you perform this exercise, be careful to follow the directions about keeping the mouse button or specific keys pressed. If you accidentally release the mouse button at the wrong time, simply start the exercise again from step 1.

1 Select the Zoom tool (Q), and click the plate of shells at the bottom of the document window to zoom in to at least 100% view (use 200% view if the entire plate of shells will still fit in the document window on your screen).

2 Select the Elliptical Marquee tool (◯), hidden under the Rectangular Marquee tool (▢).

● **Note:** You don't have to include every pixel in the plate of shells, but the selection should be the shape of the plate and should contain the shells comfortably.

3 Move the pointer over the plate of shells, and drag diagonally across the oval plate to create a selection, but *do not release the mouse button*. It's OK if your selection does not match the plate shape yet.

If you accidentally release the mouse button, draw the selection again. In most cases—including this one—the new selection replaces the previous one.

4 Still holding down the mouse button, hold down the spacebar, and continue to drag the selection. Instead of resizing the selection, now you're moving it. Position the selection so that it more closely aligns with the plate.

▶ **Tip:** The technique of holding down the spacebar to reposition as you draw also works with other drawing tools in Photoshop, such as the shape tools and the Pen tool.

5 Carefully release the spacebar (but not the mouse button) and continue to drag, trying to make the size and shape of the selection match the oval plate of shells as closely as possible. If necessary, hold down the spacebar again, and drag to move the selection marquee into position around the plate of shells.

Begin dragging a selection. *Press the spacebar to move it.* *Complete the selection.*

▶ **Tip:** If you want to resize a selection after releasing the mouse button, choose Select > Transform Selection.

6 When the selection border is positioned appropriately, release the mouse button.

7 Choose View > Fit On Screen or use the slider in the Navigator panel to reduce the zoom view so that you can see all of the objects in the document window.

Leave the Elliptical Marquee tool and the selection active for the next exercise.

Moving selected pixels with a keyboard shortcut

Now you'll use a keyboard shortcut to move the selected pixels onto the shadow box. The shortcut temporarily switches the active tool to the Move tool, so you don't need to select it from the Tools panel.

1 If the plate of shells is not still selected, repeat the previous exercise to select it.

2 With the Elliptical Marquee tool (⬭) selected in the Tools panel, press Ctrl (Windows) or Command (macOS), and hover the pointer within the selection. Continue to hold down the key for the next step.

The pointer icon now includes a pair of scissors (▸✂), indicating that the selection will be cut from its current location.

3 While continuing to hold down the Ctrl or Command key, drag the plate of shells onto the area of the shadow box labeled "C." (You'll use another technique to nudge the oval plate into the exact position in a minute.)

4 Release the mouse button and the key, but don't deselect the plate of shells.

● **Note:** In step 2, if you try to move the pixels but Photoshop displays an alert saying "Could not use the Move tool because the layer is locked," make sure you start dragging by positioning the pointer inside the selection.

Moving a selection with the arrow keys

You can make minor adjustments to the position of selected pixels by using the arrow keys. You can nudge the selection in increments of 1 pixel or 10 pixels.

When a selection tool is active in the Tools panel, the arrow keys nudge the selection border, but not the contents. When the Move tool is active, the arrow keys move both the selection border and its contents.

You'll use the arrow keys to nudge the plate of shells. Before you begin, make sure that the plate of shells is still selected in the document window.

1 Select the Move tool (✛), and press the Up Arrow key (▭) on your keyboard a few times to move the oval upward.

Notice that each time you press the arrow key, the plate of shells moves 1 pixel. Experiment by pressing the other arrow keys to see how they affect the selection.

▶ **Tip:** If a selection becomes deselected accidentally, choose Select > Reselect.

Softening the edges of a selection

To smooth the hard edges of a selection, you can apply anti-aliasing or feathering or use the Select and Mask option.

Anti-aliasing smooths the jagged edges of a selection by softening the color transition between edge pixels and background pixels. Since only the edge pixels change, detail loss is minimal. Anti-aliasing is useful when you cut, copy, and paste selections to create composite images.

Anti-aliasing is available for the Lasso, Polygonal Lasso, Magnetic Lasso, Elliptical Marquee, and Magic Wand tools. (Select the tool to display its options in the options bar.) To apply anti-aliasing, you must select the option before making the selection. Once a selection is made, you cannot add anti-aliasing to it.

Feathering blurs edges by building a transition at the boundary between the selection and its surrounding pixels. This can blur detail at the edge of the selection.

You can define feathering for the marquee and lasso tools as you use them, or you can add feathering to an existing selection. Feathering effects become apparent when you move, cut, or copy the selection.

- To feather a selection edge using the Select and Mask option, make a selection, and then click Select and Mask in the options bar to open its dialog box. In there you can smooth the outline, feather it, or contract or expand it.

- To anti-alias a selection edge, select a lasso tool, or the Elliptical Marquee or Magic Wand tool, and select Anti-alias in the options bar.

- To define a feathered edge for a selection you're about to draw, select any of the lasso or marquee tools. Enter a Feather value in the options bar. This value defines the width of the feathered edge and can range from 1 to 250 pixels.

- To define a feathered edge for an existing selection, choose Select > Modify > Feather. Enter a value for the Feather Radius, and click OK.

2 Hold down the Shift key as you press an arrow key.

When you hold down the Shift key, the selected pixels move 10 pixels every time you press an arrow key.

Sometimes the selection marquee can distract you as you make adjustments. You can hide the edges of a selection temporarily without actually deselecting and then display the selection border once you've completed the adjustments.

3 Choose View > Show > Selection Edges to deselect the command, hiding the selection border around the plate of shells.

4 Use the arrow keys to nudge the plate of shells until it's positioned over the silhouette so that there's a shadow on the left and bottom of the plate. Then choose View > Show > Selection Edges to reveal the selection border again.

▶ **Tip:** Selection edges, guidelines, and other visible items that aren't actual objects are called *extras*, so another way to hide the selection edges is to deselect the View > Extras command or press its keyboard shortcut, Ctrl+H (Windows) or Command+H (macOS).

Hidden selection edges *Visible selection edges*

5 Choose Select > Deselect, or press Ctrl+D (Windows) or Command+D (macOS).

6 Choose File > Save to save your work so far.

Selecting with the lasso tools

As we mentioned earlier, Photoshop includes three lasso tools: the Lasso tool, the Polygonal Lasso tool, and the Magnetic Lasso tool. You can use the Lasso tool to make selections that require both freehand and straight lines, using keyboard short-cuts to move back and forth between the Lasso tool and the Polygonal Lasso tool. You'll use the Lasso tool to select the mussel. It takes a bit of practice to alternate between straight-line and freehand selections—if you make a mistake while you're selecting the mussel, simply deselect and start again.

▶ **Tip:** Because the lasso tools are manual, they can be the most time-consuming way to create a selection. They are typically most useful for selecting simple shapes or adjusting an existing selection.

1 If the window magnification is below 100%, select the Zoom tool (Q), and click the mussel to zoom in to at least 100%.

2 Select the Lasso tool (𝒫). Starting at the lower-left section of the mussel, drag around the rounded end of the mussel, tracing the shape as accurately as possible. *Do not release the mouse button.*

3 When you reach a corner or straight part of the edge, press the Alt (Windows) or Option (macOS) key, and then release the mouse button so that the lasso pointer changes to the polygonal lasso shape (𝕩). *Do not release the Alt or Option key.*

4 Begin clicking along the end of the mussel to place anchor points, following the contours of the mussel. Be sure to hold down the Alt or Option key throughout this process. This lets you create perfectly straight segments along the selection.

▶ **Tip:** Go slowly until you become comfortable with the Lasso tool. If you make a mistake or accidentally release the mouse button during steps 2–8, choose Edit > Undo, and start again at step 2.

Drag with the Lasso tool. *Click with the Polygonal Lasso tool.*

The selection border automatically stretches like a rubber band between anchor points.

5 When you reach the tip of the mussel, hold down the mouse button as you release the Alt or Option key. The pointer again appears as the lasso icon.

6 Carefully drag around the tip of the mussel, holding down the mouse button.

7 When you finish tracing the tip and reach the straight segments along the lower side of the mussel, first press Alt or Option again, and then release the mouse button. Click along the straight segments of the lower side of the mussel as needed. Continue to trace the straight and curved mussel edges until you arrive back at the starting point of your selection at the left end of the mussel.

8 Click the starting point of the selection, and then release Alt or Option. The mussel is now entirely selected. Leave the mussel selected for the next exercise.

● **Note:** To make sure that the selection is the shape you want when you use the Lasso tool, end the selection by dragging across the starting point of the selection. If you start and stop the selection at different points, Photoshop draws a straight line between the start and end points of the selection.

Rotating a selection

Now you'll rotate the mussel.

Before you begin, make sure that the mussel is still selected.

1 Choose View > Fit On Screen to resize the document window to fit on your screen.

2 Press Ctrl (Windows) or Command (macOS) as you drag the selected mussel to the section of the shadow box labeled "D."

The pointer changes to the Move tool icon when you press Ctrl (Windows) or Command (macOS).

3 Choose Edit > Transform > Rotate.

The mussel and selection marquee are enclosed in a bounding box.

▶ **Tip:** You can constrain rotation to common angles such as 90 degrees by holding down the Shift key as you drag the bounding box.

4 Move the pointer outside the bounding box so that it becomes a curved, two-headed arrow (↰). Drag to rotate the mussel to a 90-degree angle. You can verify the angle in the transformation values display next to the pointer, or in the Rotate box in the options bar. Press Enter or Return to commit the transformation.

5 If necessary, select the Move tool (✛), and drag to reposition the mussel, leaving a shadow to match the others. When you're satisfied, choose Select > Deselect.

6 Choose File > Save.

Selecting with the Magnetic Lasso tool

You can use the Magnetic Lasso tool to make freehand selections of areas with high-contrast edges. When you draw with the Magnetic Lasso tool, the selection border automatically snaps to the edge between areas of contrast. You can also control the selection path by occasionally clicking the mouse to place anchor points in the selection border.

You'll use the Magnetic Lasso tool to select the nautilus so that you can move it to the shadow box.

1 Select the Zoom tool (🔍), and click the nautilus to zoom in to at least 100%.

2 Select the Magnetic Lasso tool (⦚), hidden under the Lasso tool (⦾).

3 Click once along the left edge of the nautilus, and then move the Magnetic Lasso tool along the edge to trace its outline.

▶ **Tip:** In low-contrast areas, you may want to click to place your own fastening points. You can add as many as you need. To remove the most recent fastening point, press Delete, and then move the mouse back to the remaining fastening point and continue selecting.

Even if you don't hold down the mouse button, the tool snaps to the edge of the nautilus and automatically adds fastening points.

4 When you reach the left side of the nautilus again, double-click to return the Magnetic Lasso tool to the starting point, closing the selection. Or you can move the Magnetic Lasso tool over the starting point and click once.

5 Double-click the Hand tool (🖑) to fit the entire image in the window.

6 Select the Move tool (✛), and drag the nautilus onto its silhouette in the section of the frame labeled "E," leaving a shadow below it and on the left side.

7 Choose Select > Deselect, and then choose File > Save.

Selecting from a center point

In some cases, it's easier to make elliptical or rectangular selections by drawing a selection from an object's center point. You'll use this technique to select the head of the screw for the shadow box corners.

1 Select the Zoom tool (Q), and zoom in on the screw to a magnification of about 300%. Make sure that the entire screw head is visible in your document window.

2 Select the Elliptical Marquee tool (◯) in the Tools panel.

3 Move the pointer to the approximate center of the screw.

4 Click and begin dragging. Then, without releasing the mouse button, press Alt (Windows) or Option (macOS) as you continue dragging the selection to the outer edge of the screw.

The selection is centered over its starting point.

▶ **Tip:** To select a perfect circle, press Shift as you drag. Hold down Shift while dragging the Rectangular Marquee tool to select a perfect square.

5 When you have the entire screw head selected, release the mouse button first, and then release Alt or Option (and the Shift key if you used it). Do not deselect, because you'll use this selection in the next exercise.

6 If necessary, reposition the selection border using one of the methods you learned earlier. If you accidentally released the Alt or Option key before you released the mouse button, select the screw again.

Resizing and copying a selection

Now you'll move the screw to the lower-right corner of the wooden shadow box and then duplicate it for the other corners.

Resizing the contents of a selection

You'll start by moving the screw, but it's too large for the space. You'll need to resize it as well.

Before you begin, make sure that the screw is still selected. If it's not, reselect it by completing the previous exercise.

1 Choose View > Fit On Screen so that the entire image fits within the document window.

2 Select the Move tool (⊹) in the Tools panel.

3 Position the pointer within the screw selection.

The pointer becomes an arrow with a pair of scissors (▶✂), indicating that dragging the selection will cut it from its current location and move it to the new location.

4 Drag the screw onto the lower-right corner of the shadow box.

Tip: If the screw won't move or resize smoothly, as if it gets "stuck," hold down the Control key to temporarily disable snapping to magenta Smart Guides as you drag. Or permanently disable them by deselecting the View > Show > Smart Guides command.

5 Choose Edit > Transform > Scale. A bounding box appears around the selection.

6 Drag one of the corner points inward to reduce the screw to about 40% of its original size or until it is small enough to sit on the shadow box frame.

As you resize the object, the selection marquee resizes, too. Both resize proportionally by default.

7 Press Enter or Return to commit the change and remove the transformation bounding box.

8 Use the Move tool to reposition the screw after resizing it so that it is centered in the corner of the shadow box frame.

Tip: If you don't want to maintain original proportions while resizing, press the Shift key as you drag a corner handle of a transformation bounding box.

9 Leaving the screw selected, choose File > Save to save your work.

Moving and duplicating a selection simultaneously

You can move and duplicate a selection at the same time. You'll copy the screw for the other three corners of the frame. If the screw is no longer selected, reselect it now, using the techniques you learned earlier.

1 With the Move tool (✛) selected, press Alt (Windows) or Option (macOS) as you position the pointer inside the screw selection.

The pointer changes, displaying the usual black arrow and an additional white arrow, which indicates that a duplicate will be made when you move the selection.

2 Continue holding down the Alt or Option key as you drag a duplicate of the screw straight up to the top-right corner of the frame. Release the mouse button and the Alt or Option key, but don't deselect the duplicate image.

3 Hold down Alt+Shift (Windows) or Option+Shift (macOS), and drag a new copy of the screw straight left to the upper-left corner of the frame.

Pressing the Shift key as you move a selection constrains the movement horizontally or vertically in 45-degree increments.

4 Repeat step 3 to drag a fourth screw to the lower-left corner of the frame.

5 When you're satisfied with the position of the fourth screw, choose Select > Deselect, and then choose File > Save.

Copying selections

You can use the Move tool to copy selections as you drag them within or between images, or you can copy and move selections using commands on the Edit menu. The Move tool uses less memory, because it doesn't use the clipboard.

Photoshop has several copy and paste commands on the Edit menu:

- **Copy** takes the selected area on the active layer and puts it on the clipboard.
- **Copy Merged** creates a merged copy of all the visible layers in the selected area.
- **Paste** inserts the clipboard contents at the center of the image. If you paste into another image, the pasted content becomes a new layer.

On the Edit > Paste Special submenu, Photoshop also provides specialized pasting commands to give you more options in certain situations:

- **Paste without Formatting** pastes text without the formatting it may have been copied with, such as font and size. It helps ensure that text pasted from another document or application matches the formatting of a Photoshop text layer.
- **Paste in Place** pastes clipboard content at the location it had in the original image, instead of at the center of the document.
- **Paste Into** pastes clipboard content inside the active selection in the same or a different image. The source selection is pasted onto a new layer, and the area outside the selection is converted into a layer mask.
- **Paste Outside** is the same as Paste Into except that Photoshop pastes the content outside the active selection and converts the area inside the selection to a layer mask.

If two documents have different pixel dimensions, content you paste between them may appear to change size. This is because content maintains its pixel dimensions when pasted into a document with different pixel dimensions. You can resize a pasted selection, but the image quality of the selection may decrease if enlarged.

Cropping an image

Now that your composition is in place, you'll crop the image to a final size. You can use either the Crop tool or the Crop command to crop an image.

1 Select the Crop tool (⌐┼), or press C to switch from the current tool to the Crop tool. Photoshop displays a crop boundary around the entire image.

2 In the options bar, make sure Ratio is selected in the Preset pop-up menu and that there are no ratio values specified. (If there are, click Clear.) Then confirm that Delete Cropped Pixels is selected.

When Ratio is selected but no ratio values are specified, you can freely crop the image to any proportions.

► **Tip:** To crop an image with its original proportions intact, choose Original Ratio from the Preset pop-up menu in the options bar.

3 Drag the crop handles so that the shadow box is in the highlighted area, omitting the backgrounds from the original objects at the bottom of the image. Crop the frame so that there's an even area of white around it.

4 When you're satisfied with the position of the crop area, click the Commit Current Crop Operation button (✓) in the options bar.

5 Choose File > Save to save your work.

You've used several different selection tools to move all the seashells into place. The shadow box is complete!

Review questions

1 Once you've made a selection, what area of the image can be edited?

2 How do you add to and subtract from a selection when using a tool such as the Quick Selection or Lasso tool?

3 How can you move a selection while you're creating it?

4 What is the difference between the Quick Selection tool and the Object Selection tool?

5 How does the Magic Wand tool determine which areas of an image to select? What is tolerance, and how does it affect a selection?

Review answers

1 When a selection is active, edits apply only within that selection.

2 To add to a selection, click the Add To Selection button in the options bar, and then click the area you want to add. To subtract from a selection, click the Subtract From Selection button in the options bar, and then click the area you want to subtract. You can also add to a selection by pressing Shift as you drag or click; to subtract, press Alt (Windows) or Option (macOS) as you drag or click.

3 To reposition a selection as you're creating it, keep holding down the mouse button as you also hold down the spacebar and drag.

4 The Quick Selection tool attempts to detect content edges, while the Object Selection tool attempts to recognize subjects (such as people) and objects in the image.

5 The Magic Wand tool selects adjacent pixels based on their similarity in color. The Tolerance value determines how many color tones the Magic Wand tool will select. The higher the tolerance setting, the more tones are selected.

4 LAYER BASICS

Lesson overview

In this lesson, you'll learn how to do the following:

- Organize artwork on layers.

- Create, view, hide, and select layers.

- Rearrange layers to change the stacking order of artwork.

- Apply blending modes to layers.

- Resize and rotate layers.

- Apply a gradient to a layer.

- Apply a filter to a layer.

- Add text and layer effects to a layer.

- Add an adjustment layer.

- Save a copy of the file with the layers flattened.

 This lesson will take less than an hour to complete. To get the lesson files used in this chapter, download them from the web page for this book at adobepress.com/PhotoshopCIB2023. For more information, see "Accessing the lesson files and Web Edition" in the Getting Started section at the beginning of this book.

As you work on this lesson, you'll preserve the start files. If you need to restore the start files, download them from your Account page.

PROJECT: TRAVEL POSTCARD

In Photoshop, you can organize different parts of an image using layers. Each layer can then be edited as discrete artwork, giving you tremendous flexibility as you compose and revise an image.

About layers

Note: Some file formats, such as JPEG and GIF, don't support layers. To save those images with layers, you must save them in Photoshop or TIFF format. Also, some color modes (on the Image > Mode submenu), such as Bitmap and Indexed Color, don't support layers. The lesson files in this chapter are Photoshop documents in RGB color mode.

Every Photoshop file contains one or more *layers*. All new layers in an image are transparent until you add text or artwork. Working with layers is analogous to placing portions of a drawing on clear sheets of film, such as those viewed with an overhead projector: Individual sheets may be edited, repositioned, and deleted without affecting the other sheets. When the sheets are stacked, the entire composition is visible.

Many of the lesson files for this book have a *background layer*, a layer behind all others that is always completely opaque. Photoshop documents intended for print, digital camera images, and scanned images typically have a background layer. Photoshop documents created for mobile devices and websites might not have a background layer; for example, website graphics may need transparent areas that won't block a web page's background or other elements. To learn more about the background layer, see "About the background layer" on page 78.

Getting started

You'll start the lesson by viewing an image of the final composition.

Note: If Bridge isn't installed, you'll be prompted to install it. For more information, see page 3.

1 Start Photoshop, and then simultaneously hold down Ctrl+Alt+Shift (Windows) or Command+Option+Shift (macOS) to restore the default preferences. (See "Restoring default preferences" on page 5.)

2 When prompted, click Yes to delete the Adobe Photoshop Settings file.

3 Choose File > Browse In Bridge to open Adobe Bridge.

4 In the Favorites panel, click the Lessons folder. Then double-click the Lesson04 folder in the Content panel to see its contents.

5 Study the 04End.psd file. Move the thumbnail slider to the right if you want to see the image in more detail.

Note: If Photoshop displays a dialog box telling you about the difference between saving to Cloud Documents and On Your Computer, click Save On Your Computer. You can also select Don't Show Again, but that setting will deselect after you reset Photoshop preferences.

This layered composite represents a postcard. You will assemble it in this lesson as you learn how to create, edit, and manage layers.

6 Double-click the 04Start.psd file to open it in Photoshop.

7 Choose File > Save As, rename the file **04Working.psd**, and click Save. Click OK if you see the Photoshop Format Options dialog box.

Saving another version of the start file frees you to make changes without worrying about overwriting the original.

Using the Layers panel

The Layers panel lists all the layers in an image, displaying the layer names and thumbnails of the content on each layer. You can use the Layers panel to hide, view, reposition, delete, rename, and merge layers. The layer thumbnails are automatically updated as you edit the layers.

1 If the Layers panel is not visible in the work area, choose Window > Layers.

The Layers panel lists five layers for the 04Working.psd file (from top to bottom): Postage, HAWAII, Flower, Pineapple, and Background.

2 Select the Background layer to make it active (if it's not already selected). Notice the layer thumbnail and the icons shown for the Background layer:

▶ **Tip:** Use the context menu to hide or resize the layer thumbnail (the small preview picture next to the layer name). Right-click (Windows) or Control-click (macOS) a thumbnail in the Layers panel to open the context menu, and then choose a thumbnail size.

- The lock icon (🔒) indicates that the layer is protected from layer changes. That's why the options above the layer list are unavailable. However, it's still possible to edit the layer content itself, such as painting on it.

- The eye icon (👁) indicates that the layer is visible in the document window. If you click the eye, the document window no longer displays that layer.

The first task for this project is to add a photo of the beach to the postcard. First, you'll open the beach image in Photoshop.

3 In Photoshop, choose File > Open, navigate to the Lesson04 folder, and then double-click the Beach.psd file to open it.

The Layers panel changes to display the layer information for the active Beach.psd file. Notice that only one layer appears in the Beach.psd image: Layer 1. It's not a Background layer, so it can use layer features such as transparency.

About the background layer

If you see a layer named Background at the bottom of the Layers panel and it displays a lock icon, it's a *background layer*, which does not act like other layers. You can't change a background layer's position in the stacking order, and it's always opaque (no transparent areas). When you flatten the layers of a Photoshop document, the document contains only a background layer.

You can convert a background layer to a regular layer or create a document without a background layer. When a Photoshop document has no background layer, any pixels that don't contain content can be transparent. That makes it possible for the content in a Photoshop document to have a non-rectangular shape when placed over another background in Photoshop or in other applications.

To convert a background layer into a regular layer:

Click the lock icon next to the Background layer name. It changes to a default layer name. (Or, double-click the Background layer, set options, and click OK.)

To convert a regular layer into a background layer:

1 Select a layer in the Layers panel.

2 Choose Layer > New > Background From Layer.

Renaming and copying a layer

To add content, drag and drop one or more files or Photoshop layers into a Photoshop document window. You can drag layers from a source document window, drag them from the Layers panel, or drag a compatible file from the desktop. Each item you drop into a Photoshop document is added as a separate layer.

You'll drag the Beach.psd image onto the 04Working.psd file. Before you begin, make sure that both the 04Working.psd and Beach.psd files are open and that the Beach.psd file is selected.

First, you'll give Layer 1 a more descriptive name.

1 In the Layers panel, double-click the name Layer 1, type **Beach**, and then press Enter or Return. Keep the layer selected.

2 Choose Window > Arrange > 2-Up Vertical. Photoshop displays both of the open image files. Select the Beach.psd image so that it is the active file.

3 Select the Move tool (✛), and use it to drag the Beach.psd image onto the 04Working.psd document window.

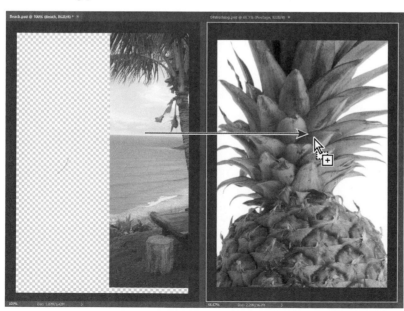

▶ **Tip:** Dragging many layers to another document can be easier if you combine them into a layer group first. Select them in the Layers panel, and then choose Layer > Group Layers. Now you have only one thing to drag: the layer group (which uses a folder icon).

● **Note:** When you rename a layer, make sure you double-click the layer name text. If you double-click outside the name, other layer options may appear instead.

▶ **Tip:** If you hold down Shift as you drag an image from one file into another, the dragged image automatically centers itself in the target image window.

▶ **Tip:** You can also transfer layers between documents by copying and pasting: Select layers in the Layers panel, choose Edit > Copy, switch to another document, and choose Edit > Paste.

Tip: Need images for a project like this one? In Photoshop, choose File > Search Adobe Stock to download low-resolution placeholder images from the Adobe Stock online photo library. If you license the images, Photoshop replaces the placeholders with high-resolution images.

The Beach layer now appears in the 04Working.psd file document window and its Layers panel, between the Background and Pineapple layers. Photoshop always adds new layers directly above the selected layer; you selected the Background layer earlier.

4 Close the Beach.psd file without saving changes to it.

Viewing individual layers

Tip: If you need to center the Beach layer, select the Beach layer in the Layers panel, choose Select > All, and then choose Layer > Align Layers To Selection > Horizontal Centers (or Vertical Centers, as needed). Then choose Select > Deselect.

The 04Working.psd file now contains six layers. Some of the layers are visible, and some are hidden. The eye icon (👁) next to a layer thumbnail in the Layers panel indicates that the layer is visible.

1 Click the eye icon (👁) next to the Pineapple layer to hide the image of the pineapple.

You can hide or show a layer by clicking this icon or clicking in its column, also called the Show/Hide Visibility column.

2 Click again in the Show/Hide Visibility column to display the pineapple.

Adding a border using the Stroke layer style

Now you'll add a white border around the Beach layer to create the impression that it's an old photograph.

1 Select the Beach layer. (To select the layer, click the layer name in the Layers panel.)

The layer is highlighted, indicating that it is active. Changes you make in the document window affect the active layer.

2 To make the opaque areas on this layer more obvious, hide all layers except the Beach layer: Press Alt (Windows) or Option (macOS) as you click the eye icon (👁) next to the Beach layer.

The white background and other objects in the image disappear, leaving only the beach image against a checkerboard background. The checkerboard indicates transparent areas of the active layer.

3 Choose Layer > Layer Style > Stroke.

The Layer Style dialog box opens. Now you'll select the options for the white stroke around the beach image.

Tip: When the Preview option is enabled in a dialog box such as Layer Style, you can watch the selected layer change as you adjust the options.

4 Specify the following settings:

- Size: **5** px

- Position: Inside

- Blend Mode: Normal

- Opacity: **100**%

- Color: White (Click the Color box, and select white in the Color Picker.)

Note: Layer styles apply to the opaque pixels of a layer only. For example, the Stroke layer style draws its line around the opaque pixels of the Beach layer and doesn't change the transparent pixels.

5 Click OK to commit the effect to the layer.

Rearranging layers

The order in which the layers of an image are organized is called the *stacking order*. Stacking order determines how the image is viewed—you can change the order to make certain parts of the image appear in front of or behind other layers.

You'll rearrange the layers so that the beach image is in front of another image that is currently hidden in the file.

1 Make the Postage, HAWAII, Flower, Pineapple, and Background layers visible by clicking the Show/Hide Visibility column next to their layer names.

▶ **Tip:** When you want to hide or show a continuous series of layers, you can also drag through their eye icons in the Show/Hide Visibility column, instead of clicking each eye icon separately.

The beach image is almost entirely blocked by images on other layers.

2 In the Layers panel, drag the Beach layer up so that it is positioned between the Pineapple and Flower layers—as you drag, a blue line indicates where it will be dropped—and then release the mouse button.

The Beach layer moves up one level in the stacking order, and the beach image appears on top of the pineapple and background images but under the postmark, flower, and the word "HAWAII."

▶ **Tip:** You can also control the stacking order of layered images by selecting them in the Layers panel, choosing Layer > Arrange, and then choosing Bring To Front, Bring Forward, Send Backward, or Send To Back.

Changing the opacity of a layer

You can reduce the opacity of any layer to reveal the layers below it. In this case, the postmark is too dark on the flower. You'll edit the opacity of the Postage layer to let the flower and other images show through.

1 Select the Postage layer, and then click the arrow next to the Opacity field to display the Opacity slider. Drag the slider to 25%. You can also type **25** in the Opacity box or scrub the Opacity label.

The Postage layer becomes partially transparent so you can better see the layers underneath. Notice that the change in opacity affects only the content of the Postage layer. The Pineapple, Beach, Flower, and HAWAII layers remain opaque.

2 Choose File > Save to save your work.

Duplicating a layer and changing the blending mode

You can apply different blending modes to a layer. *Blending modes* affect how the color pixels on one layer blend with pixels on the layers behind it (see the "Blending Modes" sidebar on page 86). First you'll use blending modes to increase the intensity of the image on the Pineapple layer so that it doesn't look so dull. Then you'll change the blending mode on the Postage layer. (Currently, the blending mode for both layers is Normal.)

1 Click the eye icons next to the HAWAII, Flower, and Beach layers to hide them.

Tip: If you prefer using the menu bar, Duplicate Layer is also available by choosing Layer > Duplicate Layer.

2 Right-click or Control-click the Pineapple layer name, and choose Duplicate Layer from the context menu. (Make sure you click the layer name; other areas may display a different context menu.) Click OK in the Duplicate Layer dialog box.

A layer called "Pineapple copy" appears above the Pineapple layer in the Layers panel.

3 With the Pineapple copy layer selected, choose Overlay from the Blending Modes menu in the Layers panel.

▶ **Tip:** Notice that the image changes as you move the mouse over the options in the Blending Modes menu. This is a quick way to preview which one will do what you want.

The Overlay blending mode blends the Pineapple copy layer with the Pineapple layer beneath it to create a vibrant, more colorful pineapple with deeper shadows and brighter highlights.

▶ **Tip:** If the effect of a blending mode is too strong, reduce the Opacity of that layer.

4 Select the Postage layer, and choose Multiply from the Blending Modes menu.

▶ **Tip:** As the list of layers becomes longer, it can be difficult to locate the layer you want. You can use the filter field at the top of the Layers panel to limit the layer list by attributes such as layer kind, layer name, effect, and more.

The Multiply blending mode multiplies the color values of its layer with those of the underlying layers. In this example, areas of the postmark that are over the pineapple are darkened using the tonal values of the pineapple.

Each blending mode uses different math to combine a layer with the layers behind it. Overlay tends to increase contrast; Multiply tends to darken its layer.

5 Choose File > Save to save your work.

▶ **Tip:** In the Layers panel list, you can display the selected layers only and hide the rest: Choose Select > Isolate Layers. When you do this, the filter switch in the Layers panel turns red to let you know that some layers are hidden in the list.

Blending modes

Blending modes affect how the color pixels on a layer blend with pixels on the layers beneath them. The default blending mode, Normal, hides pixels beneath the top layer unless the top layer is partially or completely transparent. Each of the other blending modes lets you control the way the pixels in the layers interact with each other.

Often, the best way to see how a blending mode affects your image is simply to try it. You can easily experiment with various blending modes in the Layers panel, watching the image change as you move the mouse over the options in the Blending Modes menu. As you experiment, keep in mind how different groups of blending modes affect an image. Generally, if you want to:

- Darken underlying layers, try Darken, Multiply, Color Burn, Linear Burn, or Darker Color.
- Lighten underlying layers, try Lighten, Screen, Color Dodge, Linear Dodge, or Lighter Color.
- Increase the contrast between layers, try Overlay, Soft Light, Hard Light, Vivid Light, Linear Light, Pin Light, or Hard Mix.
- Change the color values of the image, try Hue, Saturation, Color, or Luminosity.
- Create an inversion effect, try Difference or Exclusion.

The following blending modes tend to be used more often and are good ways to start experimenting:

- **Multiply** does what the name implies: It multiplies the selected layer's color values with the color values of underlying layers.

- **Lighten** uses the lightest color value it finds after comparing pixels on the selected layer to underlying layers.

Multiply

- **Overlay** increases contrast in underlying layers, especially in light and dark areas. The difference is smaller the closer the selected layer's color value is to middle gray, which applies no change to underlying layers.

Lighten

- **Luminosity** replaces the luminance of underlying pixels, using the selected layer.

Overlay

Luminosity

Difference

- **Difference** subtracts darker colors from lighter ones. It's a great way to visually identify the differences between two nearly identical images on separate layers.

When you apply different blending modes to multiple layers, you can change the effect by applying the blending modes in a different order in the layer stack. Also, applying a blending mode to a layer group gives you a different result than applying the same blending mode to each layer in the group.

Resizing and rotating layers

Changing the position, size, and angle of layers gives you many creative possibilities. In Photoshop, these kinds of edits are called *transformations*. You performed transformations in Chapter 3 with selections, and they also apply to layers.

1 Click the Visibility column on the Beach layer to make the layer visible.

2 Select the Beach layer in the Layers panel, and choose Edit > Free Transform.

A Transform bounding box appears around the beach image. The bounding box has square handles on each corner and each side.

First, you'll resize and angle the layer.

3 Drag a corner handle inward to scale the beach photo down by about 50%. (Watch the Width and Height percentages in the options bar.)

4 With the bounding box still active, position the pointer just outside the bounding box until the pointer becomes a curved double arrow. Drag clockwise to rotate the beach image approximately 15 degrees. You can also enter **15** in the Set Rotation box in the options bar.

▶ **Tip:** The Edit > Free Transform command is so useful that you may want to memorize its keyboard shortcut: Ctrl-T (Windows) or Command-T (macOS).

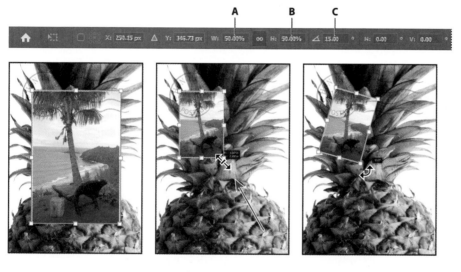

A. *Width value*
B. *Height value*
C. *Set Rotation box*

5 Click the Commit Transform button (✓) in the options bar.

6 Make the Flower layer visible. Then select the Move tool (✛), and drag the beach photo so that its corner is tucked neatly beneath the flower, as in the illustration after step 7.

▶ **Tip:** You can also commit a transformation by clicking far outside the transform bounding box. Just make sure you aren't clicking somewhere that will alter a setting or layer accidentally.

7 Choose File > Save.

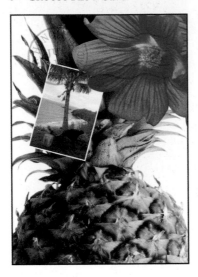

Using a filter to create artwork

Next, you'll create a new layer with no artwork on it. (Adding empty layers to a file is comparable to adding blank sheets of clear film to a stack of images.) You'll use this layer to add realistic-looking clouds to the sky with a Photoshop filter.

1 In the Layers panel, select the Background layer to make it active, and then click the Create A New Layer button (⊞) at the bottom of the Layers panel.

● **Note:** You can also create a new layer by choosing Layer > New > Layer or by choosing New Layer from the Layers panel menu.

A new layer, named Layer 1, appears between the Background and Pineapple layers. The layer has no content, so it has no effect on the image.

2 Double-click the name Layer 1, type **Clouds**, and press Enter or Return to rename the layer.

3 In the Tools panel, click the foreground color swatch, select a sky blue color from the Color Picker, and click OK. We selected a color with the following values: R=48, G=138, B=174. The Background Color remains white.

4 With the Clouds layer still active, choose Filter > Render > Clouds.

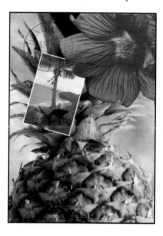

▶ **Tip:** If you expect to use a certain color frequently in multiple documents, add it to your Creative Cloud Libraries. Create a swatch of the color in the Swatches panel, and then drag the swatch to a library in the Libraries panel. Now that color is available to any Photoshop document that you open.

Realistic-looking clouds appear behind the image.

5 Choose File > Save.

Dragging to add a new layer

You can add a layer to an image by dragging an image file from Bridge or from the desktop in Explorer (Windows) or the Finder (macOS). You'll add another flower to the postcard now.

▶ **Tip:** If you're adding artwork from a Creative Cloud library, you can simply drag and drop it from the Libraries panel into a Photoshop document. You can also do this with Adobe Stock images stored in your Creative Cloud Libraries.

1 If Photoshop fills your monitor, reduce the size of the Photoshop window:

- On Windows, click the Restore button (⧉) in the upper-right corner, and then drag any corner of the Photoshop window to make it smaller.

- On a Mac, click the green Maximize/Restore button (●) in the upper-left corner of the document window, or drag any corner of the Photoshop window to make it smaller.

2 In Photoshop, select the Pineapple copy layer in the Layers panel to make it the active layer.

3 In Explorer (Windows) or the Finder (macOS), navigate to the Lessons folder you downloaded from the peachpit.com website. Then navigate to the Lesson04 folder, and position that window so you can see its contents next to the Photoshop window.

4 Select Flower2.psd, and drag it from Explorer or the Finder onto your image.

▶ **Tip:** You can drag images from a Bridge window to Photoshop as easily as you can drag from the Windows or Mac desktop.

The Flower2 layer appears in the Layers panel, above the Pineapple copy layer.

5 Now that you are done importing, you can make the Photoshop application window larger again if it will give you more room to work comfortably.

6 Position the Flower2 layer in the lower-left corner of the postcard so that about half of the top flower is visible.

● **Note:** If you don't see the Commit Transform button in the options bar, the Photoshop application window may be too narrow. Either resize the window to be wider, or press the Enter or Return keyboard shortcut for committing an edit.

7 Click the Commit Transform button (✓) in the options bar to accept the layer. Its layer icon indicates that Photoshop placed the image as a Smart Object, which is a layer you can edit without making permanent changes. You'll work more extensively with Smart Objects in Lesson 5, "Quick Fixes."

Adding text

Now you're ready to create some type using the Horizontal Type tool, which places the text on its own type layer. You'll then edit the text and apply a special effect.

1 Make the HAWAII layer visible. You'll add text just below this layer and apply special effects to both layers.

2 Choose Select > Deselect Layers to ensure that no layers are selected.

3 In the Tools panel, select the Horizontal Type tool (**T**). Then choose Window > Character to open the Character panel. Do the following in the Character panel:

• Select a condensed font (we used Birch Std, which you can add from Adobe Fonts; if you use a different font, adjust other settings accordingly).

• Select a font style (we used Regular).

• Select a large font size (we used 36 points).

• Select a large tracking value () (we used 250).

• Click the color swatch, select a shade of grassy green in the Color Picker, and click OK to close the Color Picker.

• If the font does not have a bold variant, click the Faux Bold button (**T**).

• Click the All Caps button (**TT**).

• Select Crisp from the Anti-aliasing menu (ªa).

4 In the options bar or Paragraph panel, click the Center Text icon (≣).

5 Click just below the "W" in the word "HAWAII," and type **Island Paradise**, replacing the selected placeholder text that appears. Then click the Commit Any Current Edits button (✓) in the options bar.

As you type, the text expands out from the center because you selected centered text alignment. The Layers panel now includes a layer named Island Paradise with a "T" thumbnail, indicating that it is a type layer. This layer is at the top of the layer stack because no layers were selected when it was created.

▶ **Tip:** If a font has a bold variant, always choose that instead of applying the Faux Bold option. True bold fonts are precisely crafted to be typographically consistent and well designed; Faux Bold is computer generated.

6 If the text is slightly off center relative to the "HAWAII" text, select the Move tool (⊕), and drag to reposition the "Island Paradise" text layer as needed.

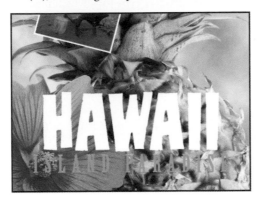

Applying a gradient to a layer

You can apply a color gradient to all or part of a layer. In this example, you'll apply a gradient to the word "HAWAII" to make it more colorful. First you'll select the letters, and then you'll apply the gradient.

1 Select the HAWAII layer in the Layers panel to make it active.

● **Note:** Make sure you click the thumbnail, rather than the layer name, or you'll see a different context menu.

2 Right-click or Control-click the thumbnail in the HAWAII layer, and choose Select Pixels.

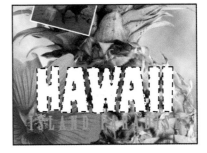

All non-transparent pixels on the HAWAII layer (the white lettering) are selected. Now that you've selected the area to fill, you'll apply a gradient.

3 In the Tools panel, select the Gradient tool (▬).

4 Click the Foreground Color swatch in the Tools panel, select a bright shade of orange in the Color Picker, and click OK. The Background Color should still be white.

5 In the options bar, make sure that Linear Gradient (▬) is selected.

6 In the options bar, click the arrow next to the Gradient Editor box to open the Gradient Picker. Select the Foreground To Background swatch (it's the first one in the Basics group), and then click anywhere outside the Gradient Picker to close it.

● **Note:** Though the layer contains the word "HAWAII," it is no longer an editable type layer. The text was rasterized (converted to pixels).

▶ **Tip:** To list the gradient options by name rather than by sample, click the menu button in the Gradient Picker, and choose either Small List or Large List. Or, hover the pointer over a thumbnail until a tool tip appears, showing the gradient name.

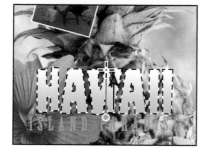

7 With the selection still active, drag the Gradient tool from the bottom to the top of the letters. If you want to be sure you drag straight up, hold down the Shift key and then drag. When the pointer reaches the top of the letters, release the mouse button.

The gradient extends across the type, starting with orange at the bottom and gradually blending to white at the top.

8 Save the work you've done so far.

▶ **Tip:** You can also apply a gradient that's already saved as a preset in the Gradients panel. See the sidebar "Using the Gradients panel" later in this chapter.

Applying a layer style

You can enhance a layer by adding a shadow, stroke, satin sheen, or other special effect from a collection of automated and editable layer styles. These styles are easy to apply, and they link directly to the layer you specify.

Like layers, layer styles can be hidden by clicking their eye icons (👁) in the Layers panel. Layer styles are nondestructive, so you can edit or remove them at any time.

Earlier, you used a layer style to add a stroke to the beach photo. Now, you'll add drop shadows to the text to make it stand out.

▶ **Tip:** You can also open the Layer Style dialog box by clicking the Add A Layer Style button at the bottom of the Layers panel and then choosing Drop Shadow or another layer style from the pop-up menu.

1. Select the Island Paradise layer, and then choose Layer > Layer Style > Drop Shadow.

2. In the Layer Style dialog box, make sure that the Preview option is selected, and then, if necessary, move the dialog box so that you can see the "Island Paradise" text in the image window. A drop shadow is now applied.

3. In the Structure area, select Use Global Light, and then specify the following settings:

 - Blend Mode: Multiply
 - Opacity: **75**%
 - Angle: **78** degrees
 - Distance: **5** px
 - Spread: **30**%
 - Size: **10** px

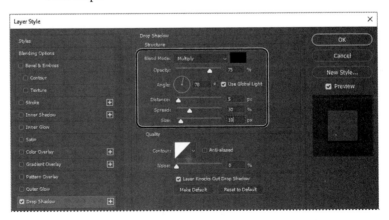

▶ **Tip:** You can also change Global Light settings by choosing Layer > Layer Style > Global Light.

When Use Global Light is selected, a *global* (shared) lighting angle is available in many layer effects that use shading. If you set a lighting angle in one of these effects, every other effect with Use Global Light selected inherits the same angle setting.

Angle determines the lighting angle at which the effect is applied to the layer. Distance determines the offset distance for a shadow or satin effect. Spread determines how gradually the shadow fades toward the edges. Size determines how far the shadow extends.

Because the Preview option is selected, as you make changes Photoshop updates the drop shadow preview in the document window.

4 Click OK to accept the settings and close the Layer Style dialog box.

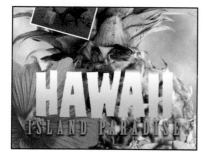 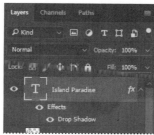

In the Layers panel, the layer style appears nested in the Island Paradise layer. An Effects heading is listed first, and under that, the layer styles applied to the layer appear. An eye icon (◉) appears next to the effect category and next to each effect. To turn off an effect, click its eye icon. Click the visibility column again to restore the effect. To hide all layer styles for that layer, click the eye icon next to Effects. To collapse the list of effects, click the arrow to the right of the layer name.

5 Make sure that eye icons appear for both items nested in the Island Paradise layer.

6 Press Alt (Windows) or Option (macOS), and in the Layers panel, drag the Effects listing or the fx symbol (*fx*) for the Island Paradise layer onto the HAWAII layer.

► **Tip:** If you expect to use a layer style frequently in multiple documents, add it to your Creative Cloud Libraries. First create or open a library. In the document, select a layer that uses the style, click the Add Content button (**+**) at the bottom of the Libraries panel, and then click Layer Style. Now you can apply that style to any open Photoshop document.

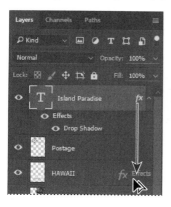 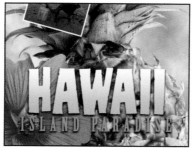

The Drop Shadow layer style is applied to the HAWAII layer, copying the settings you applied to the Island Paradise layer. Now you'll add a green stroke around the word "HAWAII."

7 Select the HAWAII layer in the Layers panel, click the Add A Layer Style button (*fx*) at the bottom of the panel, and then choose Stroke from the pop-up menu.

8 In the Structure area of the Layer Style dialog box, specify the following settings:

- Size: **4** px

- Position: Outside

- Blend Mode: Normal

- Opacity: **100**%

▶ **Tip:** Here's a quick way to match the color of the "Island Paradise" text. When the Color Picker is open for the Stroke Color, position the pointer outside the Color Picker dialog box so that it changes into an eyedropper icon. Click the Island Paradise to sample its green color, loading it into the Color Picker.

- Color: Green (Select a shade that goes well with the one you used for the "Island Paradise" text.)

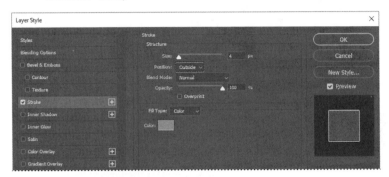

9 Click OK to apply the stroke.

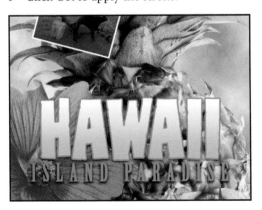

Now you'll add a drop shadow and a satin sheen to the flower.

Using the Gradients panel

Earlier in this chapter, you applied a gradient to the "HAWAII" text in the lesson file by dragging the Gradient tool, which creates a gradient based on the settings in the options bar for the Gradient tool. That's a good way to do it if you want to adjust gradient settings before you apply it.

You can also apply a gradient to a selected layer by using the Gradients panel. Select a layer, display the Gradients panel (Window > Gradients), and click a gradient preset. The presets you saw in the options bar for the Gradient tool are the same ones listed in the Gradients panel.

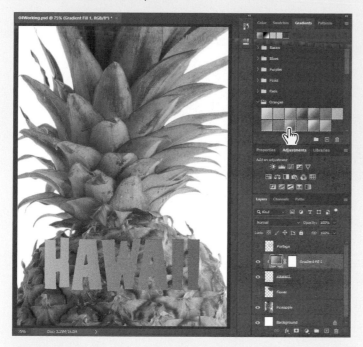

Instead of changing a layer's pixels, the Gradients panel applies a Gradient Fill layer, using the selected layer as a clipping mask (for more about clipping masks, see page 100). A Gradient Fill layer changes the appearance of the layer it's applied to but doesn't alter the layer itself, so you can edit the gradient (by double-clicking) or remove it at any time. If you apply another gradient, it's applied as another Gradient Fill layer, so you can compare their effects by hiding and showing each. Or keep both, combining them by adjusting opacity and blending modes.

For a text layer, the gradient is applied as a Gradient Overlay effect, and applying another gradient updates the Gradient Overlay effect settings.

Other types of Photoshop presets are organized in similar panels. In the Gradients, Swatches, Patterns, or Shapes panel, click any preset to apply it to a selected layer. You can manage the presets in those panels using the buttons along the bottom of the panel or the commands on the panel menu.

10 Select the Flower layer, and choose Layer > Layer Style > Drop Shadow. Then change the following settings in the Structure area:

- Opacity: **60**%

- Distance: **13** px

- Spread: **9**%

- Make sure Use Global Light is selected and that the Blend Mode is Multiply. Do not click OK.

Note: Be sure to click the word "Satin." If you click only the check box, Photoshop applies the layer style with its default settings, but you won't see the options.

11 With the Layer Style dialog box still open, click the word "Satin" on the left to select it and display its options. Then make sure Invert is selected, and apply the following settings:

- Color (next to Blend Mode): Choose a color that enhances the flower color, such as a fuchsia hue

- Opacity: **20**%

- Distance: **22** px

The Satin layer effect applies interior shading to create a satiny finish. The contour controls the shape of the effect; Invert flips the contour curve.

12 Click OK to apply both layer styles. In the Layers panel you can see the two layer styles applied to the Flower layer, and you can use the eye icons to see what the Flower layer looks like with and without the layer styles applied.

Before applying layer styles

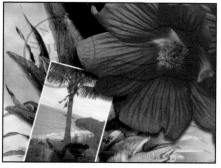

The flower with the drop shadow and satin layer styles applied

Adding an adjustment layer

You can add adjustment layers to apply color and tonal adjustments without permanently changing the pixel values in the image. For example, if you add a Color Balance adjustment layer to an image, you can experiment with different colors repeatedly, because the change occurs only on the adjustment layer. If you decide to return to the original pixel values, you can hide or delete the adjustment layer.

You've used adjustment layers in other lessons. Here, you'll add a Hue/Saturation adjustment layer to change the color of the purple flower. An adjustment layer affects all layers below it in the image's stacking order unless a selection is active when you create it or you create a clipping mask.

1 Select the Flower2 layer in the Layers panel.

2 Click the Hue/Saturation icon in the Adjustments panel to add a Hue/Saturation adjustment layer.

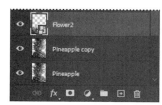 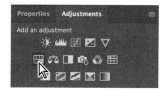

3 In the Properties panel, apply the following settings:

- Hue: **43**
- Saturation: **19**
- Lightness: **0**

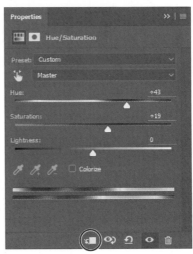

The changes affect the Flower2, Pineapple Copy, Pineapple, Clouds, and Background layers. The effect is interesting, but you want to change only the Flower2 layer.

4 In the Properties panel, click the Create Clipping Mask button (⬒). It's the first button along the bottom of the panel, and you see it when the Properties panel displays options for a layer that can become a clipping mask, such as an adjustment layer.

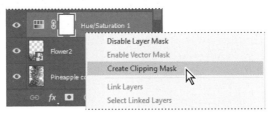

An arrow appears in the Layers panel, indicating that the adjustment layer applies only to the Flower2 layer. You'll learn more about clipping masks in Lesson 6, "Masks and Channels," and Lesson 7, "Typographic Design."

▶ **Tip:** You can also find the Create Clipping Mask and Release Clipping Mask commands (and their keyboard shortcut) on the Layer menu, on the Layers panel menu, and by right-clicking the layer name. You can also create a clipping mask for a layer by Alt-clicking (Windows) or Option-clicking (macOS) the line under that layer in the Layers panel.

100 LESSON 4 Layer Basics

Extra credit

Using an effect more than once in a layer style

A great way to add visual impact to a design element is to apply multiple instances of effects such as strokes, glows, or shadows. You don't have to duplicate layers to do this, because you can apply multiple instances of an effect inside the Layer Style dialog box.

1 Open 04End.psd in your Lesson04 folder.

2 In the Layers panel, double-click the Drop Shadow effect applied to the HAWAII layer.

3 In the effects list on the left side of the Layer Style dialog box, click the + button to the right of the Drop Shadow effect, and select the second Drop Shadow effect.

Now for the fun part! You can adjust your second drop shadow to change options such as color, size, and opacity.

4 In the Drop Shadow options area, click the color swatch, move the pointer outside the Layer Style dialog box so that the pointer changes into an eyedropper, and click the bottom flower to sample its purplish color. Then match the Drop Shadow settings as shown here, and click OK.

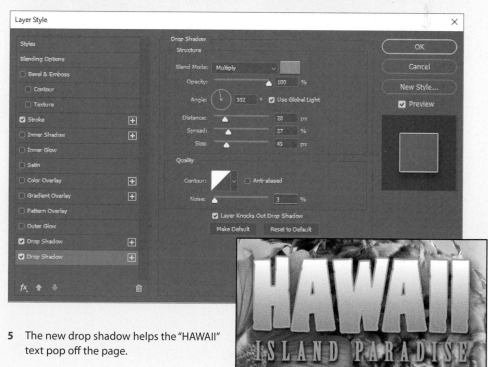

5 The new drop shadow helps the "HAWAII" text pop off the page.

Updating layer effects

Layer effects are automatically updated when you make changes to a layer. You can edit the text and watch how the layer effect updates to match.

1 Select the Island Paradise layer in the Layers panel.

2 In the Tools panel, select the Horizontal Type tool (**T**).

3 In the options bar, change the Size by a few points, and press Enter or Return.

You changed the settings for the entire type layer, even though you didn't select the text by highlighting the characters (as you would have to do in a word processing program). This worked because in Photoshop, you can change settings for an entire type layer by selecting it in the Layers panel, as long as a type tool is selected.

If you add more text to a layer that has a layer effect applied to it, the new text takes on the same layer effect. Changing the type size may leave too little space above the "Island Paradise" and "HAWAII" type layers, so if you need to, you can adjust that.

4 Select the Move tool (✛), and drag the "Island Paradise" type layer as needed.

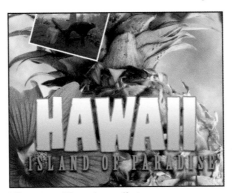

When you add text, layer effects are automatically applied.

Reposition the text beneath the word "HAWAII."

5 Choose File > Save.

Creating a border from a selection

The Hawaii postcard is nearly done. The elements are almost all arranged correctly in the composition. You'll finish up by positioning the postmark and then adding a white postcard border.

● **Note:** The Auto-Select option can save time by letting you select a layer by clicking it with the Move tool, instead of having to select it in the Layers panel. But in documents where many layers overlap, if clicking keeps selecting the wrong layer, try turning off Auto-Select.

1 Select the Move tool, and in the options bar, make sure Auto-Select is disabled.

2 Select the Postage layer, and then use the Move tool (✛) to drag it to the middle right of the image, as in the illustration.

3 Select the Island Paradise layer in the Layers panel, and then click the Create A New Layer button (⊞) at the bottom of the panel.

4 Choose Select > All.

5 Choose Select > Modify > Border. In the Border Selection dialog box, type **10** pixels for the Width, and click OK.

A 10-pixel border is selected around the entire image. Now, you'll fill it with white.

6 Select white for the Foreground Color, and then choose Edit > Fill.

7 In the Fill dialog box, choose Foreground Color from the Contents menu, and click OK.

8 Choose Select > Deselect.

9 Double-click the Layer 1 name in the Layers panel, and rename the layer **Border**.

Use layer comps to store and switch among design ideas

The Layer Comps panel (choose Window > Layer Comps) provides one-click flexibility in switching between different views of a multilayered image file. A layer comp is simply a saved state of the settings in the Layers panel. Whenever you want to preserve a specific combination of layer properties, create a new layer comp. Then, by switching from one layer comp to another, you can quickly review the two designs. The beauty of layer comps becomes apparent when you want to demonstrate a number of possible design arrangements. When you've created a few layer comps, you can review the design variations without having to tediously select and deselect eye icons or change settings in the Layers panel.

Say, for example, that you are designing a brochure, and you're producing a version in English as well as in French. You might have the French text on one layer and the English text on another in the same image file. To create two different layer comps, you would simply turn on visibility for the French layer and turn off visibility for the English layer and then click the Create New Layer Comp button in the Layer Comps panel. Then you'd do the inverse—turn on visibility for the English layer, turn off visibility for the French layer, and click the Create New Layer Comp button—to create an English layer comp. To view the different layer comps, click the Layer Comp box for each comp in the Layer Comps panel in turn.

Layer comps can be an especially valuable feature when the design is in flux or when you need to create multiple versions of the same image file. If some aspects need to stay consistent among layer comps, you can change the visibility, position, or appearance of one layer in a layer comp and then sync it to see that change reflected in all the other layer comps.

Flattening and saving files

When you finish editing all the layers in your image, you can merge or *flatten* layers to reduce the file size. Flattening combines all the layers into a single background layer. However, you cannot edit layers once you've flattened them, so you shouldn't flatten an image until you are certain that you're satisfied with all your design decisions. Rather than flattening your original PSD files, it's a good idea to save a copy of the file with its layers intact, in case you need to edit a layer later.

To appreciate what flattening does, notice the two numbers for the file size in the status bar at the bottom of the document window. The first number represents what the file size would be if you flattened the image. The second number represents the file size without flattening. This lesson file, if flattened, would be 2–3MB, but the current file is much larger. So flattening is well worth it in this case.

Note: If the sizes do not appear in the status bar, click the status bar pop-up menu arrow, and choose Document Sizes

1. Select any tool except the Type tool (**T**), to be sure that you're not in text-editing mode. Then choose File > Save (if it is available) to be sure that all your changes have been saved in the file.

2. Choose Image > Duplicate.

3. In the Duplicate Image dialog box, name the file **04Flat.psd**, and click OK.

4. Leave the 04Flat.psd file open, but close the 04Working.psd file.

5. Choose Flatten Image from the Layers panel menu.

Tip: The Flatten Image command is also on the Layer menu and on the context menu when you right-click/Control-click a layer name.

Only one layer, named Background, remains in the Layers panel.

6 Choose File > Save. Even though you chose Save rather than Save As, the Save As dialog box appears, because this document has not yet been saved to storage.

7 Make sure the location is on your computer in the Lessons/Lesson04 folder, and then click Save to accept the default settings and save the flattened file.

You have saved two versions of the file: a one-layer, flattened copy as well as the original file, in which all the layers remain intact.

You've created a colorful, attractive postcard. This lesson only begins to explore the vast possibilities and the flexibility you gain when you master the art of using Photoshop layers. You'll get more experience and try out different techniques for layers in almost every chapter as you move forward in this book.

Tip: Flattening always means merging all layers into one. If you want to merge only some of the layers in a file, click the eye icons to hide the layers you don't want to merge, and then choose Merge Visible from the Layers panel menu.

Extra credit

Creating a pattern

Photoshop offers several features that work together to help you make patterns quickly and easily. You'll create a pattern for a new border around the artwork you created in this lesson.

1 In the Lesson04 folder, open 04End.psd, save it as **04End_Pattern.psd**, and then choose Layer > Flatten Image.

2 Choose Layer > New Fill Layer > Solid Color, name it Pattern Background, click OK, use the Color Picker to specify white, and click OK.

3 Choose File > Place Linked; in the Lesson04 folder, select PalmLeaf.ai and click Place; click OK in the Open as Smart Object dialog box; and then when the graphic appears in the document, press Return or Enter. This is vector art from Adobe Illustrator, but you can create a pattern using only Photoshop layers.

Pattern Preview helps you visualize a pattern you create.

4 Zoom out to at 30% magnification or less, and then choose View > Pattern Preview. If an alert message appears, click OK. Pattern Preview simulates what the document would look like if tiled as a pattern, by repeating it outside the canvas.

5 Draw a colored dot with the Ellipse tool to add another element to the pattern.

6 Refine your pattern by moving, rotating, or scaling the leaf and dot layers until you're happy with the pattern preview. Feel free to add more layers to the pattern.

You can adjust pattern fill layer settings.

7 Select the layers that make up your pattern, choose Edit > Define Pattern, name it **Leaf**, and click OK.

8 Choose View > Pattern Preview to deselect it, and hide the layers that make up your pattern.

9 Select only the Pattern Background layer, choose Layer > New Fill Layer > Pattern, name it **Border**, and click OK. In the Pattern Fill dialog box, select your new pattern from the pop-up menu of thumbnail previews. Reduce the Scale and adjust the Angle until it looks good; then click OK.

10 Unlock the Background layer by clicking its lock icon, and drag to stack it above the Border layer. Choose Edit > Free Transform, and scale it down to reveal the new border.

Scale down the design to reveal the pattern fill layer behind it.

Your new pattern is added to the Patterns panel, and you can edit the Leaf layer at any time by double-clicking it in the Layers panel.

Extra credit

Exploring design options with Adobe Stock

Visualizing different ideas for a design project is easier when you can experiment with images. The Libraries panel in Photoshop gives you direct access to millions of Adobe Stock images. We'll add a stock image of a ukulele to this lesson's composition.

1 In the Lesson04 folder, open 04End.psd. Save it as **04End_Stock**.

2 In the Layers panel, select the Beach layer.

3 In the Libraries panel, open or create a library, type **ukulele** into the search field, set the search field menu (⌄) to Adobe Stock, and locate any vertical image of a ukulele on a white background.

4 Drag the ukulele image into the document. Drag a corner handle to proportionally scale the image to about 25% of its original size. Apply the changes to finish importing the image.

5 Choose Current Library from the search field menu (⌄). The image was added to your library. Click the ✕ to clear the search.

6 Now remove the background. With the ukulele layer selected, choose the Object Selection tool (▦) in the Tools panel (it may be hidden in its tool group). Hover the pointer over the ukulele until a magenta highlight appears, and then click to select the outline of the ukulele. Click the Add Layer Mask button (▣) at the bottom of the Layers panel.

7 With the Move tool, drag the ukulele to the upper-left corner so that it partially overlaps the small photo of the beach view. You've just added an Adobe Stock photo to your postcard image!

Licensing an image

Until it's licensed, the ukulele image is a low-resolution version with an Adobe Stock watermark. You don't have to license the ukulele image for this lesson, but you must license images used in a real project. With the ukulele layer (not mask) selected, click License Asset in the Properties panel and follow the prompts. After licensing, the image is automatically replaced with a high-resolution version without a water-mark. If you plan to license many images, consider an Adobe Stock monthly plan or a pack of credits.

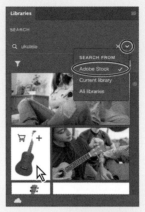

Adobe Stock search results

Stock image in document

You've added a new element to your postcard using Adobe Stock!

Review questions

1 What is the advantage of using layers?

2 When you create a new layer, where does it appear in the Layers panel stack?

3 How can you make artwork on one layer appear in front of artwork on another layer?

4 How can you apply a layer style?

5 When you've completed your artwork, what can you do with layers to minimize the file size without changing the quality, dimensions, or compression?

Review answers

1 Layers let you move and edit different parts of an image as discrete objects. You can also hide individual layers as you work on other layers.

2 In the Layers panel, a new layer always appears immediately above the selected layer. If no layer is selected, a new layer appears at the top of the layer list.

3 You can make artwork on one layer appear in front of artwork on another layer by dragging layers up or down the stacking order in the Layers panel or by using the Layer > Arrange commands—Bring To Front, Bring Forward, Send Backward, and Send To Back. However, you can't change the layer position of a background layer unless you convert it to a regular layer (unlock it or double-click to rename it).

4 To apply a layer style, select the layer, and then click the Add A Layer Style button in the Layers panel, or choose Layer > Layer Style > [style].

5 To minimize file size, you can flatten the image, which merges all the layers onto a single background. It's a good idea to keep a duplicate with layers intact before you flatten the document, in case you have to make changes to a layer later.

5 QUICK FIXES

Lesson overview

In this lesson, you'll learn how to do the following:

- Remove red eye.

- Brighten an image.

- Adjust the features of a face.

- Combine images to create a panorama.

- Crop and straighten an image and fill in any resulting empty areas.

- Blur the background of an image using Iris Blur.

- Merge two images to extend depth of field.

- Apply optical lens correction to a distorted image.

- Remove an object and seamlessly fill the empty space.

- Adjust the perspective of an image to match another image.

 This lesson will take about an hour to complete. To get the lesson files used in this chapter, download them from the web page for this book at adobepress.com/PhotoshopCIB2023. For more information, see "Accessing the lesson files and Web Edition" in the Getting Started section at the beginning of this book.

As you work on this lesson, you'll preserve the start files. If you need to restore the start files, download them from your Account page.

PROJECT: RED EYE REDUCTION

PROJECT: CORRECTING
IMAGE DISTORTION

PROJECT: PANORAMA FROM MULTIPLE IMAGES

Sometimes just one or two clicks in Photoshop can
turn an image from so-so (or worse) to awesome.
Quick fixes get you the results you want without a lot
of fuss.

Getting started

Not every image requires a complicated makeover using advanced features in Photoshop. In fact, once you're familiar with Photoshop, you can often improve an image quickly. The trick is to know what's possible and how to find what you need.

In this lesson, you'll make quick fixes to several images using a variety of tools and techniques. You can use these techniques individually or team them up when you're working with an image that needs just a little more help.

1 Start Photoshop, and then immediately hold down Ctrl+Alt+Shift (Windows) or Command+Option+Shift (macOS) to restore the default preferences. (See "Restoring default preferences" on page 5.)

2 When prompted, click Yes to delete the Adobe Photoshop Settings file.

Improving a snapshot

If you're sharing a snapshot with family and friends, you may not need it to look professional. But you probably don't want glowing eyes, and it would be good if the picture isn't too dark to show important detail. Photoshop gives you the tools to make quick changes to a snapshot.

Correcting red eye

Red eye occurs when the retina of a subject's eye is reflected by the camera flash. It commonly occurs in photographs taken in a dark room, because the subject's irises are wide open. Fortunately, red eye is easy to fix in Photoshop. In this exercise, you will remove the red eye from the woman's eyes in the portrait.

You'll start by viewing the before and after images in Adobe Bridge.

● **Note:** If you haven't installed Bridge, you'll be prompted to do so when you choose Browse In Bridge. For more information, see page 3.

● **Note:** If Bridge asks you if you want to import preferences from a previous version of Bridge, click No.

1 Choose File > Browse In Bridge to open Adobe Bridge.

2 In the Favorites panel in Bridge, click the Lessons folder. Then, in the Content panel, double-click the Lesson05 folder to open it.

3 Adjust the thumbnail slider, if necessary, so that you can see the thumbnail previews clearly. Then look at the RedEye_Start.jpg and RedEye_End.psd files.

RedEye_Start.jpg

RedEye_End.psd

▶ **Tip:** You may want to select Don't Show Again for dialog boxes that appear when opening or saving files in this chapter. In other lessons involving one or two documents, that option is reset when you reset preferences after a lesson. But in this lesson you open and save several documents, so selecting Don't Show Again could save you steps before you reset the preference again.

Not only does red eye make an ordinary person or animal appear unusual, but it can distract from the subject of the image. It's easy to correct red eye in Photoshop, and you'll quickly lighten this image too.

4 Double-click the RedEye_Start.jpg file to open it in Photoshop.

5 Choose File > Save As, choose Photoshop for the Format, name the file **RedEye_Working.psd**, and click Save.

6 Select the Zoom tool (🔍), and then drag to zoom in to see the woman's eyes. If Scrubby Zoom isn't selected, drag a marquee around the eyes to zoom in.

7 Select the Red Eye tool (⁺⊙), hidden under the Spot Healing Brush tool (🩹).

8 In the options bar, reduce the Pupil Size to **23%** and the Darken Amount to **62%**.

The Darken Amount specifies how dark the pupil should be.

9 Click the pupil in the woman's left eye. The red reflection disappears.

10 Click the pupil in the woman's right eye to remove the red reflection there, too.

● **Note:** If Photoshop displays a dialog box telling you about the difference between saving to Cloud Documents and On Your Computer, click Save On Your Computer. You can also select Don't Show Again, but that setting will deselect after you reset Photoshop preferences.

Pupil Size: 23% Darken Amount: 62%

If the red reflection is directly over the pupil, clicking the pupil usually removes it. If it doesn't, you can try clicking the highlight or try dragging the Red Eye tool around the entire pupil.

11 Choose View > Fit On Screen to see the entire image, and save your work.

Brightening an image

The woman's eyes no longer glow red, but the overall image is a bit dark. You can brighten an image in several different ways, as you've already seen. You can try adding adjustment layers for Brightness/Contrast, Levels, and Curves, depending on the degree of adjustment you want to make. For a quick fix or a good starting point, try the Auto button or the presets, which are available in both the Levels and Curves adjustments. Let's try a Curves adjustment layer for this image.

1 Click Curves in the Adjustments panel.

2 Click Auto. In this example, the automatic correction adds a midpoint on the curve and raises its value, lightening the image mostly around the midtones.

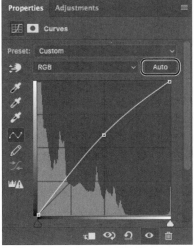

3 Choose Lighter (RGB) from the Preset menu. The curve changes slightly. The difference is that a preset applies the same curve to every image, while Auto analyzes the layer and creates a curve customized for it.

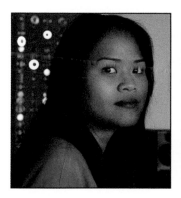 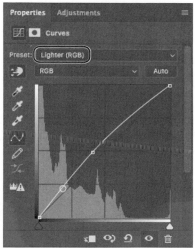

4 Click the Reset To Adjustment Defaults button (↺) at the bottom of the Properties panel to revert to the unadjusted image.

5 Select the on-image adjustment tool (⇥) in the Curves panel, and then click the center of the forehead and drag up. Clicking with that tool adds a curve point that corresponds to the tonal level you clicked in the image. When you drag up, you raise that point and the curve, brightening the image from that tonal level.

▶ **Tip:** If you want to use the Auto button or the white point or black point samplers (eyedropper icons) in the Curves or Levels adjustments, use them before applying manual adjustments. Like presets, adjustments by those tools replace manual adjustments.

▶ **Tip:** To see how much you've brightened the image, hide the Curves layer, and then show it again.

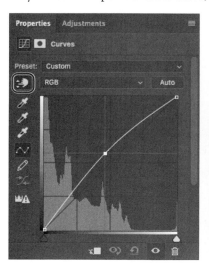 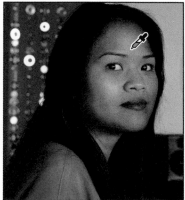

6 Choose Layer > Flatten Image.

7 Save the file.

Adjusting facial features with Liquify

The Liquify filter is useful when you want to distort only part of an image. It includes Face-Aware Liquify options that can automatically recognize faces in images and then lets you easily adjust facial features such as the size of or distance between the eyes. This can be useful for photos used in advertising and fashion, when portraying a certain look or expression may be more important than faithfully representing a specific person.

1 With RedEye_Working.psd still open, choose Filter > Liquify.

2 In the Properties panel, if the Face-Aware Liquify options are collapsed (hidden), click the right-facing triangle to expand them.

3 Make sure the Eyes section is expanded and that the link icon (⦵) is selected for both Eye Size and Eye Height. Enter **32** for Eye Size and **10** for Eye Height.

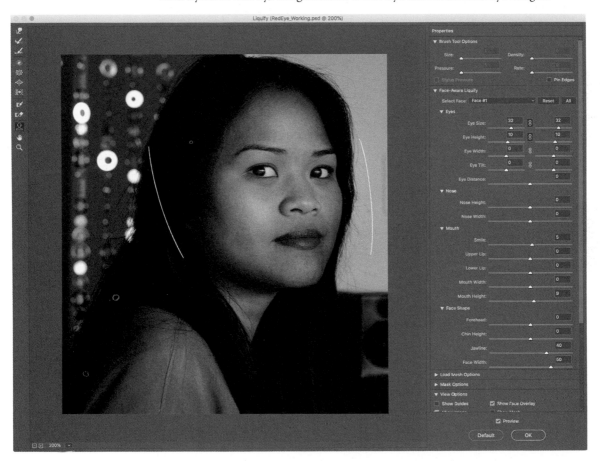

▶ **Tip:** When the Face tool (⬚) is selected in the Liquify toolbar, handles appear as you hover the pointer over different parts of the face. You can drag those handles to adjust different parts of the face directly, as an alternative to dragging the Face-Aware Liquify sliders.

When the link icon (⅜) is not selected for an Eyes option, you can set different values for the left and right eyes.

4 Make sure the Mouth section is expanded, and then enter **5** for Smile and **9** for Mouth Height.

5 Make sure the Face Shape section is expanded, and then enter **40** for Jawline and **50** for Face Width.

6 Deselect and reselect the Preview option to compare the image before and after your changes.

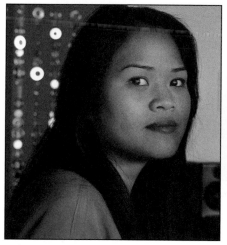 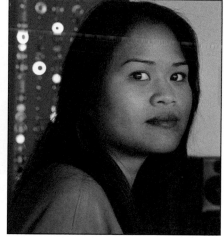

Before Face-Aware Liquify *After Face-Aware Liquify*

▶ **Tip:** The Face-Aware Liquify options have a limited range because they're designed for subtle, believable distortions. If you want to exaggerate faces into caricatures or extreme expressions, you may want to use the more advanced manual tools along the left side of the Liquify dialog box. Or try the face-altering filters in Filter > Neural Filters, which you'll explore in Lesson 15, "Exploring Neural Filters."

Feel free to experiment with any of the Face-Aware Liquify options to get a better sense of the possibilities for quick, easy alterations.

7 Click OK to exit Liquify. Close the document and save your changes.

The Face-Aware Liquify features are available only when Photoshop recognizes a face in an image. It may not recognize a face that is turned too far away from the camera or partially covered by hair, sunglasses, or a hat shadow.

When a workspace totally changes

Some Photoshop features, such as Liquify, open a dedicated workspace — a maximized dialog box covering most of the screen. If you're new to Photoshop, this can be confusing, because panels that were open may be temporarily inaccessible. For example, if panels such as Layers and Color were open before using Liquify, the dedicated Liquify workspace covers those panels as long as Liquify is open.

When a dedicated workspace is open, how do you restore the regular workspace? Look for OK and Cancel buttons. For example, when your Liquify edits are complete, click OK to apply your changes and return to the normal Photoshop workspace.

Blurring around a subject

The interactive blurs in the Blur Gallery let you customize a blur as you preview it on your image. You'll apply an elliptical blur effect to focus the viewer's attention on the unblurred center of the effect—in this case, the egret. You'll apply the blur as a Smart Filter so that you have the option of changing it later.

You'll start by looking at the start and end files in Bridge.

1 Choose File > Browse In Bridge to open Adobe Bridge.

2 In the Favorites panel in Bridge, click the Lessons folder. Then, in the Content panel, double-click the Lesson05 folder to open it.

3 Compare the Egret_Start.jpg and Egret_End.psd thumbnail previews.

Egret_Start.jpg Egret_End.psd

▶ **Tip:** The Iris Blur option in this example is strictly elliptical in shape, and the other Blur Gallery options are similarly geometric. If you want background blur to recognize and avoid a subject's outline, try the Depth Blur Neural Filter with Focus Subject selected. You'll explore Neural Filters in Chapter 15.

In the final image, the egret stands out more, because its reflection and the grass around it have been blurred. Iris Blur, one of the interactive blurs in the Blur Gallery, makes the task easy.

4 Choose File > Return To Adobe Photoshop, and choose File > Open As Smart Object.

5 Select the Egret_Start.jpg file in the Lesson05 folder, and click OK or Open.

Photoshop opens the image. There is one layer in the Layers panel, and it's a Smart Object, as indicated by the badge on the layer thumbnail icon.

6 Choose File > Save As, choose Photoshop for the Format, name the file **Egret_Working.psd**, and click Save. Click OK in the Photoshop Format Options dialog box.

7 Choose Filter > Blur Gallery > Iris Blur. The Blur Gallery dialog box opens.

A blur ellipse is centered on your image. You can adjust the location and scope of the blur by moving the center pin, feather handles, and ellipse handles. At the top-right corner of the Blur Gallery task space, you also see the expandable Field Blur, Tilt-Shift Blur, Path Blur, and Spin Blur panels; those are additional types of blur you can apply.

8 Drag the center pin so that it's at the bottom of the bird's body.

9 Click the ellipse, and drag inward to tighten the focus around the bird.

A. *Center* **B.** *Ellipse* **C.** *Feather handle* **D.** *Blur*

10 Press Alt (Windows) or Option (macOS) as you click and drag the feather handles to match those in the first image below. Pressing Alt or Option lets you drag each handle separately.

11 Click and drag on the Blur ring to reduce the amount of blur to **5** px, creating a gradual but noticeable blur. You can also change the same value by moving the Blur slider in the Iris Blur area of the Blur Tools panel.

 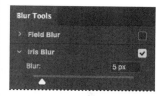

12 Click OK in the options bar to apply the blur.

The blur may be a little too subtle. You'll edit the blur to increase it slightly.

13 Double-click Blur Gallery in the Egret layer in the Layers panel to open it again. Adjust the blur to **6** px, and click OK in the options bar to apply it.

The egret is accentuated by blurring the rest of the image. Because you applied the filter to a Smart Object, you can hide or edit the effect without altering the original image.

14 Save the file, and then close it.

▶ **Tip:** Background blur is most convincing when the amount of blur is higher for more distant objects, but the effects in Blur Gallery aren't tied to real depth. Some cameras can record actual depth info so that software can use it. For example, if you have a smartphone camera that can include an HEIF depth map with a photo, you can create a more realistic background blur effect by loading the depth map into the Lens Blur filter (choose Filter > Blur > Lens Blur).

Blur Gallery

The Blur Gallery includes five interactive blurs: Field Blur, Iris Blur, Tilt-Shift, Path Blur, and Spin Blur. Each gives you on-image selective motion blur tools, with an initial blur pin. You can create additional blur pins by clicking on the image. You can apply a single blur or a combination of blurs, and you can create a strobe effect for path and spin blurs.

Before *After*

Before *After*

Field Blur applies a gradient blur to areas of the image, defined by pins you create and settings you specify for each. When you first apply Field Blur, a pin is placed in the center of the image. You can adjust the blur relative to that point by dragging the blur handle or specifying a value in the Blur Tools panel; you can also drag the pin to a different location.

Iris Blur progressively blurs everything outside the focus ring. Adjust the ellipse handles, feather handles, and blur amount to customize the iris blur. It can be a quick way to approximate a shallow depth-of-field blur effect.

Before *After*

Before *After*

Tilt-Shift simulates an image taken with a tilt-shift lens, where the image has very shallow depth of field with the focus point in the distance. This blur defines a plane of sharpness and then fades outward to a blur. You can use this effect to simulate photos of miniature objects.

Spin Blur is a radial-style blur measured in degrees. You can change the size and shape of the ellipse, re-center the rotation point by pressing Alt or Option as you click and drag, and adjust the blur angle. You can also specify the blur angle in the Blur Tools panel. Multiple spin blurs can overlap. This blur can be useful for illustrating the rotation of propellers, wheels, or gears.

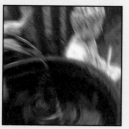

Before After Before After

Path Blur creates motion blurs along paths you draw. You control the shape and amount of the blur.

When you first apply a Path Blur, a default path appears. Drag the end point to reposition it. Click the center point and drag to change the curve. Click to add additional curve points. The arrow on the path indicates the blur's direction.

You can also create a multiple-point path or a shape. Blur shapes describe the local motion blurs, similar to camera shake. The Speed slider in the Blur Tools panel determines the speed for all the path blurs. The Centered Blur option ensures that the blur shape for any pixel is centered on that pixel, resulting in more stable-feeling motion blurs; to make the motion appear more fluid, deselect this option.

If you wanted to illustrate the blurs of individual animal legs moving in different directions, you could add a separate instance of Path Blur to each leg.

Some blur types provide additional options in the Effects tab, where you specify the bokeh parameters to control the appearance of blurred areas. Light Bokeh brightens the blurred areas; Bokeh Color adds more vivid colors to lightened areas that aren't blown out to white; Light Range determines the range of tones that the settings affect.

You can add a **strobe effect** to spin and path blurs. Select the Motion Effects tab to bring its panel forward. The Strobe Strength slider determines how much blur shows between flash exposures (0% gives no strobe effect; 100% gives full strobe effect with little blur between exposures). Strobe Flashes determines the number of exposures.

Before After

Applying a blur will smooth out visible digital image noise or film grain that's in the original image, and this mismatch between the original and blurred areas can make the blur appear artificial. You can use the Noise tab to restore noise or grain so that blurred areas match up with unblurred areas. Start with the Amount slider, and then use the other Noise options to match the character of the original grain. Increase the Color value if the original has visible color noise, and lower the Highlights value if you need to balance the noise level in the highlights compared to the shadows.

Creating a panorama

Sometimes a vista is too large for a single shot. Photoshop makes it easy to combine multiple images into a panorama so that your viewers can get the full effect.

Once again, you'll take a look at the end file first to see where you're going.

1 Choose File > Browse In Bridge.

Tip: In Bridge, you can preview a selected image in full-screen mode by pressing the spacebar. This is useful for previewing detailed or large images such as a panorama. Press the spacebar again to close the preview.

2 Navigate to the Lesson05 folder, if you're not there already. Then, look at the Skyline_End.psd thumbnail preview.

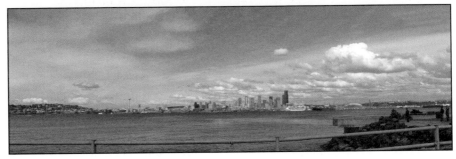

Skyline_End.psd

You'll combine four shots of the Seattle skyline into a single wide panorama image so that viewers get a sense of the whole scene. Creating a panorama from multiple images requires only a few clicks. Photoshop does the rest.

3 Return to Photoshop.

Tip: You can also open selected images from Bridge directly into Photomerge by choosing Tools > Photoshop > Photomerge.

4 With no files open in Photoshop, choose File > Automate > Photomerge.

5 In the Source Files area, click Browse, and navigate to the Lesson05/Files For Panorama folder.

6 Shift-select all the images in the folder, and click OK or Open.

7 In the Layout area of the Photomerge dialog box, select Perspective.

The best option for merging photos isn't always Perspective; it depends on how the originals were photographed. If you're not completely happy with the result of a particular merge, you can always try again with a different Layout option. If you're not sure which one to use, you can simply click Auto.

8 At the bottom of the Photomerge dialog box, select Blend Images Together, Vignette Removal, Geometric Distortion Correction, and Content Aware Fill Transparent Areas. Then click OK.

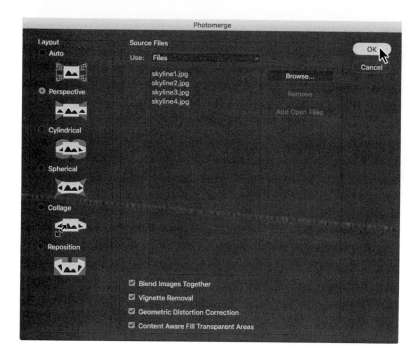

Blend Images Together blends images based on the optimal borders between them, instead of creating a simple rectangular merge. Vignette Removal helps ensure consistent brightness when merging images that are darker around their edges. Geometric Distortion Correction compensates for barrel, pincushion, or fish-eye distortion. Content Aware Fill Transparent Areas automatically patches the empty areas between the merged image edges and the sides of the canvas.

Photoshop creates the panorama image. It's a complex process, so you may have to wait a few moments while Photoshop works. When it's finished, you'll see the full vista in the document window with five layers in the Layers panel. The bottom four layers are the original four images you selected. Photoshop identified the overlapping areas of the images and matched them, correcting any angular discrepancies. The top layer, containing "(merged)" in the layer name, is a single panorama image blended from all of the images you selected, combined with formerly empty areas filled in by Content Aware Fill. Those areas are indicated by the selection.

● **Note:** Photomerge requires more time when you merge more images, or images with large pixel dimensions. Photomerge works faster on computers that are newer or that have more RAM.

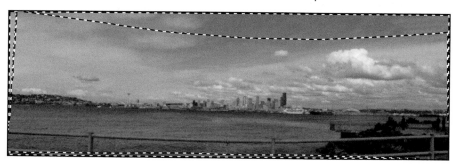

▶ **Tip:** If you want to see how the panorama looks without the areas created by Content Aware Fill, hide the top layer.

Getting the best results with Photomerge

If you know you're going to create a panorama when you take your shots, keep the following guidelines in mind to get the best result:

Overlap images by 15% to 40% Sufficient overlap helps Photomerge blend edges seamlessly. Over 50% overlap won't help and makes you take too many images.

Use a consistent focal length If you use a zoom lens, keep the focal length the same for all the pictures in the panorama.

Stay level Keep the horizon at the same vertical position in each frame to avoid a tilted panorama. If your camera has a level indicator in the viewfinder, use it.

Use a tripod if possible You'll get the best results if the camera is at the same height for each shot. A tripod with a rotating head makes that easier.

Take the photos from the same position If you're not using a tripod with a rotating head, try to stay in the same position as you take the photos so that they are taken from the same viewpoint.

Avoid lenses that produce creative distortion They can interfere with Photomerge. (The Auto option does adjust for images you take with fisheye lenses.)

Use the same exposure and aperture Images blend more smoothly if the exposure is consistent across frames; auto-exposure may create unexpected exposure variations. Using the same aperture setting maintains consistent depth of field.

Try different layout options If you don't like the results, try again using a different layout option. Often, Auto selects the appropriate option, but sometimes you'll get a better image with one of the other options.

Tip: If you plan to create panoramas of interiors or with objects close to the camera, rotating a camera by hand or on a tripod may introduce parallax errors where items don't line up. You can avoid such errors by using a tripod attachment (sometimes called a *nodal slide*) that precisely rotates the camera around the entrance pupil of the specific lens you use.

9 Choose Select > Deselect.

10 Choose Layer > Flatten Image.

Tip: In the finished panorama files, the layers created from the original images have masks. Photoshop created the masks to blend the edges where adjacent images match. You can edit those masks, but if you won't need to, flattening the image results in a smaller file size.

11 Choose File > Save As. Choose Photoshop for the Format, and name the file **Skyline_Working.psd**. Save the file in the Lesson05 folder. Click Save.

The panorama looks great, but it's a little dark. You'll add a Levels adjustment layer to brighten it a little bit.

12 Click the Levels icon in the Adjustments panel to add a Levels adjustment layer.

13 Select the White Point eyedropper in the Properties panel, and then click a white area of the clouds.

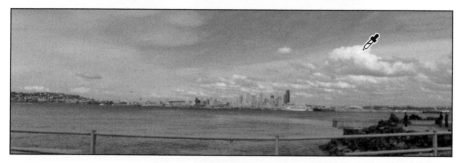

Note: Step 13 works when you click an area that is close to, but not exactly, pure white. If an image doesn't change when you click it with the White Point eyedropper, you probably clicked an area that can't become any whiter and there is no color cast to correct. That happens when the pixel values where you clicked are already pure white in all color channels (such as RGB 255,255,255).

The entire image brightens. The sky appears more blue, because the image was originally a little warm. The White Point eyedropper neutralized the warm cast.

14 Save your work. Click OK in the Photoshop Format Options dialog box.

It's that easy to create a panorama!

Note: In step 14, the Photoshop Format Options alert may appear because a layer was added. The Photoshop Format Options dialog box usually won't appear for Photoshop documents containing only a Background layer.

Filling empty areas when cropping

The panorama image looks great except for two things: The horizon is slightly tilted, and the lower handrail is incomplete where the rocks on the right descend into the water. If you were to rotate the image, empty areas might appear at the corners, requiring a tighter crop and losing parts of the image. Fortunately, the same Content-Aware technology that filled in empty areas resulting from the panorama merge can also fill in empty areas that can result from straightening and cropping.

1 Make sure **Skyline_Working.psd** is open, and make sure the Background layer is selected in the Layers panel.

2 Choose Layer > Flatten Image.

3 In the Tools panel, select the Crop tool. The crop rectangle and its handles appear around the image.

4 In the options bar, select the Straighten icon (⬚), and make sure Content-Aware is selected.

5 Position the Straighten pointer on the horizon at the left edge of the image, and drag to the right to create a Straighten line that's aligned with the horizon; release the mouse button when you reach the end of the horizon at the right edge of the image.

Notice there is now white space that needs to be filled near the corners.

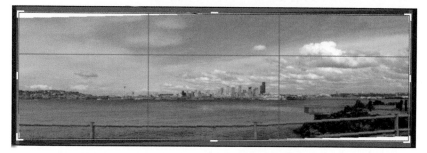

6 With the crop rectangle still active, drag the image down until the incomplete part of the lower guardrail is outside the crop rectangle.

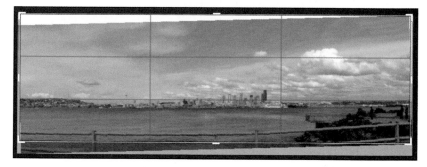

7 Click the Commit button in the options bar (✔) to apply the current crop settings. Content-Aware Crop fills in the empty areas at the top and sides of the image.

▶ **Tip:** The keyboard shortcut for the Commit button is pressing the Enter or Return key.

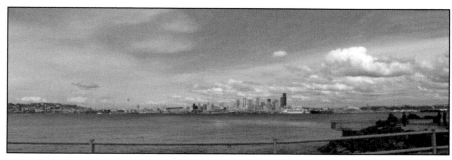

8 Save your changes, and close the document.

Replacing a sky

When you find the right subject for a photo illustration or composite but it doesn't have quite the right sky to match the mood or time of day you want to convey, you can easily swap out the sky in Photoshop. Sky Replacement does many of the tough parts for you, such as creating a mask for the sky and making colors more consistent between the photo and the new sky.

1 In the Lesson05 folder, open the document Skyline_End.psd, and then choose Edit > Sky Replacement.

2 Select an image from the Sky list. The sky updates in the document; you can compare the original and new sky by clicking the Preview option. To use your own sky image, click the gear icon in the Sky list and choose Get More Skies > Import Images.

3 Check the quality of the automatically composited image. Are the colors of the two images consistent? Do you see any issues with the edge quality of the automatic sky mask? You can zoom in to check edges.

4 If you notice problems, use the Sky Replacement options. For example, you can reposition the sky image with the Sky Move tool, edit the mask edge with the Sky Brush tool, or change the Scale value in Sky Adjustments.

5 When you are satisfied with the Sky Replacement settings, make sure New Layers is selected in the Output To menu, and click OK.

If Output is set to New Layers, notice in the Layers panel that Sky Replacement automatically created layers to add the new sky and adjustments separately from the original layer. After you click OK in Sky Replacement, you can edit the layers and masks it created (you'll learn more about layer masks in Lesson 6). Hiding the new layers reveals the original sky.

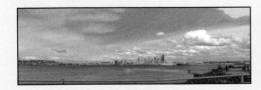
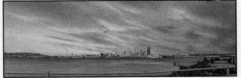

Correcting image distortion

The Lens Correction filter fixes common camera lens flaws, such as barrel and pincushion distortion, chromatic aberration, and vignetting. *Barrel distortion* is a lens defect that causes straight lines to bow out toward the edges of the image. *Pincushion distortion* is the opposite effect, causing straight lines to bend inward. *Chromatic aberration* appears as a color fringe along the edges of image objects. *Vignetting* occurs when the edges of an image, especially the corners, are darker than the center.

▶ **Tip:** If you capture photos with your camera set to save raw files, the Adobe Camera Raw plug-in module (for processing raw files in Photoshop and Bridge) has similar lens correction options in its Optics panel.

Some lenses exhibit these defects depending on the focal length or the f-stop used. The Lens Correction filter can apply settings based on the camera, lens, and focal length that were used to make the image. The filter can also rotate an image or fix image perspective caused by tilting a camera vertically or horizontally. The filter's grid makes it easier and more accurate to make these adjustments than using the Transform command.

1 Choose File > Browse In Bridge.

2 Navigate to the Lesson05 folder if you're not already there, and then look at the Columns_Start.psd and Columns_End.psd thumbnail previews.

Columns_Start.psd

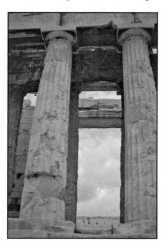
Columns_End.psd

In this case, the original image of a Greek temple is distorted, with the columns appearing to be bowed. This photo was shot at a range that was too close with a wide-angle lens. You'll quickly correct the lens barrel distortion.

3 Double-click the Columns_Start.psd file to open it in Photoshop.

4 Choose File > Save As. In the Save As dialog box, name the file **Columns_Working.psd**, and save it in the Lesson05 folder. Click OK if the Photoshop Format Options dialog box appears.

▶ **Tip:** If the crop rectangle from the previous exercise is still visible and distracting, switch to a tool such as the Hand tool.

5 Choose Filter > Lens Correction. The Lens Correction dialog box opens.

6 At the bottom of the dialog box, make sure Show Grid and Preview are selected.

An alignment grid overlays the image. To the right are options for automatic corrections based on lens profiles. In the Custom tab are manual controls for correcting distortion, chromatic aberration, and perspective.

The Lens Correction dialog box includes auto-correction options. You'll adjust one setting in the Auto Correction tab and then customize the settings.

7 In the Correction area of the Auto Correction tab, make sure Auto Scale Image is selected and that Transparency is selected from the Edge menu.

8 Select the Custom tab.

> **Tip:** Watch the alignment grid as you make these changes so that you can see when the vertical columns are straightened in the image.

9 In the Custom tab, drag the Remove Distortion slider to about **+52.00** to remove the barrel distortion in the image. Alternatively, you could select the Remove Distortion tool (🔲) and drag in the image preview area until the columns are straight. The adjustment causes the image borders to bow inward. However, because you selected Auto Scale Image, the Lens Correction filter automatically scales the image to adjust the borders.

10 Click OK to apply your changes and close the Lens Correction dialog box.

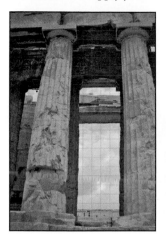

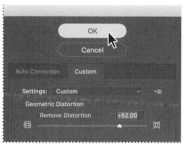

▶ **Tip:** If the photo file contains lens information saved by a digital camera, or if you know the exact lens that was used, options in the Auto Correction tab may provide a better starting point. When the correct Lens Model and Lens Profiles are selected, the profile may provide precise corrections for that lens, which you can refine in the Custom tab.

The curving distortion caused by the wide-angle lens and low shooting angle is reduced.

11 (Optional) To compare the image before and after the last change, press Ctrl+Alt+Z (Windows) or Command+Option+Z (macOS) to undo the filter, and then press the same keys to redo the filter. That's a keyboard shortcut for the Edit > Toggle Last State command, so you can press it repeatedly to go back and forth between the last two states of the document.

12 Choose File > Save to save your changes, click OK if the Photoshop Format Options dialog box appears, and then close the image.

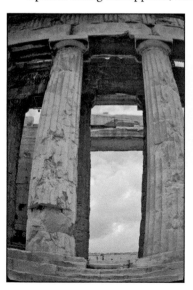

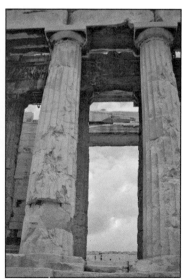

The temple looks much more stable now!

Extending depth of field

Sometimes you have to choose to focus on either the background or the foreground of a scene because the *depth of field*—the range of distances in focus—is narrow. If you want a wider range of distances to be in focus (more depth of field), but it isn't possible because of limitations of the equipment or the location, you can take a set of photos focused along the range of distances you want to appear sharp. You can merge the photos in Photoshop using a process sometimes called *focus stacking*. You get a single image with the combined depth of field of the image set.

Because you'll need to align the images exactly, it's helpful to use a tripod to keep the camera steady. However, you may be able to get good results with a handheld camera if you can frame and align them consistently. In this exercise, you'll add depth of field to an image of a wine glass in front of a beach.

1 Choose File > Browse In Bridge.

2 Navigate to the Lesson05 folder, if you're not there already, and then look at the Glass_Start.psd and Glass_End.psd thumbnail previews.

▶ **Tip:** See if your camera has a feature with a name such as "focus bracketing" that takes multiple shots focused at a series of distances. This feature makes it easier to photograph a consistent image set for focus stacking.

Glass_Start.psd

Glass_End.psd

The first image has two layers. Depending on which layer is visible, either the glass in the foreground or the beach in the background is in focus. You'll extend the depth of field to make both clear.

3 Double-click the Glass_Start.psd file to open it.

4 Choose File > Save As. Name the file **Glass_Working.psd**, and save it in the Lesson05 folder. Click OK if the Photoshop Format Options dialog box appears.

5 In the Layers panel, hide the Beach layer so that only the Glass layer is visible. The glass is in focus, but the background is blurred. Then, show the Beach layer again. Now the beach is in focus, but the glass is blurred.

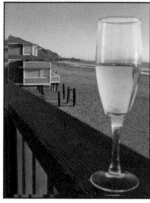

You'll merge the layers, using the part of each layer that is in focus. First, you need to align the layers.

6 In the Layers panel, Shift-click to select both of the layers.

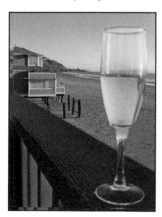

7 Choose Edit > Auto-Align Layers.

Because these images were shot from the same angle, Auto will work just fine.

Tip: When aligning layers that are not involved in a panorama, Reposition is often the best alignment option to use. In this exercise, Reposition is the projection that the Auto option chose.

8 Select Auto, if it isn't already selected. Make sure neither Vignette Removal nor Geometric Distortion is selected. Then click OK to align the layers.

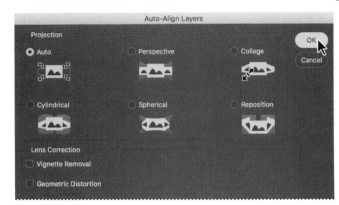

Now that the layers are perfectly aligned, you're ready to blend them.

9 Make sure both layers are still selected in the Layers panel. Then choose Edit > Auto-Blend Layers.

Tip: The technique in this exercise, called *focus stacking*, is useful for macro photography, where depth of field is typically very shallow. Multiple images with shallow depth of field are shot at different focus distances and then merged.

10 Select Stack Images and Seamless Tones And Colors, if they aren't already selected. Make sure Content Aware Fill Transparent Areas is not selected, and then click OK.

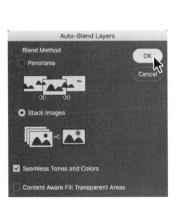

Both the wine glass and the beach behind it are in focus, because Auto-Blend Layers combined the sharpest parts of each image. In the Layers panel, notice that both original layers are preserved, and the blending is achieved by masks that hide the out-of-focus areas of each image so that only the sharp areas of each are visible.

11 Save your work, and close the file.

Removing objects using Content-Aware Fill

You've used the content-aware features in some pretty impressive ways in earlier lessons and to fill in the sky in the panorama project in this lesson. Now you'll use Content-Aware Fill to remove an unwanted object and have Photoshop convincingly fill in the area instead of leaving a blank space.

1 Choose File > Browse In Bridge.

2 Navigate to the Lesson05 folder, if you're not there already, and then look at the JapaneseGarden_Start.jpg and JapaneseGarden_End.jpg thumbnail previews.

JapaneseGarden_Start.jpg *JapaneseGarden_End.jpg*

You'll use the Content-Aware Fill tool to simplify the composition by removing the cone-shaped rock near the left edge of the photo, and its reflection.

3 Double-click the JapaneseGarden_Start.jpg file to open it in Photoshop.

4 Choose File > Save As, choose Photoshop for the format type, and name the new file **JapaneseGarden_Working.psd**. Click Save. Click OK if the Photoshop Format Options dialog box appears.

5 Select the Lasso tool ().

6 Drag a selection marquee around the rock on the left and the rock's reflection below it, including some of the water around it. The selection can be approximate.

7 Choose Edit > Content-Aware Fill.

▶ **Tip:** Preview is a panel, so you can drag the divider between the image and the Preview panel. You can drag the Preview panel tab to undock it, making Preview a floating panel. This Preview panel is available only when using Content-Aware Fill.

A. *Sampling Brush tool* **B.** *Sampling area* **C.** *Content-Aware Fill options* **D.** *Preview zoom* **E.** *Reset*

The left side of the Content-Aware Fill dialog box displays the image and the selection you made. The colored area (displayed in green by default) indicates areas Content-Aware Fill will sample (use as a source) for filling the removed area.

The right side previews the fill you get from the sampling area, combined with the settings in the Content-Aware Fill options panel. The most important settings to look at first are the Sampling Area Options.

- Auto is selected by default. It analyzes the image to improve the sampling area and excludes areas that it thinks are dissimilar to the area around the selection. Notice that the trees are not part of the sampling area; that's because Auto decided that tree areas are too dissimilar to the water you selected.

- Rectangular uses the entire image as the sampling area, except the selection.

- Custom doesn't apply an initial sampling area. You use the Sampling Brush tool to manually paint the parts you want Photoshop to use as the sampling area.

How do you choose which one to use? Start with Auto, because if it works well, it will require the least amount of manual retouching. Try the other options when Auto produces results that aren't easy to work with.

If the Preview panel shows parts of the selection that still aren't sufficiently convincing, you can use the Sampling Brush to customize the sampling area further. The Sampling Brush is the first tool in the toolbar along the left side of the Content-Aware Fill workspace. (If you think the image is already convincing enough, you can skip steps 8–10. Results can vary based on your initial selection.)

8 Press the [key to reduce the Sampling Brush tool until the options bar indicates that the brush size is around 175 pixels. The Sampling Brush tool is selected by default when you open the Content-Aware Fill dialog box.

Notice that a minus sign (−) appears in the Sampling Brush pointer. This is because the tool is set to Subtract mode, which is indicated in the options bar.

9 Paint over unwanted areas (such as foliage, or the edge where the water meets the foliage) to exclude it from the sampling area. Areas you exclude no longer appear with the green sampling color. As you do this, the fill is recalculated, and you can evaluate the updated results in the Preview panel.

Tip: If you need to make the selection larger or smaller by the same amount, use the Expand or Contract button, respectively, in the options bar; those buttons appear when the Lasso tool is selected.

10 As soon as the fill looks like it consists only of water and believable reflections, you can stop painting.

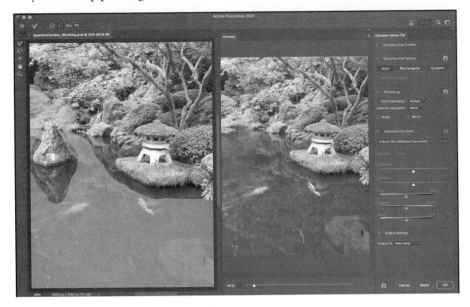

It may take some trial and error for the results to be successful. You may be able to improve the results using the following techniques:

- Use the Sampling Brush in Subtract mode to exclude more areas to stop them from contributing incorrect content to the fill. For example, it might help to also exclude the edges where the water meets the lantern base and other leaves.

Tip: To quickly switch the Lasso tool between selection modes, press the E key.

- Use the Lasso tool to change the original selection. For example, try using the Lasso tool in Subtract from Selection mode to trim the selection where unwanted foliage is included, while still including all of the rock.

- Adjust the Fill Settings. For this exercise, adjusting the Color Adaptation setting should be the most useful. You probably won't use the other options, although they are useful in other situations. Rotation Adaptation is useful for re-creating missing areas of content that are radial (such as flower petals) or along an arc. Scale helps adapt a fill for patterned content. The Mirror option can be useful for symmetrical content.

11 If there are additional areas you want to fill, click Apply. The previous selection is committed, and now you can create a new selection to fill.

12 When you're finished, click OK, and then choose Select > Deselect.

In the Layers panel, notice that by default, the fill is created as a new layer named Background Copy. If you hide the new layer, you can see the entire original image in the Background layer.

▶ **Tip:** If you don't want Content-Aware Fill to create the fill as a new layer, before closing Content-Aware Fill, change the Output To option in Output Settings.

13 Save your work, and then close it.

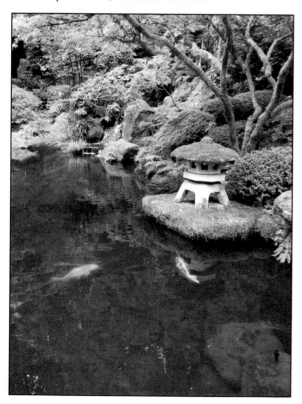

Extra credit

Transformations with the Content-Aware Move tool

With the Content-Aware Move tool, you need only a few quick steps to duplicate a thistle so that it combines seamlessly with the background and is also different enough that it doesn't look like an exact copy of the original.

1 Open Thistle.psd in your Lesson05/Extra Credit folder.

2 Select the Content-Aware Move tool (✕) (grouped with the healing brush and Red Eye tools).

3 In the options bar, choose Extend from the Mode menu. Choosing Extend duplicates the thistle; if you just want to reposition the single thistle, you would choose Move.

4 With the Content-Aware Move tool, draw a selection around the thistle, with a margin large enough to include a little of the grass around it.

5 Drag the selection to the left, and drop it in the empty area of grass.

6 Right-click (Windows) or Control-click (macOS) the dragged thistle, and choose Flip Horizontal.

7 Drag the top-left transformation handle to make the thistle smaller. If you think the copy of the thistle should be farther from the original, position the pointer inside the transformation rectangle and drag the thistle copy slightly to the left.

8 Press Enter or Return to apply the transformations. Leave the content selected so you can adjust the Structure and Color options in the Options bar to improve how the new thistle blends with the background.

9 Choose Select > Deselect, save your changes, and close the document.

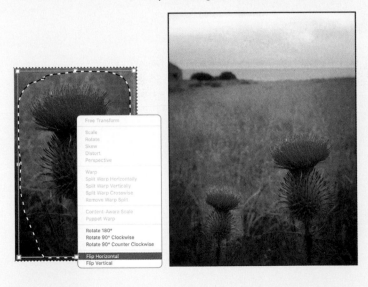

Adjusting perspective in an image

The Perspective Warp feature lets you adjust the way objects in your image relate to the scene. You can correct distortions, change the angle from which an object appears to be viewed, or shift the perspective of an object so that it merges smoothly with a new background.

Using the Perspective Warp feature is a two-step process: defining the planes and adjusting them. You start in Layout mode, drawing *quads* to define two or more planes; it's a good idea to align the edges of the quads so that they are parallel with the lines of the original object. Then you switch to Warp mode and manipulate the planes you defined.

You'll use Perspective Warp to merge images with different perspectives.

1 Choose File > Browse In Bridge.

2 Navigate to the Lesson05 folder, if you're not there already, and then look at the Bridge_Start.psd and Bridge_End.psd thumbnail previews.

Bridge_Start.psd

Bridge_End.psd

In the Bridge_Start.psd file, the image of the train has been combined with the image of a trestle bridge, but their perspectives don't match. If you're illustrating a story about a flying train that is making a landing on a trestle bridge, this might be perfect. But if you want a more realistic image, you'll need to adjust the perspective of the train to put it firmly on the tracks. You'll use Perspective Warp to do just that.

3 Double-click the Bridge_Start.psd file to open it in Photoshop.

4 Choose File > Save As, and rename the file **Bridge_Working.psd**. Click OK in the Photoshop Format Options dialog box.

5 Select the Train layer.

● **Note:** Perspective Warp can work faster on a computer that qualifies for graphics acceleration. To see if your computer qualifies, see the "Getting Started" section for a link to the Photoshop system requirements.

The tracks are on the Background layer. The train is on the Train layer. Because the Train layer is a Smart Object, you can apply Perspective Warp and then modify the results if you're not satisfied.

6 Choose Edit > Perspective Warp.

A small animated tutorial appears, showing you how to draw a quad, which defines a plane.

7 Watch the animation, and then close it.

Now you'll create quads to define the planes of the train image.

8 Draw the quad for the side of the train: Click above the top of the smokestack, drag down to the railroad tie below the front wheel, and then drag across to the end of the caboose.

▶ **Tip:** Not sure if you've properly drawn the perspective of quads around a subject? They should look like a shipping container fitted to the subject.

9 Drag a second quad for the front of the train, dragging across the cowcatcher at the bottom and into the trees at the top. Drag it to the right until it attaches to the left edge of the first quad.

10 Drag the corners of the planes to match the angles of the train. The bottom line of the side plane should run along the bottom of the train wheels; the top edge should border the top of the caboose. The front plane should mirror the lines of the cowcatcher and the top of the light.

Now that the quads are drawn, you're ready for the second step: warping.

11 Click Warp in the options bar. Close the tutorial window that appears.

12 Click the Automatically Straighten Near Vertical Lines button, next to Warp in the options bar.

Lines close to vertical are made vertical, making it easier to adjust its perspective.

13 Drag the handles to manipulate the planes, moving the back end of the train down and into perspective with the tracks. Exaggerate the perspective toward the caboose for a more dramatic result.

14 Warp other parts of the train as needed. You may need to adjust the front of the train. Pay attention to the wheels; make sure you don't distort them as you warp the perspective.

While there are precise ways to adjust perspective, in many cases you may need to trust your eyes to tell you when it looks right. Remember that you can return to tweak it again later, because you're applying Perspective Warp as a Smart Filter.

15 When you're satisfied with the perspective, click the Commit Perspective Warp button (✓) in the options bar.

16 To compare the changed image with the original, hide the Perspective Warp filter in the Layers panel. Then show the filter again.

If you want to make further adjustments, double-click the Perspective Warp filter in the Layers panel. You can continue to adjust the existing planes or click Layout in the options bar to reshape them. Remember to click the Commit Perspective Warp button to apply your changes.

17 Save your work, and close the file.

Changing the perspective of a building

In the exercise, you applied Perspective Warp to one layer to change its relationship with another. But you can also use Perspective Warp to change the perspective of an object in relationship to others in the same layer. For example, you can shift the angle from which you view a building.

In this case, you apply Perspective Warp the same way: In Layout mode, draw the planes of the object you want to affect. In Warp mode, manipulate those planes.

Of course, because you're shifting angles within a layer, other objects on the layer will change too, so you need to watch for any irregularities.

In this image, as the perspective of the building shifts, so does the perspective of the trees surrounding it.

Review questions

1 What is red eye, and how do you correct it in Photoshop?

2 Why might some parts of the Photoshop workspace become inaccessible or hidden, such as the Color and Layers panels? And how do you return to the normal workspace?

3 How can you create a panorama from multiple images?

4 Which common camera lens flaws can the Lens Correction filter fix?

5 When you use Content-Aware Fill and the selection is filled with the wrong content, what are some of the first things you can try to correct this?

Review answers

1 Red eye occurs when a camera flash is reflected in the retinas of a subject's eyes. To correct red eye in Photoshop, zoom in to the subject's eyes, select the Red Eye tool, and then click or drag around each eye.

2 If standard panels can't be opened, you are probably working in a dedicated workspace that provides options only for a specific task, such as applying Liquify or Blur Gallery effects. Many menu commands and panels aren't available in a dedicated workspace. To exit a dedicated workspace and keep the edits you made in it, look for an OK button and click it. (When not in a dedicated workspace, panels can be opened and hidden using the Window menu or by a preset on the Window > Workspace menu.)

3 To blend multiple images into a panorama, choose File > Automate > Photomerge, select the files you want to combine, and click OK.

4 The Lens Correction filter can fix common camera lens flaws such as barrel and pincushion distortion, in which straight lines bow out toward the edges of the image (barrel) or bend inward (pincushion); chromatic aberration, where a color fringe appears along the edges of image objects; and vignetting at the edges of an image, especially corners, that are darker than the center.

5 When Content-Aware-Fill uses the wrong content in a fill, you can use the Sampling Brush or Lasso tools to exclude unwanted content from the sampled area, and you can try a different Sampling Area Option.

6

MASKS AND CHANNELS

Lesson overview

In this lesson, you'll learn how to do the following:

- Create a mask to remove a subject from a background.

- Refine a mask to include complex edges.

- Create a quick mask to make changes to a selected area.

- Edit a mask using the Properties panel.

- Manipulate an image using Puppet Warp.

- Save a selection as an alpha channel.

- View a mask using the Channels panel.

- Load a channel as a selection.

- Create a pattern by drawing a star-shaped vector graphic with rounded corners.

This lesson will take about an hour to complete. To get the lesson files used in this chapter, download them from the web page for this book at adobepress.com/PhotoshopCIB2023. For more information, see "Accessing the lesson files and Web Edition" in the Getting Started section at the beginning of this book.

As you work on this lesson, you'll preserve the start files. If you need to restore the start files, download them from your Account page.

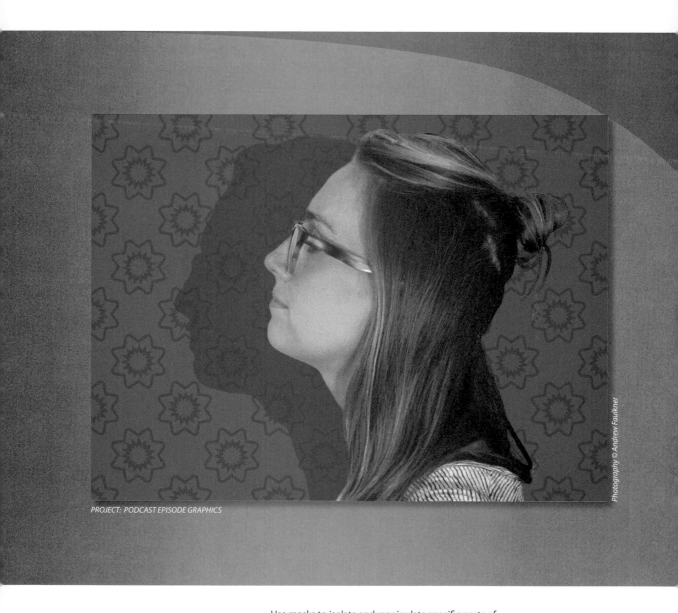

Use masks to isolate and manipulate specific parts of an image. The cutout portion of a mask can be altered, but the area surrounding the cutout is protected from change. You can create a temporary mask to use once, or you can save masks for repeated use.

Working with masks and channels

Out of the camera, a digital image is an opaque rectangle. To combine part of that image with others, you hide the area outside the subject. Or you might want to apply an adjustment layer or filter only to certain areas of a layer. The recommended way to do both is by using a *mask*, a way to mark areas of a layer as transparent.

▶ **Tip:** The way masks work is similar to applying masking tape to panes or wall trim before you paint a house: Masked areas are protected from being changed.

Using a mask is more useful than deleting unwanted areas of a layer, because it's reversible: For example, if you notice that you accidentally trimmed off part of the subject, a mask lets you restore the trimmed area to correct the mistake.

In addition to color channels, an image can contain *alpha channels*, useful for saving and reusing selections and marking transparent areas for an entire document.

● **Note:** Masks and alpha channels don't print and aren't visible; you see their effects only on visible layers.

It can be challenging to paint or draw a mask or channel edge that precisely follows a nonsharp border of a subject, such as fuzzy hair. Photoshop provides automated tools to help you quickly create complicated selections and masks.

Getting started

First, you'll view the image that you'll create using masks and channels.

1. Start Photoshop, and then simultaneously hold down Ctrl+Alt+Shift (Windows) or Command+Option+Shift (macOS) to restore the default preferences. (See "Restoring default preferences" on page 5.)

2. When prompted, click Yes to delete the Adobe Photoshop Settings file.

3. Choose File > Browse In Bridge to open Adobe Bridge.

● **Note:** If Bridge isn't installed, the File > Browse In Bridge command in Photoshop will start the Creative Cloud desktop app, which will download and install Bridge. After installation completes, you can start Bridge.

4. Click the Favorites tab on the left side of the Bridge window. Select the Lessons folder, and then double-click the Lesson06 folder in the Content panel.

5. Study the 06End.psd file. To enlarge the thumbnail so that you can see it more clearly, move the thumbnail slider at the bottom of the Bridge window to the right.

In this lesson, you'll create a graphic for a podcast. The model was photographed in front of a different background. You'll use Select And Mask to quickly isolate the model over the final background. You'll also tilt the model's head up a little more and create a pattern for the background.

● **Note:** If Photoshop displays a dialog box telling you about the difference between saving to Cloud Documents and On Your Computer, click Save On Your Computer. You can also select Don't Show Again, but that setting will deselect after you reset Photoshop preferences.

6. Double-click the 06Start.psd thumbnail to open it in Photoshop. Click OK if you see an Embedded Profile Mismatch dialog box.

7. Choose File > Save As, rename the file to **06Working.psd**, and click Save. Click OK if the Photoshop Format Options dialog box appears.

Saving a working version of the file lets you return to the original if you need it.

About masks and alpha channels

Alpha channels, quick masks, clipping masks, layer masks, vector masks—what's the difference? They're all forms of the same idea: an image overlay that uses white, black, and gray areas to control which areas of a layer are visible or transparent. Choose the right one by understanding the following important differences:

- A **color channel** stores one of the visible components of a color image. For example, an RGB image has three color channels: red, green, and blue.

- An **alpha channel** stores a selection as a grayscale image. Alpha channels exist independently of layers and color channels. You can convert alpha channels to and from selections or paths. In some file formats such as PNG, an alpha channel marks transparent areas of an image in a way that other applications recognize.

- A **layer mask** is an alpha channel attached to a specific layer in Photoshop, controlling which parts of the layer are revealed or hidden. It appears as a white thumbnail next to the layer thumbnail in the Layers panel until you paint black in it; an outline around the layer mask thumbnail indicates that it's selected.

- A **vector mask** is a layer mask made of resolution-independent vector objects, not pixels, useful when precise mask edge control is more important than being able to edit a mask with a brush. You create vector masks using the commands on the Layer > Vector Mask submenu and using the pen or shape tools.

- A **clipping mask** is created when a layer masks another layer. The thumbnail preview of a clipped layer is indented in the layer list, with a right-angle arrow pointing to the layer below. The name of the clipped base layer is underlined.

- A **channel mask** is a mask created using the tonal contrast in a color channel, such as in the green channel in an RGB image. Creating channel masks is useful for advanced techniques for masking, color correction, and sharpening. For example, the edge between trees and sky may be clearest in the blue channel.

- A **quick mask** is a temporary mask you create to restrict painting or other edits to a specific area of a layer. It's a selection in pixel form; instead of editing the selection marquee, you edit a quick mask using painting tools.

▶ **Tip:** Because masks mark which areas of a layer are visible, they also control where your edits are visible. For example, if you paint a masked layer with the Brush tool, the brush strokes are visible only on the unmasked (white) areas of a layer.

Using Select And Mask and Select Subject

Photoshop provides a set of tools focused on creating and refining masks, collected in a task space called Select And Mask. Inside Select And Mask, you'll use the Select Subject tool to get a fast head start on the mask that will separate the model from the background. Then you'll refine the mask using other Select And Mask tools, such as the Quick Selection tool.

1 In the Layers panel, make sure both layers are visible and the Model layer is selected.

2 Choose Select > Select And Mask.

▶ **Tip:** When any selection tool is active, the Select And Mask button is available in the options bar. You can choose Select > Select and Mask when the Select and Mask button is not shown.

Tip: The first time you use Select And Mask, a tutorial tip may pop up. You may view it before you continue with the lesson, or you can click Later or Close.

Select And Mask opens with the image. A semitransparent "onion skin" overlay indicates masked areas. For now, the checkerboard pattern covers the entire image, because you haven't yet identified the areas to unmask.

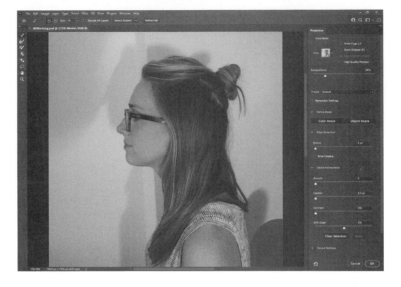

Tip: For more help making selections, refer to Lesson 3, "Working with Selections."

Tip: When a selection tool is active, you can enter Select And Mask by clicking the Select And Mask button in the options bar instead of having to find the command in the menus.

3 Click the View menu in the View Mode section of the Properties panel, and choose Overlay. The masked area is now shown as a semitransparent red color instead of the onion skin checkerboard. It's solid because nothing is masked yet.

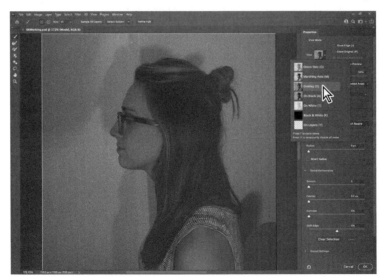

Tip: Quickly cycle through the View Modes by pressing the F key. Viewing different modes helps you spot selection mistakes that might not be obvious in other modes.

The different View Modes are provided so that you can see the mask more easily over various backgrounds. In this case, the red overlay will make it easier to see missed areas and edges where loose hair isn't properly masked.

4 In the options bar, click the Select Subject button.

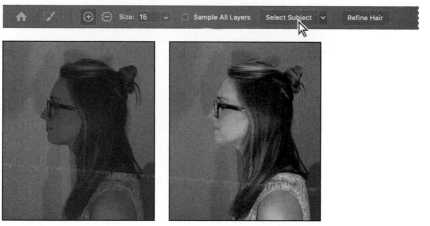

● **Note:** In the Select Subject button drop-down list, you can choose where to process the selection. Cloud processing may produce better results, using a larger machine learning model on a powerful remote computer. Processing on your device is usually faster. Changing this setting affects the next image only; you can set this permanently in the Image Processing panel of the Preferences dialog box.

Using advanced machine learning technology, the Select Subject feature is trained to identify typical subjects of a photo, including people, animals, and objects, and then create a selection for them. The selection may not be perfect, but it's often close enough for you to refine easily and rapidly with other selection tools.

5 Click the View menu in the View Mode section of the Properties panel, and choose Black & White. This View Mode helps make the mask edge easier to see.

6 In the Properties panel, expand the Refine Mode if needed, and click Color Aware. If a message appears, click OK. The mask edge changes.

▶ **Tip:** You don't have to be in the Select And Mask dialog box to use the Select > Subject command. It's available even when a selection tool is not active. Also, it's OK to use Select Subject first and then enter Select And Mask to refine the selection.

The two Refine Modes interpret potential subject edges differently. Color Aware can work well on simple backgrounds like the one in this lesson. Object Aware may work better on more complex backgrounds. If you want to compare the two results, choose Edit > Toggle Last State to switch between them.

7 Click the View menu in the View Mode section of the Properties panel, and choose Overlay to better compare the edge to the actual image.

Notice that there are a few areas over the chest that were missed by Select Subject. You can easily add them to the selection using the Quick Selection tool.

8 Make sure the Quick Selection tool () is selected. In the options bar, set up a brush with a size of **15** px.

9 Drag the Quick Selection tool over the missed areas (without extending into the background) to add the missed areas to the selection. Notice that the Quick Selection tool fills in the selection as it detects content edges, so you don't have to be exact. It's okay if you release the mouse button and drag more than once.

▶ **Tip:** When editing a selection, increase the magnification if it helps you see missed areas.

Where you drag teaches the Quick Selection tool which areas should be revealed and are not part of the mask. Do not drag the Quick Selection tool over or past the model's edge to the background, because this teaches the Quick Selection tool to include part of the background in the mask, and you don't want that. If you accidentally add unwanted areas to the mask, either choose Edit > Undo or reverse the edit by painting over it with the Quick Selection tool in Subtract mode. To enable Subtract mode for the Quick Selection tool, click the Subtract From Selection icon (⊖) in the options bar.

▶ **Tip:** You can adjust the opacity of the onion skin by dragging the Transparency slider under the View Mode options.

As you drag the Quick Selection tool over the model, the overlay disappears from the areas that you are marking to be revealed. Don't worry about total perfection at this stage.

10 Click the View menu in the View Mode section again, and choose On Layers. This shows you how the current Select And Mask settings look over any layers that are behind this layer. In this case, you're previewing how the current settings will mask the Model layer over the Episode Background layer.

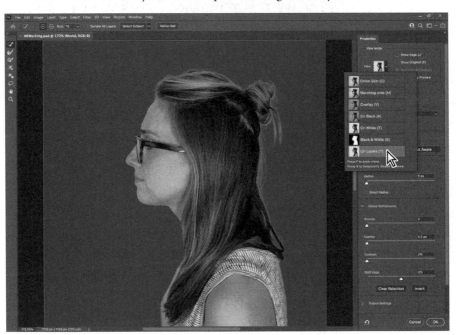

Inspect the edges around the model at a high magnification, such as 400%. Some of the original light background may still show between the model's edge and the podcast background, but overall the Select Subject and Quick Selection tools should have created clean edges for the shirt and face. Don't be concerned about edge gaps or imperfect hair edges, because you'll take care of those next.

Getting better and faster results with Select And Mask

When using Select And Mask, it's important to use different tools for image areas that should be fully revealed, for areas that should be fully masked, and for partially masked edges (such as fuzzy dog hair). Try these recommendations:

- The Select Subject button can be a fast way to create an initial selection.

- The Quick Selection tool is useful for rapidly touching up a selection produced by Select Subject or for creating an initial selection. As you drag it, it uses edge detection technology to find mask edges automatically. Don't drag it on or over a mask edge; keep it fully inside (in Add mode) or outside (in Subtract mode) the areas that should be revealed.

- To paint or draw solid mask edges manually (without using any automatic edge detection), use the Brush, Lasso, or Polygonal Lasso tool. These also have an Add mode for marking revealed areas and a Subtract mode for marking masked areas.

- Instead of having to switch between Add and Subtract modes with the toolbar, you can leave a tool in Add mode, and when you want to temporarily use the tool in Subtract mode, hold down the Alt (Windows) or Option (macOS) key.

- To improve the mask along edges containing complex transitions such as hair, drag the Refine Edge Brush along those edges. Do not drag the Refine Edge brush over areas that should be fully revealed or fully masked.

- You don't have to do all of your selecting inside Select And Mask. For example, if you've already created a selection with another tool such as Color Range, leave that selection active, and then click Select > Select And Mask in the options bar to clean up the mask.

► **Tip:** In Select And Mask, the Polygonal Lasso tool is grouped with the Lasso tool.

Refining a mask

The mask is pretty good so far, but Select Subject didn't quite capture all of the model's hair. For example, some of the strands coming off of the bun on the back of the model's head are discontinuous. In Select And Mask, the Refine Edge Brush tool is designed to mask edges with challenging details.

1 At a magnification of 300% or higher, inspect the hair edges at the back of the model's head.

2 Select the Refine Edge Brush tool (). In the options bar, set up a brush with a size of **20** px and Hardness of **100**%.

▶ **Tip:** If you use a tool to make the initial selection (instead of Select Subject), click the Refine Hair button. It should result in less manual brushing with the Refine Edge Brush tool.

3 Drag the Refine Edge Brush tool between the hair bun and the ends of the hair, where the selection needs to be improved. As you drag the Refine Edge Brush tool over the hair edge, you should see that the missing hair strands falling from the bun are now included in the visible areas.

4 Scroll down to the loop of hair that falls over the back of the shirt.

Select Subject correctly masked the background inside the hair loop. However, a more subtle hole above still needs to reveal the podcast background, so you'll use the Refine Edge Brush to add that hole to the mask.

5 In the options bar, set up a Refine Edge brush with a size of **15** px, with a Hardness of **100**%.

6 Drag the Refine Edge Brush tool over the enclosed area that should be transparent. Gaps in the hair should become masked as transparent, and fine hairs are added to the visible edge.

7 Click the View option, and choose Black & White to more clearly evaluate the current mask edge. Inspect the mask at different magnifications. When you're done, choose View > Fit On Screen. Black areas indicate transparency.

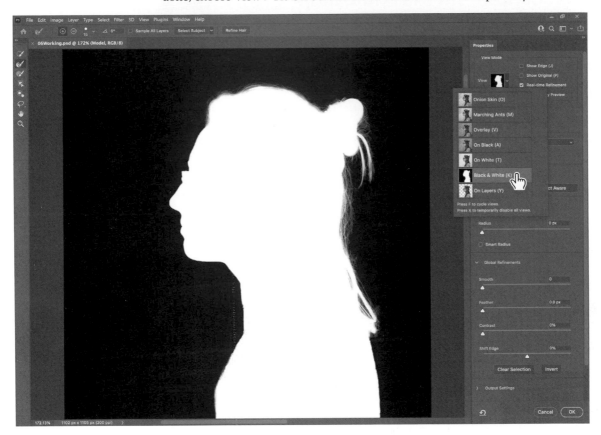

▶ **Tip:** Gray pixels should appear only in transitional edges of a mask. All areas fully outside the subject should be solid black, and all areas fully inside should be solid white.

If you see hairs or other details that are masked but should be visible, drag the Refine Edge brush over them. The finer the details you want to mask, the smaller you should set the Refine Edge brush size. It's okay if the brush size is slightly larger than the details you want to mask, and you don't have to drag the Refine Edge Brush tool precisely.

If you see Refine Edge Brush tool mistakes that need to be erased, such as inner areas incorrectly added to the mask, drag the Refine Edge Brush tool over the mistakes while holding down the Alt (Windows) or Option (macOS) key.

▶ **Tip:** A quick way to remember what color to paint in a mask is the phrase "black conceals, white reveals."

If you see individual spots or discrete areas that need to be fully visible or fully transparent, you can paint them out using the Brush tool, the third one down in the toolbox. To make areas visible, paint them with white; to make areas hidden, paint them with black. You can also drag the Lasso tool to enclose any areas you want to add, subtract, or intersect with the mask, depending on its mode in the options bar.

Adjusting Global Refinements

At this point the mask is in good shape but needs to be tightened up a little. You can tune the overall appearance of the mask edge by adjusting the Global Refinements settings.

1 Click the View menu in the View Mode section of the Properties panel, and choose On Layers. This lets you preview adjustments over the Episode Background layer, which is behind the Model layer.

2 In the Global Refinements section, move the sliders to create a smooth, unfeathered edge along the face. The optimal settings depend on the selection you created, but they'll probably be similar to ours. We moved the Smooth slider to 1 to reduce the roughness of the outline, Contrast to 20% to sharpen the transitions along the selection border, and Shift Edge to –15% to move the selection border inward and help remove unwanted background colors from selection edges. (Adjusting Shift Edge to a positive number would move the border outward.)

● **Note:** Pay attention to details while using Global Refinements. For example, if you adjust Smooth and the mask edge starts to round corners or grind down important details, that means Smooth is set too high. Similarly, setting Feather too high can create unsightly halos along the edge.

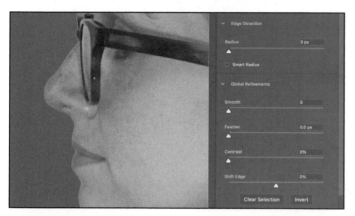

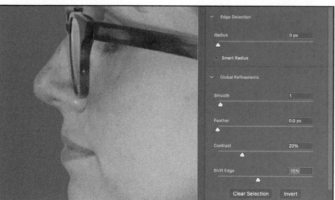

3 Take one more look at this preview of the current mask over the background layer, and make any remaining corrections as needed.

Completing the mask

▶ **Tip:** If you mask
many images that need
similar settings, click
the Preset menu and
choose Save Preset to
create a named preset
of Select and Mask
properties that you can
apply at any time.

When you're satisfied with the mask preview, you can create its final output as a selection, a layer with transparency, a layer mask, or a new document. For this project, we want to use this as a layer mask on the Model layer, which was selected when you entered Select And Mask.

1 If the Output Settings are hidden, click the disclosure icon (⟩) to reveal them.

2 Zoom in to 200% or more so that you can more easily see the light fringing around the face edge that's due to the Model layer's original background color seeping in behind the mask.

3 Select Decontaminate Colors to suppress those color fringes. If Decontaminate Colors creates unwanted artifacts, reduce the Amount until the effect looks the way you want. We set Amount to 25%.

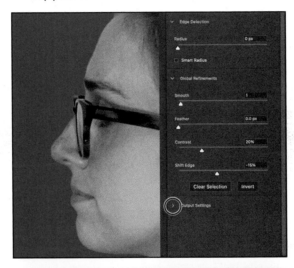

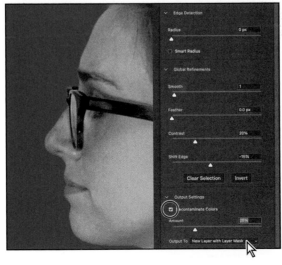

4 Choose New Layer With Layer Mask from the Output To menu. Then click OK.

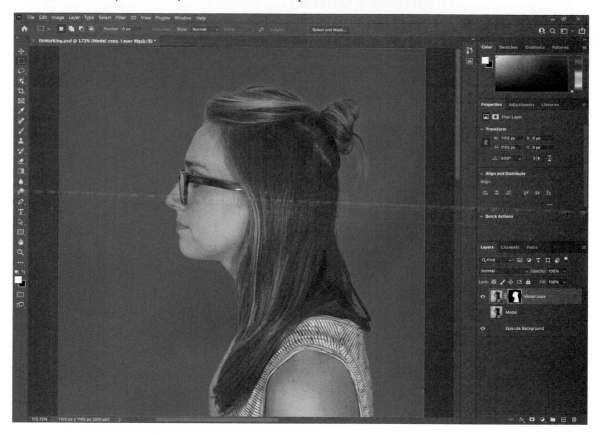

5 In the Layers panel, the Model Copy layer now has a layer mask (pixel mask) that was generated by Select And Mask.

The layer was copied because using the Decontaminate Colors option requires generating new pixels. The original Model layer is preserved and automatically hidden. If you wanted to start over, you could delete the Model Copy layer, make the original Model layer visible again and selected, and open Select And Mask again.

If the mask isn't perfect, you can continue to edit it at any time. When a layer mask thumbnail is selected in the Layers panel, you can click the Select And Mask button in the Properties panel, click it in the options bar (if a selection tool is active), or choose Select > Select And Mask.

6 Save your work.

● **Note:** If you had not selected Decontaminate Colors, it would have been possible to choose a Layer Mask output option that would have added a layer mask to the Model layer without copying it.

Creating a quick mask

To change the color of the glasses frames, you'll use a quick mask, because you won't need the mask after you're done with this one task and so that you can create the mask by painting. First, you'll clean up the Layers panel.

1 Hide the Episode Background layer so you can concentrate on the model. Make sure the Model copy layer is selected.

2 Click the Edit In Quick Mask Mode button near the bottom of the Tools panel. (Until now, you have been working in the default Standard mode.)

In Quick Mask mode, a red overlay appears as you make a selection, masking the area outside the selection the way a rubylith, or red acetate, was used to mask images in traditional print shops. (This idea is similar to the Overlay view mode you saw in Select And Mask.) You can apply changes only to the unprotected area that is visible and selected. Notice that the highlight color for the selected layer in the Layers panel is red, indicating you're in Quick Mask mode.

Note: If you are using a small display and the Tools panel is in single-column mode, the Quick Mask Mode button may be past the bottom of the screen. If the Tools panel is in two-column mode, the Quick Mask Mode button is at the bottom-left corner of the panel.

3 In the Tools panel, select the Brush tool ().

4 In the options bar, make sure that the mode is Normal. Open the Brush pop-up panel, and select a small brush with a diameter of **13** px and a Hardness of **100**%. Click outside the panel to close it.

5 Paint the earpiece of the glasses frames. (Magnify the view if it helps you paint more precisely.) The area you paint will appear red, creating a mask.

6 Continue painting with the Brush tool to mask the earpiece of the frames and the frame around the lenses. Reduce the brush size to paint around the lenses. You can stop where the earpiece goes under the hair.

▶ **Tip:** Here, you're making a selection by painting the area you want to select. Compare this to Chapter 3, where you made selections using tools that create a selection marquee.

In Quick Mask mode, Photoshop treats the red overlay as a grayscale mask, where shades of gray correspond to degrees of mask transparency. When using a painting or editing tool in Quick Mask mode, keep these principles in mind:

• Painting with black adds to the mask (the red overlay), subtracting from the selected area.

• Painting with white erases the mask, adding to the selected area.

• Painting with gray or reduced opacity adds semitransparent areas to the mask, where darker shades are more transparent (more masked).

7 Click the Edit In Standard Mode button (▣), which is the same as the Enter Quick Mask Mode button.

Exiting Quick Mask mode converts the Quick Mask into a selection.

8 Choose Select > Inverse to select the area you originally masked.

9 Choose Image > Adjustments > Hue/Saturation. The commands on the Adjustments menu affect pixels directly, without creating an adjustment layer.

▶ **Tip:** If you want to keep the selection for future use, save it as an alpha channel (Select > Save Selection); otherwise, it will be lost as soon as the area is deselected.

10 In the Hue/Saturation dialog box, change the Hue to **+70**. The new green color fills the glasses frame. Click OK.

 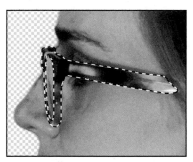

11 Choose Select > Deselect.

Manipulating an image with Puppet Warp

Note: Photoshop provides several different ways to warp a layer. You'll use Puppet Warp because it's the easiest way to pivot part of an image, such as tilting the head back in this example.

The Puppet Warp feature gives you flexibility in manipulating an image. You can reposition areas, such as hair or an arm, just as you might pull the strings on a puppet. Place pins wherever you want to control movement. You'll use Puppet Warp to tilt the model's head back so she appears to be looking up.

1 Zoom out so you can see the entire model.

2 With the Model Copy layer selected in the Layers panel, choose Edit > Puppet Warp.

A mesh appears over the visible areas in the layer—in this case, the mesh appears over the model. You'll use the mesh to place pins where you want to control movement (or to ensure there is no movement).

3 Click to add pins around the body and along the base of the head, as shown below. Each time you click, Puppet Warp adds a pin. About 10 to 12 pins should work.

The pins you've added around the shirt will keep it in place as you tilt the head.

4 Select the pin at the nape of the neck. A blue dot appears in the center of the pin to indicate that it's selected.

5 Press Alt (Windows) or Option (macOS). A larger circle appears around the pin, and a curved double arrow appears next to it. Continue pressing Alt or Option as you drag the pointer to rotate the head backwards. You can see the angle of rotation in the options bar; you can enter **170** there to rotate the head back.

6 When you're satisfied with the rotation, click the Commit Puppet Warp button (✓) in the options bar, or press Enter or Return.

Note: Be careful not to Alt-click or Option-click the dot itself, or you'll delete the pin.

7 Save your work so far.

Using an alpha channel to create a shadow

Just as different information in an image is stored on different layers, channels also let you access specific kinds of information. Alpha channels store selections as grayscale images. Color information channels store information about each color in an image; for example, an RGB image automatically has red, green, blue, and composite channels.

To avoid confusing channels and layers, think of channels as containing an image's color and selection information, and think of layers as containing painting, shapes, text, and other content.

You'll first convert the transparent areas of the Model copy layer to a selection and then fill it with black on another layer to create a shadow. Because the selection will be altered to make the shadow, you'll now save the current form of the selection as an alpha channel so that you can load it again later if needed.

1 In the Layers panel, Ctrl-click (Windows) or Command-click (macOS) the layer thumbnail icon for the Model Copy layer. The masked area is selected.

2 Choose Select > Save Selection. In the Save Selection dialog box, make sure New is chosen in the Channel menu. Then name the channel **Model Outline**, and click OK.

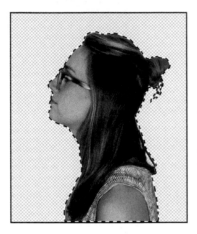
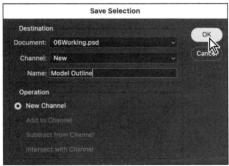

▶ **Tip:** Now that the original selection outline of the model is saved as an alpha channel, you can reuse that selection at any time, even from another Photoshop document, by choosing the Select > Load Selection command.

Nothing changes in the Layers panel or in the document window. However, a new channel named Model Outline has been added to the Channels panel. The selection is still active.

About alpha channels

As you work in Photoshop, you will eventually encounter alpha channels (saved selections). It's good to know a few things about them:

- An image can contain up to 56 channels, including all color and alpha channels.
- Alpha channels are 8-bit grayscale, storing 256 gray levels.
- You can specify a name, color, mask option, and opacity for each channel. (The opacity affects the preview of the channel, not the image.)
- All new channels have the same pixel dimensions as the containing document.
- You can edit an alpha channel mask using painting tools and filters.
- You can convert alpha channels to spot-color channels.
- The Select > Load Selection command lets you bring in an alpha channel from another document, as long as both documents have the same pixel dimensions.

3 Click the Create A New Layer icon (⊞) at the bottom of the Layers panel. Drag the new layer below the Model Copy layer so that the shadow will be below the image of the model. Double-click the new layer's name, and rename it **Shadow**.

4 With the Shadow layer selected, choose Select > Select And Mask. This loads the current selection into the Select And Mask task space.

5 Click the View menu in the View Mode section of the Properties panel, and choose On Black.

6 In the Global Refinements section, move the Shift Edge slider to **+36%**.

7 In the Output Settings section, make sure Selection is selected in the Output To menu, and then click OK.

● **Note:** Some image file formats offer the option to save an alpha channel with the image document. If you use this option, Photoshop creates an alpha channel that includes all areas of the composite image that are not occupied by an opaque pixel.

8 Choose Edit > Fill. In the Fill dialog box, choose Black from the Contents menu, and then click OK.

The Shadow layer displays a filled-in black outline of the model. Shadows aren't usually as dark as the person who casts them, so you'll reduce the layer opacity.

9 In the Layers panel, change the layer opacity to **30%**.

The shadow is in exactly the same position as the model, where it can't be seen. You'll shift it.

10 Choose Select > Deselect to remove the selection.

11 Choose Edit > Transform > Rotate. Rotate the shadow by hand, or enter **–15°** in the Rotate field in the options bar. Then drag the shadow to the left, or enter **545** in the X field in the options bar. Click the Commit Transform button (✓) in the options bar, or press Enter or Return, to accept the transformation.

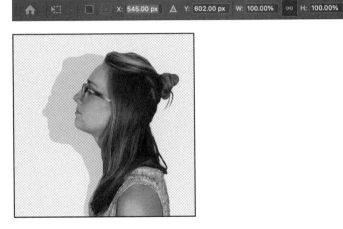

12 Click the eye icon for the Episode Background layer to make it visible, and delete the Model layer (the one without the mask).

13 Choose File > Save to save your work so far.

Creating a pattern for the background

The design for the episode graphic incorporates a pattern into the background. You'll quickly create the pattern by customizing a vector graphic shape.

Customizing a polygon shape

The background is based on star shapes. There is no star tool in Photoshop, but you can easily create one by customizing a shape drawn with the Polygon tool.

1 In the Lesson06 folder, open the document 06Pattern.psd. It opens in its own document tab.

2 Select the Polygon tool (⬡), which is grouped with the Rectangle tool. In the options bar, make sure the tool is set to **Shape**.

3 Hold down Shift and draw a polygon shape about 340 pixels wide. If it isn't centered on the canvas, after drawing you can reposition it with the Move tool.

4 With the shape layer still selected, in the Appearance section of the Properties panel set the Fill to None, set the Stroke to **20px**, and apply a blue Stroke color slightly darker than the background; we used R=27, G=58, B=185.

5 Set the polygon Number Of Sides to **8**, and set the Star Ratio to **70%**. When the Star Ratio is less than 100%, the number of sides becomes the number of points.

6 In the Layers panel, duplicate the star shape layer by dragging and dropping it on the Create A New Layer button.

7 In the Properties panel, change the Rotate angle to **24**.

▶ Tip: The Edit >
Free Transform Path
command may appear
as Free Transform if
you switched to the
Move tool in step 3.
The command is Free
Transform Path when
the current tool can
edit paths or shapes.

8 Choose Edit > Free Transform Path, and hold down the Alt (Windows) or Option
 (macOS) key as you drag a corner handle to shrink the duplicate star layer to fit
 inside the larger star. Press Enter or Return to apply the transformation.

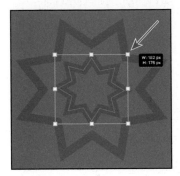

9 Choose View > Pattern Preview to see how the design looks as a pattern. If a
 message appears, click OK. Only the original shape on the canvas is editable, but
 Pattern Preview updates to account for any changes you make.

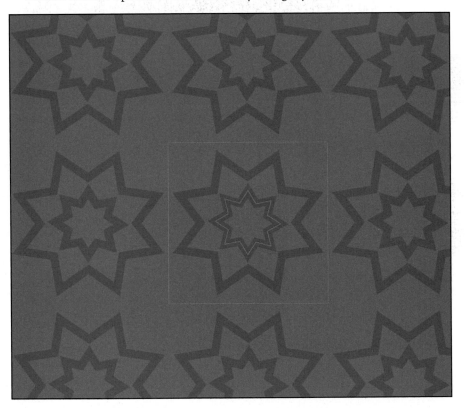

10 Select the Move tool, select Polygon 1 (the large star) in the Layers panel, and look for a small circular handle inside the top-right star point. If you don't see the handle, make sure Show Transform Controls is selected in the options bar, and increase the view magnification.

11 Drag the handle to change the sharp star points to rounded points. We used a radius of 20 pixels. The pattern preview updates.

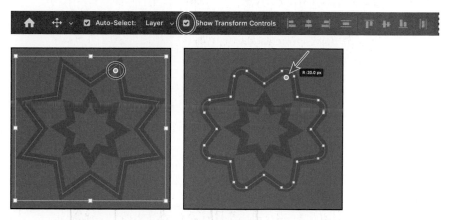

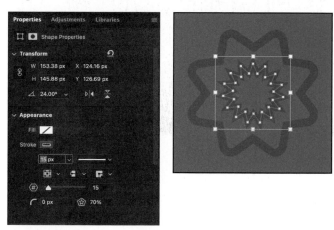

12 In the Layers panel, select Polygon 1 copy (the small star). In the Properties panel, set the Number Of Points to **15** and reduce the Stroke Width to **15 px**.

13 Choose Edit > Define Pattern, name it **Podcast Pattern**, and click OK. This creates a pattern preset that you can use in any Photoshop document.

14 Choose File > Save As, rename the file to 06Pattern_Working.psd, and click Save. Click OK if the Photoshop Format Options dialog box appears.

15 Switch to 06Working.psd, and select the Episode Background layer.

16 In the Layers panel, click the Create New Fill Or Adjustment Layer button, and choose Pattern.

17 In the Pattern Fill dialog box, click the pattern picker, and at the bottom of the list, select the blue pattern you created. Set Angle to **45** degrees, set Scale to **35%**, and click OK.

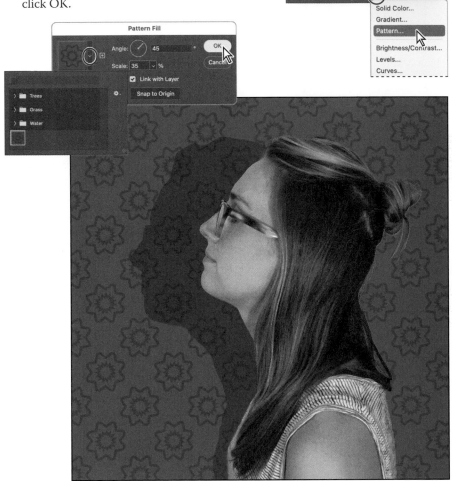

18 Save your work. Your podcast background is ready for the next step!

Review questions

1 What is the benefit of using a quick mask?

2 When you have a selection created by a quick mask, what happens when you deselect?

3 When you save a selection as an alpha channel, where is the alpha channel stored?

4 How can you edit a mask in a channel once you've saved it?

5 How do channels differ from layers?

Review answers

1 Quick masks are helpful for creating one-time selections. In addition, using a quick mask is an easy way to edit a selection using the painting tools.

2 As with any other selection, a quick mask selection disappears when you deselect it.

3 Alpha channels are stored in the Channels panel, along with the visible color channels.

4 You can paint in an alpha channel using black, white, and shades of gray.

5 Alpha channels are storage areas for saved selections. All layers set to be visible will be present in printed or exported output. But only the color channels are visible in printed or exported output; alpha channels are not. Layers contain information about image content, while alpha channels contain information about selections and masks.

7 TYPOGRAPHIC DESIGN

Lesson overview

In this lesson, you'll learn how to do the following:

- Use guides to position text in a composition.

- Make a clipping mask from type.

- Merge type with other layers.

- Preview fonts.

- Format text.

- Flow text along a path.

- Control type and positioning using advanced features.

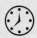 This lesson will take less than an hour to complete. To get the lesson files used in this chapter, download them from the web page for this book at adobepress.com/PhotoshopCIB2023. For more information, see "Accessing the lesson files and Web Edition" in the Getting Started section at the beginning of this book.

As you work on this lesson, you'll preserve the start files. If you need to restore the start files, download them from your Account page.

LATEST PODCASTS ABOUT TYPE

TYPECAST

THE
TREND
CAST

WHAT'S NEW IN WEB TYPE?

WHAT'S NEW IN 3D TYPE?

WHAT'S NEW IN TYPE EFFECTS?

What's Hot?
DESIGNER INTERVIEWS

What's Not?
COMIC SANS
GRADIENT TYPE
SCRIPT FONTS

TYPE

TYPOGRAPHY

HEAR IT FROM
THE MASTERS
AVOID TYPE DISASTERS

PROJECT: PODCAST EPISODE GRAPHICS

Photoshop provides powerful, flexible text tools so you can add type to your images with great control and creativity.

About type

● **Note:** If some fonts installed on your computer aren't available in Photoshop, check to see if they are PostScript Type 1 fonts, which are an old font format that is no longer supported. Consider licensing OpenType versions of those fonts, which may be available as Adobe Fonts.

A Photoshop type layer consists of vector-based shapes that describe the letters, numbers, and symbols of a typeface. Many typefaces are available in more than one format. The TrueType format is widely used, and the OpenType format is preferred by professionals (see "OpenType in Photoshop" on page 191, later in this lesson).

Photoshop preserves the vector-based character outlines, so type renders at the full resolution of the Photoshop document as you edit, scale, or resize type layers. However, the pixel dimensions of the document limit how sharp type can be. As you magnify a document, jagged type edges appear sooner in a document with smaller pixel dimensions, such as in low-resolution graphics designed for websites.

Getting started

● **Note:** Though this lesson starts where Lesson 6 left off, use the 07Start.psd file. We've included a path and a sticky note in the start file that won't be in the 06Working.psd file you saved.

In this lesson, you'll work on a design that represents an episode of a podcast series about typography. You'll start with the artwork you created in Lesson 6: The episode artwork has a model, her shadow, and the blue background. You'll add and stylize type for the episode artwork, including warping the text.

You'll start the lesson by viewing an image of the final composition.

1. Start Photoshop, and then simultaneously hold down Ctrl+Alt+Shift (Windows) or Command+Option+Shift (macOS) to restore the default preferences. (See "Restoring default preferences" on page 5.)

2. When prompted, click Yes to delete the Adobe Photoshop Settings file.

● **Note:** If Bridge is not installed, you'll be prompted to download and install it. See page 3 for more information.

3. Choose File > Browse In Bridge to open Adobe Bridge.

4. In the Favorites panel on the left side of Bridge, click the Lessons folder, and then double-click the Lesson07 folder in the Content panel.

5. Select the 07End.psd file. Increase the thumbnail size to see the image clearly by dragging the thumbnail slider to the right.

You'll apply the type treatment in Photoshop to finish the episode artwork. All of the type controls you need are available in Photoshop, so you don't have to switch to another application to complete the project.

● **Note:** If Photoshop displays a dialog box telling you about the difference between saving to Cloud Documents and On Your Computer, click Save On Your Computer. You can also select Don't Show Again, but that setting will deselect after you reset Photoshop preferences.

6. Double-click the 07Start.psd file to open it in Photoshop.

7. Choose File > Save As, rename the file **07Working.psd**, and click Save.

8. Click OK in the Photoshop Format Options dialog box.

9 Choose Graphic and Web from the Workspace Switcher in the options bar.

The Graphic and Web workspace displays the Character and Paragraph panels that you'll use in this lesson, along with the Glyphs and Layers panels. The Tools panel may look different than it has in other lessons, because the Graphic and Web workspace includes a customized Tools panel.

Creating a clipping mask from type

A *clipping mask* is an object or a group of objects whose shape masks other artwork so that only areas within the clipping mask are visible. In effect, you are clipping the artwork to the visible pixels of the layer. In Photoshop, you can create a clipping mask from shapes or letters. In this exercise, you'll use letters as a clipping mask to allow an image in another layer to show through.

Adding guides to position type

You'll be adding multiple type layers that need to line up on the canvas. To simplify alignment, you'll start by adding nonprinting guides to help position the type.

Tip: The View > Actual Size command makes the Photoshop ruler match a real-world ruler. Actual Size works best with print documents, not documents measured in pixels.

Tip: If you find it difficult to position the vertical ruler guide exactly at 4.25", holding down Shift will snap the guide to the 4.25" ruler tick mark.

1 Choose View > Fit On Screen to see the whole canvas clearly.

2 Choose View > Rulers to display rulers along the left and top borders of the document window.

3 If the rulers aren't displaying in inches, right-click (Windows) or Control-click (macOS) the rulers, and choose Inches.

4 Drag a vertical guide from the left ruler to the center of the document (4.25").

Adding point type

Now you're ready to add type to the composition. You can enter *point type* (short text anchored to a point) or *paragraph type* (multiple lines that can recompose as you resize their text container) First, you'll create point type.

1 In the Layers panel, select the Pattern Fill 1 layer.

2 Select the Horizontal Type tool (**T**), and, in the options bar, do the following:

- Choose a serif typeface, such as Minion Pro Regular, from the Font Family pop-up menu.

- Type **115 pt** for the Size, and press Enter or Return.

- Click the Center Text button.

3 In the Character panel, change the Tracking value to **50**.

The Tracking value specifies the overall space between letters, which affects the density in a line of text.

4 Position the pointer over the center guide you added to set an insertion point, roughly where the guide crosses the edge of the model's shadow, click, and then type **TYPECAST** in all capital letters. Then click the Commit Any Current Edits button (✔) in the options bar.

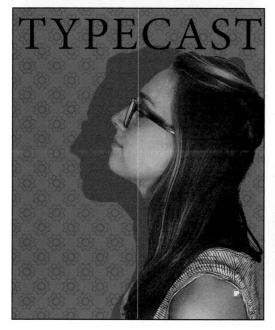

● **Note:** After you type, you must commit your editing in the layer by clicking the Commit Any Current Edits button, switching to another tool or layer, or clicking away from the text layer. You cannot commit to current edits by pressing Enter or Return; doing so would create a new line of type.

The word "TYPECAST" is added, and it appears in the Layers panel as a new type layer named TYPECAST. You can edit and manage the type layer as you would any other layer. You can add or change the text, change the orientation of the type, apply anti-aliasing, apply layer styles and transformations, and create masks. You can move, restack, and copy a type layer, or edit its layer options, just as you would for any other layer.

The text is big enough, but not modern enough, for this design. Try a different font:

5 Double-click the "TYPECAST" text to edit it.

6 Open the Font Family pop-up menu in the options bar. Hover the pointer over the font list, either with the mouse or using arrow keys.

When the pointer is over a font name, Photoshop temporarily applies that font to the selected text so you can preview the font in context.

▶ **Tip:** When a type layer is selected in the Layers panel, the Properties panel displays type settings— another place you can change type options such as the font.

7 Select Myriad Pro Semibold or a similar font, and then click the Commit Any Current Edits button (✓) in the options bar.

That's much more appropriate.

8 If needed, use the Move tool to drag the "TYPECAST" text to adjust its position close to the top of the design.

9 Choose File > Save to save your work so far.

Making a clipping mask and applying a shadow

You added the letters in black, the default text color. However, you want the letters to appear to be filled with a texture from an image, so you'll use the letters to make a clipping mask that will allow another image layer to show through.

1 In the Layers panel, make sure the TYPECAST layer is selected.

2 Choose File > Place Embedded, navigate to the Lesson07 folder, and double-click the Metal.tif file. It appears with a bounding box so that you can scale it or move it into place.

3 With the bounding box still active, drag the Metal layer up until it's aligned with the top of the canvas. Then press Enter or Return to finish placing the file.

 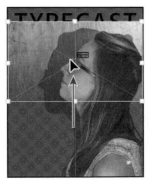 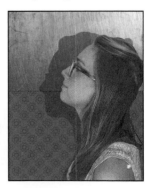

4 With the Metal layer selected, choose Create Clipping Mask from the Layers panel menu (≡).

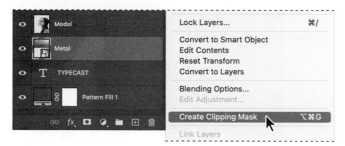

▶ **Tip:** You can also create a clipping mask by holding down the Alt (Windows) or Option (macOS) key and clicking between the Metal and TYPECAST type layers. Or, choose Layer > Create Clipping Mask when the Metal layer is selected.

Creating a clipping mask lets the metal texture show through the "TYPECAST" letters of the next layer back. A small arrow in the Metal layer and the underlined type layer name indicate the clipping mask is applied.

Next, you'll add an inner shadow to give the letters depth.

5 Select the TYPECAST layer. Then, click the Add A Layer Style button (*fx*) at the bottom of the Layers panel, and choose Inner Shadow from the pop-up menu.

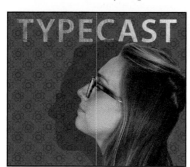

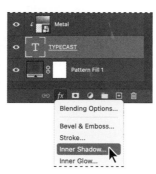

6 In the Layer Style dialog box, make sure the Blend Mode is set to Multiply, Opacity is set to **48**%, Distance to **18**, Choke to **0**, and Size to **16**. If the Preview option is enabled, you can see how changing the options affects the layer. Then click OK.

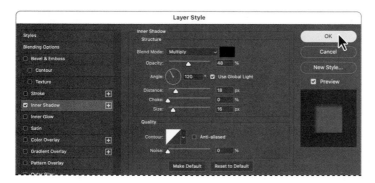

The Inner Shadow option adds a sense of dimension to the title text.

7 Choose File > Save to save your work so far.

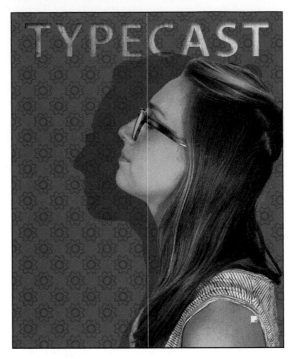

Julieanne Kost is an official Adobe Photoshop evangelist.

Tool tips from the Photoshop evangelist

Type tool tricks

- Shift-click in the document window with the Horizontal Type tool to create a new type layer—in case you're close to another block of type and Photoshop tries to select text on the existing type layer.

- Double-click the thumbnail icon of any type layer in the Layers panel to select all of the type on that layer.

- With any text selected, right-click (Windows) or Control-click (macOS) on the text to access the context menu. Choose Check Spelling to run a spell-check.

Paragraph and character styles

If you frequently work with type in Photoshop or if you need to consistently format a significant amount of type in an image, then paragraph and character styles can help you work more efficiently. A paragraph style is a collection of type attributes that you can apply to an entire paragraph with a single click. A character style is a collection of attributes that you can apply to individual characters. You can work with these styles by opening their panels: Choose Window > Paragraph Styles and Window > Character Styles.

The concept of type styles in Photoshop is similar to that in page layout applications such as Adobe InDesign and word-processing applications such as Microsoft Word. However, styles behave a little differently in Photoshop. For the best results working with type styles in Photoshop, keep the following in mind:

- By default, all text you create in Photoshop has the Basic Paragraph style applied. The Basic Paragraph style is defined by your text defaults, but you can change the style definition by double-clicking the style name.

- Deselect all layers before you create a new style.

- If the selected text has been changed from the current paragraph style (usually the Basic Paragraph style), those changes (considered overrides) persist even when you apply a new style. To ensure that all the attributes of a paragraph style are applied to text, apply the style, and then click the Clear Override button (↩) in the Paragraph Styles panel.

- Want to use the styles from another Photoshop document? Open the Paragraph Styles or Character Styles panel menu, choose Load Styles, and select the document containing the styles you want. To save the current styles as defaults for all new documents, choose Type > Save Default Type Styles. To use your default styles in an existing document, choose Type > Load Default Type Styles.

Creating type on a path

In Photoshop, you can create type that follows along a path that you draw with a pen or shape tool. The direction the type flows depends on the order in which anchor points were added to the path. When you use the Horizontal Type tool to add text to a path, the letters are perpendicular to the baseline of the path. If you change the location or shape of the path, the type moves with it.

You'll create type on a path to make it look as if questions are coming from the model's mouth. We've already created the path for you; we stored it in the Paths panel.

1 In the Layers panel, select the Model layer.

2 Choose Window > Paths to show the Paths panel.

3 In the Paths panel, select Speech Path to make it active and visible.

The path appears to be coming out of the model's mouth.

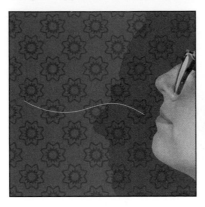

4 Select the Horizontal Type tool.

5 In the options bar, click the Right Align Text button.

6 In the Character panel, select the following settings:

- Font Family: Myriad Pro
- Font Style: Regular
- Font Size (⌐T): **14** pt
- Tracking (⧖): **–10**
- Color: White
- All Caps (**TT**)

● Note: The path won't print or export because it isn't a shape layer—it exists only in the Paths panel. But the text on the path is a type layer, so the type will print and export.

7 Move the Horizontal Type tool over the path. When a small slanted line appears across the I-bar, click near the end of the path closest to the model's mouth, and type **What's new in 3D type?**.

As you type on the path, the text is added from the right because Right Align Text was selected in step 5.

8 With the Horizontal Type too, select "3D TYPE?" and change its font style to Bold. Click the Commit Any Current Edits button (✔) in the options bar.

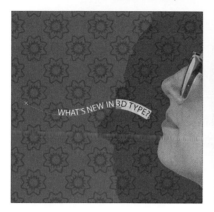

9 In the Layers panel, select the What's new in 3D type? layer, choose Duplicate Layer from the Layers panel menu, and click OK.

You can't see the duplicate text layer yet, because it's exactly on top of the original text layer. But the Layers panel shows that the duplicate layer has the word "copy" at the end of the layer name. You'll move the copy away from the original.

10 Choose Edit > Free Transform Path. Rotate the path approximately 15 degrees, and then shift the path up above the first path and a little to the right, as in the figure below. Click the Commit Transform button in the options bar.

11 With the Type tool, select "3D" in the upper copy of the text layer, and replace it with **web**. Click the Commit Any Current Edits button in the options bar.

When you edit the characters on a text layer, the layer name automatically updates to match. (The layer name will not update if you edited the layer name to differ from the actual text on the layer.)

● **Note:** When you position a type tool over a character that has alternate glyphs available, a grid may appear containing alternates you can select from (see the sidebar on page 190). If the alternate glyphs get in your way, disable Enable Type Layer Glyph Alternates in the Type panel of the Preferences dialog box.

● **Note:** If you can't remember how to rotate using a transform bounding box, position the pointer near the outside of the transform bounding box until the pointer changes to a rotate icon (an arc with two arrows), and drag.

12 Repeat steps 9–11, replacing the words "3D type" with **type effects**. Rotate the left side of the path about –15 degrees, and move it below the original path.

13 Choose File > Save to save your work so far.

Warping point type

The text on a curvy path is more interesting than straight lines would be, but you'll warp the text to make it more playful. *Warping* lets you distort type to conform to a variety of shapes, such as an arc or a wave. The warp style you select is an attribute of the type layer—you can change a layer's warp style at any time to change the overall shape of the warp. Warping options give you precise control over the orientation and perspective of the warp effect.

1 If necessary, zoom or scroll to move the visible area of the document window so that the sentences to the left of the model are in the center of the screen.

Note: If you don't see the Warp Text command on the context menu, right-click/Control-click the layer or layer name, not the layer thumbnail.

2 Right-click (Windows) or Control-click (macOS) the What's new in 3D type? layer in the Layers panel, and choose Warp Text from the context menu.

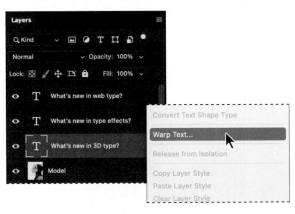

3 In the Warp Text dialog box, choose Wave from the Style menu, and select the Horizontal option. Specify the following values: Bend, **+33**%; Horizontal Distortion, **−23**%; and Vertical Distortion, **+5**%. Then click OK.

The Bend slider specifies how much warp is applied. Horizontal Distortion and Vertical Distortion determine the perspective of the warp.

▶ **Tip:** Do you want to simulate type wrapping around a beverage can? With a type layer selected, choose Edit > Transform > Warp, then choose Cylinder from the Warp pop-up menu in the options bar.

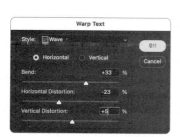
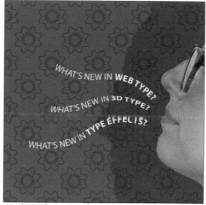

The words "What's new in 3D type?" appear to float like a wave on the design.

4 Repeat steps 2 and 3 to warp the other two text layers you typed on a path. Feel free to try different settings.

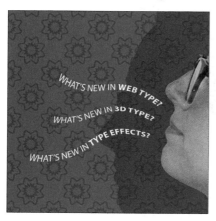
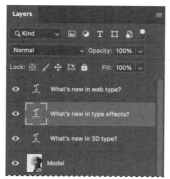

5 Save your work.

Designing paragraphs of type

All of the text you've added so far has been point type because it's a single line. However, many designs call for full paragraphs of text. You can add paragraph type and apply paragraph styles. You don't have to switch to a dedicated page layout program for sophisticated paragraph type controls.

Using guides for positioning

You will add paragraphs to the design. First, you'll add some guides to the work area to help you position the paragraphs.

1 If necessary, zoom or scroll so that you can see the entire top half of the document.

2 Drag a guide from the left vertical ruler, placing it approximately ¼" from the right edge of the canvas.

3 Drag a guide down from the top horizontal ruler, placing it approximately 2" from the top of the canvas.

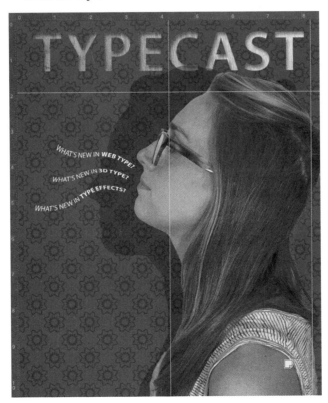

Adding paragraph type from a sticky note

You're ready to add the text. In a real-world design environment, the text might be provided to you in a word-processing document or the body of an email message, which you could copy and paste into Photoshop. Or you might have to type it in. Another easy way to add a bit of text is for the copywriter to attach it to the image file in a sticky note, as we've done for you here.

1 Position the Move tool near the edge of the yellow sticky note in the lower-right corner of the image window, and when it appears as a black pointer only (▶), double-click to open the Notes panel.

▶ **Tip:** You create notes using the Note tool, which is hidden when the Graphics and Web workspace is active. You can find the Note tool quickly by choosing Edit > Search. However, if you want to collect comments from multiple people, it may be easier to use the cloud-based Share for Review online comment feature (choose File > Share for Review).

2 All nine lines of the text should be selected; if they aren't, click in the note text and choose Select > All. Choose Edit > Copy, and close the Notes panel.

3 Select the Model layer. Then, select the Horizontal Type tool (**T**).

4 Position the pointer where the guides intersect at about ¼" from the right edge and 2" from the top of the canvas. Hold down the Shift key as you start to drag a text box down and to the left. Then release the Shift key, and continue dragging until the box is about 4 inches wide by 6 inches high. The new text layer is created in front of the Model layer that was selected (above the Model layer in the Layers panel).

5 Choose Edit > Paste to add the text from the note.

6 Select the first three lines ("The Trend Cast"), and then apply the following settings in the Character panel:

- Font Family: Myriad Pro (or another sans serif font)
- Font Style: Regular
- Font Size (⊤T): **70** pt
- Leading (↕A): **55** pt
- Tracking (⁗A): **50**
- Color: White

▶ **Tip:** In step 4, the reason you press Shift is to make sure you create a new type layer. If you don't press Shift, the Horizontal Type tool might instead select text in the nearby text layer containing the "TYPECAST" headline.

● **Note:** If the text isn't visible, make sure the new type layer is above the Model layer in the Layers panel.

▶ **Tip:** If you paste text and it includes unwanted formatting, you can instead choose the Edit > Paste Without Formatting command in Photoshop to remove all formatting from the pasted text.

7 With the text still selected, click the Right Align Text button in the options bar or Paragraph panel.

8 Select just the word "Trend," and change the Font Style to Bold.

You've formatted the title. Now you'll format the rest of the text.

9 Select the rest of the text you pasted. In the Character panel, select the following:

- Font Family: Myriad Pro

- Font Style: Regular

- Font Size: **22** pt

- Leading: **28** pt

- Tracking: **0**

- Deselect All Caps (**TT**)

● **Note:** *Leading* (pronounced "ledding") determines the vertical space between lines.

The text looks good, but it's all the same. You'll make the headlines stand out more.

10 Select the "What's Hot?" text, change the following in the Character panel, and then press Enter or Return:

- Font Style: Bold

- Font Size: **28** pt

11 Repeat step 10 for the "What's Not!" subhead.

12 Select the word "TREND." Then, in the Character panel, change the text color to blue. We used R=0, G=174, B=239 (or #00aeef in hexadecimal RGB).

13 Click the Commit Any Current Edits button in the options bar.

14 Save your changes.

Saving as Photoshop PDF

The type you've added consists of vector-based outlines, which remain crisp and clear as you zoom in or resize them. However, if you save the file as a JPEG or TIFF image, Photoshop rasterizes the type, so you lose that flexibility. When you save a Photoshop PDF file, vector type is preserved.

You can preserve other Photoshop editing capabilities in a Photoshop PDF file too. For example, you can retain layers, color information, and even notes.

To ensure you can edit the document later, select Preserve Photoshop Editing Capabilities in the Save Adobe PDF dialog box. This will result in a larger PDF file.

To preserve any notes in the file and convert them to Acrobat comments when you save to PDF, select Notes in the Save area of the Save As dialog box.

You can open a Photoshop PDF file in Acrobat or Photoshop, place it in another application, print it, or upload it to a website. For more information, see "Saving the Image as Photoshop PDF" in Lesson 14, "Producing and Printing Consistent Color."

Finishing up

Now, you'll clean up a bit before saving the finished project.

1 With the Move tool, right-click (Windows) or Control-click (macOS) near the top-left corner of the yellow note icon, and choose Delete Note from the context menu; click Yes to confirm that you want to delete the note.

2 Hide the guides: Choose View > Show > Guides to deselect the command. Then choose View > Fit on Screen to get a nice look at your work.

3 Choose File > Save.

Congratulations! You've added and stylized all of the type. Now that the design is ready to go, you'll export a copy to upload to the podcast service.

Tip: Want a design to have a familiar look, but not with the exact font that look is known for? Try Font Similarity. Choose a font in the Font Family menu in either the Type tool options bar or the Character panel. You'll see options at the top of the font list; click the Show Similar Fonts button.

The font list will now show the 20 most similar fonts available either on your system or from Adobe Fonts.

Tip: The keyboard shortcut for hiding and showing guides (View > Show > Guides) is Ctrl+; (Windows) or Command+; (macOS).

► **Tip:** Use the Glyphs panel (Window > Glyphs) to access the full range of alternate characters in OpenType fonts. When editing text, double-click a character in the Glyphs panel to add it to the text.

The Glyphs panel

The Glyphs panel lists all characters available for a font, including specialized characters and alternate versions such as swashes. Above the font name and style menus is a row of recently used glyphs. It's blank if you haven't used any glyphs yet. A menu under the font name lets you display a writing system such as Arabic, or a category of characters such as punctuation or currency symbols. A black dot in the bottom-right corner of a character's box indicates that alternates are available for that character; click and hold the mouse on the character to view its alternate glyphs or to choose one to enter into a text layer.

4 Choose File > Export > Export As, choose JPG from the Format menu, leave the rest of the settings as they are, and click Export. Change the filename to **07Upload.jpg**, make sure it will be saved into the Lesson07 folder, and click Save.

5 Close the document window and save any changes.

OpenType in Photoshop

OpenType is a cross-platform font file format developed jointly by Adobe and Microsoft. The format uses a single font file for both Mac and Windows, so you can move files from one platform to another without font substitution or reflowed text. OpenType offers expanded character sets and layout features, such as swashes and discretionary ligatures, that aren't available in traditional PostScript and TrueType fonts. This, in turn, provides richer linguistic support and advanced typography control. You can identify OpenType fonts in the Photoshop font menu because they appear with an OpenType icon (*O*). Here are some highlights of OpenType:

The OpenType menu. The Character panel menu includes an OpenType submenu that displays all available features for a selected OpenType font, including ligatures, alternates, and fractions. Dimmed features are unavailable for that typeface, check marks appear next to features that have been applied.

Discretionary ligatures. To add a discretionary ligature to two OpenType letters, such as to "th" in the Bickham Script Standard typeface, select them in the file, and choose OpenType > Discretionary Ligatures from the Character panel menu.

Swashes. Adding swashes or alternate characters works the same way as discretionary ligatures: Select the letter, such as a capital "T" in Bickham Script, and choose OpenType > Swash to change the ordinary capital into an ornate (swash) "T."

True fractions. To create true fractions, type the fraction's characters—for example, 1/2. Then, select the characters, and from the Character panel menu, choose OpenType > Fractions. Photoshop applies the true fraction (½).

Color fonts. While you can apply a color to a font in Photoshop, a format called OpenType-SVG allows multiple colors and gradients to be part of the font design itself. For example, a color font may provide the letter "A" in solid blue as well as solid red and in a blue-to-green gradient.

Emoji fonts. Another example of OpenType-SVG fonts are emoji fonts, made possible because OpenType-SVG allows vector graphics to be used as font characters. The Photoshop font family menu indicates color and emoji fonts with an OpenType SVG icon ().

Variable fonts. When you want a certain font weight but Regular is too thin and Bold is too thick, you can use a variable font that lets you customize attributes such as weight, width, and slant in the Properties panel. The Photoshop font family menu indicates variable fonts with an OpenType VAR icon ().

Note that some OpenType fonts have more options than others.

> **Tip:** Want to know if a character has OpenType alternates? Just select it. If a thick underline appears under a selected character, moving the pointer over that character reveals the alternate glyphs available for that character in the font applied to it. You can select from those glyphs just as you can in the Glyphs panel, or you can click a triangle to open the Glyphs panel.

Extra credit

Using Match Fonts to keep your projects consistent

We want to identify a font that was used in another design and apply it to text that says "Premiere Episode" (see the file MatchFont.jpg in the Lesson07 folder). We'd like to use that font for another episode. But the only available file is flattened, so the original type layer is lost. Because no type layer is available, it's impossible to select the text to find out which font was used. Fortunately, you don't have to guess which font is in the image because, in Photoshop, you can let the Match Font feature figure it out for you. Thanks to the magic of intelligent imaging analysis, using just a picture of a Latin font, Photoshop can use machine learning to detect which font it is. Match Font then shows you a list of similar fonts. Match Font is also useful for identifying fonts in photos, such as in the text on a sign in a street scene.

1. Open MatchFont.jpg in the Lesson07 folder.

2. Use the Rectangular Marquee tool to tightly select the area containing the mystery font.

3. Choose Type > Match Font. Photoshop displays a list of fonts similar to the font in the image, including active fonts on your system and Adobe Fonts.

4. To list only the fonts on your computer, deselect Show Fonts Available To Activate From Adobe Fonts.

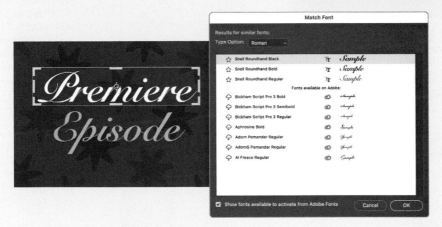

5. Select a script font that most closely resembles the font in the image from the list of fonts that Match Font determined to be similar. Your Match Font results may look different than ours.

6. Click OK. Photoshop selects the font you clicked, so you can now create new text with it.

Review questions

1 How is a Photoshop text layer different than a pixel (image) layer?

2 What are the two kinds of text layers in Photoshop? How are they different?

3 What is a clipping mask, and how do you make one from type?

Review answers

1 Text in Photoshop consists of vector-based shapes that describe the letters, numbers, and symbols of a typeface. When you add type to an image in Photoshop, the characters appear on a text layer at the same resolution as the image file. As long as it's a type layer, Photoshop preserves the type outlines so that the text remains sharp when you scale or resize type, save a Photoshop PDF file, or print the image to a high-resolution printer.

2 You can create point type or paragraph type. Point type is anchored to a point created where you click a type tool. Paragraph type can contain multiple lines that can recompose as you resize their text container; you create it by dragging a type tool.

3 A clipping mask is an object or group that masks another layer using its visible pixels — you see only the areas of the layer that match up with the visible pixels of the clipping mask. To use a text layer as a clipping mask, make sure the layer you want to reveal is directly above the text layer, select the layer you want to show through the letters, and apply the Create Clipping Mask command (found on the Layer menu, the Layers panel menu, or the layer's context menu).

8 VECTOR DRAWING TECHNIQUES

Lesson overview

In this lesson, you'll learn how to do the following:

- Differentiate between bitmap and vector graphics.
- Draw straight and curved paths using the Pen tool.
- Save paths.
- Draw and edit shape layers.
- Draw custom shapes.
- Use Smart Guides.

This lesson will take about 90 minutes to complete. To get the lesson files used in this chapter, download them from the web page for this book at adobepress.com/PhotoshopCIB2023. For more information, see "Accessing the lesson files and Web Edition" in the Getting Started section at the beginning of this book.

As you work on this lesson, you'll preserve the start files. If you need to restore the start files, download them from your Account page.

PROJECT: PROMOTIONAL POSTCARD

Unlike bitmap images, vector graphics retain their crisp
edges when you enlarge them to any size. You can draw
vector shapes and paths in your Photoshop images and
add vector masks to control what is shown in an image.

About bitmap images and vector graphics

Before working with vector shapes and vector paths, it's important to understand the basic differences between the two main categories of computer graphics: *bitmap images* and *vector graphics*. You can use Photoshop to work with either kind of graphic; in fact, you can combine both bitmap and vector data in an individual Photoshop image file.

Bitmap images, technically called *raster images*, are based on a grid of dots known as *pixels*. Each pixel is assigned a specific location and color value. In working with bitmap images, you edit groups of pixels rather than objects or shapes. Because bitmap graphics can represent subtle gradations of shade and color, they are appropriate for continuous-tone images such as photographs or artwork created in painting programs. A disadvantage of bitmap graphics is that they contain a fixed number of pixels. As a result, they can lose detail and appear jagged when scaled up onscreen or printed at a lower resolution than they were created for.

Vector graphics are made up of lines and curves defined by mathematical objects called *vectors*. These graphics retain their crispness whether they are moved, resized, or have their color changed. Vector graphics are appropriate for illustrations, type, and graphics such as logos that may be scaled to different sizes.

In the lessons so far, you've worked with bitmap images on Photoshop layers. A different type of layer—a shape layer—contains vector graphics in Photoshop.

Logo drawn as vector art.

Logo rasterized as bitmap art.

About paths and the Pen tool

In Photoshop, the outline of a vector shape is called a *path*. A path is a curved or straight line segment you draw using the Pen tool, the Freeform Pen tool, the Curvature Pen tool, or a shape tool. The Pen and Curvature Pen tools draw paths with great precision; shape tools create rectangles, ellipses, and other shape paths; and the Freeform Pen tool draws paths as if you were drawing with a pen on paper.

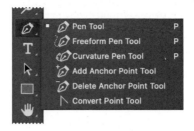

Paths can be open or closed. An open path (such as a wavy line) has two distinct endpoints. A closed path (such as a circle) is continuous. The type of path you draw affects how it can be selected and adjusted.

Unlike the pixels created by the painting tools, a path doesn't make a printable mark on its own. A path is more like a selection marquee in vector form, so you can use a path to mark an area of a layer with pixels using a *fill* (color, pattern, or other content) or a *stroke* (outline). To use a path as a vector object that you can fill, stroke, print, export, and continue to edit as a vector object, create it as a *shape* layer.

Getting started

In this lesson, you'll create a postcard that will help promote a citrus fruit farm. You've been given an image of oranges, but because the farm wants to convey the idea that they grow more than just oranges, it's been decided that one of the oranges will be recolored to look like a lemon. Recoloring one item requires isolating it by creating a mask of its outline, and a quick and precise way to create a clean outline of that item is using the Pen tool to draw a vector path.

Before you begin, view the image you'll be creating.

1 Start Photoshop, and then simultaneously hold down Ctrl+Alt+Shift (Windows) or Command+Option+Shift (macOS) to restore the default preferences. (See "Restoring default preferences" on page 5.)

2 When prompted, click Yes to delete the Adobe Photoshop Settings file.

3 Choose File > Browse In Bridge.

4 In the Favorites panel, click the Lessons folder, and then double-click the Lesson08 folder in the Content panel.

5 Select the 08End.psd file, and press the spacebar to see it in full-screen view.

To create this postcard, you'll trace an image and use that tracing to make a vector mask that lets you change the color of one of the oranges. First, you'll practice making paths and selections using the Pen tool.

6 When you've finished looking at the 08End.psd file, press the spacebar again. Then double-click the 08Practice_Start.psd file to open it in Photoshop.

7 Choose File > Save As, rename the file **08Practice_Working.psd**, and click Save. If the Photoshop Format Options dialog box appears, click OK.

● **Note:** If Bridge isn't installed, the File > Browse In Bridge command in Photoshop will start the Creative Cloud desktop app, which will download and install Bridge. After installation completes, you can start Bridge. For more information, see page 3.

● **Note:** If Photoshop displays a dialog box telling you about the difference between saving to Cloud Documents and On Your Computer, click Save On Your Computer. You can also select Don't Show Again, but that setting will deselect after you reset Photoshop preferences.

Drawing a shape with the Pen tool

The Pen tool is commonly used for creating vector graphics on a computer. You'll find the Pen tool in many applications, including Adobe Illustrator (which first featured the Pen tool in 1987), Adobe Photoshop, and Adobe InDesign. Even video applications such as Adobe Premiere Pro and Adobe After Effects include the Pen tool, because you can use it to draw precise shapes, masks, and paths for motion graphics and visual effects. The Pen tool may not be easy to learn, but trust us: Knowing how to use the Pen tool is worth the effort and investment to learn, because it's a marketable skill across many creative digital disciplines.

▶ **Tip:** The Curvature Pen tool offers a potentially simpler way to draw precise vector paths; consider learning it if you find the Pen tool to be challenging to use. The Pen tool is taught in this lesson because it's a traditional and industry-standard tool for precisely drawing vector graphics.

The Pen tool works a little differently than a brush or pencil tool. We've created a practice file that you'll use to learn how to draw a straight path, a simple curve, and an S-curve with the Pen tool.

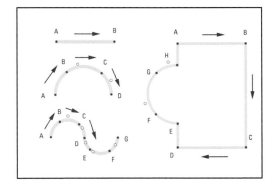

Creating paths with the Pen tool

You can use the Pen tool to create paths that are straight or curved, open or closed. If you're unfamiliar with the Pen tool, it can be confusing to use at first. Understanding the elements of a path and how to create those elements with the Pen tool makes paths much easier to draw.

To create a straight path, click the mouse button. The first time you click, you set the first *anchor point*. Each time that you click thereafter, a straight line is drawn between the previous anchor point and the current one. To draw complex straight-segment paths with the Pen tool, click each time you want to add a new segment.

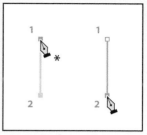

Creating a straight line.

To create a curved path, drag to both place an anchor point and extend a direction line for that point, and then click or drag to place the next anchor point. Each direction line ends in two direction points; the positions of direction lines and points determine the size and shape of the curved segment. Moving the direction lines and points reshapes the curves in a path.

Smooth curves are connected by anchor points called *smooth points*. Sharply curved paths are connected by *corner points*. When you move a direction line on a smooth point, the curved segments on both sides of the point adjust simultaneously, but when you move a direction line on a corner point, only the curve on the same side of the point as the direction line is adjusted.

A. *Curved line segment*
B. *Direction point*
C. *Direction line*
D. *Selected anchor point*
E. *Unselected anchor point*

You can move path segments and anchor points, either individually or as a group. When a path contains multiple segments, you can drag individual anchor points to adjust individual segments of the path, or select all anchor points in a path to edit the entire path. Use the Direct Selection tool (⭢) to select and adjust an anchor point, a path segment, or an entire path.

Creating a closed path differs from creating an open path, in the way that you end it. To end an open path, press Enter or Return. To create a closed path, position the Pen tool pointer over the starting point, and click. Closing a path automatically ends the path. After the path closes, the Pen tool pointer appears with a small *, indicating that your next click will start a new path.

Creating a closed path.

When you first draw a path, it appears in the Paths panel as a Work Path, which is only temporary. Save any work path you want to use again in the future, especially if you want to use multiple paths in the same document. To save a work path, double-click it in the Paths panel, type a name in the Save Path dialog box, and click OK. It's added as a new named path in the Paths panel and remains selected. If you don't save a work path, it's lost as soon as you deselect it and then start drawing again. (Saving the path isn't necessary when you draw a path as a shape, because a shape is created as a named layer.)

First, you'll configure the Pen tool options and the work area.

1 In the Tools panel, select the Pen tool (⟡).

2 In the options bar, select or verify the following settings:

- Choose Shape from the Tool Mode pop-up menu.

- In the Path Options menu, make sure that Rubber Band is not selected.

- Make sure that Auto Add/Delete is selected.

- Choose No Color from the Fill pop-up menu.

- Choose a green color from the Stroke pop-up menu. We used the green swatch in the CMYK presets group.

- Enter **4 pt** for the stroke width.

- In the Stroke Options window, choose Center (the second option) from the Align menu.

▶ **Tip:** The Align stroke option controls whether the stroke width sits entirely to one side of a path or the other or is centered over the path.

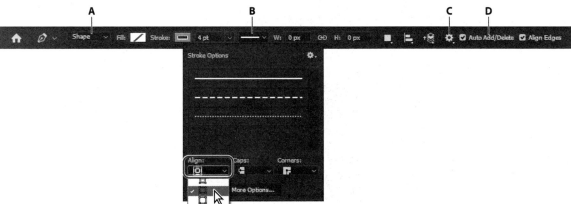

A. Tool Mode menu **B.** Stroke Options menu **C.** Path Options menu **D.** Auto Add/Delete

Drawing a straight line

You'll start by drawing a straight line. Anchor points mark the ends of path segments; the straight line you'll draw is a single path segment with two anchor points.

1 Drag the Paths panel tab out of the Layers panel group so that you can see both it and the Layers panel at the same time. You can dock the Paths panel with another panel group.

The Paths panel displays thumbnail previews of the paths you draw. Currently, the panel is empty, because you haven't started drawing.

2 If necessary, zoom in so that you can easily see the lettered points and red circles on the shape template. Make sure you can see the whole template in the document window, and be sure to reselect the Pen tool after you zoom.

3 On the first shape, click point A, and release the mouse button. You've created an anchor point.

4 Click point B. You've created a straight line with two anchor points.

5 Press Enter or Return to stop drawing.

Create an anchor point.

Click to create a straight line.

Complete the path.

The path you drew appears in the Paths panel and as a new layer in the Layers panel.

● **Note:** If a tutorial pops up for the Curvature Pen tool, you don't need to read it at this time. It will probably close on its own, or you can close it.

● **Note:** The new path appears in both the Paths and Layers panels because the Tool Mode menu in the options bar is set to Shape, so drawing a new path also creates a new shape layer. If the Tool Mode menu was set to Path, the new path would be added to the Paths panel only.

Drawing curves

On curved segments, selecting an anchor point displays one or two direction lines, depending on the shapes of adjacent segments. You adjust the shape of a curved segment by dragging the direction point at the end of a direction line, and the direction line shapes the curve. You'll create curved lines, using smooth points.

1 Click A on the semicircle, and release the mouse to create the first anchor point.

2 Click point B, but don't release the mouse button. Instead, drag to the open red circle to the right of point B to create a curved path segment and a smooth anchor point. Then release the mouse button.

▶ **Tip:** The red circles indicate where you should stop dragging an anchor point's direction point to form the desired shape of the curve. If you drag the direction point to a different location, the curve will have a different shape.

Create an anchor point.

Click and hold. *Drag to curve the path segment.*

Smooth anchor points have two linked direction lines. When you move one, the curved segments on both sides of the path adjust simultaneously.

3 Position the pointer over point C, click and drag down to the open red circle below, and then release the mouse button. You've created a second curved path segment and another smooth point.

4 Click point D, and release the mouse to create the final anchor point. Press Enter or Return to complete the path.

Click C to create a point.

Drag to curve the segment.

Click D to finish the semicircle.

▶ **Tip:** What's the advantage of drawing paths using points and handles, instead of drawing directly as with a real pen or pencil? For most people, it's difficult to draw curves and straight lines without bumps or other errors. Points and handles let you draw perfect curves and straight lines. If you prefer to draw normally, you can use the Freeform Pen tool.

When you draw your own paths using the Pen tool, use as few points as possible to create the shape you want. The fewer points you use, the smoother the curves are, and the easier it is to edit the shape later.

Using the same techniques, you'll draw an S-shaped curve.

5 Click point A, and then click and drag from point B to its open red circle.

6 Continue with points C, D, E, and F, in each case clicking the point and then dragging to the corresponding open red circle.

7 Click point G to create the final anchor point, and then press Enter or Return to complete the path.

Each of the three shapes is on its own layer in the Layers panel. Only one path is in the Paths panel, because the Paths panel shows only the Shape Path for the layer that's currently selected in the Layers panel.

Notice that the curves you drew with the Pen tool are much smoother and easier to precisely control than if you had drawn them freehand.

Drawing a more complex shape

Now that you've got the idea, you'll have a chance to draw a more complex object.

1 Click point A on the shape on the right side to set the first anchor point.

2 Press the Shift key as you click point B. Pressing the Shift key constrains the line to 45-degree angles, which in this case ensures you'll get a horizontal line.

3 Press the Shift key as you click points C, D, and E to create straight path segments.

4 Click point F, and drag to the open red circle to create a curve. Then release the mouse button.

5 Click point G, and drag to the open red circle to create another curve. Then release the mouse button.

6 Click point H to create a corner point.

When you move a direction line on a corner point, only the curve on the same side of the point as the direction line is adjusted, so you can create a sharp transition between two segments.

7 Click point A to draw the final path segment and close the path. Closing a path automatically ends the drawing; if you click or drag the Pen tool, it will create a new path. After you close a path, you don't need to press Enter or Return unless you also want to deselect the path.

▶ **Tip:** If you notice that you slightly missed the red dot on the template while dragging a curve point, you can reposition the point without starting over. Keeping the mouse button down, hold down the spacebar and drag until the point is in the right place. Then release the spacebar to continue dragging the direction lines of that anchor point.

Start with straight segments. Drag to create a curve. Close the path.

8 Close the file without saving changes. You have successfully used the Pen tool to draw both curves and straight lines.

Drawing a path traced from a photo

Now you're ready to draw a path around a real object. You'll use the techniques you've practiced to draw a path around the edge of one orange out of several. The path you draw will later be converted into a layer mask so that you can change the color of that orange. The orange is partially covered by surrounding oranges, so the path you draw will be a combination of curved and straight segments, like the shapes you've practiced on. Later, you'll combine the altered image with text and a shape layer to create a promotional postcard for a citrus farm.

1 From Photoshop or Bridge, open the 08Start.psd file.

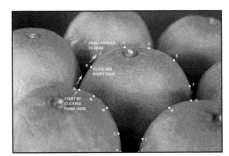

The image includes two layers: the background layer and a template layer named Path Guide that you will trace to draw the path.

2 Choose File > Save As, rename the file **08Working.psd**, and click Save. If the Photoshop Format Options dialog box appears, click OK.

3 Select the Pen tool, and then, in the options bar, choose Path from the Tool Mode pop-up menu.

Because Path is now selected in the options bar instead of Shape, what you see when you draw will be different than in the practice exercise. You'll be drawing a path, not a shape. The path you draw will appear as a temporary work path in the Paths panel, and a shape layer won't be created.

The reason you're switching to a path is because you won't need to print or export the path you're about to draw. You'll use the path as a starting point for creating a mask, so the path itself doesn't need to be a visible part of the final document. For more information about shapes and paths, see the sidebar "Comparing shapes, paths, and pixels."

Comparing shapes, paths, and pixels

When you use the Pen tool or the tools grouped with it, or the Rectangle tool or any of the tools grouped with it, a menu in the options bar lets you choose whether you want the tool to draw a shape, a path, or, in some cases, pixels.

This is an important decision, because each option has different advantages:

Shape. A shape is a vector object created on its own layer in the Layers panel. You can apply the same layer effects, masks, and other properties that you would to a pixel layer. The difference is that you can continue to edit the shape as a vector path, using path editing tools such as the Pen tool and the Direct Selection tool. You can't edit a shape layer using pixel-based tools such as brushes. You can change a shape layer's fill and stroke. Because a shape is a layer, when its layer visibility is enabled, it's visible and will print and export.

A selected shape layer also displays its path in the Paths panel.

Path. A path is a vector object that doesn't display, print, or export, so it doesn't appear in the Layers panel; you'll find it in the Paths panel. A path is useful for creating type along a path, clipping paths, and in other "backstage" roles where editing a vector path saves time. For example, sometimes it's faster to create a selection by first drawing and editing a path and then converting that to a selection.

Because a path is not a layer, it's visible in the document window only when it's selected in the Paths panel, and it can't have a stroke and fill. If it's hard to see, you can improve its visibility by clicking the Path Options menu (the gear) in the options bar and adjusting the path's Thickness and Color. Because a path isn't visible in a printed or exported image, those options affect only the visibility of the path while drawing in Photoshop.

Pixels. Some tools, such as the Rectangle tool and the tools grouped with it, also offer a Pixels option. Drawing with the Pixels option creates pixels on the currently selected layer, without creating a vector path or shape layer.

The Pixels option creates a pixel layer, so you won't be able to edit the resulting layer using path editing tools. Instead, use pixel-based tools such as the brushes, eraser, and selection tools.

4 With the Pen tool selected, click point A. A new temporary Work Path appears in the Paths panel.

5 Click point B, and drag to the open circle on the right to create the initial curve.

6 Click point C, and drag to the open circle to its right.

7 Continue tracing the orange, clicking and dragging curve segments for points D through F.

8 Click point G (do not drag). This creates the corner at point G.

> **Tip:** When tracing along a well-defined edge, the Pen tool is not the only useful tool. For some shapes and edges, you might find it easier to use the Magic Lasso tool, the Object Selection tool, or the Quick Selection tool.

9 At points H and I, click and drag to their corresponding open circles to create their curved segments.

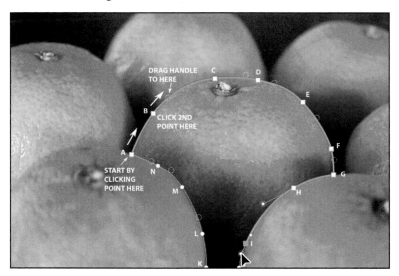

10 Click point J to create a corner.

11 Hold down Shift to create a perfectly level segment as you click point K.

12 At points L, M, and N, click and drag to their corresponding open circles to create their curved segments.

13 Position the pointer over point A, and when you see a small circle by the Pen tool pointer, click to close the path. The circle indicates that the pointer is close enough to close the path.

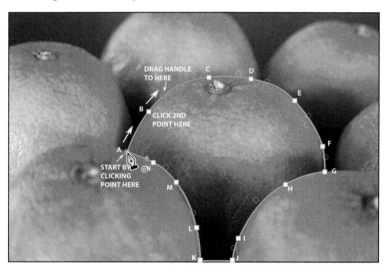

14 Evaluate your path. If you want to adjust any segments, do step 15; otherwise skip to step 16.

15 Select the Direct Selection tool (⟩) (grouped with the Path Selection tool (▶)), and then press the Esc key (or click in the document window away from the path) so that no points are selected but you can still see the path. Then do any of the following with the Direct Selection tool as needed:

- To reposition a point or a straight segment, drag it.

- To change the shape of a curved segment between two points, drag the segment (not points).

- To change the shape of a curved segment extending from a point, drag its direction point to adjust the angle of that direction line.

16 When you're done, leave the path selected, and save your work so far.

▶ **Tip:** To move the entire path, drag it with the Path Selection tool, grouped with the Direct Selection tool.

Converting a path to a selection and a layer mask

▶ **Tip:** If you'd prefer to create a mask that you can always edit as a path, create a vector mask for the layer instead. Skip step 2, and then, in step 4, make sure the Lemon path is selected in the Paths panel when you add the new Hue/Saturation adjustment layer.

Using the Pen tool made it easy to create a precise outline of the orange in the center of the image. But the goal is to change the color of that orange without changing the others, through a layer mask. Creating the layer mask requires making a selection. Fortunately, it's easy to convert a path to a selection.

The path is a work path, which is temporary; it will be replaced if you draw another path. You can still create a selection from a work path, but first, it's a good practice to save any path you might want to use again in the future.

1 In the Paths panel, double-click Work Path. In the Save Path dialog box, type **Lemon** for the name, and click OK.

2 Make sure the Lemon path is selected in the Paths panel, and then click the Load Path as a Selection button (⸬) at the bottom of the Paths panel.

You're going to change the color of the selected orange to lemon yellow, using a Hue/Saturation adjustment layer through a layer mask of the orange. You currently have an active selection for this orange. That will make it quick and easy to create the layer mask, because an active selection is automatically converted to a layer mask when you add an adjustment layer.

▶ **Tip:** It's just as easy to convert a selection into a path. When a selection is active, click the Make Work Path from Selection button in the Paths panel; it's the button to the right of the one you clicked in step 2.

3 In the Layers panel, hide the Path Guide layer, because you no longer need it, and select the Background layer.

4 In the Adjustments panel, click the Hue/Saturation button (▦) to add a new Hue/Saturation adjustment layer in the Layers panel. It automatically includes a layer mask, created from your selection.

5 In the Properties panel, change the Hue setting so that the orange in the center changes to a lemon yellow color. We entered a Hue value of **+17**.

6 Save the document.

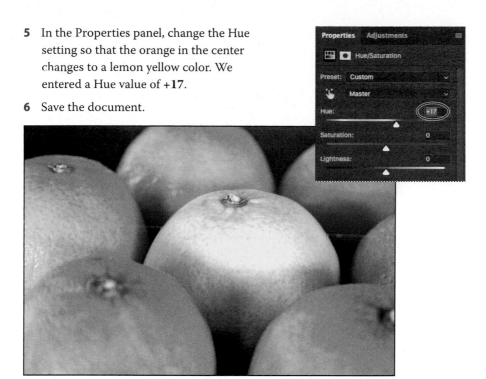

▶ **Tip:** After you change the color of the center orange, you may notice minor errors along the edges of the layer mask. Remember that you can edit a layer mask: Click the layer mask thumbnail in the Layers panel to select it, and then use the Brush tool to paint white where you want the color applied by the adjustment layer to be visible, or paint black where you want the color of the Background layer to be visible. (If it was a vector mask, you would edit it using the Direct Selection tool and Pen tool.)

You used the Pen tool to quickly and precisely draw a path that traces the outline of an object in an image (the orange that now looks like a lemon), and you converted the path into a selection and used that selection to create a layer mask that isolates the subject when applying an adjustment layer.

Creating a logo with text and a custom shape

Now you'll create a logo that will overlay the image, using text and a shape layer.

1 If the rulers aren't visible, choose View > Rulers to display them.

2 Right-click (Windows) or Control-click (macOS) the rulers, and if they are currently displaying in pixels, choose Inches. This document will become a printed postcard, and Inches is an appropriate unit of measure for print.

3 In the Layers panel, make sure the Hue/Saturation adjustment layer is selected so that the layer you're about to create will be added above it.

4 Select the Horizontal Type tool (**T**), and, in the options bar, do the following:

- Choose a bold or heavy typeface from the Font Family pop-up menu. We used Arial Bold; you can choose another font that looks good as a logo.

- Type **55 pt** for the Size, and press Enter or Return.

- Click the Right Align Text button, because you'll soon add a graphic element to the left of the text.

- Click the color swatch and set the text color to white.

5 Drag the Horizontal Type tool to create a text layer across the bottom of the canvas, inset about half an inch away from the sides and bottom. Ours is about 9 inches wide by 1 inch tall.

6 Type **Citrus Lane Farms** to replace the placeholder text, click the Commit button (✓) in the options bar, and leave the text layer selected in the Layers panel.

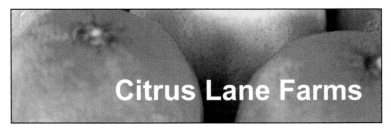

7 This font looks better with tighter letter spacing. With the text selected, in the Character or Properties panel, apply a negative Tracking value; for our font we used **–25**.

8 In the Properties panel, select the All Caps button (**TT**) in the Type Options group. If you don't see this option, scroll down in the Properties panel.

9 If needed, use the Move tool to reposition the text layer so that it looks better relative to the bottom and right sides. Leave space to the left of the text for a graphic you're about to add.

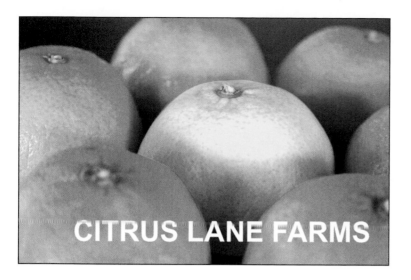

Adding a preset shape

When you need a shape such as a symbol or object, one place you can turn to is the Shapes panel, which contains a wide selection of premade graphics. When you add a shape to a document, it becomes a shape layer.

A shape is a vector object drawn using paths, which has two advantages. You can edit it using the same techniques you used to edit the paths you drew earlier in this lesson. Also, like a text layer, a path is resolution-independent, so it will always be as smooth and detailed as the document resolution allows.

You find shapes in the Shapes panel. It's easy to use, because it works like the other Photoshop panels that contain preset effects, such as the Swatches, Gradients, and Brushes panels: You see small visual previews of each preset, you can organize them in groups (folders), and you can create your own.

1 Choose Window > Shapes to open the Shapes panel. The Shapes panel includes groups of shape presets.

2 Expand the Flowers presets group.

▶ **Tip:** Photoshop includes more preset groups than you see by default in a presets panel list. In the panel menu, choose Legacy Shapes and More to load additional preset groups, including presets that were available in previous versions of Photoshop.

Extra credit

Using Creative Cloud Libraries with linked Smart Objects

When you organize and share your design assets using Creative Cloud Libraries, you and your team can use those library items in many Creative Cloud desktop and mobile apps. Let's take a look:

1 Open 08End.psd. If the Libraries panel isn't open, choose Window > Libraries.

2 In the Libraries panel menu, click Create New Library, name it **Citrus Lane Farms**, and click Create.

3 In the Layers panel, select the Flower layer, and then hold down Shift as you click the Citrus Lane Farms text layer so that the two layers are selected.

4 Click the Add Elements button (+), and choose Graphic to add both layers as a single library item.

After the Libraries panel finishes syncing the logo to Creative Cloud, it will be available in Creative Cloud applications and mobile apps that use Creative Cloud Libraries.

The appearance of the Citrus Lane Farms text layer was adjusted to look good over the image of the oranges; it should be tested over a wide range of backgrounds and edited as needed for readability. A library item is a Smart Object linked to Creative Cloud, so you can edit it in Photoshop by double-clicking it in the Libraries panel. When you save changes, it updates in all documents that use it.

Adding a color

A library can store colors for use across Adobe applications.

1 With the Eyedropper tool, click the flower in the document window so that its color becomes the foreground swatch in the Tools panel.

2 At the bottom of the Libraries panel, click the Add Elements button (+), and click the Foreground Color swatch, adding it to the current library.

Collaborating

When you share a Creative Cloud Library, your team always has the current version of those assets. In the Libraries panel menu, choose Invite People. The Creative Cloud desktop app opens; fill in the Invite screen that appears. When the people you invited are signed into their Creative Cloud accounts, they will see your shared library in their Creative Cloud applications.

Adding assets to libraries using Adobe mobile apps

Use Adobe mobile apps—such as Adobe Capture—to record color themes, shapes, and brushes from real life and add them to your Creative Cloud libraries. Library assets you add with mobile apps automatically sync to your Creative Cloud account, so you'll see the new assets in your Libraries panel when you return to your computer.

3 Drag the last shape preset, and drop it to the left of the Citrus Lane Farms logo.

The flower shape now appears in the Layers panel. The shape currently has a transform bounding box around it so that you can make adjustments before committing it to the document. And yes, there are some adjustments to be made.

Tip: Want to save your own shape preset? Draw a path or shape, select it with the Path Selection tool, choose Edit > Define Custom Shape, name it, and click OK. It's added to the Shapes panel; if a shape group is active, it's added to that group.

4 Drag any handle on the shape to resize it to be about 1.5 inches tall.

5 Drag the flower to position it between the left edge of the document and the Citrus Lane Farms text.

6 Click the Commit Transform button (✓) in the options bar, or press Enter or Return. The transformation bounding box disappears.

A shape is added using the current fill and stroke settings for shapes, which were the ones set for the practice shape earlier. The flower shape is intended to have a solid yellow fill. That change could not be done while the bounding box was active, but now that it's been committed to the document, the colors can be changed.

7 Make sure the flower shape is still selected in the Layers panel.

8 In the Layers panel, double-click the name of the shape layer, type **Flower**, and press Return or Enter to rename the layer.

9 Select any shape tool, such as the Rectangle tool or any tool grouped with it. The options bar now displays settings for shapes.

Tip: If the magenta Smart Guides prevent you from making precise adjustments, hold down the Control key as you drag.

Tip: Do you wish one of the preset shapes was slightly different? All shapes are paths, so after you add a shape to the document, you can edit it by using the Pen tool or any of the tools grouped with it, or the Direct Selection tool.

10 In the options bar, click the Fill swatch, expand the RGB swatch presets group that appears in the drop-down menu, and click the yellow swatch.

11 In the options bar, click the Stroke swatch, and set it to No Color. Close the pop-up menu by pressing Enter or Return.

12 Choose Select > Deselect Layers. Now you can see the flower shape without its path being highlighted.

13 If needed, use the Move tool to reposition the flower and text, composing them relative to each other as a logo and relative to the edges of the document.

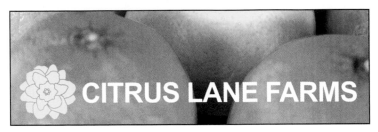

14 Save your file.

You've combined an image, a color adjustment layer masked with the help of a path you drew by hand, a pre-made shape, and a text layer. The postcard is ready to go!

Extra credit

Quickly adding color and effects using presets

You can use presets to quickly enhance the look of both the text and the flower in the logo. The way that you do this is similar to how you added the flower shape with the Shapes panel and changed its color using the Swatches panel.

1 Open 08Working.psd (if it isn't already open), and save it as **08StylePresets.psd**.

2 Start by applying a preset to the flower. In the Styles panel (Window > Styles), expand the Basics preset group.

3 Drag the second preset from the Basics group, and drop it on the flower in the document window. The style is applied to the flower shape layer. Then drag the same style and drop it on the text.

You can apply a preset by dragging and dropping it on a layer or by clicking a preset when the layer is selected. Either way is fine.

In this example, the Basic style applies a simple stroke and drop shadow. But the possibilities are much wider. Explore your design options by freely editing the presets in the Styles, Gradients, Patterns, and Swatches panels and applying them to layers until you get the look you want. And you can add your own presets to those panels.

You can see that the effects have been applied in the Layers panel, and you can fine-tune those effects in different ways:

- Click the eye icon for different layer effects to disable or enable them.

- Double-click an effect name to open the Layer Style dialog box, where you can edit effects.

- If you try to apply a style and it doesn't seem to change the layer, you may first need to delete effects already applied to the layer: In the Layers panel, drag that layer's Effects heading to the Delete (trash can) icon at the bottom of the Layers panel. Note that a preset may also alter a layer's Opacity and Fill Opacity, so you may have to set those back to the default of 100%.

- If you don't see any effects listed after a layer after applying a style, the preset may have been applied as a fill or stroke instead of a layer style. To edit it, double-click the shape layer thumbnail (not the name).

- If you applied a preset to a shape, select any shape tool, such as the Rectangle tool, to display shape options in the options bar. Click the Fill or Stroke swatch to edit the preset.

Extra credit

Using Smart Guides to maintain alignment and equal spacing

Let's take this design to the next level. You can use the Citrus Lane Farms logo to make a repeated motif for packaging or other signage. Smart Guides can help you position the images evenly.

1 Open 08End.psd, and save it as **08SmartGuides.psd**. Choose View > Show, and make sure there is a check mark next to the Smart Guides command, indicating that it's enabled. If not, select the Smart Guides command to enable it.

2 Select the Flower layer. Then select the Move tool, hold down the Alt (Windows) or Option (macOS) key as you drag a copy of the Flower layer up until the value in the magenta box indicates that it's about 3 inches away from the original, and then release the mouse button. Notice that the magenta Smart Guides help keep the Flower copy perfectly aligned with the original. Without Smart Guides, you'd have to also press Shift to keep the copy aligned. The Alt or Option key copies the selected layer.

3 In the Layers panel, change the Opacity of the Flower copy layer to 50%.

4 Make sure the Move tool and Flower copy layer are still selected. Hold down the Alt (Windows) or Option (macOS) key as you use the Move tool to drag a copy of the Flower copy layer to the right, until the magenta values indicate that the layer and its copy are about 1 inch apart and still aligned. Then release the mouse button.

5 This time, with the Flower copy 2 layer still selected, hold down Alt or Option as you drag the Flower copy 2 layer to the right; release the mouse when two transformation values boxes appear between the three flower layers across the top. The boxes let you know that the distance between the three flower layers is now equal. Using Smart Guides is a fast and easy way to make sure layers you drag are evenly spaced, without having to do math or use a distribution command.

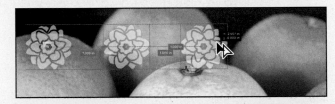

6 Repeat step 4 so that you have four equally spaced flowers.

Review questions

1 What is the difference between a bitmap image and a vector graphic?

2 After using the Pen tool to add an anchor point to a path, how do you make sure the next path segment is a curve?

3 How can you add a preset shape to the document?

4 For paths and shapes, why would you use the Direct Selection tool instead of the Selection tool?

5 What are some ways to change the shape of a curved path segment?

Review answers

1 Bitmap, or raster, images are based on a grid of pixels and are appropriate for continuous-tone images such as photographs or artwork created in painting programs. Vector graphics are made up of shapes based on mathematical expressions and are appropriate for illustrations, type, and drawings that require clear, smooth lines.

2 Drag (instead of clicking) to create the next point with the Pen tool.

3 To add a preset shape, open the Shapes panel, find the shape, and drag it into the document window.

4 The Direct Selection tool lets you edit the points, segments, and direction lines of a path or shape. The Selection tool lets you move and resize an entire path or shape.

5 You can change the shape of a curved path segment by using the Direct Selection tool to drag either of a curved segment's two anchor points, the direction points for either anchor point, or the curved segment itself.

9

ADVANCED COMPOSITING

Lesson overview

In this lesson, you'll learn how to do the following:

- Apply and edit Smart Filters.

- Use the Liquify filter to distort an image.

- Apply color effects to selected areas of an image.

- Apply filters to create various effects.

- Use the History panel to return to a previous state.

- Upscale a low-resolution image for high-resolution printing.

This lesson will take about an hour to complete. To get the lesson files used in this chapter, download them from the web page for this book at adobepress.com/PhotoshopCIB2023. For more information, see "Accessing the lesson files and Web Edition" in the Getting Started section at the beginning of this book.

As you work on this lesson, you'll preserve the start files. If you need to restore the start files, download them from your Account page.

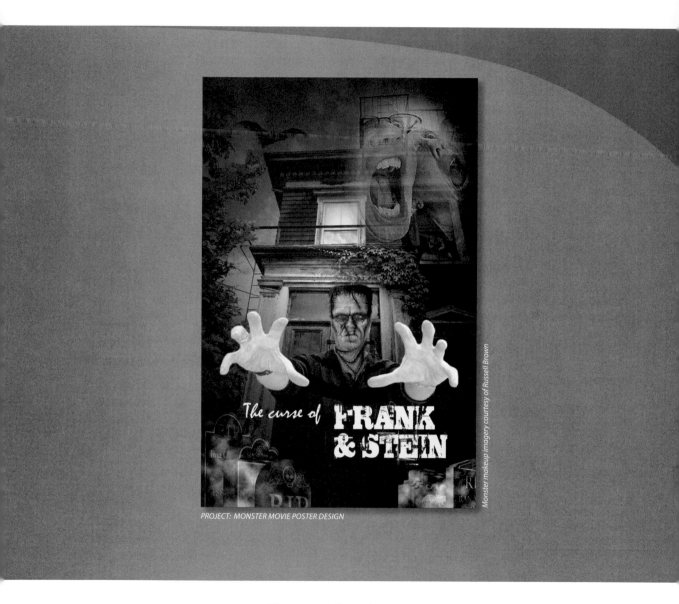

PROJECT: MONSTER MOVIE POSTER DESIGN

Monster makeup imagery courtesy of Russell Brown

Filters can transform ordinary images into extraordinary digital artwork. Smart Filters let you edit those transformations at any time. The wide variety of features in Photoshop lets you be as creative as you want to be.

Getting started

In this lesson, you'll assemble a montage of images for a movie poster as you explore filters in Photoshop. First, look at the final project to see what you'll be creating.

1 Start Photoshop, and then simultaneously hold down Ctrl+Alt+Shift (Windows) or Command+Option+Shift (macOS) to restore the default preferences. (See "Restoring default preferences" on page 5.)

2 When prompted, click Yes to delete the Adobe Photoshop Settings file.

3 Choose File > Browse In Bridge.

4 In Bridge, choose Favorites from the menu on the left, and then click the Lessons folder. Double-click the Lesson09 folder.

5 View the 09_End.psd thumbnail. Move the slider at the bottom of the Bridge window if you need to zoom in to see the thumbnail more clearly.

● **Note:** If Bridge isn't installed, the File > Browse In Bridge command in Photoshop will start the Creative Cloud desktop app, which will download and install Bridge. After installation completes, you can start Bridge.

This file is a movie poster that comprises a background, a monster image, and several smaller images. Each image has had one or more filters or effects applied to it.

The monster is composed of an image of a perfectly normal (though slightly threatening) guy with several ghoulish images applied. These monstrous additions are courtesy of Russell Brown, with illustration by John Connell.

6 In Bridge, navigate to the Lesson09/Monster_Makeup folder, and open it.

7 Shift-click the first and last items to select all the files in the Monster_Makeup folder, and then choose Tools > Photoshop > Load Files Into Photoshop Layers.

Photoshop imports all the selected files as individual layers in a new Photoshop file. The designer used a red layer color to indicate components of the monster's look.

8 In Photoshop, choose File > Save As. Choose Photoshop for the Format, and name the new file **09Working.psd**. Save it in the Lesson09 folder. Click OK in the Photoshop Format Options dialog box.

● **Note:** If Photoshop displays a dialog box telling you about the difference between saving to Cloud Documents and On Your Computer, click Save On Your Computer. You can also select Don't Show Again, but that setting will deselect after you reset Photoshop preferences.

Arranging layers

Your image file contains eight layers, imported in alphabetical order. In their current positions, they don't make a very convincing monster. You'll rearrange the layer order and resize their contents as you start to build your monster.

1 Zoom out or scroll so that you can see the entire document canvas. Also, if you can't see all of the layers in the Layers panel at once, drag the top edge of the Layers panel to make it taller.

2 In the Layers panel, drag the Monster_Hair layer to the top of the layer stack, if it isn't already on top.

3 Drag the Franken layer to the bottom of the layer stack.

● **Note:** If the wrong layer becomes selected when you try to drag the Franken layer to the bottom of the image, deselect Auto-Select in the options bar.

4 Select the Move tool (⊕), and then in the document window, drag the Franken layer (the image of the person) to the bottom of the canvas.

▶ **Tip:** The keyboard shortcut for Free Transform is Ctrl+T (Windows) or Command+T (macOS). This is a good all-in-one shortcut to learn because you can use it to move, scale, or rotate selected layers.

5 In the Layers panel, Shift-select every layer except the Franken layer, and choose Edit > Free Transform.

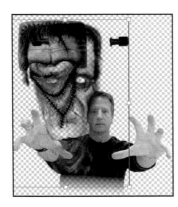

6 Drag down from a corner of the selection to resize all the selected layers to about 50% of their original size. (Watch the width and height percentages in the options bar.)

7 With the Free Transform bounding box still active, position the layers over the head of the Franken layer. Then press Enter or Return to commit the transformation.

8 Zoom in to see the head area clearly.

9 Hide all layers except the Green_Skin_Texture and Franken layers.

10 Select only the Green_Skin_Texture layer, and use the Move tool to center it over the face.

► **Tip:** If magenta Smart Guides appear, making it difficult to position the Green_Skin_Texture layer, hold down the Control key to temporarily disable snapping to Smart Guides as you drag. Or permanently disable them by deselecting the View > Show > Smart Guides command.

Tip: For more detailed control over how the texture fits the face, choose Edit > Transform > Warp, drag the transform grid or handles, and then press Return or Enter to commit the changes.

11 Choose Edit > Free Transform again to adjust the fit of the texture to the face. Using the eyes and mouth as a guide, press arrow keys to nudge the entire layer into position. Drag handles on the bounding box to adjust the width and height. (To adjust without preserving proportions, Shift-drag a handle.) When you've positioned the skin texture, press Enter or Return to commit the transformation.

 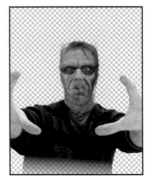

12 Save your file.

Using Smart Filters

Unlike regular filters, which permanently change an image, Smart Filters are nondestructive: They can be adjusted, turned off and on, and deleted. However, you can apply Smart Filters only to a Smart Object.

Applying the Liquify filter

You'll use the Liquify filter to tighten the eye openings and change the shape of the monster's face. Because you want to be able to adjust the filter settings later, you'll use the Liquify filter as a Smart Filter. So you'll first need to convert the Green_Skin_Texture layer to a Smart Object.

Tip: In the Layers panel, the thumbnail icon for the Green_Skin_Texture layer now displays a small badge in the bottom-right corner to indicate that it is a Smart Object.

1 Make sure the Green_Skin_Texture layer is selected in the Layers panel, and then choose Filter > Convert for Smart Filters. This creates a Smart Object. Click OK if you're asked to confirm the conversion to a Smart Object.

2 Choose Filter > Liquify.

Photoshop displays the layer in the Liquify dialog box.

3 In the Liquify dialog box, if the Face-Aware Liquify group of options is expanded, click the disclosure triangle next to it to collapse the group.

You already explored Face-Aware Liquify in Lesson 5. While Face-Aware Liquify is a quick and powerful way to modify facial features, the amount of face editing you can do with those options is limited. In this lesson, you'll try some manual Liquify techniques, which you may prefer when you want to create a more expressive face. Hiding the Face-Aware Liquify options makes it easier to concentrate on the other options in the Liquify dialog box.

● **Note:** Step 4 doesn't change the document; it just changes how much you see of other layers while you work on the layer that was selected when you entered the Liquify dialog box.

4 Select Show Backdrop, and then choose Behind from the Mode menu. Set the Opacity to **75**.

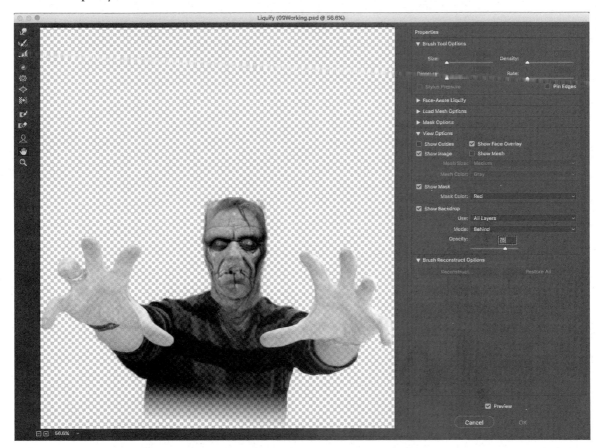

5 Select the Zoom tool (🔍) from the Tools panel on the left side of the dialog box, and zoom in to the eye area.

6 Select the Forward Warp tool (〰) (the first tool).

The Forward Warp tool pushes pixels forward as you drag.

7 In the Brush Tool Options area, set Size to **150** and Pressure to **75**.

8 With the Forward Warp tool, pull the monster makeup's right eyebrow down to close the eye opening. Then pull up from under the eye.

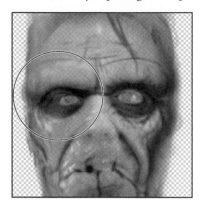

9 Repeat step 8 on the left eyebrow and under-eye area. You might prefer to use the Forward Warp tool differently for each eye, to create an even scarier face.

10 When you've closed the gap around the eyes, click OK.

Because you've applied the Liquify filter as a Smart Filter, you can freely remove or change your Liquify edits later without losing image quality, by double-clicking the Smart Object in the Layers panel.

Positioning other layers

Now that you've got the skin texture in place, you'll move the other layers into position, working up from the lowest layers in the Layers panel.

1 Make the Green_Nose_Stitches layer visible, and select it in the Layers panel.

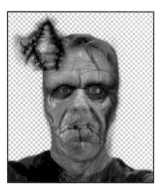

2 Choose Edit > Free Transform, and then position the layer over the nose, resizing it as necessary. Press Enter or Return to commit the transformation.

▶ **Tip:** To resize from the center of a selection, hold down Alt (Windows) or Option (macOS) as you drag a bounding box handle.

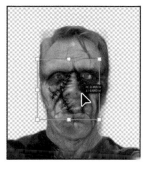

You'll repeat the process to position the rest of the layers.

3 Make the Green_Neck_Stitches layer visible, and select it. Then move it over the neck. If you need to adjust it, choose Edit > Free Transform, resize it, and press Enter or Return.

▶ **Tip:** If you only need to move a layer, you can simply drag it with the Move tool. In these steps, choosing Edit > Free Transform lets you both move and resize a layer.

4 Make the Green_Ear_Staples layer visible, and select it. Move the staples over his right ear. Choose Edit > Free Transform, resize and reposition the staples, and then press Enter or Return.

5 Make the Enhanced_Green_Forehead layer visible, and select it. Move it over the forehead; it's probably a bit large. Choose Edit > Free Transform, resize the forehead to fit his head, and press Enter or Return.

6 Make the Bolts layer visible, and select it. Drag the bolts so they're positioned on both sides of the neck. Choose Edit > Free Transform, and resize them so that they fit snugly against the neck. When you have them in position, press Enter or Return to commit the transformation.

7 Finally, make the Monster_Hair layer visible, and select it. Move it over the forehead. Choose Edit > Free Transform, and then resize the hair so it fits properly against the forehead. Press Enter or Return to commit the change.

8 Save your work so far.

Editing a Smart Filter

With all the layers in position, you can further refine the eye openings and experiment with the bulges in the eyebrows. You'll return to the Liquify filter to make those adjustments.

1 In the Layers panel, double-click Liquify, listed under Smart Filters in the Green_Skin_Texture layer.

Photoshop opens the Liquify dialog box again. This time, all the layers are visible in Photoshop, so when Show Backdrop is selected, you see them all. Sometimes it's easier to make changes without a backdrop to distract you. Other times, it's useful to see your edits in context.

2 Zoom in to see the eyes more closely.

3 Select the Pucker tool (🔲) in the Tools panel, and click on the outer corner of each eye.

The Pucker tool moves pixels toward the center of the brush as you click or hold the mouse button, or drag.

4 Select the Bloat tool (◈), and click the outer edge of an eyebrow to expand it; do the same for the other eyebrow.

The Bloat tool moves pixels away from the center of the brush as you click or drag.

5 Experiment with the Pucker, Bloat, and other tools in the Liquify filter to customize the monster's face.

Remember that you can change the brush size and other settings. You can undo individual steps using the Undo keyboard shortcut (Ctrl+Z on Windows and Command+Z on Mac) if the Edit menu isn't available. If you want to discard all current changes and start over, it's easiest to click Cancel and then return to the Liquify dialog box.

6 When you're happy with the monster's face, click OK, and save your work.

▶ **Tip:** The Pucker, Bloat, and other tools on the left side of the Liquify panel provide more control over Liquify distortions than the Face-Aware Liquify options, and they work on any part of an image. But Face-Aware Liquify is easier for quick and subtle adjustments to facial features.

Painting a layer

There are many ways to paint objects and layers in Photoshop. One of the simplest is to use the Color blending mode and the Brush tool. You'll use this method to paint the exposed skin green on your monster.

1 Select the Franken layer in the Layers panel.

2 Click the Create A New Layer button (⊞) at the bottom of the Layers panel.

Photoshop creates a new layer, named Layer 1.

▶ **Tip:** Be sure to distinguish the blending mode of a layer (shown in the Layers panel) from the blending mode of a tool (shown in the options bar). To learn more about blending modes, including a description of each one, see "Blending modes" in Photoshop Help.

3 With Layer 1 selected, choose Color from the Blending Mode menu at the top of the Layers panel.

The Color blending mode combines the luminance of the base color (the color already on the layer) with the hue and saturation of the color you're applying. It's a good blending mode to use when you're coloring monochrome images or tinting color images.

4 In the Tools panel, select the Brush tool (✏). In the options bar, select a **60**-pixel brush with a Hardness of **0**.

5 Hold down Alt or Option (to temporarily switch to the Eyedropper tool) as you click the forehead to sample a green color there. Then release the Alt or Option key to return to the Brush tool.

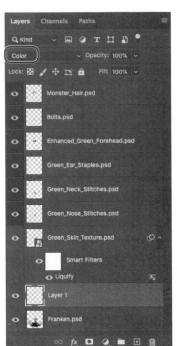

The sampled color becomes the new Foreground color, loaded into the Brush tool.

6 Ctrl-click (Windows) or Command-click (macOS) the thumbnail in the Franken layer to select its contents. Notice that a selection marquee appears on the layer.

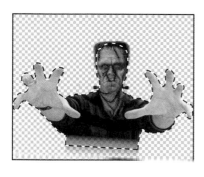

Usually, you select an entire layer in the Layers panel. When you do that, the layer is active, but there isn't actually an active selection. When you Ctrl-click (Windows) or Command-click (macOS) the thumbnail of the layer, Photoshop selects the contents of the layer, so you have an active selection. It's a quick way to select all of the contents of a layer—but without the transparent areas.

7 Make sure Layer 1 is still selected in the Layers panel, and then use the Brush tool to paint over the hands and arms. You can paint quickly where the hands are against transparent areas, because painting outside the selection has no effect. However, remember that the shirt is part of the selection, so as you paint the skin close to the shirt color, take care to paint only the skin and not the shirt.

► **Tip:** To change the brush size as you paint, press the bracket keys on your keyboard. The Left Bracket key ([) decreases the brush size; the Right Bracket (]) increases it.

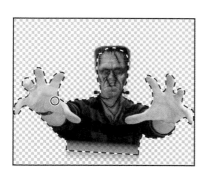 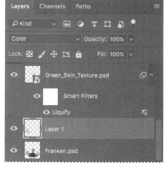

8 Paint any areas of the face or neck where the original flesh color shows through the Green_Skin_Texture layer.

9 When you're happy with the green skin, choose Select > Deselect. Save your work.

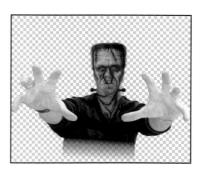

► **Tip:** Step 6 selects nontransparent areas of a layer. The goal here to is to recolor the skin, so another approach is to choose Select > Color Range and choose Skin Tones from the Select menu. That would specifically select the skin and not the shirt.

Adding a background

You've got a good-looking monster. Now it's time to put him in his spooky environment. To easily move the monster onto a background, you'll first merge the layers.

▶ **Tip:** Merging or flattening layers permanently combines them into a single layer. That also reduces the file size of the Photoshop document. If you want to preserve the ability to edit selected layers separately, select layers and choose New Group from Layers instead of Merge Visible in step 1. Then, in step 6, drag that layer group from the Layers panel to the other document.

1 Make sure all the layers are visible. Then choose Merge Visible from the Layers panel menu.

Photoshop merges all the visible layers into one. It's named Layer 1 because that was the selected layer at the time of the merge.

2 Rename Layer 1 **Monster**.

3 Choose File > Open. Navigate to and open the Backdrop.psd file in the Lesson09 folder.

4 Choose Window > Arrange > 2-Up Vertical to display both the monster and backdrop files.

5 Click the 09Working.psd file to make it active.

6 Select the Move tool (✛), drag the Monster layer, and then drop it onto the Backdrop.psd file. Position the monster so his hands are just above the movie title.

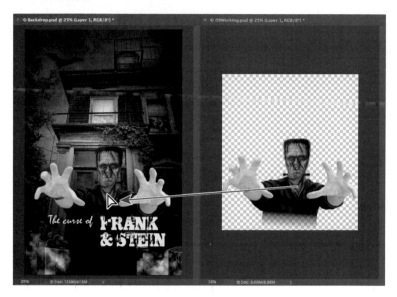

7 Close the 09Working.psd file, saving changes when prompted.

From now on, you'll work on the movie poster file itself.

8 Choose File > Save As, and save the file with the name **Movie-Poster.psd**. Click Save, and then click OK in the Photoshop Format Options dialog box.

Using the History panel to undo edits

You've used the Edit > Undo command to back out of the last change you applied. You can also choose Edit > Redo to reapply a change you just undid. Repeatedly choosing either command steps you back or forward through multiple edits.

You can choose Edit > Toggle Last State to undo and redo only the most recent change. For a quick before/after comparison of your last edit, press the Toggle Last State keyboard shortcut: Ctrl+Alt+Z (Windows) or Command+Option+Z (macOS).

A more visual way to step backward and forward through your changes is to use the History panel; choose Window > History to see it. The History panel shows you a list of your changes. To go back to a certain edit (for example, four steps ago), just select it in the History panel, and continue working from that point.

Applying filters and effects

You'll add a tombstone to the poster, and you'll experiment with filters and effects to see what works, using the History panel to reverse course if necessary.

1 In Photoshop, choose File > Open.

2 Navigate to the Lesson09 folder, and double-click the T1.psd file to open it.

The tombstone image is plain, but you'll add texture and color to it.

► Tip: A quick way to do step 3 is to press the D key, the keyboard shortcut for setting the foreground color to the default of black and the background color to the default of white.

3 In the Tools panel, click the Default Foreground And Background Colors icon (⬛) to return the default foreground color to black.

You'll start by adding a little atmosphere to the tombstone.

4 Choose Filter > Render > Difference Clouds.

The original is dull. Clouds add drama.

● Note: The Difference Clouds you get may not match the figure shown; Difference Clouds renders uniquely each time you run it.

You'll leave the top of the tombstone in focus but blur the rest using an iris blur.

5 Choose Filter > Blur Gallery > Iris Blur. Photoshop enters the Blur Gallery task space that displays just the tools for certain blur effects.

6 In the document window, drag the Iris Blur ellipse up so that the top of the tombstone is in focus and the rest is not. Then click OK.

► Tip: If you want to change the shape and area of the blur effect, drag the handles. Dragging the circle near the center is an alternate way to control the Blur Amount option that you see in the Iris Blur options, on the right side of the Blur Gallery task space.

By default, the ellipse is centered. Shift the focus higher.

You'll use adjustment layers to make the image darker and change its color.

7 Click the Brightness/Contrast icon (☀) in the Adjustments panel. Then, in the Properties panel, move the Brightness slider to **70**.

8 Click the Channel Mixer icon (◐) in the Adjustments panel.

9 In the Properties panel, choose Green from the Output Channel menu, and then change the Green value to **+37** and the Blue value to **+108**.

The tombstone takes on a green cast.

● **Note:** The green channel is set as the Output Channel, so the adjustments changed the green channel to 37% of its original amount while adding 108% of the blue channel to the green channel.

The Channel Mixer is a useful option for correcting color balance, usually by applying much smaller values than you used here. The Channel Mixer is also an alternative to the Black & White adjustment for controlling how colors are converted to grayscale and for tinting effects. In this case, you used the Channel Mixer to make a purely creative color adjustment to an image.

Tip: The Exposure adjustment is primarily intended for correcting HDR images, but in this lesson it's used as a creative effect.

10 Click the Exposure icon () in the Adjustments panel. In the Properties panel, move the Exposure slider to **+.90** to brighten the lighter areas of the image.

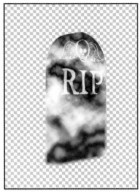

Undoing multiple steps

The tombstone certainly looks different than it did when you started, but it doesn't quite match the tombstones that are already in the poster. You'll use the History panel to revisit the steps you've taken.

1 If the History panel isn't already open, choose Window > History. Drag the bottom of the panel down so that you can see the entire list.

Note: The History panel lists the steps you have done in the current session only. The list is reset when you close a document, so when you open a document, the History panel is empty.

The History panel records the recent steps you've performed on the image. The current state is selected.

2 Click the Blur Gallery state in the History panel.

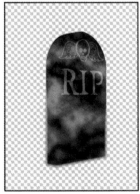

The states below the selected state are dimmed, and the image has changed. The color is gone, as are the Brightness/Contrast settings. At this point, the Difference Clouds filter has been run, and the iris blur has been applied. Everything else has been removed. There are no adjustment layers listed in the Layers panel.

3 Click the Modify Channel Mixer Layer state in the History panel.

Many of the states are restored. The color has returned, along with the brightness and contrast settings. There are two adjustment layers in the Layers panel. However, the states below the one you selected remain dimmed, and the Exposure adjustment layer is not listed in the Layers panel.

You'll return almost to the beginning to apply different effects to the tombstone.

4 Click Difference Clouds in the History panel.

Everything following that state is dimmed.

5 Choose Filter > Noise > Add Noise.

Adding noise will give the tombstone a more stone-like texture.

6 In the Add Noise dialog box, set the Amount to **3**%, select Gaussian, and select Monochromatic. Then click OK.

▶ **Tip:** If the Noise adjustments are hard to see, click the magnifying glass icon in the Add Noise dialog box.

The states that were dimmed after the state you selected (Difference Clouds) are no longer in the History panel. They were replaced by the task you just performed (Add

Noise). You can click any state to return to that point in the process, but as soon as you perform a new task, Photoshop replaces all dimmed states.

The tombstone is ready to join the others in your movie poster.

7 Choose Window > Arrange > Tile All Vertically.

8 With the Move tool, drag the tombstone you just created to the Movie-Poster.psd file. Click OK if you see a color management warning.

9 Drag the tombstone to the bottom-left corner, with the top third of it showing.

10 Choose File > Save to save the Movie-Poster.psd file. Then close the T1.psd file without saving it.

Note: A Paste Profile Mismatch dialog box may appear when you drag a layer between documents with different document color profiles. For this lesson, clicking OK is fine because it will convert the layer colors to match the destination document.

You've had a chance to try some new filters and effects and to use the History panel to backtrack. By default, the History panel retains only the last 50 states. You can change the number of levels in the History panel by choosing Edit > Preferences > Performance (Windows) or Photoshop > Preferences > Performance (macOS) and entering a different value for History States.

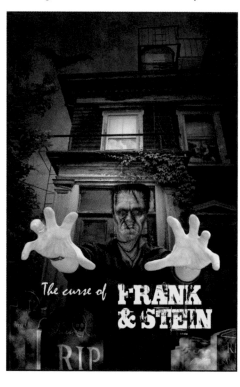

Improving a low-resolution image

At times, you might need to use an image where the only version available has low pixel dimensions. Although that may work for web pages and social media, it may not contain enough information for high-quality printing. It is possible for Photoshop to *resample* an image—increase its pixel dimensions by creating new pixels based on existing ones. The Preserve Details (Enlargement) option can be a good choice for upsampling a low-resolution image.

In your movie poster, you want to use a low-resolution image that was posted on a social media site. You'll need to resize it without compromising quality for your printed poster.

1 Choose File > Open, navigate to the Lesson09 folder, and open the Faces.jpg file

2 Zoom in to 300% or more so you can see the pixels.

3 Choose Image > Image Size.

4 Make sure the Resample option is selected.

5 Change the width and height measurements to Percent, and then change their values to **400**%.

The width and height are linked by default so that images resize proportionally. If you need to change the width and height separately for a project, click to deselect the link icon to unlink the values.

6 Drag in the preview window to pan so that you can see the glasses.

7 In the Resample menu, choose Bicubic Smoother (Enlargement). The image looks less rough than it did before.

The Resample menu includes options that control how to adjust the image for enlargement or reduction. Automatic is the default, and it picks a method based on whether you're enlarging or reducing, but you may find that another option might look better depending on the image.

8 With the Resample option still selected, choose Preserve Details (Enlargement) from the Resample menu.

The Preserve Details option results in a sharper enlargement than Bicubic Smoother, but this may also make image noise more visible.

Note: In addition to the Resample options in the Image Size dialog box, Photoshop offers other ways to increase the pixel dimensions of an image while enhancing its details, such as Super Zoom (found in Filters > Neural Filters) and Super Resolution (in Adobe Camera Raw). But if the full-resolution original image has enough detail and it's available to you, that's a better option than enlarging the image in software.

Note: Your version of Photoshop may display a Preserve Details 2.0 option in the Resample menu. This is an upgraded version of Preserve Details provided as a Technology Preview for comparison with the older Preserve Details option. Use the option that produces better results for the image you're scaling up.

9 Move the Reduce Noise slider to **50%** to smooth the image.

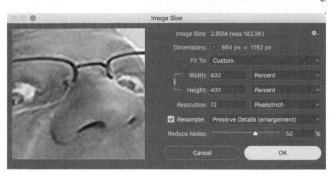

10 In the Image Size dialog box, click and hold in the preview window to see the original image so you can compare it to the current settings. You can also compare the current settings to the Bicubic Smoother option by switching between them in the Resample menu. When upscaling or downscaling, choose the Resample method that produces the best balance between preserving details and smoothing pixel jagginess, and then use Reduce Noise to remove noise that remains. If the Reduce Noise value removes too much detail, lower it.

11 Click OK. Now you'll paste the image into a feathered selection on the poster.

12 Choose Select > All, and then choose Edit > Copy.

13 Select the Movie-Poster.psd tab to bring it to the front, and then select the Elliptical Marquee tool (◯), hidden under the Rectangular Marquee tool (▭).

14 In the options bar, enter **50 px** for Feather to soften the edge of the pasted image.

15 Draw an oval in the upper-right corner of the poster, above the monster's head. The oval should overlap the window and fire escape.

16 Make sure Layer 1 is selected, and then choose Edit > Paste Special > Paste Into. Click OK if you see the Paste Profile Mismatch dialog box.

17 Select the Move tool (✛), and center the pasted image in the feathered area.

18 In the Layers panel, choose Luminosity from the Blending Mode menu, and move the Opacity slider to **50%**.

19 You've finished the poster! Close the Movie-Poster.psd document, saving changes. Then close the Faces.jpg file without saving it.

Review questions

1 What are the differences between using a Smart Filter and a regular filter to apply effects to an image?

2 What do the Bloat and Pucker tools in the Liquify filter do?

3 What does the History panel do?

4 What is the relationship of the Undo and Redo commands to the History panel?

Review answers

1 Smart Filters are nondestructive: They can be adjusted, turned off and on, and deleted at any time without altering the pixels of a layer. In contrast, regular filters permanently change a layer or image; once applied, they cannot be removed. A Smart Filter can be applied only to a Smart Object layer.

2 The Bloat tool moves pixels away from the center of the brush; the Pucker tool moves pixels toward the center of the brush.

3 The History panel records recent steps you've performed in Photoshop during the current session. You can return to an earlier step by selecting it in the History panel.

4 The Undo and Redo commands move back or forward, respectively, through the steps in the History panel.

10 PAINTING WITH THE MIXER BRUSH

Lesson overview

In this lesson, you'll learn how to do the following:

- Customize brush settings.

- Clean the brush.

- Mix colors.

- Create a custom brush preset.

- Use wet and dry brushes to blend color.

This lesson will take about an hour to complete. To get the lesson files used in this chapter, download them from the web page for this book at adobepress.com/PhotoshopCIB2023. For more information, see "Accessing the lesson files and Web Edition" in the Getting Started section at the beginning of this book.

As you work on this lesson, you'll preserve the start files. If you need to restore the start files, download them from your Account page.

PROJECT: DIGITAL PAINTING

The Mixer Brush tool gives you flexibility, color-mixing
abilities, and brush strokes as if you were painting on
a physical canvas.

About the Mixer Brush

In previous lessons, you've used brushes in Photoshop to perform various tasks. The Mixer Brush is unlike other brushes in that it lets you mix colors with each other. You can change the wetness of the brush and how it mixes the brush color with the color already on the canvas.

Some Photoshop brush types can have realistic bristles, so you can add textures that resemble those in paintings you might create in the physical world. While this is a great feature in general, it's particularly useful when you're using the Mixer Brush. Combining different bristle settings and brush tips with different wetness, paint-load, and paint-mixing settings gives you opportunities to create exactly the look you want.

Getting started

In this lesson, you'll get acquainted with the Mixer Brush as well as the brush tip and bristle options available in Photoshop. Start by taking a look at the final projects you'll create.

1 Start Photoshop, and then simultaneously hold down Ctrl+Alt+Shift (Windows) or Command+Option+Shift (macOS) to restore the default preferences. (See "Restoring default preferences" on page 5.)

2 When prompted, click Yes to delete the Adobe Photoshop Settings file.

3 Choose File > Browse In Bridge to open Adobe Bridge.

4 In Bridge, click Lessons in the Favorites panel. Double-click the Lesson10 folder in the Content panel.

5 Preview the Lesson10 end files.

You'll use the palette image to explore brush options and learn to mix colors. You'll then apply what you've learned to transform the landscape image into a painting.

6 Double-click 10Palette_Start.psd to open the file in Photoshop.

7 Choose File > Save As, and name the file **10Palette_Working.psd**. Click OK if the Photoshop Format Options dialog box appears.

8 Click the Choose a Workspace icon at the top-right corner of the application frame, and choose the Painting workspace.

● **Note:** You can paint more naturally and expressively by using a stylus and a graphics tablet. If the stylus can sense attributes such as pressure and angle, you can use Photoshop brush settings to apply them to your brush strokes.

Selecting brush settings

The practice image includes a palette and four tubes of color, which you'll use to sample the colors you're working with. You'll change settings as you paint different colors, exploring brush tip settings and wetness options.

1 Select the Zoom tool (🔍), and zoom in on the four tubes of paint, leaving some empty space above the red tube.

2 Select the Eyedropper tool (🖊), and click the red tube to sample its color.

The foreground color changes to red.

3 Select the Mixer Brush tool (✏) in the Tools panel. (When another workspace is selected, you may find the Mixer Brush hidden under the Brush tool [✏].)

● **Note:** When you hold down the Eyedropper tool on the image, Photoshop displays a sampling ring that previews the color you're selecting. The sampling ring is available if Photoshop can use the graphics processor on your computer (see the Performance panel in Photoshop preferences).

4 Choose Window > Brush Settings to open the Brush Settings panel. Select the first brush.

The Brush Settings panel contains brush presets and several options for customizing brushes.

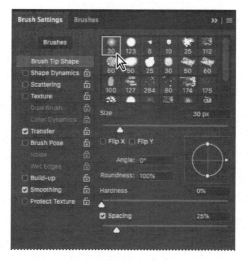

▶ **Tip:** Looking for a specific brush name in the Brush Settings panel? Hover the pointer over a brush thumbnail, and its name will pop up in a tool tip.

Experimenting with wetness options and brushes

The effect of the brush is determined by the Wet, Load, and Mix fields in the options bar. *Wet* controls how much paint the brush picks up from the canvas. *Load* controls how much paint the brush holds when you begin painting (as with a physical brush, it runs out of paint as you paint with it). *Mix* controls the ratio of paint from the canvas and paint from the brush.

You can change these settings separately. However, it's faster to select a standard combination from the pop-up menu.

1 In the options bar, choose Dry from the pop-up menu of blending brush combinations.

When you select Dry, Wet is set to 0%, Load to 50%, and Mix is not applicable. With the Dry preset, you paint opaque color; you can't mix colors on a dry canvas.

2 Paint one continuous zigzag stroke in the area above the red tube. As you continue painting without releasing the mouse, the red paint eventually fades and runs out.

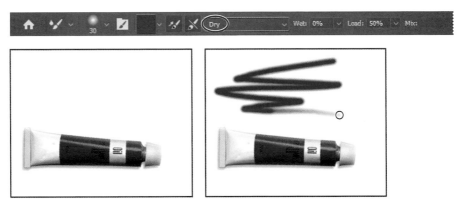

Note: You can also sample paint by Alt-clicking or Option-clicking the Mixer Brush tool. This samples the area within the brush size as an image, unless you selected Load Solid Colors Only in the Current Brush Load menu in the options bar.

3 With the Eyedropper tool, sample the blue color from the blue tube of paint.

4 Select the Mixer Brush. For the blue paint, in the Brush Settings panel we chose the Round Sketch Ballpoint Pen brush (the first brush in the second row). Choose Wet from the pop-up menu in the options bar.

If the brush you select doesn't match the one shown here, resize the Brush Settings panel so that the brush thumbnails display six columns across.

5 Paint above the blue tube. The paint mixes with the white background.

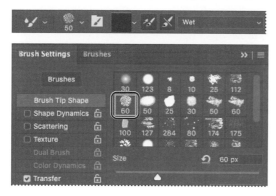

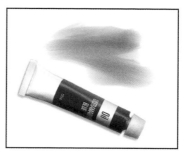

● **Note:** If you aren't getting the same results from the brushes, make sure the Background layer is selected in the Layers panel.

6 Choose Dry from the menu in the options bar, and then paint again above the blue tube. A much darker, more opaque blue appears and doesn't mix with the white background.

7 Sample the yellow color from the yellow paint tube, and then select the Mixer Brush. For the yellow paint, in the Brush Settings panel we chose the Pencil KTW 1 brush (the fourth brush in the second row). Choose Dry from the menu in the options bar, and then paint in the area over the yellow paint tube.

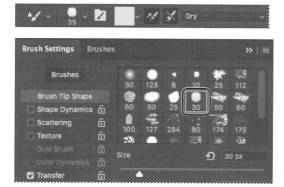

● **Note:** If the brushes in your Brush Settings panel don't match the ones shown in this lesson, open the Brushes panel, Shift-select all brushes and brush folders in the list, click the Delete Brush button (🗑), click OK to confirm, and then choose Restore Default Brushes from the Brushes panel menu.

8 Choose Very Wet from the menu in the options bar, and then paint some more. Now the yellow mixes with the white background.

9 Sample the green color from the green paint tube, and then select the Mixer Brush. For the green paint, in the Brush Settings panel we chose the Hard Round 30 brush (the sixth brush in the fifth row). Choose Dry from the menu in the options bar.

10 Paint a brush stroke above the green paint tube. Experiment on your own, painting over the green stroke with different Mixer Brush settings.

Mixing colors

Note: Depending on the complexity of your project and the performance of your computer, you may need to be patient. Mixing colors can be an intensive process.

You've used wet and dry brushes, changed brush settings, and mixed the paint with the background color. Now, you'll focus more on mixing colors with each other as you add paint to the painter's palette.

1 Zoom out just enough to see the full palette and the paint tubes.

2 Select the Paint mix layer in the Layers panel so the color you paint won't blend with the brown palette on the Background layer.

The Mixer Brush tool mixes colors only on the active layer unless you select Sample All Layers in the options bar.

3 Use the Eyedropper tool to sample the red color from the red paint tube, and then select the Mixer Brush. In the Brush Settings panel, select the Soft Round 30 brush (the first brush in the first row). Then choose Wet from the pop-up menu in the options bar, and paint in the top circle on the palette.

4 Click the Clean The Brush After Each Stroke icon (✖) in the options bar to deselect it.

Tip: If the paint tubes are covered by the Brush Settings panel, feel free to rearrange your workspace to make room. For example, collapse or close panels you aren't using. But make sure you can still see the Layers panel.

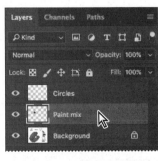

Tip: You can use the Eyedropper tool to sample a color even if the layer that contains the color isn't selected.

5 Use the Eyedropper tool to sample the blue color from the blue paint tube, and then use the Mixer Brush tool to paint in the same circle, mixing the red with the blue until the color becomes purple.

6 Use the Eyedropper tool to sample the purple color from the circle you just painted, and then paint in the next circle.

7 In the options bar, choose Clean Brush from the Current Brush Load pop-up menu. The preview changes to indicate transparency, meaning the brush has no paint loaded.

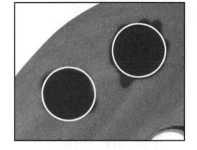

▶ Tip: Use the Eyedropper tool to sample the color, since it's on a different layer.

To remove the paint load from a brush, you can choose Clean Brush in the options bar. To replace the paint load in a brush, sample a different color.

If you want Photoshop to clean the brush after each stroke, select the Clean The Brush After Each Stroke icon (✖) in the options bar. To load the brush with the foreground color after each stroke, select the Load The Brush After Each Stroke icon (✔) in the options bar. By default, both of these options are selected.

8 Use the Eyedropper tool to sample the blue color from the blue paint tube, and then use the Mixer Brush to paint blue in half of the next circle.

9 Sample the yellow color from the yellow paint tube, and slowly paint over the blue with a wet brush to mix the two colors.

▶ Tip: When switching tools often as in these steps, it's useful to watch the pointer icon to make sure the active tool is the one you currently want.

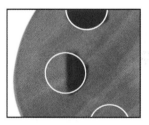 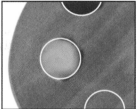

10 Fill the last circle with yellow and red paint, mixing the two with a wet brush to create an orange color.

11 Hide the Circles layer in the Layers panel to remove the outlines on the palette. You've mixed paint colors on a digital palette!

12 Choose File > Save, and close the document.

Julieanne Kost is an official Adobe Photoshop evangelist.

Tool tips from the Photoshop evangelist

Mixer Brush shortcuts

There are no default keyboard shortcuts for the Mixer Brush tool, but you can create your own.

To create custom keyboard shortcuts:

1 Choose Edit > Keyboard Shortcuts.

2 Choose Tools from the Shortcuts For menu.

3 Scroll down to the bottom of the list.

4 Select a command, and then enter a custom shortcut. You can create shortcuts for the following commands:

- Load Mixer Brush
- Clean Mixer Brush
- Toggle Mixer Brush Auto-Load
- Toggle Mixer Brush Auto-Clean
- Toggle Mixer Brush Sample All Layers
- Sharpen Erodible Tips

Mixing colors with a photograph

When you come up with a great brush, you probably want to save all of its settings so that you can use that brush again in a later project. While Photoshop already has a tool preset feature that lets you save tool settings, brushes have more options than most tools. For this reason, Photoshop has convenient brush presets that can remember everything about a brush.

▶ **Tip:** If you've used earlier versions of Photoshop, you'll find that the brush presets in Photoshop CC 2018 or later are simpler and more powerful than in previous versions.

Earlier, you mixed colors with a white background and with each other. Now, you'll use a photograph as your canvas. You'll add colors and mix them with each other and with the background colors to transform a photograph of a landscape into a painting.

1 Choose File > Open. Double-click the 10Landscape_Start.jpg file in the Lesson10 folder to open it.

2 Choose File > Save As. Rename the file **10Landscape_Working.jpg**, and click Save. Click OK in the JPEG Options dialog box.

Photoshop includes numerous brush presets, which are very handy. But if you need a different brush for your project, you might find it easier to create your own brush preset or download brush presets that another artist has created and shared online. In the following exercises, you'll load, edit, and save custom brush presets.

Loading custom brush presets

The Brushes panel displays visual samples of the strokes created by different brushes. If you already know the name of the brush you want to use, it can be easier to display the brushes by name. You'll list them by name now, so you can find your preset for the next exercise.

▶ **Tip:** If you have enough space on your screen, you can see more brushes at once by making the Brushes panel wider or taller.

1 In the Brushes panel (choose Window > Brushes if it's not open), expand one of the brush preset groups to see how the brushes are organized.

Now you'll load brush presets that you'll use for this exercise. Loading brush presets is how you use brush presets that you've downloaded or purchased.

2 Click the Brushes panel menu, and choose Import Brushes.

▶ **Tip:** If you want
to share your custom
brushes with others or
back them up, select
the brushes or brush
groups, and choose
Export Selected Brushes
from the Brushes panel
menu.

3 Navigate to the Lesson10 folder, select CIB Landscape Brushes.abr, and
click Open or Load. The CIB Landscape Brushes group appears at the end of the
Brushes panel list.

4 Click to expand the CIB Landscape Brushes group, revealing the brushes
it contains.

Some of the presets contain not only a stroke preview and a name, but also a color
swatch. That's because a color can be part of a brush preset.

Creating a custom brush preset

For the next exercise, you'll create and save a variation on a brush preset that exists in the CIB Landscape Brushes you just imported.

1 Select the Mixer Brush, and then, in the CIB Landscape Brushes group in the Brushes panel, select the Round Fan Brush. You'll use this brush preset as the starting point for the brush preset you'll create.

2 Change the following settings in the Brush Settings panel:

- Size: **36** px
- Shape: Round Fan
- Bristles: **35%**
- Length: **32%**
- Thickness: **2%**
- Stiffness: **75%**
- Angle: **0°**
- Spacing: **2%**

▶ **Tip:** In the Brush Settings panel, the Brush Tip Shape options include the Angle setting, which simulates the rotation angle at which you hold the brush handle. Some graphics tablets can use a stylus that lets you rotate the brush tip as you paint, by rotating the stylus. If you don't have such a stylus, you can rotate the brush tip angle by one degree as you paint, by pressing the Left Arrow or Right Arrow keys. Add the Shift key to rotate in 15-degree increments. The current brush angle is displayed at the end of the options bar.

3 Click the Foreground color swatch in the Tools panel. Select a medium-light blue color (we chose R=86, G=201, B=252).

4 Choose Dry from the pop-up menu in the options bar.

Now it's time to save the settings as a brush preset.

5 Choose New Brush Preset from the Brush Settings panel menu.

▶ Tip: The options in the New Brush dialog box make it possible to save the brush size, the tool settings, and the brush color in the preset.

6 Name the brush **Sky Brush**, select all of the options in the New Brush dialog box, and then click OK.

Your new brush is saved in the CIB Landscape Brushes group because it was based on a brush preset from that group. Feel free to reorganize your brush presets any way you like by dragging and dropping presets into brush preset groups within the Brushes panel. You can create a brush preset group by clicking the Create A New Group button (⬚) at the bottom of the Brushes panel. You can change the order of the Brushes panel list and organize brush preset groups into subgroups.

Painting and mixing colors with brush presets

You'll paint the sky first, using the brush preset you just created.

1 Select the Sky Brush from the Brushes panel.

Presets are saved on your system, so once added, they are always available.

2 Paint over the sky, moving in close to the trees. Because you're using a dry brush, the blue paint isn't mixing with the colors beneath it.

3 Select the Clouds Brush.

4 Use this brush to scrub diagonally in the upper-right corner of the sky, blending the two colors with the background color.

▶ **Tip:** When using different brush presets, observe how brush behavior is affected by the settings in both the options bar and the Brush Settings panel. It's a good way to learn how to create your own brush presets.

When you're satisfied with the sky, move on to the grass and trees.

5 Select the Green Grass Highlight Brush. Then paint short vertical strokes over the darker green grass areas so that they become bright green grass.

Tip: If you want to create less jittery strokes with the Mixer Brush, like near the edges of the trees, try increasing the Set Smoothing for Stroke percentage in the options bar.

6 Select the Foreground Tree Brush, and then paint the darker areas of the tree. Then select the Background Trees Brush, and paint the two smaller trees on the right side of the painting. Select the Tree Highlights Brush, and paint the lighter areas of the trees. These are Wet brushes so that you can blend colors.

Tip: For different effects, paint in different directions or customize the brush size or other settings. With the Mixer Brush tool, you can go wherever your artistic instincts lead you.

So far, so good. The brown grasses are all that remain to be painted.

7 Select the Brown Grass Brush. Paint along the brown grass with up-and-down strokes for the look of a field. Use the same brush to paint the trunk of the tree.

8 Select the Foreground Grass Brush. Then paint using diagonal strokes to blend the colors in the grass.

9 Choose File > Save, and close the document.

Voilà! You've created a masterpiece with your paints and brushes, and there's no mess to clean up.

Brushes from Kyle T. Webster

In 2017, award-winning brush designer Kyle T. Webster joined Adobe. At the same time, Adobe acquired the popular brush collections at KyleBrush.com. Kyle has drawn for *The New Yorker*, *TIME*, *The New York Times*, *The Wall Street Journal*, *The Atlantic*, *Entertainment Weekly*, Scholastic, Nike, IDEO, and many other distinguished editorial, advertising, publishing, and institutional clients. His illustration work has been recognized by the Society of Illustrators, Communications Arts, and American Illustration. Kyle now works closely with Adobe product teams on the development of future brushes for Adobe Creative Cloud.

To add the Kyle T. Webster brushes to Photoshop, open the Brushes panel (Window > Brushes), and choose Get More Brushes from the Brushes panel menu. After you download a brush pack and with Photoshop running, double-click the downloaded ABR file to add its brushes as a new group in the Brushes panel.

Painting with symmetry

If you're painting a design that uses symmetry, try the Paint Symmetry brush option. When a brush type that supports Paint Symmetry is selected, you'll see the Paint Symmetry icon (⟨⟩) in the options bar. Click that icon, and select the type of symmetry axis you want; it appears as a guide object in the document. Move, scale, or rotate the guide if you want, and then press Enter or Return. As you paint with Paint Symmetry, each of your brush strokes is repeated across the axes you set up.

You might use a single axis for simple mirror symmetry, but you can also use multiple axes arranged in different ways. For example, you can use horizontal and vertical axes to design tiles, or radial axes to design mandalas.

The axes are actually paths, so you can see and edit them in the Paths panel. You can even create your own custom axis. Draw with a tool such as the Pen, Curvature Pen, or Custom Shape tool in Path mode (not Shape mode). With the path selected in the Paths panel, choose Make Symmetry Path from the Paths panel menu.

Painting gallery

The painting tools and brush tips in Photoshop let you create all kinds of painting effects.

The following pages show examples of art created with the brush tips and tools in Photoshop.

Image © Megan Lee, www.megan-lee.com

Image © Victoria Pavlov, pavlovphotography.com

Image © sholby, www.sholby.net

Image © sholby, www.sholby.net

Image © sholby, www.sholby.net

Continues on next page

Painting gallery (continued)

Image © Andrew Faulkner, www.andrew-faulkner.com

Image © Lynette Kent, www.LynetteKent.com

Review questions

1 What does the Mixer Brush do that other brushes don't?

2 How do you load a Mixer Brush with color?

3 How do you clean a brush?

4 What is the name of the panel that you use to manage brush presets?

Review answers

1 The Mixer Brush mixes the current brush color with colors on the canvas.

2 You can load color on a Mixer Brush by sampling a color with the Eyedropper tool or changing the Foreground color. If the brush is clean, you can choose Load Brush from the pop-up menu in the options bar to load the brush with the foreground color.

3 To clean a brush, choose Clean Brush from the pop-up menu in the options bar.

4 You manage brush presets in the Brushes panel.

11 EDITING VIDEO

Lesson overview

In this lesson, you'll learn how to do the following:

- Create a video timeline in Photoshop.

- Add media to a video group in the Timeline panel.

- Add motion to still images.

- Animate type and effects using keyframes.

- Add transitions between video clips.

- Include audio in a video file.

- Render a video.

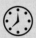 This lesson will take about 90 minutes to complete. To get the lesson files used in this chapter, download them from the web page for this book at adobepress.com/PhotoshopCIB2023. For more information, see "Accessing the lesson files and Web Edition" in the Getting Started section at the beginning of this book.

As you work on this lesson, you'll preserve the start files. If you need to restore the start files, download them from your Account page.

You can edit video files in Photoshop using many
of the same effects you use to edit image files. You
can create a movie from video files, still images, Smart
Objects, audio files, and type layers; apply transitions;
and animate effects using keyframes.

Getting started

In this lesson, you'll edit a video that was shot using a smartphone. You'll create a video timeline, import clips, add transitions and other video effects, and render the final video. First, look at the final video to see what you'll be creating.

1 Start Photoshop, and then simultaneously hold down Ctrl+Alt+Shift (Windows) or Command+Option+Shift (macOS) to restore the default preferences. (See "Restoring default preferences" on page 5.)

2 When prompted, click Yes to delete the Adobe Photoshop Settings file.

3 Choose File > Browse In Bridge.

4 In Bridge, select the Lessons folder in the Favorites panel. Then, double-click the Lesson11 folder in the Content panel.

5 Double-click the 11End.mp4 file to open it in the default video player for your system, such as QuickTime Player (macOS) or Movies & TV (Windows).

● **Note:** If Bridge isn't installed, the File > Browse In Bridge command in Photoshop will start the Creative Cloud desktop app, which will download and install Bridge. After installation completes, you can start Bridge.

6 Click the Play button to view the final video.

The short video is a compilation of clips from a day at the beach. It includes transitions, layer effects, animated text, and a musical track.

7 Close the video player, and return to Bridge.

8 Double-click the 11End.psd file to open it in Photoshop.

About the Timeline panel

If you've used a video-editing application such as Adobe Premiere® Pro or Adobe After Effects®, the Timeline panel is probably familiar. You use the Timeline panel to assemble and arrange video clips, images, and audio files for a movie file. You can edit the duration of each clip, apply filters and effects, animate attributes such as position and opacity, mute sound, add transitions, and perform other standard video-editing tasks without ever leaving Photoshop.

1 Choose Window > Timeline to open the Timeline panel.

Each video clip or image is represented in a box in the Timeline panel and as a layer in the Layers panel. In the Timeline panel, video clips are blue and image files are purple. Audio tracks appear below the video tracks; audio clips are green.

▶ **Tip:** If the Timeline is too short to display both video groups and the audio track all at once, make the Timeline panel taller by dragging its top border up.

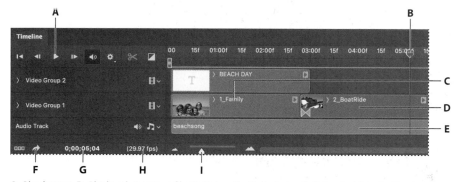

A. *Play button* B. *Playhead* C. *Image file* D. *Video clip* E. *Audio track* F. *Render Video button*
G. *Current time* H. *Frame rate* I. *Control Timeline Magnification slider*

The timeline contents should appear visible as in the figure above. If they're collapsed against the left side so that content titles and previews aren't visible, drag the magnification slider (below the timeline) to the right to see time in more detail.

2 Click the Play button in the Timeline panel to view the movie.

The playhead moves across the time ruler, displaying each frame of the movie.

3 Press the spacebar to pause playback.

4 Drag the playhead to another point in the time ruler.

The playhead's time location determines what appears in the document window.

When you work with video, Photoshop displays guides across the document window. To minimize the chance that your content will be cut off along the edges of some televisions, keep important content within the center area marked by the guides.

▶ **Tip:** If you don't want to see the guides, choose View > Show > Guides and deselect that command.

5 When you've finished exploring the end file, close it, but leave Photoshop open. Don't save any changes you might have made.

Creating a new video

Working with video is a little different from working with still images in Photoshop. You may find it easiest to create the Photoshop document first and then import the assets you'll be using. You'll choose a preset made for video and then add nine video and image files to include in your movie.

Photoshop includes several film and video presets for you to choose from. You'll create a new file and select an appropriate preset.

Note: This lesson uses the 720p preset as a balance between quality and good editing performance on a wide range of computers. If your video clips are 1080p or higher and you have a more powerful or more recent computer, you can use a 1080p or 4K preset for your projects.

1 In the Home screen, click the New File button, or choose File > New.

2 Name the file **11Working.psd**.

3 Click Film & Video in the document type bar at the top of the dialog box.

4 In the Blank Document Presets section, choose HDV/HDTV 720p.

5 Accept the default settings for the other options, and click Create.

Note: If Photoshop displays a dialog box telling you about the difference between saving to Cloud Documents and On Your Computer, click Save On Your Computer. You can also select Don't Show Again, but that setting will deselect after you reset Photoshop preferences.

6 Choose File > Save As, and save the file in the Lesson11 folder.

Importing assets

Photoshop provides tools specifically for working with video, such as the Timeline panel, which may already be open because you previewed the end file. To ensure you have access to the resources you need, you'll select the Motion workspace and organize your panels. Then you'll import the video clips, images, and audio file you need to create the movie.

1 Choose Window > Workspace > Motion. That preset arranges panels to give priority to tools used for building a timeline.

2 Pull up the top edge of the Timeline panel so that the panel occupies the bottom third of the workspace.

3 Select the Zoom tool (🔍), and then click Fit Screen in the options bar so that you can see the entire canvas within the top half of the screen.

4 In the Timeline panel, click Create Video Timeline. Photoshop creates a new video timeline, including two default tracks: Layer 0 and Audio Track.

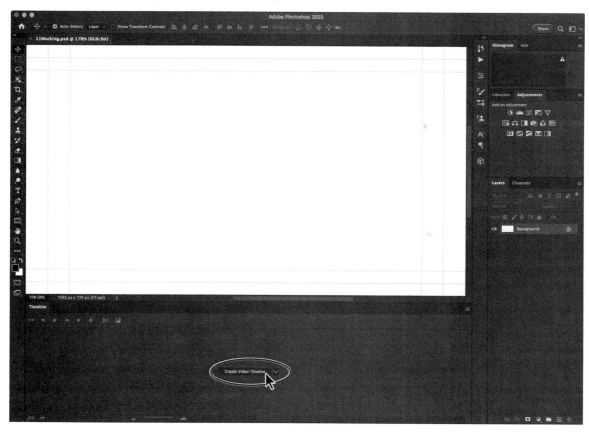

5 Click the Video menu in the Layer 0 track, and choose Add Media.

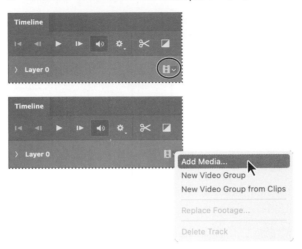

6 Navigate to the Lesson11 folder.

7 Shift-select the video and photo assets numbered 1–6, and click Open.

● **Note:** If the media appear in reverse order in the timeline, choose Edit > Undo, and when you choose Add Media again, make sure you select 1_Family.jpg first and then Shift-select 6_Sunset.jpg. Also, it will be easiest to Shift-select the media if the files are sorted by name. It's normal for the media to appear in reverse order in the Layers panel, where the bottom layer is considered the first.

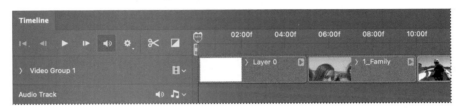

Photoshop imports all six of the assets you selected onto the same track, now named Video Group 1, in the Timeline panel. It displays still images with a purple background and video clips with a blue background. In the Layers panel, the assets appear as individual layers within the layer group named Video Group 1. You don't need the Layer 0 layer, so you'll delete it.

8 Select Layer 0 in the Layers panel, and click the Delete Layer button (🗑) at the bottom of the panel. Click Yes to confirm the deletion.

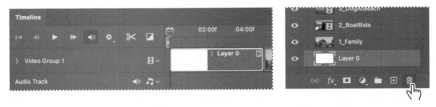

9 Choose File > Save. Click OK in the Photoshop Format Options dialog box.

Changing the duration and size of clips in the timeline

The clips are of different durations, meaning they play for different amounts of time. For this video, you want all the clips to be the same length, so you'll shorten them all to 3 seconds. The length of a clip (its *duration*) is measured in seconds and frames: 03:00 is 3 seconds; 02:25 is 2 seconds and 25 frames.

1 Drag the Control Timeline Magnification slider to the right at the bottom of the Timeline panel to zoom in on the timeline. You want to be able to see a thumbnail of each clip and enough detail in the time ruler that you can accurately change the duration of each clip.

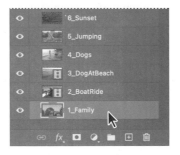

▶ **Tip:** If the Control Timeline Magnification slider is hard to control, click the magnification icons to the left and right of the slider.

2 Drag the right edge of the first clip (1_Family) to 03:00 on the time ruler. Photoshop displays the end point and the duration as you drag so that you can find the right stopping point.

3 Drag the right edge of the second clip (2_BoatRide) to a duration of 03:00.

Shortening a video clip this way doesn't change its speed; it removes part of the clip from the video. In this case, you want to use the first three seconds of each clip. If you wanted to use a different portion of a video clip, you would shorten the clip from each end. As you drag the end point of a video clip, Photoshop displays a preview so you can see exactly what content will appear in the last frame of that clip when you release the mouse button.

● **Note:** In this lesson you're shortening each clip to the same duration, but in your own videos it's OK to have clips of different durations, depending on how you want to tell your story.

4 Repeat step 3 for each of the remaining clips so that each has a duration of 3 seconds.

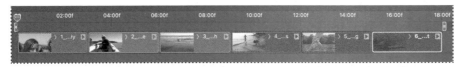

The clips are now the right duration, but some of the images are the wrong size for the canvas. You'll resize the first image before continuing.

5 Make sure the playhead is at the beginning of the timeline, and then in the Layers panel, select the 1_Family layer. That clip also becomes selected in the Timeline panel.

Tip: Along the top of a clip in the Timeline, the first triangle (>) reveals the attributes you can animate using keyframes. The second triangle (in a square at the upper-right corner of a clip) opens the Motion panel.

6 Click the triangle in the upper-right corner of the 1_Family clip in the Timeline panel to open the Motion panel.

7 Choose Pan & Zoom from the menu, and make sure Resize To Fill Canvas is selected. Then click an empty area of the Timeline panel to close the Motion panel.

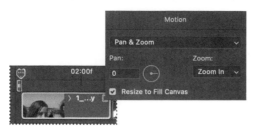

The image resizes to fit the canvas. However, you applied the effect only to quickly resize the image and not to pan and zoom, so you'll remove the effect. That will leave the image at the new size, which is what you want.

8 Open the Motion panel from the 1_Family clip again, and choose No Motion from the menu. Click an empty area of the Timeline panel to close the Motion panel.

9 Save your work.

Animating text with keyframes

Keyframes let you control animation, effects, and other changes that occur over time. A keyframe marks the point in time where you specify a value, such as a position, size, or style. To create a change over time, you must have at least two keyframes: one for the state at the beginning of the change and one for the state at the end. Photoshop interpolates the values for the positions in between so that the change happens gradually and smoothly. You'll use keyframes to animate a movie title (Beach Day) from left to right over the opening image.

Note: All content in the same video group plays in sequence. The reason you create a new video group in step 1 is to add a layer that plays at the same time as other layers. For example, a logo that appears in a corner of the frame for the entire length of a video must be in a different video group than a sequence of clips.

1 Click the Video pop-up menu in the Video Group 1 track, and choose New Video Group. Photoshop adds Video Group 2 to the Timeline panel.

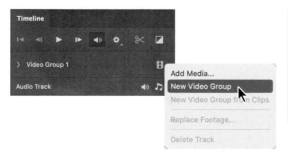

2 Select the Horizontal Type tool (T), and then click on the left edge of the image, about halfway down from the top.

Photoshop creates a new type layer, named Layer 1, in the Video Group 2 track. The type layer initially includes "Lorem Ipsum" placeholder text.

3 Type **BEACH DAY**, replacing the selected placeholder text. Click the check mark (✓) in the options bar to commit the text to the layer.

4 In the options bar, select a sans serif font such as Myriad Pro, set the type size to **600** pt, and select white for the type color.

The text is large enough that all of it doesn't fit on the canvas. That's intentional, because you'll animate the text to slide it across the canvas.

5 In the Layers panel, change the opacity for the BEACH DAY layer to **25**%.

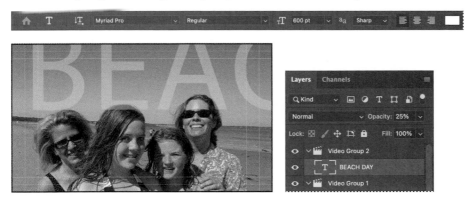

6 In the Timeline panel, drag the end point of the type layer to 03:00 so that it has the same duration as the 1_Family layer.

7 Click the triangle to the left of the BEACH DAY clip title to display the clip's attributes.

8 Make sure the playhead is at the beginning of the time ruler.

9 Click the stopwatch icon (⏱) next to the Transform property to set an initial keyframe for the layer.

The keyframe appears as a yellow diamond in the timeline.

Tip: If you prefer to move the playhead precisely using keyboard shortcuts, there are none defined by default. You can define your own: Choose Edit > Keyboard Shortcuts, choose Panel Menus from the Shortcuts For menu, expand Timeline (Video) in the list, and add your shortcuts for commands such as Next Frame and Previous Frame.

10 Select the Move tool (✛), and in the document window, drag the type layer up so that the tops of each letter are slightly clipped at the edge of the canvas (if they aren't already). Press the Shift key as you drag the type layer to the right so that

only the left edge of the letter "B" in the word "BEACH" is visible on the canvas. The keyframe you set in step 9 ensures that the text will be in this position at the beginning of the movie.

11 In the Timeline, move the playhead to the last frame of the first clip (02:29).

▶ **Tip:** Photoshop displays the playhead's current time in the lower-left corner of the Timeline panel.

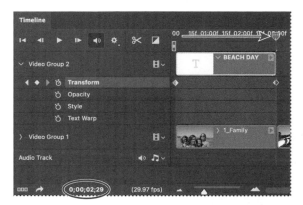

12 Press the Shift key as you use the Move tool to drag the type layer to the left over the canvas so that only the right edge of the "Y" in the word "DAY" is visible. Pressing Shift ensures that the type moves straight across as you drag.

Photoshop creates a keyframe at the current time, for the layer's new position.

13 Move the playhead across the first three seconds of the time ruler to preview the animation. The title moves across the image.

14 In the Timeline panel, click the triangle to the left of the title of the "BEACH DAY" text clip to close the clip's attributes, and then save your work.

Creating effects

One of the benefits of working with video files in Photoshop is that you can create effects using adjustment layers, styles, and simple transformations.

Adding adjustment layers to video clips

You've used adjustment layers with still images throughout this book. They work just as well on video clips. When you apply an adjustment layer in a video group, Photoshop applies it only to the layer immediately below it in the Layers panel.

1 In the Layers panel, select the 3_DogAtBeach layer.

2 In the Timeline panel, move the playhead to the beginning of the 3_DogAtBeach layer so you can see the effect as you apply it.

▶ **Tip:** To quickly snap the playhead to the first frame of a clip, hold down Shift as you drag the playhead.

3 In the Adjustments panel, click the Black & White button (▣).

4 In the Properties panel, leave the default preset, and select Tint. The default tint color creates a sepia effect that works well for this clip. You can experiment with the sliders and the tint color to modify the black-and-white effect to your taste.

5 Move the playhead across the 3_DogAtBeach clip in the Timeline panel to preview the effect.

Animating a zoom effect

Even simple transformations become interesting effects when you animate them. You'll use animation to zoom in on the 4_Dogs clip.

1 Move the playhead to the beginning of the 4_Dogs clip in the Timeline panel (09:00).

2 Click the triangle at the top-right corner of the 4_Dogs clip to display the Motion panel.

3 Choose Zoom from the pop-up menu, and choose Zoom In from the Zoom menu. On the Zoom From grid, select the upper-left corner to zoom in from that point. Make sure Resize To Fill Canvas is selected, and then click an empty area of the Timeline panel to close the Motion panel.

4 Drag the playhead across the clip to preview the effect.

You'll enlarge the image in the last keyframe to make the zoom more dramatic.

5 Click the triangle to the left of the title of the 4_Dogs clip to reveal the attributes for the clip.

There are two keyframes, which appear as red diamonds under the clip on the timeline: one for the beginning of the Zoom In effect, and one for the end.

▶ **Tip:** You can move to the next keyframe by clicking the right triangle next to the attribute (in this case, Transform) in the Timeline panel. Click the left triangle to move to the previous keyframe.

6 Click the right triangle next to the Transform attribute (under Video Group 1 on the left side of the Timeline panel) to move the playhead to the last keyframe if it's not already there, and choose Edit > Free Transform. Then enter **120%** for Width and Height in the options bar. Click the Commit Transform button (✔) to confirm the transformation.

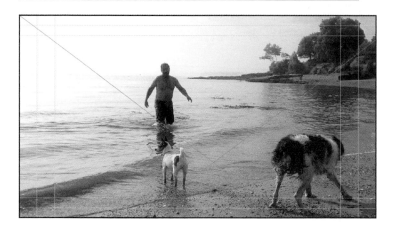

7 Drag the playhead across the 4_Dogs clip in the time ruler to preview the animation again.

8 Choose File > Save.

Animating an image to create a motion effect

You'll animate another transformation to create the appearance of motion. You want the image to begin with the diver's legs and end with his hands.

1 Move the playhead to the end of the 5_Jumping clip (14:29), and select the clip. Using the Move tool, press Shift as you drag the image down in the document window so that the hands are near the top of the canvas, putting the diver in the final position.

2 Click the triangle to the left of the clip title to display the clip's attributes, and click the stopwatch icon for the Position attribute to add a keyframe (a yellow diamond icon) under the clip.

3 Move the playhead to the beginning of the clip (12:00). Using the Move tool, press Shift as you drag the image up so that the feet are near the bottom of the canvas.

Photoshop adds a second keyframe under the clip to complete the animation.

4 Move the playhead across the time ruler to preview the animation.

As you can see, you can build animation keyframes in any order. Sometimes, as in this example, it's easier to start from the final look and then work backwards.

5 Close the clip's attributes. Then choose File > Save to save your work so far.

Adding the Pan & Zoom effect

You can easily add features similar to the pan and zoom effects used in documentaries. You'll add them to the sunset to bring the video to a dramatic close.

1 Move the playhead to the beginning of the 6_Sunset clip.

2 Click the triangle at the top-right corner of the clip to display its Motion panel. Choose Pan & Zoom from the pop-up menu, choose Zoom Out from the Zoom menu, and make sure Resize To Fill Canvas is selected.
Then click an empty area of the Timeline panel to close the Motion panel.

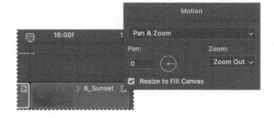

3 Move the playhead across the last clip to preview the effects.

Adding transitions

Simply drag and drop to add transitions, such as fading one clip into another.

1 Click the Go To First Frame button (⏮) in the upper-left corner of the Timeline panel to return the playhead to the beginning of the time ruler.

2 Click the Transition button (◪) near the upper-left corner of the Timeline panel. Select Cross Fade, and change the Duration value to **.25** s (a quarter of a second).

3 Drag the Cross Fade transition and drop it where the 1_Family and 2_BoatRide clips meet.

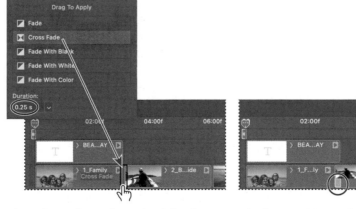

● **Note:** At low Timeline magnifications, transition icons may be condensed into small rectangles. For better visibility and control of transitions, use the Timeline magnification slider to magnify the Timeline.

Photoshop adjusts the ends of the clips to apply the transition and adds a white transition icon in the lower-left corner of the second clip.

4 Drag Cross Fade transitions between each of the other clips.

5 Drag a Fade With Black transition onto the end of the final clip.

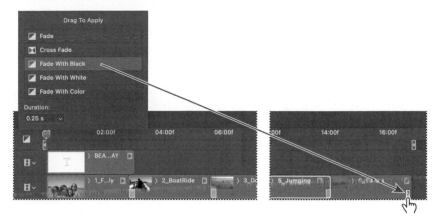

● **Note:** You may notice that adding a transition makes the sequence slightly shorter. That's because adding an 0.25 second cross fade means 0.25 seconds of the clips on both sides of the transition must now overlap to make the transition possible. Therefore, the second clip shifts earlier in time by the duration of the transition, reducing the duration of the entire sequence.

6 To make the transition smoother, extend the Fade With Black transition by dragging its left edge out to about one-third the total length of the clip.

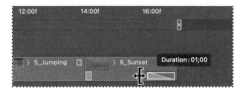

7 Play back the entire sequence; then choose File > Save.

Adding audio

You can add a separate audio track to a video file in Photoshop. In fact, the Timeline panel includes an empty audio track by default. You'll add an MP3 file to play as the soundtrack for this short video.

1 Click the musical-note icon in the Audio Track at the bottom of the Timeline panel, and choose Add Audio from the pop-up menu.

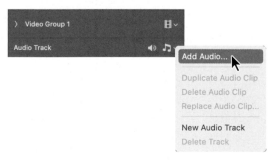

▶ **Tip:** You can also add an audio track by clicking the + sign at the far-right end of the track in the Timeline panel.

2 Select the beachsong.mp3 file from the Lesson11 folder, and click Open.

The audio file is added to the timeline, but it's much longer than the video. You'll use the Split At Playhead tool to shorten it.

3 Move the playhead to the end of the 6_Sunset clip. With the audio file still selected, click the Split At Playhead tool (✄) in the Timeline panel.

The audio file is clipped at that point, becoming two audio clips.

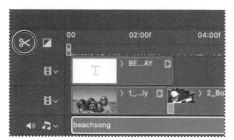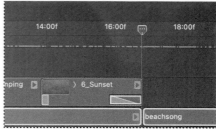

4 Select the second audio file segment, the one that begins after the end of the 6_Sunset clip. Press the Delete key on your keyboard to remove the selected clip.

Now the audio file is the same length as the video. You'll add a fade so that it ends smoothly.

5 Click the small triangle at the right edge of the audio clip to open the Audio panel. Then enter **3** seconds for Fade In and **5** seconds for Fade Out.

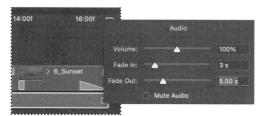

6 Click an empty area of the Timeline panel to close the Audio panel, and save your work so far.

Muting unwanted audio

So far, you've previewed portions of the video by moving the playhead across the time ruler. Now you'll preview the entire video using the Play button in the Timeline panel and then mute any extraneous audio from the video clips.

1 Click the Play button (▶) in the upper-left corner of the Timeline panel to preview the video so far.

It's looking good, but there is some unwanted background noise from the video clips. You'll mute that extra sound.

2 Click the small triangle at the right end of the 2_BoatRide clip.

3 Click the Audio tab to see audio options, and then select Mute Audio. Click an empty area of the Timeline panel to close the Audio/Video panel.

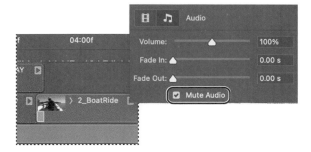

4 Click the small triangle at the right end of the 3_DogAtBeach clip, and repeat step 3 to mute this clip's audio.

5 Play the timeline to check your audio changes, and then save your work.

Rendering video

You're ready to render the timeline to a single video file. Photoshop provides several rendering options. You'll select options appropriate for streaming video to share on the YouTube website. For information about other rendering options, see Photoshop Help.

1 Choose File > Export > Render Video, or click the Render Video button (➔) in the lower-left corner of the Timeline panel.

2 Name the file **11Final.mp4**.

3 Click Select Folder, navigate to the Lesson11 folder, and click OK or Choose.

Note: The choices in the Preset menu depend on the selection in the Format menu. For the YouTube options to be available in the Preset menu, the Format menu must be set to H.264.

4 From the Preset menu, choose YouTube HD 720p 29.97.

5 Click Render.

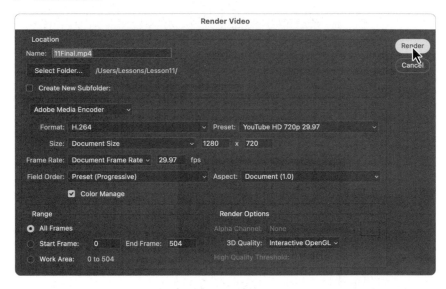

Depending on your system, this may take a while.

Photoshop displays a progress bar as it exports the video. Depending on your system, the rendering process may take several minutes.

6 Save your work.

7 Locate the 11Working.mp4 file in the Lesson11 folder in Bridge. Double-click it to view the video you made using Photoshop!

Tip: When a video is selected in Bridge, you can play it inside Bridge by pressing the spacebar on your keyboard. This plays the video in the Preview panel in Bridge. Double-clicking a video opens it in your system's default video player.

Review questions

1 What are keyframes, and how do you use them to create an animation?

2 How do you add a transition between clips?

3 How do you render a video?

Review answers

1 A keyframe marks the point in time where you specify a value, such as a position, size, or style. To create a change over time, you must have at least two keyframes: one for the state at the beginning of the change and one for the state at the end. To create an initial keyframe, click the stopwatch icon next to the attribute you want to animate for the layer. When you change the value of that attribute at a different playhead time position, Photoshop creates a new keyframe to record the change at that time.

2 To add a transition, click the Transition button near the upper-left corner of the Timeline panel, and then drag a transition onto a clip.

3 To render a video, choose File > Export > Render Video, or click the Render Video button in the lower-left corner of the Timeline panel. Then select the video settings that are appropriate for the online service or device on which you'll show the video.

12

WORKING WITH CAMERA RAW

Lesson overview

In this lesson, you'll learn how to do the following:

- Open a camera raw image in Adobe Camera Raw.

- Adjust tone and color in a raw image.

- Sharpen an image in Camera Raw.

- Synchronize settings across multiple images.

- Retouch a portrait in Camera Raw using masked adjustments.

This lesson will take about an hour to complete. To get the lesson files used in this chapter, download them from the web page for this book at adobepress.com/PhotoshopCIB2023. For more information, see "Accessing the lesson files and Web Edition" in the Getting Started section at the beginning of this book.

As you work on this lesson, you'll preserve the start files. If you need to restore the start files, download them from your Account page.

PROJECT: ADVANCED PHOTO RETOUCHING

Camera raw files give you greater flexibility, especially
for adjusting color and tone, when compared to editing
JPEG format files from a camera. You can tap into that
potential by using Adobe Camera Raw, an application
integrated with Photoshop and Bridge.

Getting started

In this lesson, you'll edit several digital images using Adobe Camera Raw, a plug-in application you can use from within Photoshop or Bridge. You'll use a variety of techniques to touch up and improve the appearance of digital photographs. You'll start by viewing the before and after images in Adobe Bridge.

1 Start Photoshop, and then simultaneously hold down Ctrl+Alt+Shift (Windows) or Command+Option+Shift (macOS) to restore the default preferences. (See "Restoring default preferences" on page 5.)

2 When prompted, click Yes to delete the Adobe Photoshop Settings file.

3 Choose File > Browse In Bridge to open Adobe Bridge.

4 In the Favorites panel in Bridge, click the Lessons folder. Then, in the Content panel, double-click the Lesson12 folder to open it.

5 Adjust the thumbnail slider, if necessary, so that you can see the thumbnail previews clearly. Then look at the 12A_Start.crw and 12A_End.psd files.

● **Note:** If Bridge isn't installed, the File > Browse In Bridge command in Photoshop will start the Creative Cloud desktop app, which will download and install Bridge. After installation completes, you can start Bridge.

● **Note:** We used Adobe Camera Raw 15, which was the current version at the time of publication. Adobe updates Camera Raw frequently; if you're using a later version, some of the steps in this lesson may not match what you see. Also, if you have used an earlier version of Camera Raw, note that the user interface was significantly redesigned in version 12.3.

12A_Start.crw

12A_End.psd

The original photograph of a Spanish-style church is a camera raw file, so it doesn't have the usual .psd or .jpg file extension you've worked with so far in this book. It was shot with a Canon SLR camera, and its document uses the Canon proprietary .crw file extension. You'll process this camera raw image to make it brighter, sharper,

and clearer, and then save it both as a JPEG file for the web and as a PSD file so that you could work on it further in Photoshop.

6 Compare the 12B_Start.nef and 12B_End.psd thumbnail previews.

 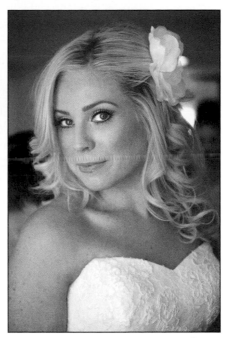

12B_Start.nef *12B_End.psd*

This time, the start file was taken with a Nikon camera, and the raw image has an .nef extension. You'll perform color corrections and image enhancements in Camera Raw and Photoshop to achieve the end result.

About camera raw files

Many digital cameras can save images in *camera raw* format. A camera raw file contains unprocessed picture data from a digital camera's image sensor, somewhat like undeveloped film. Raw sensor data is not yet converted to a standard multiple-channel color image file. It's still one unprocessed channel of sensor data, and in that form, it is not yet viewable as an image. You might then wonder: How can you view raw files, such as those included with this lesson, on the back of the camera and on your computer before you open them? The answer is that a camera typically saves a raw file with an embedded preview image that represents the camera's interpretation of the raw data.

Raw processing software such as Adobe Camera Raw interprets the unprocessed raw data into the multiple color channels (such as three RGB channels) that photo editing software such as Photoshop can edit. Camera raw files let you interpret the original image data, giving you more editing flexibility than when you edit a JPEG file saved using the camera's interpretation of the data. You can use Adobe Camera Raw to make wider and deeper changes to white balance, tonal range, contrast, color saturation, noise reduction, and sharpening than you could if the raw data was already converted to RGB. You can reprocess a raw file at any time, without degrading the original image data.

● **Note:** Camera raw files are typically unique to each camera model's sensor. If you have CRW files from three different Canon camera models and NEF files from three Nikon models, chances are those represent six different types of sensor data. If you buy a new camera, you might need an Adobe Camera Raw update that adds support for its specific raw data.

To create camera raw files, set your digital camera to save files in raw format instead of JPEG format. A raw file has a manufacturer-specific filename extension such as .nef (from Nikon) or .crw (from Canon). In Bridge or Photoshop, you can process camera raw files from a myriad of supported digital cameras from Canon, Fuji, Leica, Nikon, and other makers. You can then export the proprietary camera raw files to DNG, JPEG, TIFF, or PSD file format.

Should you always capture camera raw images instead of JPEG images? If you want maximum editing flexibility, then yes. However, camera raw images require more space to store and more processing power to edit. If your images need little to no editing after the shot, you could decide to capture and edit JPEG images instead.

Processing files in Camera Raw

When you make adjustments to an image in Camera Raw, such as straightening or cropping the image, Photoshop and Bridge store your edits separately from the original file. You can edit the image as you desire, export an edited version, and keep the original intact for different or improved adjustments in the future.

Opening images in Camera Raw

▶ **Tip:** You can open and edit TIFF and JPEG images in Camera Raw, if those formats are enabled in the File Handling preferences for Camera Raw. But those formats don't provide the same range of adjustments as a camera raw file.

You can open Camera Raw from either Bridge or Photoshop, and you can edit multiple images in Camera Raw. You can also apply the same edits to multiple files simultaneously. That's useful if you're working with images that were all shot in the same environment and that therefore need similar adjustments.

Camera Raw provides extensive controls for adjusting white balance, exposure, contrast, sharpness, tone curves, and much more. In this exercise, you'll edit one image and then apply the settings to similar images.

1 In Bridge, open the Lessons/Lesson12/Mission folder, which contains three shots of the Spanish church you previewed earlier.

2 Shift-click to select all of the images—Mission01.crw, Mission02.crw, and Mission03.crw—and then choose File > Open In Camera Raw.

3 If a Welcome to Camera Raw 15.0 screen appears, click Get Started.

Both the Set Up Camera Raw and Welcome to Camera Raw 15.0 screens appear only the first time you start Camera Raw 15 or the first time after you reset Camera Raw preferences (which are separate from Photoshop preferences).

● **Note:** If a Set Up Camera Raw screen appears, make sure New ACR Default is selected, and click OK.

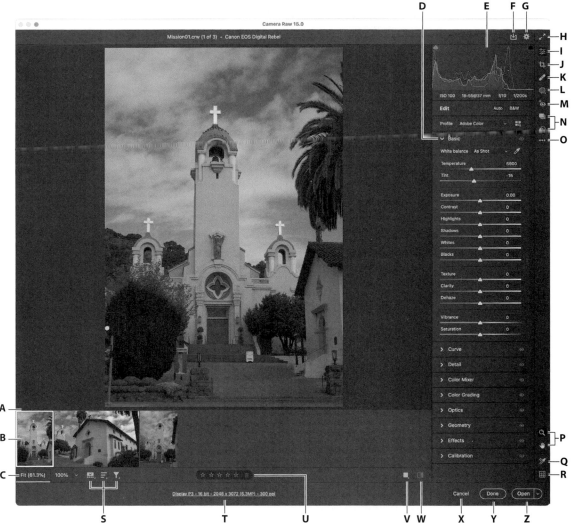

A. Filmstrip divider (drag to adjust)
B. Filmstrip
C. Zoom levels menu
D. Collapsible adjustments panels (in Edit mode; other modes display other options)
E. Histogram
F. Save a copy, with edits, of selected images

G. Camera Raw preference settings
H. Toggle Full Screen mode
I. Edit (image adjustments)
J. Crop & Rotate
K. Healing
L. Masking (local) adjustments
M. Red Eye Removal
N. Snapshots and Presets

O. More Image Settings menu
P. Zoom and Hand tools
Q. Toggle Sampler Overlay
R. Toggle Grid Overlay
S. Filmstrip, Sort, and Filter menus
T. Workflow preference settings
U. Rate, and mark for deletion

V. Before/After Views (click to cycle through options, click and hold for options)
W. Toggle between default and current settings
X. Exit and don't save changes
Y. Exit and save changes
Z. Exit, save changes, and open in Photoshop

4 If the photos appear in a vertical strip along the left side of the Adobe Camera Raw window, click and hold the filmstrip menu button (⊞) and choose Horizontal from the menu that appears. This is so that the layout matches the figures in this lesson. If you prefer the vertical filmstrip, you may use it for your own work.

Note: If more than one image is selected in Camera Raw, in the filmstrip the thumbnails for the selected images display a gray border, and the currently previewed image displays a white border.

The Camera Raw dialog box displays a large preview of the selected image, and a filmstrip displays all open images. The histogram in the upper-right corner shows the tonal range of the selected image. The workflow options below the preview window control the selected image's color space, bit depth, size, and resolution, which you can click to change. Tools along the right side of the dialog box let you zoom, pan, crop, straighten, and make other adjustments to the image.

In the default mode (Edit), Camera Raw displays a stack of collapsible panels under the histogram. You can expand individual panels to edit the selected image's color, tone, detail (sharpening and noise reduction); correct lens distortions; and more. You can also save settings as a preset so that you can apply them to other images.

Note: When you open a raw format image in Camera Raw, its appearance may seem to change. This is because the preview image created by the camera is replaced by a rendering of the current settings in Camera Raw.

The Camera Raw options within the Edit mode are intentionally organized so that you can get good results by using the tabbed panels from top to bottom. But it's okay to adjust the options in any order, and you don't have to adjust every option.

You will explore these controls now as you edit the first image file.

5 For this lesson it will be useful to see the filenames for each image. Click and hold the filmstrip menu button (⊞), and choose Show Filenames.

Note: If the filmstrip disappears, it's because you clicked the filmstrip menu button instead of clicking and holding. Click it again to display the filmstrip.

6 Click each thumbnail in the filmstrip to preview each image before you begin. When you've seen all three, select the Mission01.crw image.

Choosing an Adobe Raw profile

An *Adobe Raw profile* controls the overall color rendering of an image, a separate step combined with the adjustments that you make. You can change the raw profile at any time.

1 If the Profile panel isn't already displayed under the histogram, click the Edit button (⚏). The Profile panel is above the controls, so if it isn't visible, it might be scrolled out of view; scroll the panel stack until you can see the top.

2 Choose Adobe Landscape from the Profile menu.

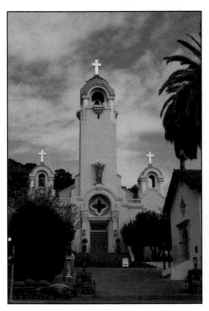

The default profile, Adobe Color, is a general-purpose profile. Adobe Landscape emphasizes colors in nature, like trees and skies, and works well for this image. The goal of Adobe Portrait is natural representation of skin tones, and Adobe Vivid adds punchy color contrast. Adobe Monochrome provides a high-quality conversion to black and white.

▶ **Tip:** You can also move among filmstrip images by pressing the Left Arrow or Right Arrow key. But if you clicked an option's field to edit its value, arrow keys move within the text, so add the Ctrl (Windows) or Command (macOS) key to view other images (for example, press Ctrl/ Command-Right Arrow).

▶ **Tip:** If you want the image to look more like the preview generated by the camera, click the Browse Profiles icon to the right of the Profile menu, scroll down to see the list of profile categories, and try a profile from the Camera Matching category.

● **Note:** Adobe Raw profiles are different than the ICC color profiles used by your display or printer. Raw profiles affect only the conversion and processing of a camera raw file into a conventional image.

▶ Tip: You can use Creative profiles to apply a visual style to an image. Click the Browse Profiles icon (▦) to the right of the Profile menu, scroll down to see the list of profile categories (such as Artistic, B&W, Modern, and Vintage), select one, then click Back.

The profile sets the ranges for the Edit controls, laying the foundation for the more precise edits you'll make in Camera Raw. If the current profile produces a look that's far from what you want, it may be difficult to get there using Edit controls alone. It's better to choose another profile as a better starting point.

Adjusting white balance

An image's white balance represents the color conditions under which it was captured. A digital camera records the white balance at the time of exposure; this is the value that initially appears in the Camera Raw dialog box image preview.

White balance comprises two components. The first is *temperature*, which is measured in kelvins and determines the level of "coolness" or "warmth" of the image—that is, its cool blue-green tones or warm yellow-red tones. The second component is *tint*, which compensates for magenta or green color casts.

Depending on the settings you're using on your camera and the environment in which you're shooting (for example, with artificial light or mixed light sources), you may want to adjust the white balance for the image.

By default, As Shot is selected in the White Balance menu, applying the white balance settings that were in your camera at the time of exposure. If you think you could improve on the current white balance setting, Camera Raw includes several other White Balance presets that you can try.

1 If you can't see White Balance options under the Profile menu, click the Basic panel heading to expand it.

2 Choose Cloudy from the White Balance menu.

▶ Tip: Adjusting white balance is easiest when there is only one light source. When a scene is lit by multiple light sources with different color characteristics, you may have to manually choose a white balance setting and also make masked color corrections over specific areas.

Camera Raw adjusts the temperature and tint for a cloudy day. Sometimes a preset is an instant fix. In this case, though, there's still a blue cast to the image. You'll adjust the white balance manually.

3 Select the White Balance tool (🖋) to the right of the White Balance menu.

To set an accurate white balance, select an object that should be white or gray. The spot where you click becomes a reference for neutral white balance; Camera Raw shifts the image colors accordingly.

4 Click the white clouds in the image. The color balance of the image changes.

5 Click a different area of the clouds. The color balance shifts again, because that area of the clouds has slightly different color values.

To find the best color balance quickly and easily, click the White Balance tool on an area that should be neutral. Clouds are not always a neutral color, depending on the time of day. In Camera Raw, clicking different areas changes color balance without altering the original image file, so you can experiment freely.

6 Click the white area of the small sign in front of the church. This removes most of the color casts.

 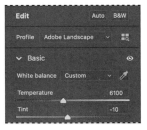

▶ **Tip:** Clicking a known neutral area, such as the sign in step 6, applies White Balance values that result in a neutral image, with unwanted color casts removed. You are then free to use options such as White Balance expressively. For example, apply a higher Temperature value to make a scene appear shot closer to sunset, or simply to evoke a warmer mood.

▶ **Tip:** To toggle
between current and
default settings with
the keyboard, press the
backslash (\) key. To
cycle through the
Before/After Views
menu, press Q.

7 To see the changes you've made, click and hold the Before/After Views button (■)
at the bottom of the window, and choose Before/After Left/Right from the pop-up
menu. (If you only click without holding, it cycles to the next option.)

▶ **Tip:** To expand
Camera Raw to fill the
screen, click the Toggle
Full Screen Mode
button (↗) near the
top-right corner of the
window, or press F.

Camera Raw displays the Before image on the left and the After image on the right
so you can compare them.

8 To see only the After image again, click and hold the Before/After Views menu
and choose Single View. Or, if you prefer, you can leave both views visible so you
can see how the image changes as you continue to alter it.

Making tonal adjustments in Camera Raw

The group of options in the middle of the Basic panel (starting with Exposure) affects how tones are distributed from dark to light in the image. Except for Contrast, moving a slider to the right in that group lightens the areas of the image that it affects, and moving it to the left darkens those areas. Exposure sets the overall brightness of the image. The Highlights and Shadows options control detail in near-white and near-black tones, respectively. The Whites option defines the *white point*, or the lightest tone of the image; tones above its value are made white. Conversely, the Blacks option sets the *black point*, or the darkest tone in the image; tones above its value are made black.

Dragging the Contrast slider to the right moves darker and lighter midtones away from the midtone; dragging left moves those tones toward the midtone. For more nuanced contrast adjustments, you can use the Clarity option, which adds depth to an image by increasing local contrast, especially around the midtones.

The Saturation option adjusts the intensity of all colors in the image equally. The Vibrance option is often more useful because it has a greater effect on undersaturated colors. For example, you can use Vibrance to bring life to an image without oversaturating any skin tones in it.

1 Click Auto at the top of the Edit mode panel stack.

▶ **Tip:** To apply Clarity properly, increase the Clarity slider until you see halos near the edge details, and then reduce the setting until the halos are not distracting.

▶ **Tip:** Clicking Auto again toggles between default settings and Auto settings.

The Auto button changes several settings in the Basic panel, and the image is greatly improved. Auto correction may produce a useful image right away, because it's based on advanced Adobe Sensei machine learning technology, which is trained using a wide variety of professionally corrected sample images. This makes Auto a quick way to reach a good starting point for your own edits. If you like the results, you can study and learn from the adjustments made by Auto. You can also choose to keep some Auto adjustments and change others. Or you can enter your own adjustments, as you are about to do.

► **Tip:** When adjusting tones, watch out for highlight or shadow clipping (loss of detail from over-adjustment). One way to preview clipping is to hold down the Alt (Windows) or Option (macOS) key while dragging a slider for Exposure, Highlights, Shadows, Whites, or Blacks. When Alt/ Option-dragging those sliders, pixels are OK if they appear black (for Exposure, Highlights, and Whites) or white (for Shadows and Blacks); otherwise, they are clipped.

2 Set the options as follows:

- Exposure: +**0.50**

- Contrast: +**0**

- Highlights: -**20**

- Shadows: +**70**

- Whites: +**20**

- Blacks: −**10**

- Clarity: +**20**

- Vibrance: +**20**

These settings brighten the image, especially the dark shadow areas, and boost color without oversaturating it.

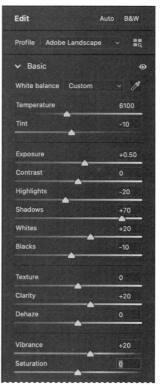

About adjusting color in Adobe Camera Raw

Over time, Adobe Camera Raw has added a number of features that allow multiple approaches to color correction and adjustment. Performing major color edits at the raw stage can be more forgiving and preserve original image quality better than making those edits in Photoshop. If you capture a raw image properly in camera, you may not need to do much more than apply an appropriate raw profile, White Balance setting, and Auto correction. When you want to solve more complex color issues in Camera Raw, you can try its other precise color tools (some of which are outside the scope of this book):

Masked adjustment tools. To apply different color or tone settings to specific areas of an image, you can click the Masking icon to add an adjustment restricted to those areas by masks you can edit. To save time, Camera Raw offers some automatically generated masks, such as Select Subject, Select Sky, Select Background, and Select People. For more information, see the sidebar "About Camera Raw mask types" later in this lesson.

Curve panel. Like Curves in Photoshop, you can use the Curve panel in Camera Raw to edit each color channel separately, adjusting the amount of a color channel at any level from black to white. This is one way to compensate for color casts that vary across highlights, midtones, and shadows.

Color Mixer panel. The Color Mixer panel lets you adjust specific ranges of colors by hue, saturation, or luminance. When you click the B&W button at the top of the Edit mode panel stack, you can use the Color Mixer to customize a color to black-and-white conversion similar to how you did in Photoshop at the end of Lesson 2.

Color Grading panel. In the Color Grading panel you can use color wheels to adjust the hue, saturation, and luminance separately for midtones, shadows, and high-lights. This type of tool is familiar to video editors. Although you can use it for color correction, conventional color grading is typically a step applied after color correction, to create an expressive color palette for a "look" or for split toning effects.

Custom raw profiles. It's possible to use Photoshop to create custom color lookup tables (CLUTs) that you can use as the basis for your own raw profile that you can apply with one click in Camera Raw.

Calibration panel. The Calibration panel adjusts the fundamental color conversion from camera raw format, which affects the range of adjustment that's possible with the rest of the panel. Today, raw profiles are a more convenient way to tune that conversion, so now the Calibration panel tends to be used as another creative option for altering color relationships within an image.

Those tools are outside the scope of this book, but when you are in Photoshop (not Camera Raw), you can learn more about them in the Search panel (Edit > Search), which also contains interactive tutorials and help documents.

The histogram in the upper-right corner of the Camera Raw dialog box simultaneously shows the red, green, and blue channels of the selected image and updates interactively as you adjust settings. As you move any tool over the preview image, the RGB values for the area under the pointer appear in the histogram. Selecting the icons at the top corners enables image overlays that indicate clipping. A red overlay marks clipped highlight detail, and blue marks clipped shadow detail.

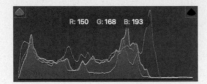

Applying sharpening

Photoshop offers several ways to sharpen, but when an image is in raw format, it's good to apply basic sharpening in the Detail panel in Camera Raw. To see the best preview of sharpening, view the image at 100% or greater magnification.

1 Click the Zoom Levels menu (41.6% ⌄) near the bottom-left corner of the window to zoom in to 100%. Then select the Hand tool (✋), and drag the image preview to pan (slide) it down until you see the cross at the top of the mission tower.

2 In the Edit mode panel stack under the histogram, scroll down until you see the Detail panel, and click its heading to expand it.

The Sharpening option determines how much Camera Raw emphasizes fine details. One approach is to exaggerate the Sharpening value at first to more easily see the effect of other sharpening options, and after those settings are tuned, reduce the Sharpening value back down to a more realistic level.

3 Change the Sharpening value to **100**.

4 Click the disclosure triangle above the right end of the Sharpening slider to reveal more options.

Many Camera Raw features have advanced options that are hidden to save space. If you see a disclosure triangle along the right side, you know there are more options available there if you need them.

5 Change the Radius value to **0.9**.

The Radius option determines how far out from a pixel that sharpening is applied. For properly focused images without motion blur, a Radius value of 1 pixel works well to start. You might decrease the Radius value for images with fine details that are precisely focused or increase Radius to help sharpen blurred details.

6 Change the Detail value to **25**, unless it's already set that way.

The Detail option controls the balance between sharpening edges and textures for images with fine details. Lower values draw sharpening toward edges leaving broad areas smoother; higher values can bring out textures in broad areas.

7 Change the Masking value to **61**.

The Masking slider is similar to the Detail slider in that it helps keep sharpening constrained along content edges, but Masking is more generally useful because it isn't just for fine details. A higher Masking value makes it easier to increase the Sharpening value without oversharpening noise and textures in broad areas of the image that should look smooth, such as a face or the sky. Lower the Masking value when you want Sharpening to emphasize details in broad areas, such as the weave of threads in fabric.

▶ **Tip:** Want to see what Masking is actually doing? Press Alt (Windows) or Option (macOS) as you drag the Masking slider. White indicates areas Camera Raw will sharpen; black areas will be left alone.

After you've adjusted the Radius, Detail, and Masking sliders, you can lower the Sharpening slider to a more reasonable final value.

8 Decrease the Sharpening slider to **70**.

Your Camera Raw edits are saved in XMP format "sidecar" files that are stored in the same folder as the original file and have the same base filename with an .xmp filename extension. If you also added masked (local) adjustments, you may also see an .acr sidecar file with the same base filename. When you move a raw image edited in Adobe Camera Raw to another computer or storage medium, be sure to move its XMP file (and ACR file, if present) with it. Camera Raw doesn't save changes into an original raw file, because raw files are intended to be read-only. Adobe Camera Raw can include edits in the same file as the raw image when exporting to the open Adobe DNG raw format.

Synchronizing settings across images

All three of the church images were shot at the same time under the same lighting conditions. Now that you've made the first one look great, you can automatically apply the same settings to the other two images using the Synchronize command.

1 Click and hold the filmstrip menu button (🔽), and choose Select All to select all of the images in the filmstrip.

2 Click and hold the filmstrip menu button again, and choose Sync Settings.

The Synchronize dialog box appears, listing all the settings you can apply to the images. By default, all options except Geometry, Crop, Healing, and Masking are selected. For this project, you can accept the default selections, even though you didn't change all the settings.

3 Click OK in the Synchronize dialog box.

● **Note:** A yellow alert triangle may temporarily appear over a preview or thumbnail image while Camera Raw is synchronizing settings to that image. When the triangle goes away, the preview or thumbnail is up to date.

When you synchronize the settings across all of the selected images, the thumbnails update to reflect the changes you made. To review the changed images, click each thumbnail in the filmstrip.

● **Note:** It's always a good idea to review images altered by synchronizing settings. Some images may have slight variations in tone and color that may require a few more minor adjustments.

Saving Camera Raw changes as new files

Many applications don't read raw files, so before sharing them, it's typically necessary to save them in a more common image file format. First, you'll save the images with adjustments as low-resolution JPEG files that you can share on the web. Then, you'll save one image, Mission01, as a Photoshop file that you can open as a Smart Object in Photoshop. When you open an image as a Smart Object in Photoshop, you can return to Camera Raw at any time to make further adjustments.

1 In the Camera Raw dialog box, click the filmstrip menu button, and choose Select All to make sure all three images are selected.

2 Click the Convert And Save Selected Images button (⎚) near the top-right corner of the Camera Raw window.

3 In the Save Options dialog box, do the following:

- Choose Save In Same Location from the Destination menu.
- In the File Naming area, leave "Document Name" in the first box.
- Choose JPEG from the Format menu, and set the Quality level to High (8–9).
- In the Color Space area, choose sRGB IEC61966-2.1 from the Space menu.
- In the Image Sizing area, select Resize To Fit, and then choose Long Side from the Resize To Fit menu.
- Enter **800** pixels. This will set the long side of an image to 800 pixels whether it's a portrait (tall) or landscape (wide) image. When you choose Long Side, the dimension of the short side will automatically be adjusted proportionally.
- Type **72** pixels/inch for the Resolution value.

These settings will save your corrected images as smaller, downsampled JPEG files, which you can share with colleagues on the web. They'll be resized so that most viewers won't need to scroll to see the entire image when it opens. Your files will be named Mission01.jpg, Mission02.jpg, and Mission03.jpg.

4 Click Save.

▶ **Tip:** If your images contain metadata that you consider private, you can restrict what metadata is included when you save copies from Camera Raw. For example, if your images contain camera information, keywords such as names of people, a copyright notice, and other metadata you entered in Bridge, choose Copyright Only from the Metadata menu to include only the copyright notice.

In the Camera Raw dialog box, a readout in the bottom-left corner indicates how many images have been processed until all the images have been saved. The CRW thumbnails still appear in the Camera Raw dialog box. However, in the Mission folder, you now also have JPEG versions as well as the original raw image files, which you can continue to edit or leave for another time.

Now you'll open a copy of the Mission01 image in Photoshop.

5 Select the Mission01.crw image thumbnail in the filmstrip in the Camera Raw dialog box. Then click the menu of options to the right of the Open button, and choose Open as Object.

● **Note:** If you see a message that says "Skip loading optional and third-party plug-ins?" click No. The message appears if the Shift key is held down when Photoshop starts up.

The Open as Object button opens the image as a Smart Object layer in Photoshop: Instead of converting the camera raw file to Photoshop format, it's preserved in camera raw format inside the Photoshop document. This lets you continue making raw-based adjustments at any time, by double-clicking the Smart Object thumbnail in the Layers panel to open Camera Raw. If, instead, you had clicked Open, the image would be permanently converted into a normal Photoshop layer, and no more raw format edits would be possible.

▶ **Tip:** To change the Open button so that it's always an Open Object button, click the underlined workflow options link at the bottom of the Camera Raw dialog box, select Open In Photoshop As Smart Object, and click OK.

● **Note:** If Photoshop displays a dialog box telling you about the difference between saving to Cloud Documents and On Your Computer, click Save On Your Computer. You can also select Don't Show Again, but that setting will deselect after you reset Photoshop preferences.

6 In Photoshop, choose File > Save As. In the Save As dialog box, choose Photoshop for the format, rename the file **Mission_Final.psd**, navigate to the Lesson12 folder, and click Save. Click OK if the Photoshop Format Options dialog box appears. Then close the file.

A photographer for more than 25 years, Jay Graham began his career designing and building custom homes. Today, Graham has clients in the advertising, architectural, editorial, and travel industries.

See Jay Graham's portfolio on the web at jaygraham.com.

Pro photo workflow

Good habits make all the difference

A sensible workflow and good work habits will keep you enthused about digital photography, help your images shine, and save you from the night terrors of losing work you never backed up. Here's an outline of the basic workflow for digital images from a professional photographer with more than 25 years' experience. To help you get the most from the images you shoot, Jay Graham offers guidelines for setting up your camera, creating a basic color workflow, selecting file formats, organizing images, and showing off your work.

Graham uses Adobe Lightroom® Classic to organize thousands of images.

"The biggest complaint from people is they've lost their image. Where is it? What does it look like?" says Graham. "So naming is important."

Start out right by setting up your camera preferences
If your camera has the option, it's generally best to shoot in its camera raw file format, which captures all the image information you need. With one camera raw photo, says Graham, "you can go from daylight to an indoor tungsten image without degradation" when it's reproduced. If it makes more sense to shoot in JPEG for your project, use fine compression and high resolution.

Start with the best material
Get all the data when you capture—at fine compression and high resolution. You can't go back later.

Organize your files
Name your images as you import them into the Lightroom catalog. "If the camera names files, eventually it resets and produces multiple files with the same name," says Graham. Use Adobe Lightroom Classic to rename, rank, and add metadata to the photos you plan to keep; cull those you don't.

Graham names his files by date (and possibly subject). He would store a series of photos taken October 18, 2017, at Stinson Beach in a folder named 171018_stinson. Within the folder, he names each image incrementally; for example, the first image would be named 171018_stinson_01. This should result in a truly unique filename for each image. "That way, it lines up on the hard drive really easily," he says. Follow Windows naming conventions to keep filenames usable on non-Macintosh platforms (32 characters maximum; only numbers, letters, underscores, and hyphens).

Convert raw images to DNG
Consider converting your camera raw images to the DNG format. Unlike many cameras' proprietary raw formats, the specifications for this format are publicly available so that software developers and device makers can more easily support it.

Keep a master image
Save your master in PSD, TIFF, or DNG format, not JPEG. Each time a JPEG is re-edited and saved, compression is reapplied, and the image quality degrades.

Show off to clients and friends
When you prepare your work for delivery, choose the appropriate color file for the destination. Convert the image to that profile, rather than assigning the profile. sRGB is generally best for viewing electronically or for printing from most online printing services. Adobe 1998 and Colormatch are the best profiles to use for RGB images destined for traditionally printed materials such as brochures. Adobe 1998 and ProPhoto RGB are best for printing with inkjet printers. Use 72 dpi for electronic viewing and 180 dpi or higher for printing.

Back up your images
You've devoted a lot of time and effort to your images: Don't lose them. To protect your photos against a range of potential disasters, it's best to have backups on multiple media such as external storage and a cloud backup service, set to back up automatically. "The question is not if your [internal] hard drive is going to crash," says Graham, reciting a common adage. "It's when."

About saving files from Camera Raw to other formats

Note: The Camera Raw dialog box doesn't have a traditional Save command (remember, the Save button actually exports a copy of each selected image). Your changes are saved when you click Done or Open, but that closes Camera Raw. The Cancel button discards all changes made during a Camera Raw session, so take care not to click the Cancel button unless you really want to start over. Avoid pressing the Esc key, a shortcut for the Cancel button.

Most websites, applications, and social media apps can't read a camera raw file or its corresponding metadata file that contains image edits, keywords, and other information you added. One way to prepare a camera raw file for other applications is to click the Open button in Adobe Camera Raw so that the image opens in Photoshop, where you can save or export the file using Photoshop commands.

If you don't need to edit the image further using Photoshop features, you can skip the step of continuing on to Photoshop. In Camera Raw you can use the Convert And Save Image button (⬇) to convert selected images to the Adobe DNG, JPEG, TIFF, or PSD format, and save those images to new files in that format.

- The **DNG (Adobe Digital Negative)** format contains raw image data from a digital camera along with metadata that defines how the image data should look. DNG is intended to be an industry-wide standard format for raw image data, helping photographers manage the variety of proprietary raw formats and providing a compatible archival format. (You can save this format only from the Camera Raw dialog box.)

- The **JPEG (Joint Photographic Experts Group)** file format is commonly used to display photographs and other continuous-tone RGB images on the web. JPEG compresses file size by selectively discarding data, starting with the visual information that our eyes are least likely to notice. The greater the compression, the lower the image quality.

- **TIFF (Tagged Image File Format)** is a flexible format supported by virtually all paint, image-editing, and page layout applications. It can save Photoshop layers. TIFF images can also be produced by most applications that control image capture hardware such as scanners.

- **PSD format** is the Photoshop native file format. Because of the tight integration between Adobe products, other Adobe applications such as Adobe Illustrator, Adobe InDesign, and Adobe After Effects can directly import PSD files and preserve many Photoshop features.

If you do click the Open button in Camera Raw to convert and open a raw file in Photoshop, you can save a copy of or export it in the additional formats that Photoshop offers, including Large Document Format (PSB), Photoshop PDF, GIF, or PNG. You may also see the Photoshop Raw format (RAW), a specialized technical file format that is not commonly used by photographers and designers—do not confuse Photoshop Raw format with camera raw files.

For more information about file formats in Camera Raw and Photoshop, see Photoshop Help.

Retouching a portrait in Camera Raw

The image editing features in Camera Raw are deep enough that it's possible to perform most correction tasks at the raw level, using Photoshop only when you need to do more advanced retouching or masking. When you don't need to continue on to Photoshop, you can simply save finished images directly from Camera Raw. You'll use a range of Camera Raw tools to improve a raw image of a bride.

Making initial corrections

The default rendering of the raw image uses the Adobe Color profile and has a slight color cast. You'll get started by correcting both.

1 In Bridge, navigate to the Lesson12 folder. Select the 12B_Start.nef file, and choose File > Open In Camera Raw.

2 In the Edit options, choose Adobe Portrait from the Profile menu, to apply a more portrait-friendly initial rendering.

3 In the Basic panel in Camera Raw, select the White Balance tool (🖊), and then click a white area in the model's dress to remove a green color cast.

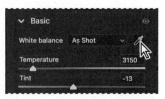

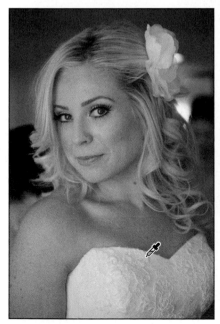

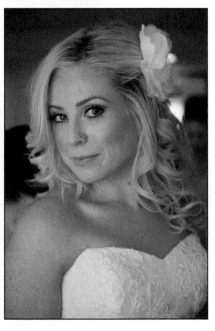

Tip: You can try other profiles to see if they work better. For this image, Adobe Color produces a similar result to Adobe Portrait, but other profiles may be too garish or contrasty for skin tones.

Tip: It may work better to click a white area of the dress that is directly lit rather than in shade. The white balance of a neutral area facing the light source is more likely to be consistent with the white balance of the light source. A neutral area in shadow might be shifted by the color of light reflected by nearby surfaces.

4 Click the filmstrip menu button (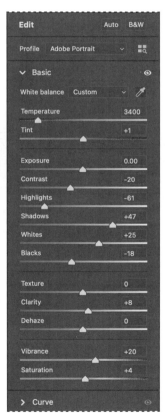) to hide it. With only one file open, you don't need to use the filmstrip. Hiding it frees up more screen space for viewing the image.

5 In the Edit options, click Auto.

The Auto corrections improve the image; the automatic Highlights adjustment reveals more detail in the white dress and lace hair piece. However, some of the changes go too far, so you'll edit certain settings.

6 Adjust specific Basic panel options:

- Double-click the slider control for Exposure to reset its value to **0**. Double-clicking is a shortcut for resetting an option to its default value.

- Set Contrast to **−20**.

- Set Clarity to **+8**.

▶**Tip:** Be careful when applying Clarity or Texture to a portrait. Higher values may emphasize skin texture and surface characteristics such as freckles and wrinkles. Apply higher Clarity and Texture values only to specific areas, by using the masked adjustment tools covered later.

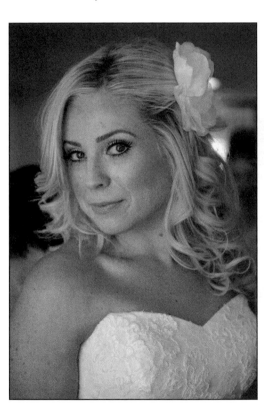

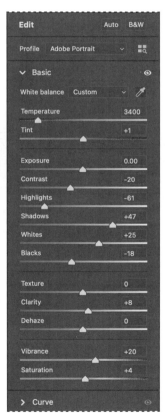

Using the Content-Aware Remove tool to correct blemishes

Now you're ready to give the model's face some focused attention. You'll use the Content-Aware Remove tool to hide blemishes and smooth the skin.

Tip: In Lesson 2, you used the Spot Healing Brush and Patch tool in Photoshop. Camera Raw offers similar Healing tools when you want to make similar edits at the raw editing stage.

1 In the toolbar along the right edge of the Camera Raw window, click the Healing icon (✐). Under the Histogram, Healing tools replace the Edit tools.

2 In the Healing options, select the Content-Aware Remove tool (✦).

The Content-Aware Remove tool can delete content such as skin blemishes and seamlessly fill them in with surrounding content. It's similar to the Spot Healing Brush tool you used in Photoshop in Lesson 2.

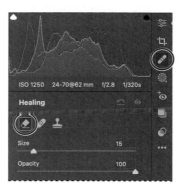

3 Set the view magnification to 100%.

4 In the Healing options, set Size to **15**, and Opacity to **100**.

About Camera Raw healing tools

What are the differences between the three Healing tools in Camera Raw? They're similar to the differences among the healing tools in Photoshop.

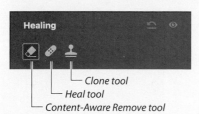

Clone tool
Heal tool
Content-Aware Remove tool

Content-Aware Remove tool. Deletes content you brush over and intelligently replaces it with content from surrounding areas. All you have to do is brush over what you want to remove. It's possible to sample a specific content source if needed.

Heal tool. Replaces content you brush over with content sampled from another part of the image, but blended in so that it's seamlessly healed.

Clone tool. Replaces content you brush over with content sampled from another part of the image, but without blending it in. Similar to the Clone Stamp tool in Photoshop, use the Clone tool in Camera Raw when you want to paint content exactly as it is in another part of the image.

The Heal and Clone tools let you change the sampling point for filled-in content. The Content-Aware Remove tool pulls content from around the area you brushed.

▶ **Tip:** If the area filled by the Content-Aware Remove tool is not seamless because it used nearby content that's visually inconsistent, as long as that edit is selected you can Ctrl-drag (Windows) or Command-drag (macOS) somewhere else in the image to define a different source for that edit.

5 Click one of the spots on the face. The Content-Aware Remove tool fills in the spot you clicked using the content around it.

6 Drag the Content-Aware Remove tool over the dark blemish on the neck. Dragging is useful here because the current Size setting may not be able to remove the entire blemish in one click.

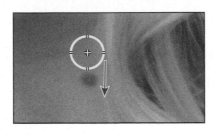

7 If Show Controls is enabled in the Healing tools, click to disable it so that you can better see the results of your corrections.

▶ **Tip:** You can toggle Show Controls with the keyboard by pressing the V key.

When Show Controls is enabled, you can see the locations of that tool's edits on the image, represented by icons. This lets you select and then change or delete your edits. When an edit draws from source content elsewhere in the image (more common when using the Heal or Clone tool), Show Controls shows you where the source is and lets you drag the source to change its location.

8 Brush over fine lines around the eyes and mouth. You can also brush away freckles and minor blemishes on her face, neck, arms, and chest. Experiment with simply clicking, using very short strokes, and creating longer brush strokes.

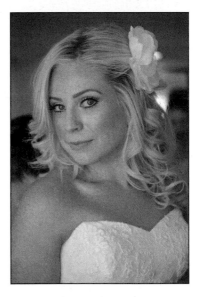

Remove distracting lines and blemishes, but leave enough that the face retains its character. You can practice by removing the jewelry on the nose, but on a real job, it may be preferable to leave the jewelry visible if it's meaningful to the subject and part of their character. The safe thing to do is to ask the subject before removing personal decoration such as jewelry.

You can also experiment with removing blemishes with the Heal tool instead of the Content-Aware Remove tool. In general, the Heal tool may do a better job of preserving existing textures.

Enhancing the face with masked adjustments

You'll use masked adjustments to brighten the eyes and lips. A mask constrains the adjustment to a specific area. Applying a Camera Raw masked adjustment is similar to painting white in an adjustment layer mask in Photoshop.

1 Use the Hand tool to change the view so that you can see the eyes.

2 Click the Masking icon (⚙), and then click Brush. The Masking panel appears, listing a New Mask and New Brush in italic because they have not yet been created. They will be created as soon as you use the brush.

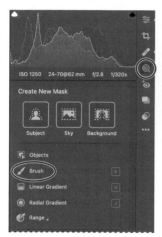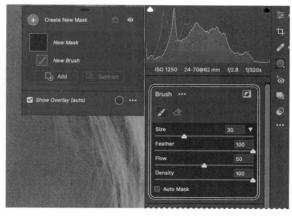

Notice that the Edit settings that were under the histogram are now under a Brush heading. When a masked adjustment is selected in the masks panel, the settings shown are for that selected adjustment—not for the entire image. You'll change Brush settings to set up what this Brush adjustment will do. You want it to increase the saturation of whatever you brush, in this case the irises of the eyes.

3 In the Brush options, change settings as follows:

- Size: **2**

- Feather: **100**

- Flow: **50**

- Density: **100**

- Auto Mask: **Off**

4 Scroll the Brush settings until you see the Color panel, and set Saturation to **+70**.

5 Drag the Brush tool over the irises in the eyes to increase their saturation.

6 If you think the irises are oversaturated, make sure Brush 1 is still selected in the masks panel, and then reduce the Saturation value until it looks reasonable.

Mask 1 no longer appears in italics because the mask was created after you brushed. If you make many masks, naming them helps you identify them later.

7 In the masks panel, double-click Mask 1, rename it **Eye Irises**, and click OK.

8 In the masks panel, select the Show Overlay option to enable it.

▶ **Tip:** When you hold down the Alt or Option key to use the Brush adjustment in Erase mode, the Brush settings may change. That's because Erase mode can have different Brush settings.

A red overlay appears, showing you where you brushed. If you see areas you did not intend to brush with the current adjustment, as long as the brush mask is selected in the masks panel you can subtract areas from the mask by holding down the Alt (Windows) or Option (macOS) key as you brush.

Now you'll create another brush mask to desaturate the red corners of the eye.

9 In the masks panel, click the blue Create New Mask button, and choose Brush.

10 In the Color panel, set Saturation to **−50**, and brush the red corners of the eyes.

 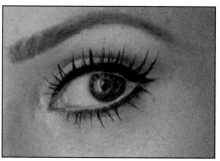

11 In the masks panel, double-click Mask 1, rename it Eye Corners, and click OK.

Note: You may notice the Add button within the Eye Irises mask. The reason you do not click Add in step 8 is that Add creates another submask within Eye Irises. Eye Irises adds Saturation, and all submasks within Eye Irises would do the same. But now you want to desaturate, so you need to create a different mask, not a submask of Eye Irises. Add is useful when you want to control multiple submasks using the same settings.

Now you'll use another brush adjustment to brighten other areas around the eyes.

12 In the masks panel, click the blue Create New Mask button, and choose Brush.

13 Scroll the Brush settings until you see the Light panel, and set Exposure to **+.50**.

14 Brush over the white areas of the eyes, the irises, and the shadows above the eye.

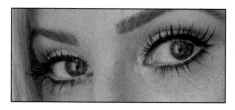 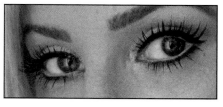

15 In the masks panel, double-click Mask 1, rename it Eye Brighten, and click OK.

Now step back and review your work.

16 In the masks panel, click the eye icon for the Eye Brighten mask to hide it; then click it again to show it. Evaluate whether you need to adjust anything, and make any needed adjustments to that mask while it is selected.

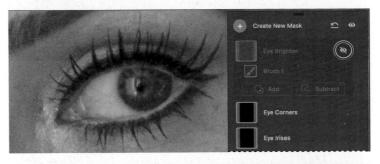

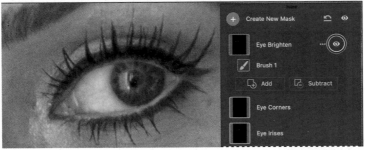

For example, if Exposure is too strong, make sure the Eye Brighten mask is selected in the masks panel and reduce the Exposure value. You can experiment with how other Light settings affect this mask, such as Shadows and Whites, to find the right combination. Or create more brush masks with different settings for each area.

Using Camera Raw as a filter

▶ **Tip:** As with other filters, if you want to be able to edit Camera Raw Filter changes at any time in the future, first convert the Photoshop layer to a Smart Object (such as by choosing Filter > Convert for Smart Filters) and apply the Camera Raw Filter to that Smart Object.

In this lesson, Camera Raw is used to preprocess a camera raw file before saving a converted copy in a standard file format, or opening the camera raw file in Photoshop after converting it to a Photoshop document.

Some features in Camera Raw, such as Texture and Clarity, are not available in Photoshop. But you can use those features in Photoshop by using Camera Raw as a filter on a selected Photoshop layer. For example, if you're working on a document in Photoshop and you want to use the Texture or Clarity options on a layer, select that layer in the Layers panel, and choose Filter > Camera Raw Filter. That opens the layer in Camera Raw, where you can apply Texture or Clarity. When you click OK to close Camera Raw, the Photoshop layer is updated with the Camera Raw changes.

Some Camera Raw features, such as the Crop tool and Save option, are not available when you use Camera Raw as a filter. It's usually because the missing features are intended to work with an entire document, but when used as a filter, Camera Raw is operating only on a layer within a Photoshop document.

Smoothing skin texture

In Camera Raw you can use a masked adjustment that automatically recognizes skin on people so that it's easier to retouch skin without affecting the entire raw image.

1. Set the view magnification to Fit.

2. In the masks panel, click the Create New Mask button, and choose Select People.

Camera Raw searches for people in the image, which may take a few moments. Then, under Person Mask Options, a list of identified people appears. In this image, there is only one person. Mask 1 appears in the masks panel; this is the current mask. A red overlay for Mask 1 appears over the image.

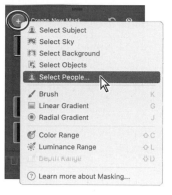

▶ **Tip:** You can also select a color range and skin tones when an image is open in Photoshop. Choose Select > Color Range, and in the Color Range dialog box, choose Skin Tones from the Select pop-up menu.

3. In Person Mask Options, if options are not active, click the circular Person thumbnail to select it.

4. Make sure that Face Skin and Body Skin are selected and that all the other options are deselected, and click Create.

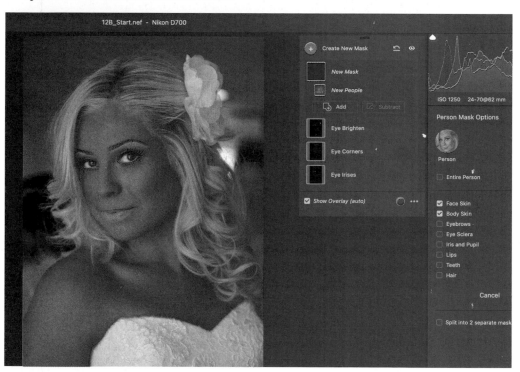

Camera Raw automatically isolates face and body skin areas and creates masks for those areas—you didn't have to do any manual masking. It creates a new Mask 1 with separate Body Skin and Face Skin submasks for the person (named Person 1).

5 Make sure Mask 1 is selected.

6 You'll need to see skin details, so set the view magnification to 100%.

7 In the options for Mask 1, scroll until you see the Effects panel, and set the Texture value to **−30**.

 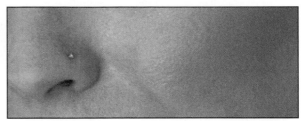

 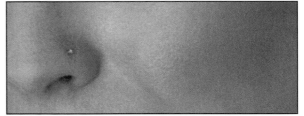

You should see the skin texture become smoother, because a negative Texture value de-emphasizes detail. (If you didn't notice the change, toggle the eye icon for Mask 1 in the masks panel.) Again, if you think the adjustment is too much or too little, go ahead and adjust the Texture value while Mask 1 is selected in the masks panel.

While the skin mask is selected, it's a good time to also make any other skin tone or color adjustments you think are needed. For example, if there is a color cast to remove from the skin, try adjusting options in Mask 1 panels such as Color and Curve. (If you want to correct a color cast across the entire image, after step 8 click the Edit button to exit masking; then adjust options in the general Edit panels.)

8 In the masks panel, double-click Mask 1, rename it **Skin**, and click OK.

9 Click the Edit button (⅗) to close the masks panel, and set the view magnification to Fit so that you can review the entire image.

You opened an image from Bridge into Camera Raw and performed portrait retouching, without opening Photoshop. If you need a finished copy to distribute, you can click the Save icon as you did with the mission buildings earlier in this lesson. If you want to apply more advanced retouching techniques that Camera Raw can't do, you can click Open to convert the image into a Photoshop document and continue editing in Photoshop. But for now, let's make sure all of the work you did in Camera Raw is saved.

10 Click Done. Great work!
 The Done button saves your changes and closes Camera Raw, returning you to Bridge.

About HDR and panoramas in Camera Raw

When you select multiple images in Camera Raw, you can choose Merge to HDR or Merge to Panorama by clicking and holding the filmstrip menu button. HDR (high dynamic range)

requires darker and lighter exposures of the same composition, while a panorama requires multiple exposures as tiles of a larger scene. Photoshop also has HDR or panorama features, but the newer process in Camera Raw is simpler, provides a preview, can process in the background, and produces a DNG file that you can edit in Camera Raw with the flexibility of a raw format image.

About Camera Raw mask types

Masking corrections in Camera Raw can potentially save you a trip to Photoshop. Camera Raw offers more mask types than the ones you used in this lesson.

Subject, Sky, Background, and People. Camera Raw uses machine learning to recognize specific types of content and create a mask for them, similar to the Select > Sky and Select > Subject commands and Object Selection tool in Photoshop.

The difference between Subject and People is that Subject can also identify and mask objects that are not people.

Objects. When Select Subject doesn't select what you want, drag the Select Objects masking tool around a specific object to select it more precisely.

Linear Gradient and Radial Gradient. Creates a mask that fades out gradually from one end to the other (for a Linear Gradient) or from the center of an ellipse outwards (for a Radial Gradient). A Linear Gradient can be useful for equalizing tone or color differences on different sides of an image. A Radial Gradient is useful for emphasizing part of an image or creating an off-center vignette.

Color Range, Luminance Range, and Depth Range. A range mask is defined by a range of colors (Color Range), tones (Luminance Range), or distances (Depth Range) that you specify. For example, if you specify a Luminance Range mask that targets just the shadow tones in an image, you can then increase Exposure and reduce Noise across that range of tones only. Or you can create a Color Range mask that targets skin tones.

The Depth Range mask is available only if a camera embedded depth metadata into the image, as some smartphone cameras do.

Review questions

1 How is editing a camera raw image different than editing a photo in a format such as JPEG or Photoshop file format?

2 What is the advantage of the Adobe Digital Negative (DNG) file format?

3 How can you apply the same settings to multiple images in Camera Raw?

4 How do you apply a Camera Raw edit to specific areas of an image?

Review answers

1 A camera raw file contains unprocessed picture data from a digital camera's image sensor. Camera raw files give photographers control over interpreting the image data, rather than letting the camera make the adjustments and conversions. When you edit the image in Camera Raw, it stores the edits separately while leaving the original raw file untouched. This way, you can edit the image the way you want, export it, and keep the original intact for future use or other adjustments.

2 The Adobe Digital Negative (DNG) file format contains the raw image data from a digital camera as well as metadata that defines what the image data means. DNG is an industry-wide standard for camera raw image data. DNG can help photographers manage proprietary camera raw file formats using an openly available standard, and it provides a compatible archival format that includes edits.

3 To apply the same settings to multiple images in Camera Raw, select the images in the filmstrip, click the filmstrip menu button, and choose Sync Settings. Then select the settings you want to apply, and click OK.

4 To apply a Camera Raw edit to specific areas of an image, click the Masking icon, and create a new mask that isolates the areas you want to edit.

13 PREPARING FILES FOR THE WEB

Lesson overview

In this lesson, you'll learn how to do the following:

- Use the Frame tool to create a placeholder for a layout.

- Create and stylize a button for a website.

- Use layer groups and artboards.

- Optimize design assets for the web.

- Record an action to automate a series of steps.

- Play an action to affect multiple images.

- Save entire layouts and individual assets using Export As.

- Design for multiple screen sizes with multiple artboards.

 This lesson will take about an hour to complete. To get the lesson files used in this chapter, download them from the web page for this book at adobepress.com/PhotoshopCIB2023. For more information, see "Accessing the lesson files and Web Edition" in the Getting Started section at the beginning of this book.

As you work on this lesson, you'll preserve the start files. If you need to restore the start files, download them from your Account page.

PROJECT: MUSEUM WEBSITE

Artboards let you create multiple designs in a single Photoshop document. For example, you can consistently design both the mobile and desktop versions of a website. When it's ready, the Export As workflow makes it easy to save layers, layer groups, and artboards as separate image assets that you can deliver to a web developer, or for review.

Getting started

In this lesson, you will build buttons for the home page of an art museum's website and then generate appropriate graphics files for each button. You'll use layer groups to assemble the buttons and then create actions to prepare a set of images for use as a second group of buttons. First, you'll view the final web design.

1 Start Photoshop, and then simultaneously hold down Ctrl+Alt+Shift (Windows) or Command+Option+Shift (macOS) to restore the default preferences. (See "Restoring default preferences" on page 5.)

2 When prompted, click Yes to delete the Adobe Photoshop Settings file.

3 Choose File > Browse In Bridge.

Note: If Bridge isn't installed, the File > Browse In Bridge command in Photoshop will start the Creative Cloud desktop app, which will download and install Bridge. After installation completes, you can start Bridge. For more information, see page 3.

4 In Bridge, click Lessons in the Favorites panel. Double-click the Lesson13 folder in the Content panel.

5 View the 13End.psd file in Bridge.

There are eight buttons at the bottom of the page, arranged in two rows. You'll transform images into buttons for the top row and use an action to prepare the buttons for the second row.

6 Double-click the 13Start.psd thumbnail to open the file in Photoshop. Click OK if you see the Missing Profile dialog box.

Note: If Photoshop displays a dialog box telling you about the difference between saving to Cloud Documents and On Your Computer, click Save On Your Computer. You can also select Don't Show Again, but that setting will deselect after you reset Photoshop preferences.

13Start.psd

13End.psd

7 Choose File > Save As, rename the file **13Working.psd**, and click Save. Click OK in the Photoshop Format Options dialog box.

Creating placeholders with the Frame tool

When you create a print, web, or mobile device project, it's common to design the layout before you have the final graphics for it. You could add temporary graphics that you plan to replace later with final graphics, but then you must manage more files. One way to simplify the design process is to create placeholder shapes, called *frames*, during the early stages of design. As you refine the design and as final graphics become available, it's easy to place the final graphics directly into placeholder frames. Designing with placeholder frames is common in page layout applications such as Adobe InDesign.

You create frames using the Frame tool. A frame can contain an imported graphic, a Smart Object, or a pixel layer. When you create a frame, it appears in the Layers panel, because a frame is like a layer group with a vector mask.

The document 13Working.psd contains empty gray boxes. The gray boxes exist only to help you position new frames that you'll create for this lesson. When you create your own designs, you can design using the Frame tool alone.

1 Choose Edit > Preferences > Units & Rulers (Windows) or Photoshop > Preferences > Units & Rulers (macOS). In the Units area of the dialog box, make sure Pixels is selected in the Rulers menu, and then click OK.

▶ **Tip:** A quick way to change the unit of measure is to right-click (Windows) or Control-click (macOS) the rulers.

You want to work in pixels because this document is intended to be a web page.

2 Choose Window > Info to open the Info panel.

The Info panel displays information dynamically as you move the pointer or make selections. Which information it displays depends on the tool that is selected. You'll use it to determine the position of the ruler guide (based on the Y coordinate) and the size of an area you select (based on the width and height). It's also handy for seeing the values of colors under the pointer.

3 If the rulers aren't visible, choose View > Rulers.

▶ **Tip:** To customize the Info panel display of the color values under the pointer, click an eyedropper or crosshair icon in the Info panel, and then choose the display option you want.

▶ **Tip:** The keyboard shortcut for showing or hiding rulers is Ctrl+R (Windows) or Command+R (macOS).

Adding a frame

Frames are easy to add, because you create them in the same way you'd create a shape such as a rectangle or circle.

▶ **Tip:** You can create an elliptical or circular frame by selecting the Elliptical Frame icon in the options bar for the Frame tool.

1 In the Tools panel, select the Frame tool (⊠).

2 Drag to create a rectangular frame over the large gray rectangle at the top of the document.

The frame appears as a rectangle with an X inside it. The X indicates that it's not just a vector shape, but also a placeholder frame. As a placeholder, it's ready to contain a graphic at any time.

Adding a graphic to a frame

▶ **Tip:** To create a frame of any shape, such as a star, first draw the shape using a Pen tool or a shape tool. Then, with the shape layer selected in the Layers panel, choose Layer > New > Convert To Frame.

When you finalize the images and other graphics that go into a document, you can add them to the placeholder frames you've created.

1 In the Layers panel, make sure the Frame 1 layer is still selected.

2 Choose File > Place Linked.

3 Navigate to the Lesson13/Art folder, select the NorthShore.jpg file, and click Place.

The image appears inside the selected frame and automatically resizes to fill the frame.

You can also drag an image from Bridge or the desktop and drop it into a frame in a Photoshop document window. This embeds the image—it makes a complete copy of it inside the Photoshop document. To have the frame link instead, so that it always loads the current version of the image from outside the Photoshop document, hold down Alt or Option as you drag.

Editing frame attributes with the Properties panel

When a frame is selected in the Layers panel, you can see and edit frame attributes in the Properties panel so that you can change a frame after you create it.

1 With the Frame tool, draw a rectangle frame between the row of four gray squares and the bottom of the document. The exact size and position isn't important, because you're about to edit it.

2 With the frame selected, enter the following values in the Properties panel (if it isn't already open, choose Window > Properties):

- Width: **180**
- Height: **180**
- X: **40**
- Y: **648**

▶ **Tip:** As in the Options bar, you can change the unit of measure in a Properties panel field by right-clicking (Windows) or Control-clicking (macOS) the field. Or you can override a field's unit of measure by typing the unit after the value; for example, **4 in.**

After you apply all of the values, the size and position of the frame should now match the first gray square.

Duplicating frames

The other three squares in the row are the same size, so instead of drawing all four squares manually, you can simply duplicate them. Duplicating a frame is similar to duplicating a layer, because frames appear in the Layers panel.

1 In the Layers panel, drag the Frame 1 layer, and drop it on the Create A New Layer button (⊞). The duplicate layer, Frame 1 Copy, appears in the Layers panel.

2 With the Frame 1 Copy layer selected, in the Properties panel change the X value to **300**. This makes the duplicate square frame line up with the second gray square.

▶ **Tip:** It's always your choice to size and position a selected layer by dragging or by precisely editing values in the Properties panel or options bar.

3 Repeat step 1 to create two more duplicate frames. In the Properties panel, change the X value of the third frame to **550** and the X value of the fourth frame to **800**.

You've created a complete row of four placeholder frames.

Adding images to frames

When graphics become available to use in the layout, you can quickly add them to each frame. One convenient way is by using the Properties panel.

1 Make sure the first square frame (Frame 1) is selected.

2 In the Properties panel, click the Inset Image menu, and choose Place From Local Disk - Linked.

3 Navigate to the Lesson13/Art folder, select the Beach.jpg file, and click Place.

The Beach.jpg file is scaled to fit the frame, the name of the frame changes to Beach Frame, and the Properties panel displays the folder path to the linked document that's placed in the frame.

4 Repeat step 2 for the other three square frames, placing the files NorthShore.jpg, DeYoung.jpg, and MaineOne.jpg. Remember that you can also add a linked image to a frame by Alt-dragging (Windows) or Option-dragging (macOS) an image from the desktop or Bridge and dropping it into a frame.

Tip: If you want to select just the frame, click the frame edge with the Move tool. This works best when there aren't nearby objects or guides that might become selected instead.

Note: If you can't select a frame or its contents with the Move tool, make sure Auto-Select Layer is enabled in the options bar when the Move tool is selected. When Auto-Select Layer is not enabled, you must click the thumbnail of the frame or the contents in the Layers panel.

5 In the Layers panel, click to select the frame layer thumbnail (the right thumbnail with the link icon) of the MaineOne Frame layer. This selects just the contents of the frame. (Clicking the left thumbnail would select the frame.)

6 Choose Edit > Free Transform, drag the image or any of its edge handles to improve the composition of the image within the frame, and press Enter or Return when you're done.

After adding graphics to frames, it's always a good idea to inspect all of the frames to make sure the graphics are well-composed within them. Feel free to adjust any of the other images within their frames.

Using layer groups to create button graphics

Layer groups make it easier to organize and work with layers in complex images, especially when there are sets of layers that work together. You'll use layer groups to assemble the layers that make up each button, and they'll come in handy when you export assets later.

The four frames you created now serve as the basis for buttons. You'll add a label to each, identifying the gallery it represents, and then add a drop shadow and a stroke.

1 If the Info panel isn't already open, choose Window > Info to open it.

Tip: If you have trouble positioning the horizontal ruler guide precisely, hold down the Shift key to constrain the increments. If that doesn't snap to 795 pixels, zoom in, because the Shift key interval depends on the view magnification.

2 Position the Move tool pointer over the horizontal ruler, and drag a ruler guide down until the Y value in the Info panel is 795 pixels.

You'll use this guide to draw a band across the bottom of the image for the label.

3 Zoom in on the first square image, of the man on the beach. Then select Beach Frame in the Layers panel.

You'll use this image to design the first button.

4 Select the Rectangle tool (▭) in the Tools panel. Then, drag to create a rectangle shape across the bottom of the image, aligned with the guides and image edges. The shape should be 180 pixels wide and 33 pixels high. Press Enter or Return to commit the new shape, which is named Rectangle 1. Rename it **Band**.

5 With the Band layer selected, click the Fill swatch in the options bar, click the Color Picker icon, and then select a dark blue; we entered the hex color 194879. Click OK to close the Color Picker, and then press Enter or Return to close the Fill options.

6 Click the Stroke swatch in the options bar, click No Color (◻), and close the Stroke options.

The new shape appears as a dark blue band at the bottom of the first image. You'll add text to it next.

7 Select the Horizontal Type tool, and select the following settings in the options bar:

- Font Family: Myriad Pro
- Font Style: Regular
- Font Size: **18** pt
- Anti-aliasing: Strong
- Alignment: Center
- Color: White

▶**Tip:** As you position the text layer, if it snaps to a vertical magenta Smart Guide that appears in the middle of the Beach Frame and Blue Band layers, that means the text layer is centered in front of those layers.

8 Click in the center of the blue band, and type **GALLERY ONE**. Use the Move tool to adjust the position of the type layer if necessary.

▶**Tip:** When multiple layers are selected in the Layers panel, you can also create a layer group from them by clicking the New Group button or by pressing the keyboard shortcut Ctrl+G (Windows) or Command+G (macOS).

9 Select both the GALLERY ONE and Band layers in the Layers panel, and choose Layer > Group Layers.

Photoshop creates a group named Group 1.

10 Double-click the Group 1 layer group, and rename it **Gallery 1**. Then expand the group. The layers you selected are indented, indicating they're part of that group.

11 Drag the Gallery 1 layer group up so that it's above all of the frame layers.

12 Choose File > Save.

Duplicating button bands and text

You've designed the label for one button. You could go through all those steps again to create the band and text for each of the other buttons, but it will be faster to duplicate the layer group you created for the first band and text, and then edit the copies as needed.

1 In the Layers panel, make sure the Gallery 1 layer group is selected.

2 With the Move tool selected, make sure Auto-Select is not selected in the options bar.

3 With the Move tool, hold down the Alt (Windows) or Option (macOS) key as you drag the Gallery One button to the right, and drop it when it snaps into alignment with the second square frame and its guides.

> **Note:** In the Layers panel, moving a selected layer group moves all layers in it, even if the group's individual layers don't appear selected in the Layers panel. What's important is that the group is selected.

Holding down Alt or Option creates a copy of the selected layer group as you drag it with the Move tool. When you release the mouse button, the copy (Gallery 1 copy) should be selected in the Layers panel.

4 Repeat step 3 by Alt-dragging (Windows) or Option-dragging (macOS) a copy of the second button over the third square frame, and then do it one more time to copy the third button over the fourth square frame, completing the row.

Now edit the text in the three copies to match their images.

5 With the Horizontal Text tool, select the ONE text in the second button, and change ONE so that it now says **GALLERY TWO**.

6 Repeat step 5 for the third and fourth buttons so that they say **GALLERY THREE** and **GALLERY FOUR**, respectively.

7 After you finish editing the GALLERY FOUR text, commit the last text edit by selecting the Move tool.

8 In the Layers panel, rename the layer groups to be consistent with their contents:

▶ **Tip:** These steps are easier if you make the Layers panel taller so that you can see multiple expanded layer groups at once.

- Double-click the name of the "Gallery 1 copy" layer group, and name it **Gallery 2**.

- Double-click the name of the "Gallery 1 copy 2" layer group, and name it **Gallery 3**.

- Double-click the name of the "Gallery 1 copy 3" layer group, and name it **Gallery 4**.

Now move each button image into its layer group.

9 In the Layers panel, do the following:

- Drag the Beach Frame layer into the Gallery 1 layer group, below the GALLERY ONE and Band layers.

● **Note:** When dragging layers in step 9, position the pointer over the layer name, not the thumbnails, before dragging.

 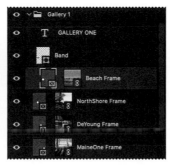

- Drag the upper NorthShore Frame layer into the Gallery 2 layer group, below the GALLERY TWO and Band layers.

- Drag the DeYoung Frame layer into the Gallery 3 layer group, below the GALLERY THREE and Band layers.

- Drag the MaineOne Frame layer into the Gallery 4 layer group, below the GALLERY FOUR and Band layers.

10 Click the arrow next to each of the Gallery layer group icons to collapse them, simplifying the Layers panel display.

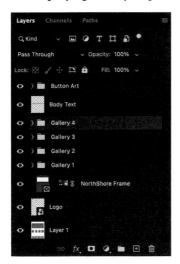

Now you'll add a drop shadow and stroke to improve the appearance of the button.

11 Select the Gallery 1 layer group in the Layers panel. Then, click the Add A Layer Style button (*fx*) at the bottom of the Layers panel, and choose Drop Shadow.

12 In the Layer Style dialog box, change the following settings in the Structure area:

- Opacity: **27**%

- Distance: **9** px

- Spread: **19**%

- Size: **18** px

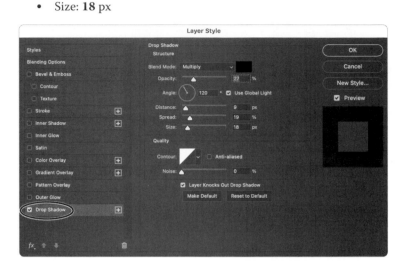

13 With the Layer Style dialog box still open, select Stroke on the left, making sure that it's enabled, and apply the following settings:

- Size: **1** px

- Position: Inside

- Color: Click the color swatch to open the Color Picker. Then click the blue band to sample its color, and click OK to select it.

14 Click OK to apply both layer styles.

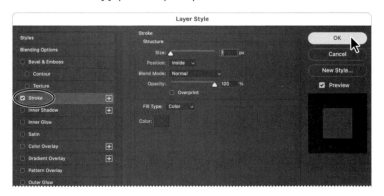

The drop shadow and stroke appear on the button's layer group in the document and also in the Layers panel.

15 In the Layers panel, position the pointer over the fx icon next to the Gallery 1 layer group. Then hold down the Alt (Windows) or Option (macOS) key as you drag the fx icon and drop it on the Gallery 2 layer group. This is a quick way to copy layer effects to another layer or layer group.

▶ **Tip:** Another way to transfer the effects of one layer or layer group to another is to drag its Effects header. That does the same thing as dragging the fx icon.

16 Repeat step 15 to copy the layer effects to the Gallery 3 and Gallery 4 layer groups.

17 In the Layers panel, expand the Button Art layer group, and then click the eye icon for the Navigation layer to make it visible. Then collapse the Button Art layer group.

This layer represents the navigation among sections of the museum website.

18 Save the file, and then close it.

Automating a multistep task

You can record a set of one or more commands and play it back to apply to a single file or a batch of files. In Photoshop this feature is called an *action*. (Some applications call this kind of feature a *macro*.) In this exercise, you'll create an action that prepares a set of images to serve as buttons for additional galleries on the web page you're designing.

Recording an action

▶ **Tip:** Actions are easy to use, but limited in scope. To automate Photoshop with more control, you can write a script. Photoshop can run scripts written in VBScript (Windows), AppleScript (macOS), or JavaScript (Windows and macOS).

You'll start by recording an action that resizes an image, changes its canvas size, and adds layer styles so that the additional buttons match the ones you've already created. You use the Actions panel to record, play, edit, and delete individual actions. You also use the Actions panel to save and load action files.

There are four images in the Buttons folder that will serve as the basis for new gallery buttons on your website. The images are large, so the first thing you'll need to do is resize them to match the existing buttons. You'll perform each of the steps on the Gallery5.jpg file as you record the action. You'll then play the action to make the same changes on the other images in the folder automatically.

1 Choose File > Open, and navigate to the Lesson13/Buttons folder. Double-click the Gallery5.jpg file to open it in Photoshop.

2 Choose Window > Actions to open the Actions panel. Close the Default Actions set (folder); you'll create and use your own set for this lesson.

3 Click the Create New Set button (◻) at the bottom of the Actions panel. In the New Set dialog box, name the set **Buttons**, and click OK.

Photoshop comes with several prerecorded actions, all in the Default Actions set. You can use action sets to organize your actions so that it's easier to find the one you want or create.

4 Click the Create New Action button (⊞) at the bottom of the Actions panel. Name the action **Resizing and Styling Images**, and click Record.

It's a good idea to name actions in a way that makes it clear what the actions do so you can find them easily later.

At the bottom of the Actions panel, the Begin Recording button turns red to let you know that recording is in progress.

Even though you're recording, there's no need to rush. Take all the time you need to perform the procedure accurately. Actions don't record in real time; they record steps as you complete them, but they play them back as quickly as possible.

You'll start by resizing and sharpening the image.

5 Choose Image > Image Size, and do the following:

- Make sure Resample is selected.

- For Width, choose Pixels from the units menu, and then change the Width to **180**.

- Confirm that the Height has changed to **180** pixels. It should, because original proportions are preserved using the Constrain Aspect Ratio link icon to the left of the Width and Height values, which is selected by default.

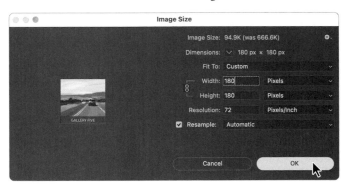

6 Click OK.

7 Choose Filter > Sharpen > Smart Sharpen, apply the following settings, and click OK:

- Amount: **100**%

- Radius: **1.0** px

You need to make some additional changes to the image that you can't make as long as the Background layer is locked. You'll convert it to a regular layer.

8 Double-click the Background layer name in the Layers panel. In the New Layer dialog box, name the layer **Button**, and click OK.

▶ **Tip:** If you want to convert a background layer to a regular layer and you don't need to name it, simply click the Background layer's lock icon in the Layers panel.

When you rename a Background layer, you're converting it to a regular layer, so Photoshop displays the New Layer dialog box. But no layers are added; the Background layer becomes the new layer.

Now that you've converted the Background layer, you can change the canvas size and add layer styles.

9 Choose Image > Canvas Size, and do the following:

▶ **Tip:** Use Canvas Size when you want to add area to or remove area from a document; use Image Size when you want to resample, change the physical dimensions, or change the resolution of a document.

- Make sure the unit of measure is set to Pixels.
- Change the Width to **220** pixels and the Height to **220** pixels.
- Click the center square in the anchor area to ensure the canvas is extended evenly on all sides.
- Click OK.

 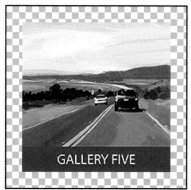

10 Choose Layer > Layer Style > Drop Shadow.

11 In the Layer Style dialog box, apply the following settings:

- Opacity: **27**%
- Angle: **120**°
- Distance: **9** px
- Spread: **19**%
- Size: **18** px

▶ **Tip:** Stay on task while the Actions panel is recording. It records any Photoshop image edits, so if you record unwanted steps, you'll have to edit them out later. The Actions panel doesn't record view changes such as scrolling and zooming.

12 With the Layer Style dialog box still open, select Stroke on the left, and apply the following settings:

- Size: **1** px
- Position: Inside
- Color: If the color swatch doesn't already match the other blue band you made, click the color swatch and sample the blue band as you did earlier.

13 Click OK to apply both layer styles.

Note: Be sure to click the word "Stroke." If you click only the checkbox, Photoshop applies the layer style with its default settings, but you won't see the options.

14 Choose File > Save As, choose Photoshop for the Format, and click Save. Click OK if the Photoshop Format Options dialog box appears.

15 Close the file. The Home screen appears, so click the Photoshop icon so that you can see the Actions panel again.

16 Click the Stop Playing/Recording button at the bottom of the Actions panel.

▶ **Tip:** As you review an action, you can edit the sequence by dragging steps, edit steps by double-clicking them (if applicable), or remove unneeded steps by deleting them.

The action you just recorded (Resizing and Styling Images) is now saved in the Buttons set in the Actions panel. Click the arrows to expand different sets of steps. You can examine each recorded step and the specific selections you made.

Batch-playing an action

Applying actions is a timesaving process for performing routine tasks on files, but you can streamline your work even further by applying actions to multiple files at once. You'll apply the action you've created to the three remaining images.

1 Choose File > Open, and navigate to the Lesson13/Buttons folder. Ctrl-select (Windows) or Command-select (macOS) the Gallery6.jpg, Gallery7.jpg, and Gallery8.jpg files, and click Open. They open as tabs in the document window.

2 Choose File > Automate > Batch.

3 In the Batch dialog box, do the following:

▶ **Tip:** You can create conditional actions that change their behavior based on criteria you define. To do this, choose Insert Conditional from the Actions panel menu.

- Confirm that Buttons is chosen in the Set menu and that Resizing and Styling Images—the action you just created—is chosen in the Action menu.
- Choose Opened Files from the Source menu.
- Make sure None is chosen for the Destination.
- Click OK.

Photoshop plays the action, applying its steps to all the files that are open. You can also apply an action to an entire folder of images without opening them.

Because you saved the file and closed it while you were recording the action, Photoshop saves each of the images as a PSD file in its original folder and then closes the file. After Photoshop closes the last file, the Home screen appears.

Note: If you get an error when running an action, click Stop. There may be a problem with the action that was recorded, especially if you had to correct a mistake while recording. Try troubleshooting or re-recording the action.

Placing files in Photoshop

The four additional button images are ready to be placed into the design. You probably noticed that each already has a blue band with its gallery name included in the image, so you don't need to perform those steps. They're ready to go.

1 If the file 13Working.psd is in the Recent list in the Home screen, click its name to reopen it. If not, choose File > Open to open it.

2 In the Layers panel, select the Gallery 4 layer group name. This ensures that the files about to be placed are not added inside any layer groups, because new layers are added above the selected layer.

3 Choose File > Place Embedded.

You'll place these files as embedded Smart Objects. Because they're embedded, the entire image is copied into the Photoshop file.

4 In the Place Embedded dialog box, navigate to the Lesson13/Buttons folder, and double-click the Gallery5.psd file.

Photoshop places the Gallery5.psd file in the center of the 13Working.psd file. But that's not where you want it to go, so you'll move it.

5 Drag the image into position below the Gallery One button. Use the guides to align the image with the one above. When it's in position, commit the change by pressing Enter or Return.

Note: The bounding box of the placed image is larger than the button, because the bounding box includes the complete extent of the drop shadow.

6 Repeat steps 3–5 to place the Gallery6.psd, Gallery7.psd, and Gallery8.psd files, aligning them below the Gallery Two, Gallery Three, and Gallery Four buttons.

7 You've completed the web page! Save your work and close the file.

Designing with artboards

Tip: If you want automatic export of layers for web and mobile user interfaces, you might try Adobe Generator. When Adobe Generator is on, Photoshop exports layers to image assets as you work. A layer naming convention controls the specs of the exported assets.

When you're designing websites or user interfaces for mobile devices, you may need to create separate image files for buttons and other content. In Photoshop, you can use the Export As feature to export an entire document or individual layers to web- and mobile-friendly formats including PNG, JPEG, or GIF. In addition to being able to export multiple layers to individual files at once, Export As makes it possible to export to multiple sizes at once if you need to produce sets of images for low- and high-resolution displays.

You may need to coordinate different ideas for a single design, or design variations for different display sizes. This is easier when you use artboards, which are like multiple canvases in a single Photoshop document. You can also use Export As to export entire artboards.

Tip: You may notice or have been taught to use the older Save For Web command in Photoshop. Although that command is still available under File > Export > Save For Web (Legacy), Save For Web can't export multiple layers, artboards, or scaling factors, while Export As can.

With Export As, you control what exports by selecting artboards or layers in the Layers panel.

Duplicating an artboard

You'll use artboards to adapt the design of the museum website for a different screen size. Later, you'll export both designs at once.

1 In the Photoshop Home screen, click Open. Navigate to the Lesson13 folder, and open the file 13Museo.psd.

2 Choose File > Save As, rename the file **13Museo_Working.psd**, and click Save. Click OK in the Photoshop Format Options dialog box.

This is a web page that's being adapted for a responsive web design so that it will work well on display sizes from desktops to smartphones.

3 Choose Select > All Layers.

● **Note:** Select > All Layers doesn't select the Background layer, because it's locked by default. However, you will find that step 4 converts the Background layer to Layer 0.

4 Choose Layer > New > Artboard From Layers, name the new artboard **Desktop**, and click OK. The artboard name appears above the new artboard and also on its new artboard group in the Layers panel.

5 Make sure the Artboard tool (⛶) is selected; it's grouped with the Move tool in the Tools panel. Then Alt/Option-click the Add Artboard button to the right of the artboard to duplicate both the Desktop artboard and its contents.

6 In the Layers panel, double-click the name of the duplicate Desktop Copy artboard, and name it **iPhone**.

7 In the Properties panel, click the Set Artboard to Preset menu, and choose **iPhone 8/7/6**. That artboard preset applies the pixel dimensions of an iPhone 8, iPhone 7, and

iPhone 6 (750 pixels wide by 1334 pixels tall). Now you can develop a design for that iPhone size, using the elements of the Desktop design. It will also be easier to maintain design consistency, because both the desktop and mobile designs are in the same document.

8 Save your work.

▶ **Tip:** You can choose artboard presets from the Size menu in the options bar when the Artboard tool is selected. If none of the artboard presets matches the display you're designing for, such as a newer model, you can enter your own values for Width and Height in the options bar or Properties panel.

Creating a design variation with artboards

You now have different artboards for desktop and smartphone display sizes; the next task is to fit the desktop-sized objects within the width of the smartphone display's pixel dimensions.

1 In the Layers panel, expand the iPhone artboard, and Shift-select the first and last layers in that artboard only. Don't select the artboard name itself.

2 Choose Edit > Free Transform.

3 In the options bar, do the following:

* Click the Toggle Reference Point checkbox to select it; this makes the reference point visible in the transformation bounding box and makes it possible for you to reposition the reference point.

* Select the top-left square of the reference point location option. Scaling, rotating, or other transformations will now be performed from the top-left corner of the bounding box (instead of the center) until the transformation is committed.

* Make sure the Maintain Aspect Ratio button (the link icon) is selected so that the selected layers will scale proportionally.

* Enter **726px** for W (Width).

4 Press Enter or Return to apply the new settings to all selected layers as a unit. (Press Enter or Return only once, to apply the value in the options bar. If you press Enter or Return a second time, it will commit the transformation.)

> **Tip:** You can position the reference point anywhere inside or outside the transformation bounding box by dragging it.

Those settings proportionally scale the selected layers to 726 pixels wide, from the top-left corner of the selection, to better fit the artboard.

5 Position the pointer inside the Free Transform bounding box, and then Shift-drag the selected layers down until you can see the entire Museo Arts logo at the top of the page.

6 Press Enter or Return to exit Free Transform mode, and choose Select > Deselect Layers.

7 In the Layers panel, select the Logo layer, and choose Edit > Free Transform.

8 Drag the bottom-right handle on the Free Transform bounding box until the transformation values next to the pointer indicate that the logo is 672 pixels wide, matching the width of the other elements. Then press Enter or Return. Enlarging the logo makes it more readable on a smartphone screen.

9 In the Layers panel, select the Banner Art, Left Column, and Right Column layers.

10 With the Move tool, Shift-drag the selected layers down until the top is even with the top of the blue button stack on the left.

▶ **Tip:** Remember that you can also nudge selected layers using the arrow keys if that makes it easier to precisely align them with the top of the blue button stack.

Now you'll take the two-column layout and make each column fill the width of the artboard. But first you'll need to accommodate them by making the artboard taller.

11 Select the iPhone artboard in the Layers panel, and then, with the Artboard tool, drag the bottom handle of the iPhone artboard until the transformation values next to the pointer indicate that it's 2800 px tall.

▶ **Tip:** You can also change the height of an artboard by entering a new Height in the Properties panel when an artboard is selected.

● **Note:** If a document uses artboards, resize them using only the Artboard tool. The Image > Image Size and Image > Canvas Size commands work best with a Photoshop document that doesn't use artboards.

12 Select the Right Column layer group in the Layers panel, and then choose Edit > Free Transform.

13 In the options bar, do the following:

- Make sure the Toggle Reference Point checkbox is selected, and then select the top-right square of the reference point location option.

- Make sure the Maintain Aspect Ratio (link) button is selected, and enter **672px** for Width.

- Press Enter or Return to apply the new width.

14 Position the pointer inside the Free Transform bounding box, and then Shift-drag the selected layer group down until the transformation values next to the pointer indicate a vertical move of 1200 px (the Y value in the options bar should say about 1680 px when the top-right square of the reference point locator is selected). Press Enter or Return to commit and exit the transformation.

15 Select the Left Column layer group in the Layers panel, and then choose Edit > Free Transform.

16 In the options bar, do the following:

- Make sure the Toggle Reference Point checkbox is selected, and then select the top-left square of the reference point location option.

- Make sure the Maintain Aspect Ratio (link) button is selected, and enter **672px** for Width.

- Press Enter or Return to apply the new width.

- Then press Enter or Return to commit and exit the transformation.

Feel free to adjust the positioning and the vertical spacing among the layer groups and layers.

17 Choose View > Fit On Screen to see both artboards at once, and then save your work.

▶ **Tip:** To nudge selected layers or layer groups when the Move tool is active, press the arrow keys. When Free Transform is active, you can also nudge by clicking in a number field and pressing the up arrow or down arrow key.

You've adapted a desktop-sized, multicolumn web page layout for a single-column, smartphone-sized layout, and both layouts exist on two artboards in one Photoshop document.

Exporting artboards with Export As (File menu)

When it's time to have a client review your designs, you can use the Export As command to easily export any artboard, layer, or layer group into its own file. You'll export the complete desktop and smartphone artboards, and then you'll export the layers of each artboard to their own folder.

1 Choose File > Export > Export As. This command exports each whole artboard so you see each artboard in the list on the left side of the Export As dialog box.

Note: The Export As dialog box doesn't preview multiple Scale All options. Artboards are previewed at 1x.

You can preview the exported dimensions and file size of each item; the preview is determined by the settings on the right side of the Export As dialog box.

Tip: Not sure about the best combination of format, compression, and visual quality? Click the 2-up tab at the top of the Export As dialog box to see two views. Select one view and change the settings; then select the other view and change its settings. Now you can compare their quality, and you can see the resulting file size below each preview.

2 In the list on the left, click the iPhone artboard to select it, and then set the Export As options to the following:

- In the Scale All section, make sure Size is set to 1x and Suffix is empty.
- In the File Settings section, choose JPG from the Format menu, and make sure Quality is set to **6**.
- In the Color Space section, make sure Convert to sRGB is selected.
- Other settings can be left at the defaults.

3 In the list on the left, click the Desktop artboard to select it, and apply the same settings as in step 2.

4 Make sure Select All is selected, click Export, navigate to the Lesson13 folder, double-click the Assets folder, and then click Save or Open.

▶ **Tip:** If you often use the Export As command with the same settings, choose File > Export > Export Preferences, and specify the settings you use the most. Now you can export to those settings in one step by choosing File > Export > Quick Export As or choosing Quick Export As (*Format*) from the Layers panel menu.

5 Switch to the desktop or Bridge, and open the Assets folder in the Lesson13 folder to see the Desktop.jpg and iPhone.jpg files representing each artboard. The filenames are based on the artboard names. You can send those files for review by a client or web development team.

6 Switch back to Photoshop.

Exporting layers as assets with Export As (Layer menu)

If the reviewers approve the design, you can then use Export As to create separate files for each layer on each artboard, such as images or buttons. Those assets can be used by a web or application developer who executes the design in code.

1 In the Layers panel, Shift-select all layers of the Desktop artboard.

2 Choose Layer > Export As. (Do not choose File > Export As.)

Notice that in the Export As dialog box, each layer is listed separately, because they will export separately.

3 Click Button Art to highlight it; then hold down Shift and click Right Column to highlight the five top layers. Now when you adjust settings in the following steps, those changes will affect all highlighted layers.

4 In the Export As dialog box, enter the same settings as you did in step 2 of the previous section (on page 348).

5 Deselect the checkbox for Layer 0 so that it will not export. It's a solid white background that should be implemented through the web page code itself.

6 Click Export, navigate to the Assets_Desktop folder in the Lesson13 folder, and click Open or Save.

You have exported all assets for the Desktop artboard into a single folder.

7 Repeat steps 1–4 for the iPhone artboard.

8 Click Export, navigate to the Assets_iPhone folder in the Lesson13 folder, and click Open or Save.

9 In Photoshop, choose File > Browse In Bridge.

► **Tip:** If a developer asks for assets at multiple scale factors (for Retina/HiDPI display resolutions), in the Export As dialog box click the plus button in the Scale All section to add and specify additional scale factors (Size) such as 2x or 3x. Those will be exported at the same time. Be sure to specify the proper option in the Suffix field for each scale factor.

10 Navigate to the Assets_Desktop folder in the Lesson13 folder, and inspect the images by browsing each file with the Preview panel open. If you want, you can also inspect the assets you exported to the Assets_iPhone folder.

Each layer you exported is in its own file. You were able to quickly produce two different sets of files for two different screen sizes:

- By using the file-based Export As command (File > Export > Export As), you created JPG images of the complete desktop and iPhone artboards.

- By using the layer-based Export As command (on the Layers panel menu or Layer > Export As), you created assets from the individual layers of each artboard.

11 In Photoshop, save your changes, and close the document.

Review questions

1 What is a layer group?

2 What is an action? How do you create one?

3 How can you create assets from layers and layer groups in Photoshop?

Review answers

1 A layer group is a set of layers organized as a unit in the Layers panel. Layer groups make it easier to work with layers in complex images, especially when there are sets of layers that need to stay together when moved or scaled.

2 An action is a set of one or more commands that you record and then play back to apply to a single file or a batch of files. To create one, click the Create New Action button in the Actions panel, name the action, and click Record. Then perform the tasks you want to include in your action. When you've finished, click the Stop Recording button at the bottom of the Actions panel.

3 Use the Export As command to create assets from artboards, layers, and layer groups in Photoshop. To create images of each whole artboard, choose the Export As command on the File menu (File > Export > Export As). To create assets from selected layers and layer groups, choose the Export As on the Layers panel menu or Layer menu (Layer > Export As).

14 PRODUCING AND PRINTING CONSISTENT COLOR

Lesson overview

In this lesson, you'll learn how to do the following:

- Understand how images are prepared for printing on presses.

- Closely examine an image before final output.

- Define RGB, grayscale, and CMYK color spaces for displaying, editing, and printing images.

- Proof an image for printing.

- Prepare an image for printing on a PostScript CMYK printer.

- Save an image as a Photoshop PDF file.

- Create and print a four-color separation.

 This lesson will take less than an hour to complete. To get the lesson files used in this chapter, download them from the web page for this book at adobepress.com/PhotoshopCIB2023. For more information, see "Accessing the lesson files and Web Edition" in the Getting Started section at the beginning of this book.

As you work on this lesson, you'll preserve the start files. If you need to restore the start files, download them from your Account page.

PROJECT: TRAVEL POSTER

To produce consistent color, you define the color space in which to edit and display RGB images and the color space in which to edit, display, and proof CMYK images. This helps ensure a close match between onscreen and printed colors.

Preparing files for printing

Note: One exercise in this lesson requires that your computer be connected to a printer that supports Adobe PostScript. If you don't have access to one, you can do most of the exercises. PostScript is not required to print photo-quality images. PostScript is more commonly used in prepress workflows (preparing jobs for printing on a press).

After you've edited an image, you probably want to share or publish it in some way. Ideally, you've been editing with the final output in mind, and you've managed file resolution, colors, file size, and other aspects of the image accordingly. But as you prepare to output the file, you have another opportunity to make sure your image will look its best.

If you plan to print the image—whether you'll print it to your own printer or send it to a service provider for professional printing—you should perform the following tasks for the best results. (Many of these tasks are described in more detail later in this lesson.)

- Determine the final destination. Whether you're printing the file yourself or sending it away, identify whether it will be printed to a PostScript desktop printer or platesetter, an inkjet printer, an offset press, or some other device. If you're going to send your work to a print service provider, ask what format they prefer. In many cases, they may request a file exported to a specific PDF standard or preset.

- Verify that the image resolution is appropriate. For professional printing, a good starting point is 300 ppi. The optimal resolution can depend on factors such as the halftone screen of a press or the grade of paper. To determine the best print resolution for your project, consult your production team, print service provider, or your printer's user manual.

- Do a "zoom test": Take a close look at the image. Zoom in to check and correct sharpness, color correction, noise, and other issues that can affect the final printed image quality.

- Be prepared to design for a *bleed* (extending the artwork past the page edge) if you want any part of a layout to print right up to the edge of a page. A bleed ensures that there isn't an unprinted gap at the page edge even if the page is trimmed a little wide of the crop marks. You may need to extend the canvas and the design on all sides (typically by ¼ inch). Again, your print service provider can recommend the bleed amount that works best on their equipment.

- Keep the image in its original color space until your service provider instructs you to convert it. Today, many prepress workflows keep content in its original color space throughout editing to preserve color flexibility as long as possible, converting images and documents to CMYK only at final output time.

- Before flattening large Photoshop documents, always ask your production team first. Some workflows may depend on preserving, not flattening, Photoshop layers so that other applications, such as Adobe InDesign, can control the visibility of imported Photoshop layers from within their documents.

- Soft-proof the image to simulate onscreen how the colors will print.

Getting started

You'll prepare a travel poster for printing on a CMYK press. The Photoshop file size is relatively large, because it contains several layers and has a resolution of 300 ppi at 11×17 inches.

First, start Photoshop, and restore its default preferences.

1　Start Photoshop, and then simultaneously hold down Ctrl+Alt+Shift (Windows) or Command+Option+Shift (Mac) to restore the default preferences. (See "Restoring default preferences" on page 5.)

2　When prompted, click Yes to delete the Adobe Photoshop Settings file.

3　Choose File > Open, navigate to the Lesson14 folder, and double-click the 14Start.psd file. The file may take longer to open on an older computer.

4　Choose File > Save As, navigate to the Lesson14 folder, and save the file as **14Working.psd**. Click OK if the Photoshop Format Options dialog box appears.

Note: If Photoshop displays a dialog box telling you about the difference between saving to Cloud Documents and On Your Computer, click Save On Your Computer. You can also select Don't Show Again, but that setting will deselect after you reset Photoshop preferences.

Performing a "zoom test"

● **Note:** If you consider changing the print size, remember that for photos, ppi resolution is tied to the print size—the same number of pixels is spread across more or less area. If this document (300 ppi at 11×17-inches) was printed at 50% size (8.5 inches tall), it would be 600 ppi. Printed at 200% size, it would be 150 ppi.

It's expensive to redo a big print job, so before you send out an image for final output, take a few minutes to make sure everything is appropriate for your output device and that you haven't overlooked any potentially problematic details. Start with the image resolution.

1 Choose Image > Image Size.

2 Verify that the width and height are the final output size in inches and that the resolution is appropriate. For most printing, 300 ppi produces good results.

This image has a width of 11" and a height of 17", which is the final size of the poster. Its resolution is 300 ppi. The size and resolution are appropriate.

3 Click OK to close the dialog box.

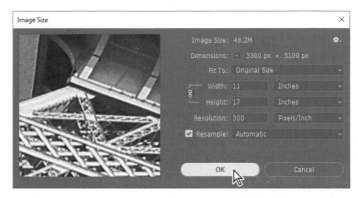

▶ **Tip:** If your keyboard has Page Up, Page Down, Home, and End keys, you can use them to inspect a magnified Photoshop document. Home goes to the top-left corner, and End goes to the bottom-right corner. Add the Ctrl key (Windows) or the Command key (Mac) to make Page Up/Page Down keys navigate horizontally, and add the Shift key to scroll in smaller increments.

Next, you'll look closely at the image and correct any problems. When you prepare your own images for printing, zoom in and scroll to view the entire image closely.

4 Select the Zoom tool in the Tools panel, and zoom in on the photos in the lower third of the poster.

The photo of tourists is flat and a little muddy-looking.

5 Select the Tourists layer in the Layers panel, and then click the Curves icon in the Adjustments panel to add a Curves adjustment layer.

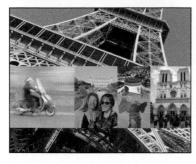

6 Click the Clip To Layer button (⌐□) at the bottom of the Properties panel to create a clipping mask.

The clipping mask ensures that the adjustment layer affects only the layer directly below it in the Layers panel. If the new adjustment layer was not made into a clipping mask, it would affect all of the layers below it.

Tip: It's best to click the White Point eyedropper tool on a spot that is the lightest neutral area of an image that contains detail, not a specular highlight.

7 In the Properties panel, select the White Point eyedropper tool, and then click the white shirt of the person behind the tourists to define that point as the brightest neutral part of the image. (Zoom in as needed to click precisely.) Because the white shirt was not very bright, clicking it as a white point reference brightens it and the rest of the tones in the rest of the image and rebalances the colors in the image.

Tip: After you click the White Point eyedropper, notice that the curves for the red, green, and blue channels have shifted to define the point you clicked as a neutral color, setting the color balance for the image. That's why it's important to click a spot that should be neutral.

The image of tourists looks better. But the image of the statue appears flat and lacks contrast. You'll fix that with a Levels adjustment layer.

8 Select the Statue layer in the Layers panel, and then click the Levels icon in the Adjustments panel to add a Levels adjustment layer.

9 Click the Clip To Layer button at the bottom of the Properties panel to create a clipping mask so that the adjustment layer affects only the Statue layer.

10 In the Properties panel, click the Calculate A More Accurate Histogram icon (⬛) to refresh the histogram display.

The alert icon next to the initial Calculate A More Accurate Histogram icon indicates that the histogram is based on cached image data. Photoshop first displays the histogram based on cached data because it displays more quickly, but is often less accurate. Refreshing the histogram ensures that it's accurate and up to date before you make edits based on it.

11 Move the input level sliders to punch up the image. We used the values 31, 1.60, 235. Remember that to increase contrast, drag the black point (left) and white point (right) input sliders toward the center, making sure that highlight and shadow detail is still visible, not clipped (excluded).

Note: In the example for step 11, the levels are adjusted manually instead of using an eyedropper. The result of using an eyedropper wouldn't look right because the image doesn't contain a truly neutral highlight, midtone, or shadow. It should retain a slightly warm color cast.

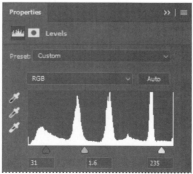

12 Save the file. The whole poster looks better after your improvements to the photos of the tourists and statue.

About color management

Because the RGB and CMYK color models use different methods to display colors, each reproduces a different color *gamut* (color range or color space). For example, RGB uses light to produce color, so its gamut includes fluorescent colors, such as those you'd see in a neon sign. In contrast, printing inks excel at reproducing certain colors that can lie outside the RGB gamut, such as some pastels and pure black.

A. *Natural color gamut*
B. *RGB color gamut*
C. *CMYK color gamut*

RGB color model

CMYK color model

But not all RGB and CMYK gamuts are alike. Each monitor and printer model differs, so each displays a slightly different gamut. For example, one brand of monitor may produce slightly brighter blues than another. The *color space* for a device is defined by the gamut it can reproduce.

The color management system in Photoshop uses International Color Consortium (ICC)–compliant color profiles that work like translators, helping to maintain color appearance when colors are converted from one color space into another. An *ICC color profile* is a description of a device's color space, such as the CMYK color space of a particular printer. You specify which profiles to use to accurately proof and print your images. Once you've selected the profiles, Photoshop can embed them into your image files so that Photoshop and other applications can consistently maintain the colors of your images.

● **Note:** Your monitor may have been factory-calibrated, but you may not know how precisely and to what standard. For example, if your print service provider recommends that your monitor use the common prepress standard of a D65 white point, how do you know how well your monitor meets that standard? To make sure, calibrate and profile your monitor with D65 set as the target standard.

About calibration and profiling

Calibration means adjusting a device to meet a standard, like making sure a monitor displays neutral gray when neutral gray color values are sent to it. A *profile* describes whether the device meets a standard, and if not, how far off it is so that a color management system can correct for the difference and show image colors accurately.

To get the most out of color management, calibrate and profile your monitor so that you evaluate color on a screen using an accurate display profile. You can use calibration/profiling software that drives a color profiling device. The software uses the device to measure the colors produced by your screen and corrects for inaccuracies by creating a customized ICC display profile of your monitor. Your system uses this display profile to show colors accurately in any software that is color-managed, such as Photoshop and most other Adobe graphics software.

RGB color model

Much of the visible color spectrum can be represented by mixing red, green, and blue (RGB) colored light in various proportions and intensities. Where the colors overlap, they create cyan, magenta, yellow, and white.

Because the RGB colors combine to create white, they are also called *additive* colors. Adding all colors together creates white—that is, all light is transmitted back to the eye. Additive colors are used for lighting, video, and monitors. For example, an LCD monitor creates color by emitting its backlight through red, green, and blue filters.

CMYK color model

The CMYK model is based on the light-absorbing quality of ink printed on a substrate (surface) such as paper or packaging. As white light strikes translucent inks, part of the spectrum is absorbed, while other parts are reflected back to your eyes.

In theory, pure cyan (C), magenta (M), and yellow (Y) pigments should combine to absorb all color and produce black. For this reason, these colors are called *subtractive* colors. But because all printing inks contain some impurities, these three inks actually produce a muddy brown and must be combined with black (K) ink to produce a denser black. (K is used instead of B to avoid confusion with blue.) Combining these inks to reproduce color is called four-color process printing.

Specifying color management defaults

By default, the Color Settings dialog box is set up for color gamuts typically used in an RGB-based digital workflow. If you're preparing artwork for printing on a press, as in the document used in this lesson, you may want to change the settings to be more appropriate for CMYK-based prepress production rather than screen display.

Many of the options in Color Settings are defaults you can override as needed, such as when assigning a profile or converting between profiles. When a document already has a color profile, Photoshop uses that instead of Color Settings defaults.

You'll customize the default settings for interpreting color.

1 Choose Edit > Color Settings to open the Color Settings dialog box.

2 Without clicking (don't change settings), hover the pointer over each part of the dialog box, including the names of sections (such as Working Spaces), the menu names, and the menu options. As you move the pointer, Photoshop displays information about each item in the Description area at the bottom of the Color Settings dialog box.

Now, you'll choose a set of options designed for a print workflow.

3 Choose North America Prepress 2 from the Settings menu. The working spaces and color-management policy options change for a prepress workflow. Then click OK.

▶ **Tip:** The Color Settings dialog box can seem complex, so remember that the only thing you usually need to do is pick the Settings preset that matches your workflow most closely. Each Settings preset changes the rest of the options for you.

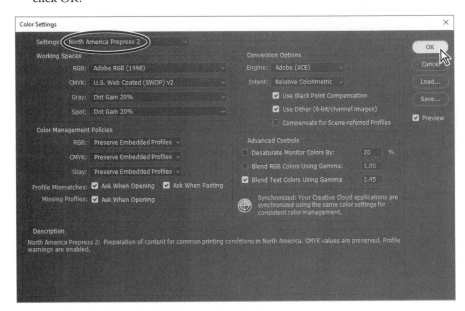

Identifying out-of-gamut colors

Colors on a monitor are displayed using combinations of red, green, and blue light (called RGB), while printed colors are typically created using a combination of four ink colors—cyan, magenta, yellow, and black (called CMYK). These four inks are called *process colors* because they are the standard inks used in the four-color printing process.

The color range covered by typical CMYK printing can reproduce many, but usually not all, of the colors in an RGB image from a digital camera or scanner. For example, colored LED lights or vivid flowers may produce colors that are outside a printer's CMYK gamut. Those colors may print with less detail and saturation than expected. Some intense blue colors in RGB can shift toward purple in CMYK.

Before you convert an image from RGB to CMYK, you can preview which RGB color values are outside the gamut of CMYK.

1 Choose View > Fit On Screen.

2 Choose View > Gamut Warning. Photoshop compares the document colors to the current CMYK color space and displays a neutral gray in the document window to indicate where document colors are outside the CMYK color gamut.

The gray gamut warning covers much of the image, especially the blue areas. A typical CMYK press can reproduce a relatively narrow range of blue compared to most RGB gamuts, so it's not unusual for an image to have RGB blue values that are outside a CMYK printing gamut. In out-of-gamut areas, the printer would end up printing the closest shade of blue its inks can reproduce on a given paper.

Because the gray indicator color can be hard to distinguish in the image, you'll change it to a more visible color.

3 Choose Edit > Preferences > Transparency & Gamut (Windows) or Photoshop > Preferences > Transparency & Gamut (Mac).

4 Click the color sample in the Gamut Warning area at the bottom of the dialog box. Select a vivid color, such as purple or bright green, and click OK.

5 Click OK to close the Preferences dialog box.

▶ **Tip:** If your gamut warning area looks different, you may be using different settings in the View > Proof Setup > Custom dialog box (see page 364).

The bright new color you chose appears instead of the neutral gray as the gamut warning color; it should be much more obvious which areas are out of gamut. If this was a real job, you might consult your prepress service provider to discuss how their press will reproduce that blue color and whether it's worth editing the color.

6 Choose View > Gamut Warning to turn off the preview of out-of-gamut colors.

Next, you'll simulate onscreen how the document colors might print, and then you'll bring those colors into the printing gamut.

▶ **Tip:** When you have concerns about how a color will reproduce on press, you can ask your prepress service provider about seeing a *hard proof* (test print).

Proofing document colors on a monitor

You'll select a proof profile so that you can view an onscreen simulation of what document colors will look like when printed. An accurate proof profile lets you proof on the screen (*soft-proof*) for printed output.

That onscreen simulation is based on a *proof setup*, which defines the printing conditions. Photoshop provides a variety of settings that can help you proof images for different uses, including for different printers and devices. For this lesson, you'll create

a custom proof setup. You can then save the settings for use on other images that will be output the same way.

1 Choose View > Proof Setup > Custom. The Customize Proof Condition dialog box opens. Make sure Preview is selected.

▶ **Tip:** A printer profile represents not only the output device, but also a specific combination of settings, ink, and paper. Changing any of those components can change the color gamut being simulated by the onscreen proof, so choose a profile that's as close as possible to the final printing conditions.

2 From the Device To Simulate menu, choose a profile that represents the final output device, such as that for the printer you'll use to print the image. If you don't have a specific printer, use the profile Working CMYK–U.S. Web Coated (SWOP) v2, the current default.

3 If you've chosen a different profile, make sure Preserve Numbers is *not* selected.

The Preserve Numbers option simulates how colors will appear if they're not converted to the output device color space. This option may be named Preserve CMYK Numbers when you select a CMYK output profile.

4 Make sure Relative Colorimetric is selected for the Rendering Intent.

A rendering intent determines how the color is converted from one color space to another. Relative Colorimetric preserves color relationships without sacrificing color accuracy and is the standard rendering intent for printing in North America and Europe.

5 Select Simulate Black Ink if it's available for the profile you chose. Then deselect it and select Simulate Paper Color; notice that selecting this option automatically selects Simulate Black Ink.

▶ **Tip:** When the Customize Proof Condition dialog box isn't open, you can view the document with or without the current proof settings by selecting or deselecting the View > Proof Colors command.

Notice that the image appears to lose contrast. Most paper is not pure white; Paper Color simulates that. Most black ink is not perfectly solid or neutral black, so Black Ink simulates the actual ink. Both get that information from the output profile, if available.

Don't be alarmed by the loss of contrast and saturation that you may see when you turn on the Display Options. While the image might look worse, the soft-proofing simulation is just being honest about how the image will actually print; paper and ink simply cannot reproduce the same range of tones and colors as a monitor. Choosing higher-quality paper stock and inks can help a printed image match the screen more closely.

6 Toggle the Preview option to see the difference between the image as it is displayed onscreen and as it will print, based on the profile you selected. Then click OK.

▶ **Tip:** If you want to check the print color simulation as you work, you can quickly toggle Proof Colors on or off by using the keyboard shortcut for View > Proof Colors: Press Ctrl-Y (Windows) or Command-Y (macOS).

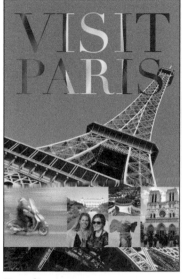
Normal image.

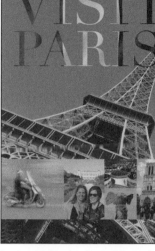
Image with Simulate Paper Color and Simulate Black Ink options selected.

7 Click the View menu, and if Proof Colors is enabled, choose Proof Colors to disable it. You can use this command to enable or disable the soft-proof settings that you set up in the Customize Proof Condition dialog box.

Bringing colors into the output gamut

The next step in preparing an image for output is to make any necessary color and tonal adjustments based on what you see in the proofs. In this exercise, you'll add some tonal and color adjustments to correct an off-color scan of the original poster.

So that you can compare the image before and after making corrections, you'll start by making a copy.

1 Choose Image > Duplicate, and click OK to duplicate the image.

2 Choose Window > Arrange > 2 Up Vertical so you can compare the images as you work.

You'll adjust the hue and saturation of the image to move all colors into gamut.

3 Select 14Working.psd (the original image) to make it active, and then select the Visit Paris layer in the Layers panel.

4 Choose Select > Color Range.

▶ **Tip:** You may not need to adjust colors that are indicated as out of gamut. You should definitely inspect them, but if those areas look acceptable and don't lose detail when proofing, you may not need to spend time editing them. Some would leave the blue sky alone because it's a flat area, so there are no details to lose after converting the file to the printer color gamut.

5 In the Color Range dialog box, choose Out of Gamut from the Select menu, and then click OK.

The areas that were marked as out of gamut earlier are now selected, so you can make changes that affect only those areas.

6 Choose View > Extras to hide the selection while you work with it.

The selection border can be distracting. When you hide extras, you no longer see the selection, but it's still in effect.

7 Click the Hue/Saturation button (▦) in the Adjustments panel to create a Hue/Saturation adjustment layer. (Choose Window > Adjustments if the panel isn't open.) The Hue/Saturation adjustment layer includes a layer mask, created from your selection.

8 In the Properties panel, do the following:

- Leave the Hue setting at the default value.

- Drag the Saturation slider to reduce the value (we used –14). Reducing Saturation is one way to bring colors into a target gamut.

- Drag the Lightness to the left to darken the image (we used –2).

9 Choose View > Gamut Warning. You have shifted most of the out-of-gamut colors so that they're in the target gamut. Choose View > Gamut Warning again to deselect it.

10 Choose View > Extras to enable it so that selection marquees and other non-printing aids will be visible again. In this case, the selection marquee doesn't reappear, because the selection was converted into the layer mask for the Hue/Saturation layer you created in step 7.

11 Close the duplicate image file (the 14Working copy tab) without saving it.

In this exercise, you shifted out-of-gamut colors into the printing gamut mostly by desaturating them. While this is quick and easy, it's considered a basic technique. Skilled image editors use more advanced techniques to preserve color detail while maintaining as much of the original color saturation as possible. Also, when an out-of-gamut color doesn't contain much detail, as in a flat blue sky, it may be acceptable to leave the colors unchanged.

Tip: You can also make adjustments with Gamut Warning on so that you know when the colors move into the printing gamut.

Converting an image to CMYK

It's generally a good idea to work in RGB mode as long as possible so that your edits can take place within the larger color gamut of RGB. Also, converting between modes can cause color value rounding errors that may result in unwanted color changes, especially over multiple conversions.

If your printing workflow requires final images to be in CMYK, save CMYK copies after completing final corrections. If you also want to output the image to an inkjet printer or distribute it digitally later, keep the original document in RGB mode.

Tip: If you aren't sure if or when you should convert images to CMYK, ask the print service provider that will output your job. They can recommend the image preparation steps that work best with their prepress equipment.

1 Click the Channels tab to bring the Channels panel to the front.

The image is currently in RGB mode, so there are three channels listed: red, green, and blue. The RGB channel is not actually a channel, but a composite of all three. You also see a channel named Hue/Saturation 1 Mask; this channel contains the mask information for the layer currently selected in the Layers panel.

2 Choose Image > Mode > CMYK Color.

3 Click Merge in the message that warns you that you might lose some adjustment layers. Merging the layers helps preserve the appearance of colors.

Another message appears, saying: "You are about to convert to CMYK using the "U.S. Web Coated (SWOP) v2" profile. This may not be what you intend. To choose a different profile, use Edit > Convert To Profile." This message lets you know that the active CMYK profile is U.S. Web Coated (SWOP) v2, the Photoshop default profile for CMYK color. That profile might not represent the actual prepress specification or proofing standard that will be used.

In a real-world job, you would ask the print service provider which CMYK profile to use for color conversions; they may be able to provide a custom profile that accurately represents the tonal and color range of their equipment. You would then load that custom CMYK profile into your operating system's standard location for ICC profiles so that you can select it as the CMYK Working Space in the Edit > Color Settings dialog box or so you can select it when converting the image to CMYK using the more advanced and precise Edit > Convert To Profile command.

4 Click OK in the message about the color profile used in the conversion.

The Channels panel now displays four channels: cyan, magenta, yellow, and black. Additionally, it lists the CMYK composite. The layers were merged during conversion, so there is only one layer in the Layers panel.

Saving the image as Photoshop PDF

Some print service providers may request that you submit a print job in PDF format. PDF is a popular delivery format because it can consistently preserve many document attributes that are important for high-quality printing on press. When print jobs are submitted in various document formats, components such as type, fonts, and transparency might not be included or might be handled in different ways.

1 Choose File > Save A Copy.

2 In the Save A Copy dialog box, navigate to the Lesson14 folder, choose Photoshop PDF from the Format menu, name the file **14Print.pdf**, and then click Save.

3 Click OK if a message appears about Save Adobe PDF settings.

4 In the Save Adobe PDF dialog box, choose [PDF/X-4:2008] from the Adobe PDF Preset menu. How do you know which preset to choose? Ask your print service provider which preset best matches their printing workflow.

The five panels along the left side of the bottom of the Save Adobe PDF dialog box (General, Compression, etc.) contain a large number of PDF options. Fortunately, if you know or have been told which Adobe PDF Preset to choose, you don't have to think about any of those options, because choosing a preset sets those options for you.

5 Click Save PDF. Photoshop saves the PDF version in the Lesson14 folder.

▶ **Tip:** PDF/X is an industry standard for storing printing information for high-quality reproduction on press. Newer PDF/X standards support more printing features.

If you want, you can open the Lesson14 folder in Adobe Bridge or on the desktop and double-click the 14Print.pdf file. It opens in the default PDF application on your computer. If Adobe Acrobat is installed, it may open in that application.

Printing to a desktop inkjet printer

Many color inkjet printers make high-quality prints of photographs and other image files. The precise settings available vary from printer to printer, and they're different than the best settings for a press. When you're printing images from Photoshop to a desktop inkjet printer, you'll get the best results if you do the following:

- Make sure the appropriate printer driver software is installed and that you've selected it. Leaving the printer driver on a generic setting such as "Any Printer" may result in problems such as incorrect page margins.

- Use the appropriate paper for your intended use. Photographic and coated papers are good choices when you're printing photos you want to display.

- Select the correct paper source and media setting in the printer settings. On some printers, those settings adjust ink appropriately. For example, if you're using glossy photo paper, choose that media type in the printer settings.

- Select the image quality in the printer settings. Higher print quality is better when viewing is critical, such as for color proofing or framed prints. Lower print quality is useful for speedier printing and might use less ink.

- Don't convert an RGB image to CMYK to print on a desktop inkjet printer, because most are designed to receive RGB color data. The printer or its driver software will do its own conversion from RGB to the ink set specifically used in that printer. Professional-quality inkjet printers typically use more inks that reproduce a wider color gamut than the four CMYK inks used on a press.

Printing a CMYK image from Photoshop

▶ **Tip:** Printing color separations on your desktop printer can help verify that colors will appear on the correct plate. But separations from a desktop printer won't match the precision of an actual platesetter. Proofs printed for jobs intended for a press are more accurate on a desktop printer with an Adobe PostScript RIP (raster image processor).

You can proof your image by printing a *color composite*, often called a *color comp*. A color composite is a single print that combines the red, green, and blue channels of an RGB image (or the cyan, magenta, yellow, and black channels of a CMYK image). This indicates what the final printed image will look like.

If you choose to print *color separations*, Photoshop prints a separate sheet, or *plate*, for each ink. For a CMYK image, it prints four plates, one for each process color. In this exercise, you'll print color separations.

If you're printing color separations directly from Photoshop, you will typically use the following workflow:

- Set the parameters for the halftone screen. Consult with your print service provider for recommended settings.

- Print test separations to make sure objects appear on the correct separation.

- Print the final separations to plate or film. This task is typically performed by your print service provider.

1 In the 14Working.psd image, choose File > Print.

By default, Photoshop prints any document as a composite image. To print this file as separations, you must set it up accordingly in the Photoshop Print Settings dialog box.

2 In the Photoshop Print Settings dialog box, do the following:

- In the Printer Setup section, make sure the selected Printer is correct.

- In the Color Management area, choose Separations from the Color Handling menu.

- In the Position And Size section, verify the settings. This 11"×17" document may be too large for many desktop printers to print at actual size. You can select Scale To Fit Media to fit the document to the current paper size; to see this option you may need to scroll down or enlarge the dialog box.

- If you're using a printer equipped with Adobe PostScript, scroll down and set PostScript Options such as halftone options. Note that the results on a desktop printer may not be identical to a prepress output device.

- Click Print. (If you don't actually want to print color separations, click Cancel or Done; the difference is that Done saves the current print settings.)

Tip: In the Photoshop Print Settings dialog box, if the Separations option is not available in the Color Handling menu, click Done, make sure the document is in CMYK mode (Image > Mode > CMYK Color), and then try again.

Tip: The Position and Size section of the Photoshop Print Settings dialog box is two sections below the Color Management section, so if you can't see it, scroll down the right-side panel. Also, you can enlarge the Photoshop Print Settings dialog box by dragging a corner or edge so that you can see more options at once.

Note: If you do not normally prepare graphics for a press, when you finish this lesson, go back to page 362, step 3, and choose North American General Purpose 2. Color Settings are not affected when you reset Photoshop preferences.

Professional color printing is a deep subject, with important details that may not be obvious from experimenting. If you're preparing images for a commercial print job, consult with your print service provider for the best settings. If you're using your own desktop printer, you can ask questions on a discussion website such as the

Extra credit

Sharing your work on Adobe Portfolio

Integrated into Adobe Creative Cloud is Adobe Portfolio, which you can use to quickly create a well-designed and functional website that showcases your creations, with one-click connections to your social media presence (such as your Instagram, Facebook, and Twitter feeds) and a prebuilt contact form that makes it easy for potential clients and customers to get in touch with you. To test it, you'll first prepare this lesson's image for viewing in a web browser.

1 Open the 14Start.psd file in Photoshop, if it isn't already open. Click OK if the Embedded Profile Mismatch dialog box appears.

As the original RGB version of the image in this lesson, 14Start.psd contains a wider color gamut than the later version that was converted to CMYK for prepress.

2 Choose File > Export > Export As to prepare the image for display on a website. It's a large, print-resolution image, so it may take a while to display in the Export As dialog box.

3 Choose JPG from the Format menu, and set Quality to **6**.

4 In the Image Size section, enter a Height in pixels to proportionally resize the exported image. We entered **1000** pixels, enough to show the image with a good amount of detail on many displays.

5 In the Color Space section, select Convert To sRGB and Embed Color Profile to help ensure consistent color in web browsers.

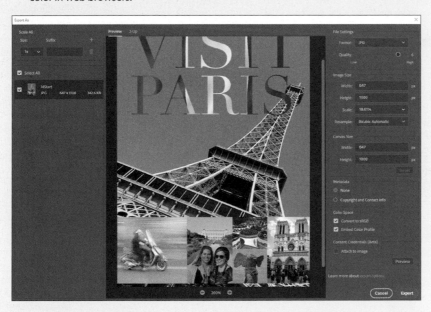

6 Click Export. Navigate to the Lesson14 folder, and click Export or Save.

Now you can start making your website. The Portfolio user interface you see may vary as Adobe updates the service. Some of the following steps may appear only when creating a Portfolio website for the first time.

1 In a web browser, go to myportfolio.com, the web address for Adobe Portfolio.

2 At the top of the Adobe Portfolio home page, click Sign In, enter your Adobe ID email address and password, and click Sign In.

3 On the next screen, click to select the type of site you want to create: Full Portfolio or Welcome Page. We clicked Welcome Page to make a quick one-page website and scrolled down to pick the Cover Left - Light theme.

4 After the site is created, click the Click To Upload An Image/Video button. Navigate to the Lesson14 folder, select 14Start.jpg, and then click Choose, Open, or Upload (the button name depends on the web browser you use). Adobe Portfolio processes the image and replaces the left-side placeholder with it.

5 Now edit the text on the splash page. On the right side of the page, double-click in any text object to edit its text. You can add a brief description of you and your work.

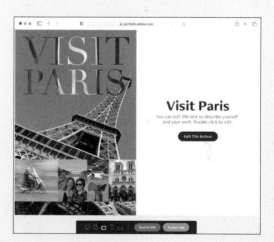

6 Click Preview. The buttons at the bottom of the preview show you how the page will look on different device displays and orientations, such as a smartphone held vertically or horizontally.

7 Click Back To Edit.

Continues on next page

Extra credit (continued)

As you move the pointer over different page elements, icons appear over them. If you see an edit icon (a blue rectangle with a pencil), click it to edit that object. If you see an add icon (a circle containing a plus sign), click it to add new content to a page, such as photos, video, or embedded media.

8 Position the pointer over the button labeled Edit This Button, click the edit icon that appears on the left side of its containing object, and in the menu that appears, click Edit Button. In the Options tab that appears on the left, you can change options such as the button text or the button font, and you can add a link. Other tabs offer options for other button states, such as how it looks when you hover the pointer over it. To exit click the back button (<) at the top-left corner of the Edit Button panel. If you want, edit other sections, such as the social media icons.

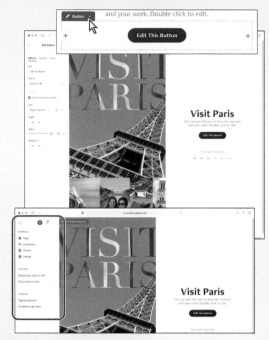

9 Use the options along the left side of the Portfolio editor to add or organize pages, customize the design (including the theme, fonts, and page backgrounds), or set options for the entire website, such as password protection. You can also create and manage multiple websites.

If your site looks good and you want the world to see it, click Publish Site. It's live!

If you have your own Internet domain name, you can easily connect it to Adobe Portfolio so that your website's address is fully consistent with your brand. To do this, click Settings, and then edit settings in the Domain Name panel.

If you don't use a custom domain name, your website address is a subdomain of myportfolio.com. For example, if you name the site "parisvisitor," then parisvisitor.myportfolio.com is the default web address.

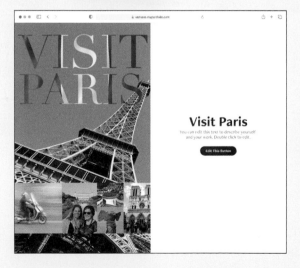

Review questions

1 What steps should you follow to reproduce color consistently?

2 What is a gamut?

3 What is a color profile?

4 What are color separations?

Review answers

1 To reproduce color consistently, first calibrate and profile your monitor, and then use the Color Settings dialog box to specify which color spaces to use. For example, you can specify which RGB color space to use for online images and which CMYK color space to use for images that will be printed. You can then proof the image, check for out-of-gamut colors, and adjust colors as needed.

2 A gamut is the range of colors that can be reproduced by a color model or real-world device. For example, the RGB and CMYK color models have different gamuts. Within each color model, various printers, printing standards, and device displays reproduce different gamuts.

3 A color profile is a description of a color space, such as the CMYK color space of a particular printer. Applications such as Photoshop can read the color profiles representing different applications, platforms, and devices, to maintain consistent color across them.

4 Color separations are separate plates for each ink used in a document being reproduced on press. Your print service provider will produce color separations of your files for the CMYK inks.

15 EXPLORING NEURAL FILTERS

Lesson overview

In this lesson, you'll learn how to do the following:

- Understand how Neural Filters are different than other filters and effects in Photoshop.

- Explore the Neural Filters workspace.

- Apply a Neural Filter to an image.

- Combine multiple Neural Filters in a single layer or document.

 This lesson will take about 30 minutes to complete. To get the lesson files used in this chapter, download them from the web page for this book at adobepress.com/PhotoshopCIB2023. For more information, see "Accessing the lesson files and Web Edition" in the Getting Started section at the beginning of this book.

As you work on this lesson, you'll preserve the start files. If you need to restore the start files, download them from your Account page.

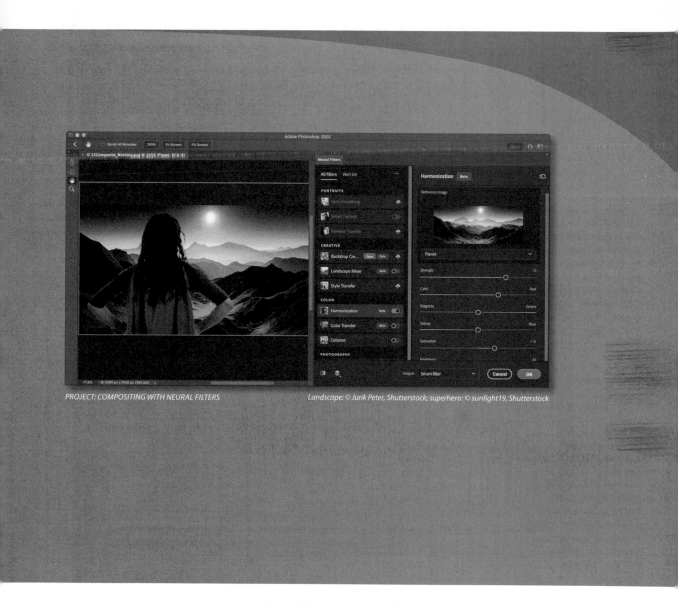

PROJECT: COMPOSITING WITH NEURAL FILTERS

Landscape: © Jurik Peter, Shutterstock; superhero: © sunlight19, Shutterstock

Neural Filters are advanced filters trained using machine learning. You can explore ideas that would be more labor-intensive, or sometimes impossible, with conventional digital photo filters and effects.

Understanding Neural Filters

If you worked through the earlier lessons in this book, you've used Photoshop filters such as Surface Blur, Smart Sharpen, Clouds, and Liquify. Those are conventional filters that produce their results with algorithms—procedural programs where the code itself determines the result.

The newer Neural Filters produce results in a different way, combining traditional algorithms with *machine learning* and other advanced techniques. Machine learning means that a filter in Neural Filters can be trained using many examples of desirable and undesirable results, potentially creating better images than what could be achieved with procedural computer code alone.

Neural Filters are different from other Photoshop effects in the following ways:

● **Note:** You can use Neural Filters if your computer meets the system requirements for Photoshop, but performance is better with a more powerful CPU, more powerful graphics hardware, and in some cases a faster Internet connection.

- Neural Filters are trained by machine learning and neural networks.

- Some filters need to be downloaded before the first time you use them. This is partly to save space on your computer, because some Neural Filters and their machine-learning models can be large. If you need to download a Neural Filter, you can do it with one click in the Neural Filters workspace.

- Some filters display a message saying that they process image data in the cloud (on Adobe Creative Cloud servers). They may need more power than a desktop computer has, or a machine-learning model may be too large to download.

It's possible to use some Neural Filters without an Internet connection, but you get the most options when your computer is connected to the Internet.

Getting started

Exploring the possibilities of Neural Filters might turn out to be the most fun you have with this book. Let's first take a look at the files you'll work with.

● **Note:** If Bridge isn't installed, the File > Browse In Bridge command in Photoshop will start the Creative Cloud desktop app, which will download and install Bridge. After installation completes, you can start Bridge. For more information, see page 3.

1 Start Photoshop, and then simultaneously hold down Ctrl+Alt+Shift (Windows) or Command+Option+Shift (macOS) to restore the default preferences. (See "Restoring default preferences" on page 5.)

2 When prompted, click Yes to delete the Adobe Photoshop Settings file.

3 Choose File > Browse In Bridge to open Adobe Bridge.

4 In Bridge, click Lessons in the Favorites panel. Double-click the Lesson15 folder in the Content panel.

5 Compare the files 15Restore.psd and 15Restore_End.psd, 15Colorize.psd and 15Colorize_End.psd, and 15Composite.psd and 15Composite_End.psd. Using Neural Filters, you'll create the finished files in just a few clicks.

Exploring the Neural Filters workspace

Note: If Photoshop displays a dialog box telling you about the difference between saving to Cloud Documents and On Your Computer, click Save On Your Computer. You can also select Don't Show Again, but that setting will deselect after you reset Photoshop preferences.

1 In Bridge, double-click the 15Restore.psd file to open it in Photoshop. If the Embedded Profile Mismatch dialog box appears, click OK.

2 Save the document as **15Restore_Working.psd** in the Lesson15 folder.

3 Choose Filter > Neural Filters.

In the Neural Filters workspace, the image appears in a large preview area on the left, and the Neural Filters panel is on the right:

- When you select a filter, its options appear in the Neural Filters panel.

- To use a filter, it must be enabled. A filter is enabled when its toggle switch is moved to the right position and in color. You can enable multiple filters.

- If the selected filter recognizes faces in the image, they're listed in the thumbnail preview menu at the top of the options. In the document, a blue rectangle indicates the selected face; gray rectangles indicate other detected faces. Select a face in the face menu or in the document.

Note: If the Neural Filters command is not available, make sure a visible layer is selected.

- To compare the current filter results with the original image, click the Show Original icon at the bottom of the workspace to select it and display the original layer. Click again to deselect it and preview the filter results again.

- When a document has multiple layers, the Layer Preview button controls whether the preview displays one layer or the entire document.

- Along the left side, the top two tools let you paint a mask to hide filter effects from some areas, similar to the layer masks you edited in Chapters 6 and 8.

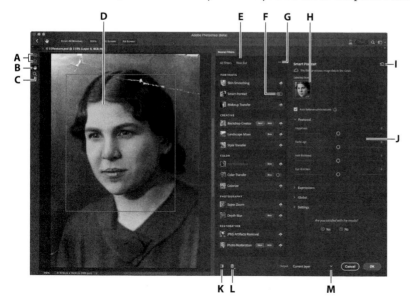

A. Add To Selection and Subtract From Selection tools

B. Hand tool

C. Zoom tool

D. Selected face

E. Filter lists

F. Filter toggle, enabled

G. Use Graphics Processor (GPU) option

H. Thumbnail menu for selecting a detected subject, such as a face

I. Reset filter options to default settings

J. Options for the selected Neural Filter

K. Show Original/Preview Changes button

L. Show current layer or all layers (Layer Preview)

M. Output options

Restoring an antique portrait photo

● **Note:** Adobe may update Neural Filters after this book is published, so the list of categories and filters you see may depend on the version of Photoshop you are using. Also, if Adobe updates how Neural Filters effects are trained, you may see different results than those in this chapter.

To learn more about Neural Filters, let's see how they can help restore old photos.

1 In the filters list, scroll down to the Restoration category, and click the toggle switch next to the Photo Restoration filter to enable and apply it. (If options are not available and a Download button appears instead, click the Download button because it means the filter is not yet installed. When the download completes, the filter will install itself and be ready for you to use.)

A. *Photo Enhancement*
B. *Enhance Face*
C. *Scratch Reduction*

● **Note:** Some Neural Filters may be labeled Beta, which means they function but are still under development. You can use them, but when the finished version is released, those filters may produce different results or some options may be different.

2 To compare the changes with the original, click the Show Original button at the bottom of the workspace. Click once to hide the changes and see the original, and click again to preview the changes again. If you don't notice a change, zoom in to 100% or higher magnification.

3 As needed, adjust the first two Photo Restoration options, and then repeat step 2 to check your work:

 • We left Photo Enhancement at its default value of 50.

 • We reduced Enhance Face to 15 to preserve more of the original film texture.

4 Scroll up or zoom out as needed until you can see the top of the image. That part of the photo print is scratched and torn.

5 Adjust Scratch Reduction to about 20. A progress bar at the bottom of the image may indicate that it will take a little while. When it's done, the scratch is intelligently removed, which you can verify using the Show Original button.

▶ **Tip:** If you increase the value of a Neural Filter option, watch out for negative side effects on some parts of the image. it's typically better to leave minor spots and wrinkles, cleaning them up quickly using the retouching techniques you learned in Lesson 2.

6 You greatly improved this image using the Restoration Neural Filter. For Output, choose Smart Filter, and then click OK to exit Neural Filters. Close the document, saving your changes.

Adding color and depth blur

You can use Neural Filters to colorize black-and-white images and add depth blur.

1 In Bridge, double-click the 15Colorize.psd file to open it in Photoshop. If the Embedded Profile Mismatch dialog box appears, click OK.

2 Save the document as **15Colorize_Working.psd** in the Lesson15 folder.

3 Choose Filter > Neural Filters.

4 In the filters list, scroll down to the Color category, and click the toggle switch next to the Colorize filter to enable it. Make sure Auto Color Image is selected.

● **Note:** If the Colorize options aren't available because the filter needs to be downloaded, download it.

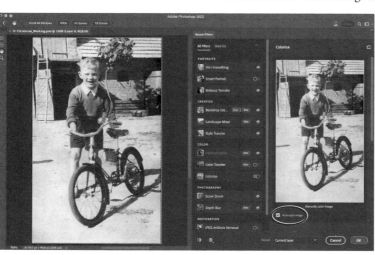

The Colorize filter applies assumed colors to objects and regions it recognizes, such as the leaves on the tree and the boy's skin and clothing. If you disagree with a color choice Colorize made (for example, if the shirt is not all the same color), you can apply custom colors to specific areas.

▶ **Tip:** For a different look, select a Profile. If the result is too strong, reduce the Profile Strength, and make any other changes you like using the other Adjustments options.

Tip: If the results of the Colorize filter aren't perfect, you can combine it with manual Photoshop techniques. For example, after closing Neural Filters, add a new layer that uses the Color blending mode, and paint on that layer to colorize the image under it.

5 In the preview image on the right, click to add a new color focal point over an area you want to change, and set its color using the color picker below the image. Repeat for other areas where you want to change the color.

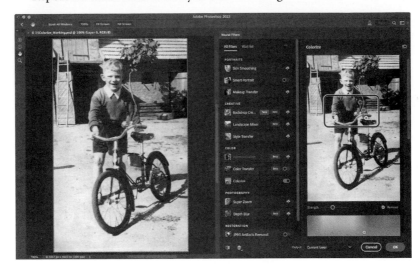

6 In the Photography category in the filters list, click the toggle switch next to the Depth Blur filter to enable it (download it if needed).

7 Adjust filter options as needed until you like the result. We disabled the Focus Subject option because it included part of the tree, and we set our Focal Range to 40 so that more of the bicycle remains in focus.

8 You've brought this image back to life! For Output, choose Smart Filter, and then click OK to exit Neural Filters. Close the document, saving your changes.

About Output options in Neural Filters

A Neural Filter may provide several options for applying filter results to the document, in the Output menu. The number of options you see may be different than in the figure below, depending on which filter and filter options are selected. Your choice affects the amount of editing flexibility you have later.

Current Layer applies the result to the selected layer. This permanently alters the original layer. The only way to back out of it is to undo it before you close and save the document. We recommend using one of the following options instead, because they leave the current layer intact.

New Layer applies the result to a full copy of the selected layer, leaving that original unchanged.

New Layer Masked applies the result to a copy of the selected layer with the changed areas showing through a layer mask. This helps ensure that areas of the image that were not supposed to be changed remain as they are on the original layer.

Smart Filter applies the result to a Smart Object created from the selected layer. You can edit the filter settings later by double-clicking that layer's Neural Filters instance in the Layers panel.

New Document applies the result to a duplicate document containing the filter results on one layer.

The choice you make can depend on the balance you want between flexibility and file size. Additional layers and Smart Objects provide more editing freedom, but tend to create larger file sizes.

When you make multiple edits within a filter, such as changing multiple faces differently in a group portrait, all changes are included in the output. For example, if you apply Smart Portrait and Style Transfer to the same layer, all of those results are applied to a single layer or Smart Filter.

Neural Filters might not produce perfect results right away. By applying Neural Filters results as a separate masked layer, you can freely blend them with the original layer to achieve a more convincing result, while still saving many steps compared to traditional, more labor-intensive methods.

Creating a more convincing composite

When compositing multiple images, the images may not be consistent in tone and color. Some Neural Filters can help resolve this.

1 In Bridge, double-click the 15Composite.psd to open it in Photoshop. If the Embedded Profile Mismatch dialog box appears, click OK.

2 Save the document as **15Composite_Working.psd** in the Lesson15 folder. Click OK in the Photoshop Format Options dialog. This image will become a thumbnail image for a video, but the color palette and subject need to be closer to the look of the art director's concept.

3 In the Layers panel, make sure the Planet layer is selected, and then choose Filter > Neural Filters.

4 In the filters list, scroll down to the Creative category, and click to enable the toggle switch next to the Landscape Mixer filter (if needed, download it first). The Landscape Mixer filter can apply the look of one landscape image to another. Depending on the landscape images you mix, you can even change a scene from summer to winter or fill a desert image with green foliage.

▶ **Tip:** You can use your own image to drive the style applied by Landscape Mixer. Click Custom, click Select An Image, and open an image from your computer. Also, Landscape Mixer options let you adjust attributes such as the amount of Day or Night and the time of year. For example, you can add snow by increasing the Winter value.

5 In the Landscape Mixer options, click different Presets to experiment with how each of them alters the landscape attributes of the layer.

6 Click the third preset. That's the one to use for this project.

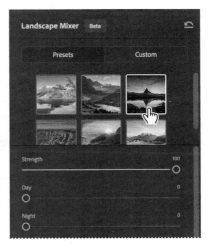

7 For Output, choose Smart Filter, and then click OK to apply the changes.

8 In the Layers panel, click the eye icon for the Heroine layer to make it visible. Its tone and color doesn't quite match up with the landscape, so let's improve that.

9 With the Heroine layer selected, choose Filter > Neural Filters, and in the Color category in the filters list, click to enable the toggle switch next to the Harmonization filter (if needed, download it first). The Harmonization filter helps match the color and tone of a layer to another layer in the document.

10 In the Reference Image section, click Select A Layer, and select Planet.

The color and tone of the Heroine layer change to better match the color and light of the Planet layer, but it could be improved.

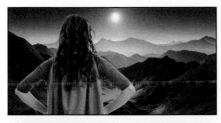
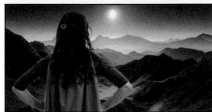

11 In the Harmonization options, drag the Cyan/Red slider about one-third of the way toward Red, drag Saturation to about +15, and reduce Brightness to about −30. Make any other adjustments that make the composite more convincing. Remember to use the Show Original button to check your work.

▶ **Tip:** The best thing you can do to make your composite images the most convincing is to make sure all of your original images are consistent in as many ways as possible—not only color and tone, but other visual details such as the quality of lighting (including sources, angles, and shadows), lens focal length, and camera distance from the ground.

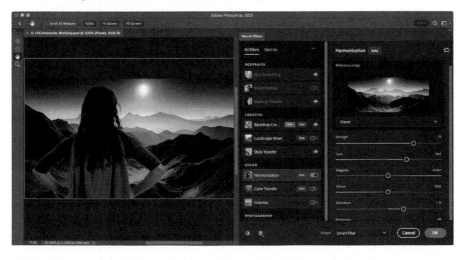

12 For Output, choose Smart Filter, and then click OK to apply the changes.

► Tip: Neural Filters results might not always produce perfect results right away. But remember that you can output the results to a separate masked layer, so you can blend them with the original layer to achieve a more convincing result, still saving many steps compared to more labor-intensive methods.

13 In the Layers panel, click the eye icon for the Guardian type layer to make it visible.

You've completed the video thumbnail … nice work! You used Neural Filters to transform the look of both images in just a few steps, making them work together to match the mood and the look of the production.

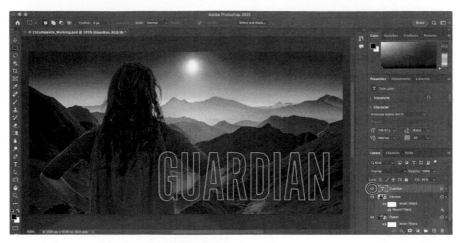

14 Save your work, and close the document.

You've learned the basics of using Neural Filters. The results created in this lesson required only a few steps each; for example, retouching the old images was almost no work compared to the steps you learned in Lesson 2 and Lesson 5.

You're ready to explore the possibilities of the Neural Filters with your own images!

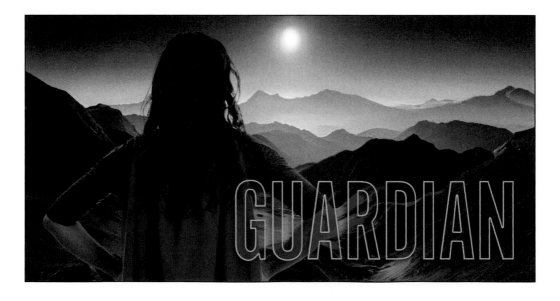

Finding the filter or effect you want

It can be a challenge to find the right filter or effect, because Photoshop offers them in multiple places in the workspace and menus, and some filters are similar to others. Here is a quick guide to the places to find filters and effects in Photoshop:

General filters are on the Filter menu and its submenus. Not every filter is visible on the submenus, so also remember to look inside the next two filter galleries.

Filter Gallery (Filter > Filter Gallery) offers many conventional (algorithmic) filters, such as Diffuse Glow and Mosaic Tiles. These are mostly intended for creative effects.

Neural Filters (Filter > Neural Filters) offer filters trained by machine learning. They can produce results that are better than, or not possible with, conventional filters.

To explore all your options, keep those multiple filter locations in mind. For example, if you want to improve skin complexion, you can use the more traditional multistep technique in Lesson 12 that uses the Surface Blur filter, compare that to the results you get from using the one-step Skin Smoothing filter in Neural Filters, and choose the result you think is better for a specific image.

Layer styles are nondestructive, easy ways to apply drop shadows, glows, and other effects you have tried in this book. You can find them by clicking the fx button at the bottom of the Layers panel or on the Layer > Layer Style submenu.

As you have practiced in this book, even a destructive filter (permanently altering layer pixels) can be applied nondestructively (allowing edits or removal later) if the layer is a Smart Object. You can prepare a selected layer for nondestructive filtering by first choosing Filter > Convert For Smart Filters.

To combine filters on a layer, you can typically apply each filter in turn. In a filter gallery dialog box or workspace (Filter Gallery, Neural Filters, and Blur Gallery), you can combine multiple filters before you exit the dialog box or workspace.

Neural Filters gallery

In addition to the Neural Filters you try in the lesson, this gallery shows examples of other Neural Filters included with Photoshop. Some are useful for restoring and correcting images; others are fun ways to explore creatively. Adobe may update or change the available Neural Filters, so the exact list of Neural Filters in Photoshop may depend on the version installed on your computer.

Before *After*

Before *After*

Smart Portrait lets you tune details of portraits such as emotions, facial expressions, facial age, and gestures such as which way the eyes are looking. In this example, the head was turned slightly forward.

Skin Smoothing can reduce acne, blemishes, and other skin irregularities, while preserving the overall character of the skin, and maintaining the sharpness of facial features such as eyes.

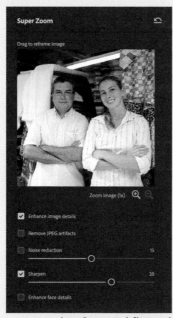

Image © mangostock. Shutterstock

Super Zoom, 3x

Super Zoom is a convenient way to enlarge part of a photo to use as a portrait. For example, you can pick out one person in a group photo and create an enhanced, sharpened enlargement for a profile picture. Or, if a person's face is too small in the middle of a smartphone photo, you can fill more of the frame with their face. Unlike many scaling methods, Super Zoom offers detail enhancement, noise reduction, and JPEG artifact removal powered by machine learning. Super Zoom is optimized for portraits, but you can try it with other types of subjects.

Before *After*

JPEG Artifacts Removal helps reduce unsightly side effects produced by applying JPEG image compression at a low quality setting. JPEG artifacts are typically seen as banding or blocks in areas that should be smooth. Although it's always better to use the highest quality version of an image, JPEG Artifacts Removal might save the day when a low-quality JPEG image is all that's available to you.

Before *After*

Style Transfer lets you apply the artistic style of one image to another image. You can choose from a range of Artist Styles presets and then customize the look further using the filter's options. You can even apply your own style by clicking the Custom tab and selecting an image from your computer.

Improving Photoshop with your usage data and images

An important way that software developers improve features based on machine learning is to train them using examples of good results and bad results. Any company that uses machine learning needs a way to train the models that their software uses, ideally using examples that represent the interests of the customers of the software. But many software developers don't have very large data sets of actual customer files, and even if they store customer files in the cloud, they typically do not have customers' permission to use their files to train software.

To make it easier to improve Photoshop, Adobe added a Product Improvement pane to the Preferences dialog box in Photoshop. The purpose of the Photoshop Improvement Program is to request permission to use your images and usage data to help improve Photoshop features; this is not necessarily limited to machine learning. The "Yes, I'd like to participate" option is disabled by default, but if you want to participate, you can enable it. When it's enabled, Adobe researchers may collect usage data, cloud documents, and other images you edit in Photoshop.

Whether or not you participate in the Photoshop Improvement Program is partly a personal decision. You may want to participate if you think your usage data might help improve how well Photoshop handles the kinds of image editing that you do.

However, if you work for a company or organization that handles confidential documents, if you need to protect the privacy or proprietary data of your clients, or if you are legally bound by nondisclosure agreements, you should be aware of the potential consequences of participating in the Photoshop Improvement Program.

For more information about how your usage information is handled, see the Adobe Product Improvement Program web page at adobe.com/privacy/apip.html.

Review questions

1 How does a filter in Neural Filters differ from other filters in Photoshop?

2 How does an Internet connection affect how you use Neural Filters?

3 Why is it typically best to choose any Neural Filters output option except Current Layer?

4 How can Neural Filters help restore digitized images of old prints and slides?

5 How can Neural Filters help with compositing multiple images?

Review answers

1 Neural Filters are trained using machine learning, so they are capable of results that are not attainable using conventional algorithmic filters.

2 If you are connected to the Internet, you can download Neural Filters and use Neural Filters that process image data in the cloud. If you choose to participate in the Photoshop Improvement Program, an Internet connection allows your usage data and images to be sent to Adobe for use by researchers.

3 The Current Layer option applies the results of Neural Filters to the selected layer, permanently changing it (destructive editing). The other Output options apply the results of Neural Filters to a separate layer or as a Smart Filter, maintaining a layer's original state, so that you can start over at any time (nondestructive editing).

4 The Photo Restoration Neural Filters (and possibly Super Zoom) can help improve the quality of digitized images of old prints and slides. The Colorize Neural Filter can re-create colors for a black-and-white photo. JPEG Artifacts Removal can improve images that were saved at a low-squality JPEG compression setting. Depth Blur can help focus attention on the subject of a photo.

5 Neural Filters such as Landscape Mixer, Harmonization, and Color Transfer can help unify a composite by making its layers more visually consistent with each other.

Appendix: Tools panel overview

Photoshop Tools panel (when the Essentials workspace is selected)

- Move (V)
- Rectangular Marquee (M)
- Lasso (L)
- Object Selection (W)
- Crop (C)
- Frame (K)
- Eyedropper (I)
- Spot Healing Brush (J)
- Brush (B)
- Clone Stamp (S)
- History Brush (Y)
- Eraser (E)
- Gradient (G)
- Blur
- Dodge (O)
- Pen (P)
- Horizontal Type (T)
- Path Selection (A)
- Rectangle (U)
- Hand (H)
- Zoom (Z)

The Move tool moves selections, layers, and guides.

The Artboard tool moves, resizes, and adds artboards.

The marquee tools make rectangular, elliptical, single-row, and single-column selections.

The lasso tools make free-hand, polygonal (straight-edged), and magnetic (snap-to) selections.

The Object Selection tool creates a tight selection when you click it over a subject it identifies or after you drag it around a subject.

The Quick Selection tool lets you quickly "paint" a selection defined by edges and contrast.

The Magic Wand tool selects similarly colored areas.

The crop tools trim, straighten, and change the perspective of images.

The Frame tool creates placeholder rectangles so you can design now and drop in final artwork later.

The Slice tool divides an image into regions that can be exported as separate images.

The Slice Select tool selects slices for editing.

The Eyedropper tool samples colors in an image.

The 3D Material Eyedropper tool loads selected material from a 3D object.

The Color Sampler tool samples up to four areas of an image.

The Ruler tool measures distances, locations, and angles.

The Note tool makes text notes that can be included with a document.

The Count tool counts objects in an image, for statistical image analysis.

The Spot Healing Brush tool quickly removes blemishes and imperfections from photographs that have a uniform background.

Continues on next page

Appendix: Tools panel overview (continued)

The Healing Brush tool paints with a sample or pattern to repair imperfections in an image.

The Patch tool repairs imperfections in a selected area of an image, using a sample or pattern.

The Content-Aware Move tool recomposes and blends pixels to accommodate a moved object.

The Red Eye tool removes red eye in flash photos with one click.

The Brush tool paints strokes using the current Brush Settings.

The Pencil tool paints hard-edged strokes.

The Color Replacement tool paints the current foreground color while preserving existing texture and details.

The Mixer Brush tool blends the brush's loaded color with an existing color.

The Clone Stamp tool paints with a sample of an image.

The Pattern Stamp tool paints with a part of an image as a pattern.

The History Brush tool paints a copy of the selected state or snapshot into the current document window.

The Art History Brush tool paints stylized strokes that simulate the look of different paint styles.

The Eraser tool replaces pixels with the current background color (for a Background layer) or with transparency (for a non-Background pixel layer).

The Background Eraser tool replaces pixels with transparency, detecting the background by sampling the color you first drag over.

The Magic Eraser tool replaces similarly colored areas with transparency in one click.

The Gradient tool creates linear, radial, angle, reflected, and diamond blends between colors.

The Paint Bucket tool fills similarly colored areas with the foreground color.

The 3D Material Drop tool drops the material loaded in the 3D Material Eyedropper tool onto the targeted area of a 3D object.

Continues on next page

Appendix: Tools panel overview (continued)

The Blur tool softens edges and details.

The Sharpen tool increases local contrast.

The Smudge tool shifts pixels in the direction you drag, resulting in a directional blur.

The Dodge tool lightens areas in an image.

The Burn tool darkens areas in an image.

The Sponge tool changes the color saturation of an area.

The pen tools draw and modify precise vector paths.

The type tools create text on an image.

The type mask tools create a selection in the shape of type.

The path selection tools make shape or segment selections showing anchor points, direction lines, and direction points.

The shape tools and Line tool draw vector graphics as paths or as a shape layer.

The Custom Shape tool adds a vector graphic selected from customizable Shape presets.

The Hand tool repositions the view of an image within its window.

The Rotate View tool turns the canvas for easier stylus painting and drawing.

The Zoom tool magnifies and reduces the view of an image.

Appendix: Keyboard shortcuts

Learning the shortcuts for tools and commands you use most often can save you time. Want to customize them? Choose Edit > Keyboard Shortcuts. While there, click Summarize to export a list updated with your own shortcuts.

Tools *Each group of tools in the Tools panel shares a shortcut. Press Shift+ the letter key repeatedly to cycle through hidden tools. This list is based on the Essentials workspace. Other workspaces may change tool groupings and keyboard shortcuts, so if a shortcut isn't working for you, check which workspace is active.*

Move tool	V	Gradient tool	G
Artboard tool	V	Paint Bucket tool	G
Rectangular Marquee tool	M	3D Material Drop tool	G
Elliptical Marquee tool	M	Dodge tool	O
Lasso tool	L	Burn tool	O
Polygonal Lasso tool	L	Sponge tool	O
Magnetic Lasso tool	L	Pen tool	P
Object Selection tool	W	Freeform Pen tool	P
Quick Selection tool	W	Curvature Pen tool	P
Magic Wand tool	W	Horizontal Type tool	T
Crop tool	C	Vertical Type tool	T
Perspective Crop tool	C	Horizontal Type Mask tool	T
Slice tool	C	Vertical Type Mask tool	T
Slice Select tool	C	Path Selection tool	A
Frame tool	K	Direct Selection tool	A
Eyedropper tool	I	Rectangle tool	U
3D Material Eyedropper tool	I	Ellipse tool	U
Color Sampler tool	I	Triangle tool	U
Ruler tool	I	Polygon tool	U
Note tool	I	Line tool	U
Count tool	I	Custom Shape tool	U
Spot Healing Brush tool	J	Hand tool	H
Healing Brush tool	J	Rotate View tool	R
Patch tool	J	Zoom tool	Z
Content-Aware Move tool	J	Default Foreground/Background Colors	D
Red Eye tool	J	Swap Foreground/Background Colors	X
Brush tool	B	Toggle Standard/Quick Mask Modes	Q
Pencil tool	B	Toggle Screen Modes	F
Color Replacement tool	B	Toggle Lock Transparent Pixels	/
Mixer Brush tool	B	Decrease Brush Size	[
Clone Stamp tool	S	Increase Brush Size]
Pattern Stamp tool	S	Decrease Brush Hardness	{
History Brush tool	Y	Increase Brush Hardness	}
Art History Brush tool	Y	Previous Brush	,
Eraser tool	E	Next Brush	.
Background Eraser tool	E	First Brush	<
Magic Eraser tool	E	Last Brush	>

Application menus *These shortcuts are for Windows. For macOS, substitute Command for Ctrl and Option for Alt.*

File

New	Ctrl+N
Open	Ctrl+O
Browse in Bridge	Alt+Ctrl+O
Close	Ctrl+W
Close All	Alt+Ctrl+W
Close Others	Alt+Ctrl+P
Close and Go to Bridge	Shift+Ctrl+W
Save	Ctrl+S
Save As	Shift+Ctrl+S
Save a Copy	Alt+Ctrl+S
Revert	F12
Export > Export As (entire document)	Alt+Shift+Ctrl+W
Export > Save for Web (Legacy)	Alt+Shift+Ctrl+S
File Info	Alt+Shift+Ctrl+I
Print	Ctrl+P
Print One Copy	Alt+Shift+Ctrl+P
Exit/Quit	Ctrl+Q

Edit

Undo	Ctrl+Z
Redo	Shift+Ctrl+Z
Toggle Last State (of undo/redo)	Alt+Ctrl+Z
Fade	Shift+Ctrl+F
Cut	Ctrl+X or F2
Copy	Ctrl+C or F3
Copy Merged	Shift+Ctrl+C
Paste	Ctrl+V or F4
Paste Special > Paste in Place	Shift+Ctrl+V
Paste Special > Paste Into	Alt+Shift+Ctrl+V
Search	Ctrl+F
Fill	Shift+F5
Content-Aware Scale	Alt+Shift+Ctrl+C
Free Transform or Free Transform Path	Ctrl+T
Transform > Again	Shift+Ctrl+T
Color Settings	Shift+Ctrl+K
Keyboard Shortcuts	Alt+Shift+Ctrl+K
Menus	Alt+Shift+Ctrl+M
Preferences > General	Ctrl+K

Image

Adjustments >	
Levels	Ctrl+L
Curves	Ctrl+M
Hue/Saturation	Ctrl+U
Color Balance	Ctrl+B
Black & White	Alt+Shift+Ctrl+B
Invert	Ctrl+I
Desaturate	Shift+Ctrl+U
Auto Tone	Shift+Ctrl+L
Auto Contrast	Alt+Shift+Ctrl+L
Auto Color	Shift+Ctrl+B
Image Size	Alt+Ctrl+I
Canvas Size	Alt+Ctrl+C
Record Measurements	Shift+Ctrl+M

Layer

New > Layer	Shift+Ctrl+N
New > Layer via Copy	Ctrl+J
New > Layer via Cut	Shift+Ctrl+J
Quick Export (selected layers)	Shift+Ctrl+'
Export As (selected layers)	Alt-Shift+Ctrl+'
Create/Release Clipping Mask	Alt+Ctrl+G
Group Layers	Ctrl+G
Ungroup Layers	Shift+Ctrl+G
Hide/Show Layers	Ctrl+,
Arrange >	
Bring to Front	Shift+Ctrl+]
Bring Forward	Ctrl+]
Send Backward	Ctrl+[
Send to Back	Shift+Ctrl+[
Lock Layers	Ctrl+/
Merge Down/Merge Layers	Ctrl+E
Merge Visible	Shift+Ctrl+E

Select

All	Ctrl+A
Deselect	Ctrl+D
Reselect	Shift+Ctrl+D
Inverse	Shift+Ctrl+I or Shift+F7
All Layers	Alt+Ctrl+A
Find Layers	Alt+Shift+Ctrl+F
Select and Mask	Alt+Ctrl+R
Modify > Feather	Shift+F6

Filter

Last Filter	Alt+Ctrl+F (Windows), Control+Command+F (macOS)
Adaptive Wide Angle	Alt+Shift+Ctrl+A
Camera Raw Filter	Shift+Ctrl+A
Lens Correction	Shift+Ctrl+R
Liquify	Shift+Ctrl+X
Vanishing Point	Alt+Ctrl+V

3D

Render 3D Layer	Alt+Shift+Ctrl+R

View

Proof Colors	Ctrl+Y
Gamut Warning	Shift+Ctrl+Y
Zoom In	Ctrl++ or Ctrl+=
Zoom Out	Ctrl+-
Fit on Screen	Ctrl+0
100%	Ctrl+1 or Alt+Ctrl+0
Extras	Ctrl+H
Show > Target Path	Shift+Ctrl+H
Show > Grid	Ctrl+'
Show > Guides	Ctrl+;
Rulers	Ctrl+R
Snap	Shift+Ctrl+;
Lock Guides	Alt+Ctrl+;

Window

Actions	Alt+F9
Brush Settings	F5
Color	F6
Info	F8
Layers	F7

Help

Photoshop Help (Discover panel)	Ctrl+F

INDEX

M

Mac, differences in work area 13
machine learning 378
macros. *See* actions
Magic Eraser tool 395
Magic Wand tool 54, 58–59, 392
Magnetic Lasso tool 54, 67–68, 392
magnification. *See* Zoom tool
 document 14–16
 Timeline panel 269
magnifying glass. *See* Zoom tool
mandalas, painting 257
marching ants. *See* selection marquee
marquee tools 54
masks 148
 in Adobe Camera Raw 309
 creating 149–152
 inverting 161
 overview 148
 refining 153–159
 terminology 149
 vector 149
Match Font command 192
megapixels 35
memory (hardware) 3
Merge Visible command 106
merging
 images 132
 images into a panorama 122
 images with different
 perspectives 141–144
 layers 105
 multiple Photoshop files 221
mistakes, correcting 25–31
Mixer Brush tool 394
 about 244
 cleaning the brush 249
mixing colors
 with a photograph 251
 with Mixer Brush tool 248
mobile devices
 designing for, with artboards 343
 using with libraries 212
monitor calibration 360
motion blur effects 121
Motion dialog box 270, 274
Motion workspace 267
Move tool 392
 Auto-Select option 103
 moving selections 60
 scissors icon 69
 using 26
moving
 layers. *See* Move tool
 panels 27
 selections 60–61
Multiply blending mode 86
muting audio 279–280

N

navigating
 in Adobe Camera Raw 287
 keyboard shortcuts 356
 using the Navigator panel 16
 with the Zoom tool 13–14
Navigator panel 16
Neural Filters 378, 117
 compared to other filters 387
 downloading filters 380
 Output options 383
 previewing changes 380
 using 379
noise, reducing 48
nondestructive filters 224
notes. *See* Note tool
 deleting 189
 Notes panel 187
Note tool 187, 393
nudging layers 347
nudging selections 63

O

Object Selection tool 61–62, 108, 392
on-image adjustment tool. *See* targeted
 adjustment tool
opacity, changing 84–85
opening images in Camera Raw 286
Open Object button (in Camera Raw) 301
OpenType font format 174, 191
OpenType SVG 191
options bar
 compared to panels 29–30
 overview 23–24
 reference point icon 343
 setting type options in 23
organizing photos 302–303
out-of-gamut color 362–363
output options, Neural Filters 383
output resolution, determining 35
Overlay blending mode 85, 86

P

Paint Bucket tool 395
painting
 layers 230
 wetness options 246
 with the Mixer Brush tool 242–256
painting gallery 258
Paint Symmetry option 257
panels
 compared to options bar 29
 docking 27
 expanding and collapsing 28–29
 moving to another group 27
 overview 27–28
 resizing 28
 reveal hidden side panels 27
 undocking 27
panning
 with the Hand tool 397
 with the Navigator panel 16
panoramas
 in Adobe Camera Raw 315
 in Photoshop 122–125
Pan & Zoom option 270, 276
Paper Color option 364
paper, simulating white 364

Paragraph panel 28
paragraph styles 181
paragraph type 176
Paste command 79
Paste in Place command 71
Paste Into command 71, 240
Paste Outside command 71
Paste Profile Mismatch dialog box 238
Paste Without Formatting
 command 71, 187
pasting layers 79
Patch tool 45, 394
Path Blur 120–121, 121
paths
 about 197
 adding type to 181–182
 closing 199
 compared to shapes 205
 converting to/from selection 208
 drawing 198–203
 drawing curved segments 199
 drawing straight segments 199
 editing 207
 moving 207
 saving 199
Path Selection tool 207, 397
Paths panel
 using 200
 work path 199
patterns
 Pattern command 107, 170
 Pattern Preview command 107, 168
 Patterns panel 215
 Pattern Stamp tool 395
patterns, creating 107, 167
Pavlov, Victoria 259
PDF. *See* Photoshop PDF file format
Pencil tool 394
Pen tool 396. *See also* paths
 drawing paths 198–202
 keyboard shortcut 197
 overview 197–198, 199
 as selection tool 198
 setting options 200–201
Perspective Crop tool 392
Perspective Warp command 141
Photomerge 122–125
photo restoration, manual 42–43
Photo Restoration Neural Filter 380
Photoshop PDF file format 189, 369
pincushion distortion 129
Pin Light blending mode 86
pixel dimensions 35
pixels
 compared to vector graphics 196
 defined 10
 path tools option 205
 resolution and 35
pixels per inch 35
Placed Linked command 322
Place Embedded command 178, 339, 340
placeholders 321
planes, Perspective Warp 142
playhead, in the Timeline panel 272

Pearson's Commitment to Diversity, Equity, and Inclusion

Pearson is dedicated to creating bias-free content that reflects the diversity of all learners. We embrace the many dimensions of diversity, including but not limited to race, ethnicity, gender, socioeconomic status, ability, age, sexual orientation, and religious or political beliefs.

Education is a powerful force for equity and change in our world. It has the potential to deliver opportunities that improve lives and enable economic mobility. As we work with authors to create content for every product and service, we acknowledge our responsibility to demonstrate inclusivity and incorporate diverse scholarship so that everyone can achieve their potential through learning. As the world's leading learning company, we have a duty to help drive change and live up to our purpose to help more people create a better life for themselves and to create a better world.

Our ambition is to purposefully contribute to a world where:

- Everyone has an equitable and lifelong opportunity to succeed through learning.

- Our educational products and services are inclusive and represent the rich diversity of learners.

- Our educational content accurately reflects the histories and experiences of the learners we serve.

- Our educational content prompts deeper discussions with learners and motivates them to expand their own learning (and worldview).

While we work hard to present unbiased content, we want to hear from you about any concerns or needs with this Pearson product so that we can investigate and address them.

- Please contact us with concerns about any potential bias at
 https://www.pearson.com/report-bias.html.

Production Notes

Adobe Photoshop Classroom in a Book (2023 release) was created electronically using Adobe InDesign. Art was produced using Adobe InDesign, Adobe Illustrator, and Adobe Photoshop. The Myriad Pro and Warnock Pro OpenType families of typefaces were used throughout this book. For information about OpenType and Adobe fonts, visit adobe.com/type/opentype/.

References to company names in the lessons are for demonstration purposes only and are not intended to refer to any actual organization or person.

Images

Photographic images and illustrations are intended for use with this book's lessons only.

Lesson 4 ukulele image from Adobe Stock, stock.adobe.com

Lesson 15 head shots: © Djomas, Shutterstock; photo of pair in fabric shop: © mangostock, Shutterstock; restoring an antique photo: © Oleksandra Vasylenko, Shutterstock; Martian landscape with craters: © Jurik Peter, Shutterstock; photo of boy with bicycle: © Elzbieta Sekowska, Shutterstock; Red cape superhero : © sunlight19, Shutterstock

Team credits

The following individuals contributed to the development of *Adobe Photoshop Classroom in a Book (2023 release)*:

Writer and Designer: Conrad Chavez

Illustrator and Compositor: David Van Ness

Project Manager: Anne-Marie Praetzel

Copyeditor and Proofreader: Kim Wimpsett

Keystroke Reviewer: Megan Ahearn

Indexer: Conrad Chavez

Technical Reviewer: David Van Ness

Production Assistant: Jéssica Jordão

Interior design: Mimi Heft

Art Director: Andrew Faulkner

Adobe Press Executive Editor: Laura Norman

Adobe Press Production Editor: Tracey Croom

Adobe Press Associate Editor: Anshul Sharma

Contributors

Jay Graham began his career designing and building custom homes. He has been a professional photographer for more than 25 years, with clients in the advertising, architectural, editorial, and travel industries. He contributed the "Pro photo workflow" tips in Lesson 12. www.jaygraham.com

Lisa Farrer is a photographer based in Marin County, CA. She contributed photography for Lesson 5.

Julieanne Kost is a veteran Adobe product evangelist.

Gawain Weaver has conserved and restored original works by artists ranging from Eadweard Muybridge to Man Ray, and from Ansel Adams to Cindy Sherman. He contributed to "Real-world photo restoration" in Lesson 2. www.gawainweaver.com

Special Thanks

We offer our sincere thanks to Stephen Nielson, Joel Baer, Russell Brown, Rikk Flohr, Steve Guilhamet, Meredith Payne Stotzner, Jeff Tranberry, and Pete Green for their support and help with this project. We couldn't have done it without you!